THE ART OF

SKETCH THEATRE

VOLUME 1

BABY TATTOO BOOKS • SKETCHTHEATRE.COM

LOS ANGELES

The Art of Sketch Theatre: Volume 1

"Baby Tattoo," "Baby Tattoo Books" and logo are trademarks of Baby Tattoo Books®.

ISBN: 978-1-61404-003-3

First Edition
This book was printed with 3 collectible covers.
10 9 8 7 6 5 4 3 2 1

Edited by Liliana Feliciano
Designed by Eric Carl

Published by
Baby Tattoo Books®
Los Angeles
www.babytattoo.com

Manufactured in China
Fabriqué en Chine

· TABLE *of* CONTENTS ·

THE ARTISTS

FOREWORD

by NEVILLE PAGE, CONCEPT DESIGNER

To say that I am very fortunate to have the career that I do would be a gross understatement. My job on a daily basis is to draw, sculpt, paint and create cool stuff. What's more, I get to do it along side others who are equally as fortunate and passionate.

I chose to be in my career because I was inspired. I always had the inherent desire to be creative but, for the most part, had no idea what I was doing. At age twelve, I clearly recall stumbling across a book in a garage sale for seventy-five cents that changed everything, *The Art of Frank Frazetta*: the sketches, the painting and yes, the boobs. They all had a profound impact on me. Boobs aside, I was immediately inspired with a honed focus on art and design. Ralph McQuarrie, Joe Johnston and Rick Baker, their gifts were my goals, and those goals have been realized. And, I have even had the great fortune to personally thank Rick Baker for planting the seed.

Here, the same has been done with *The Art of Sketch Theatre* — a repository of inspiration. I look at these artists no differently than I did the aforementioned. You should never stop being inspired. And, with the collection of artists gathered in this book, it will be impossible not to want to sharpen your pencils and either dream of a career in their respective fields or of doing better at the one you may already have. There is more that I would like to say, but as I look at the pages ahead, I am more inspired to go sharpen my own pencils.

Always remember to share the love and inspire others.

Neville Page
Lead Creature Supervisor and Illustrator, *Avatar*
Concept Designer, *Super 8*
Lead Concept Designer, *TRON: Legacy*
Lead Creature/Character Designer, *Star Trek*
Lead Creature Designer, *Cloverfield*

INTRODUCTION

by LILIANA FELICIANO

Each artist represented in this book has graced me with a preeminent moment in time, just enough to capture on camera their current flux of emotion with the beauty of lines.

They inspire us by demonstrating what skill and persistence applied to the creative mind can achieve. Here, you find a voyage with a multitude of destinations. Within each lies a compelling lesson on the art of being an artist.

Liliana Feliciano
Executive Producer, SketchTheatre.com

"My role in society, or any artist's or poet's role, is to try and express what we all feel. Not to tell people how to feel. Not as a preacher, not as a leader, but as a reflection of us all." — **John Lennon**

The
· SKETCH THEATRE ·
MISSION

SKETCH THEATRE EXISTS FOR ONE EXPRESS PURPOSE — TO EXPOSE YOU TO THE MYRIAD career opportunities available for creative individuals. Whether you're interested in comics, tattooing, painting, illustration, graphic design, fashion, animation, creating films or making music, there are more opportunities for artists today than there have ever been in history.

Through Sketch Theatre, we hope to inspire you to the realization that if you are an artist, that it is more than ok — it is a gift of potential that holds no shame in being fulfilled.

Sketch Theatre exposes aspiring artists to successful creative individuals and the various career paths they have taken. These artists all began their careers by grabbing a pen or pencil and expressing their ideas on paper. They work in a variety of fields, support themselves and are proud to call themselves artists.

When visiting SketchTheatre.com there is also the music, an essential key of inspiration. We are inspired and motivated by music more often than any other form of creative expression. Whether sitting in the dark with headphones, spinning some old vinyl, going to a concert, listening to the radio or being moved by the score of a film, music is universal and omnipresent in our lives.

We hope you get inspired... and enjoy the show!

Right: Artist and graphic designer Apricot Mantle sketches for Sketch Theatre.

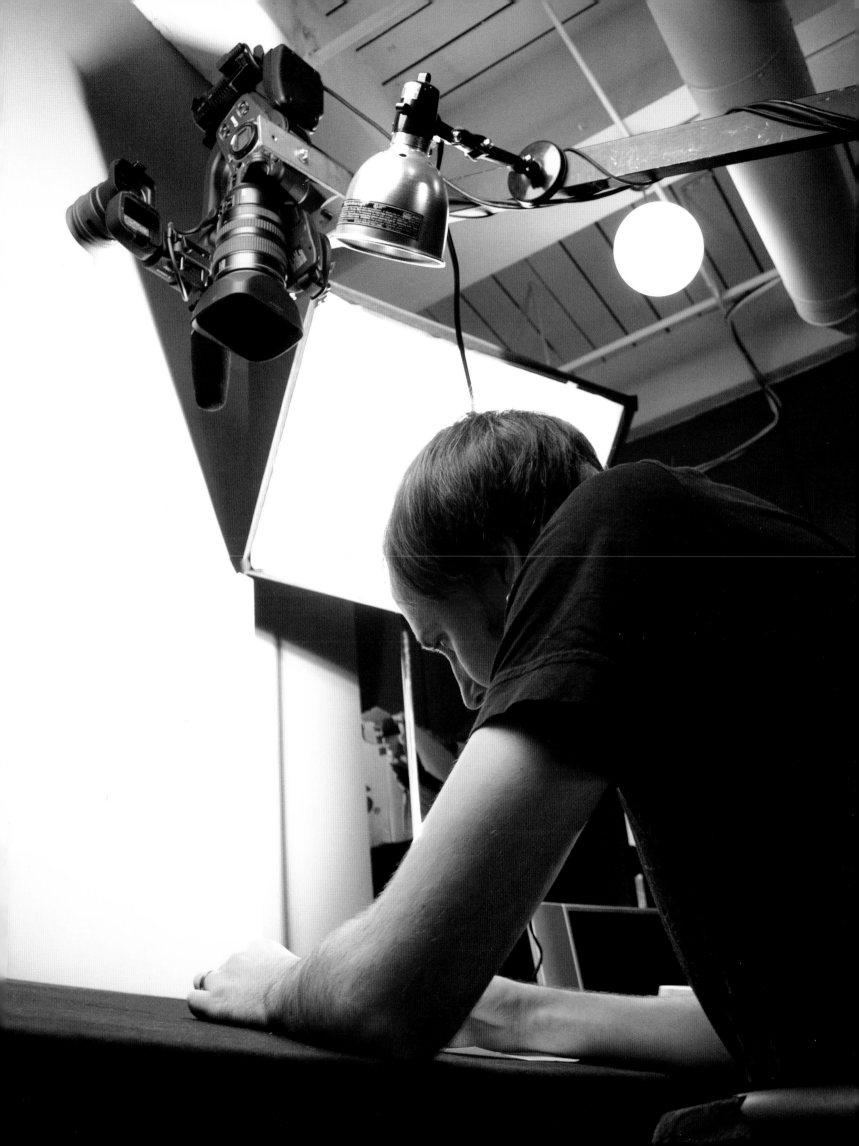

The
ARTISTS

AARON SIMS

IN THE MID-80S, AARON SIMS MOVED TO LOS ANGELES, California to begin his career as a special effects makeup artist. His work quickly attracted the attention of legendary Academy Award winner Rick Baker, with whom Sims collaborated for the next twelve years. During that time, Sims served as a leading special effects artist on some of the most popular, defining movies of the 1990s: *Gremlins 2*, *Batman Forever*, *Mighty Joe Young*, *Nutty Professor*, *How the Grinch Stole Christmas* and *Men in Black*.

Sims embraced the new computer technology with enthusiasm in the mid-90s and began to combine Softimage 3D animation software, Photoshop's painting capabilities and his knowledge and experience as a sculptor and artist.

In the late 1990's, Sims started working for Academy Award winner Stan Winston, who encouraged Sims' pioneering methods. With advanced computers and cutting-edge software, Sims altered the industry's process of design and development. In 2000, Sims introduced his design process to Steven Spielberg and became the lead character designer for *Artificial Intelligence: A.I.* Sims created unprecedented designs for all of Spielberg's robot characters and, in doing so, validated his ground-breaking approach to character creation.

Having raised the bar in the concept design industry, Sims co-created Stan Winston Digital and led the studio as art director and head concept artist on such films as *Constantine*, *Fantastic Four*, *Sky Captain and the World of Tomorrow*, *Eight Below*, *Terminator 3: Rise of the Machines*, Spielberg's *War of the Worlds*, and Tim Burton's *Big Fish*.

Sims' creative approach to concept design using digital technology has had significant effects on the film industry. Softimage development teams have advanced aspects of their software from Sims' creative use of their product. Sims has also inspired many of the current techniques used by top artists and designers in the entertainment industries.

With the same adventurous spirit that fueled his willingness to embrace digital technology, Sims founded The Aaron Sims Company to work on *30 Days of Night*, *The Golden Compass*, *I Am Legend*, *The Day the Earth Stood Still*, *The Chronicles of Narnia: Prince Caspian*, *The Incredible Hulk*, *The Mummy: Tomb of the Dragon Emperor*, *Clash of the Titans* and *Sucker Punch*.

AARON-SIMS.COM

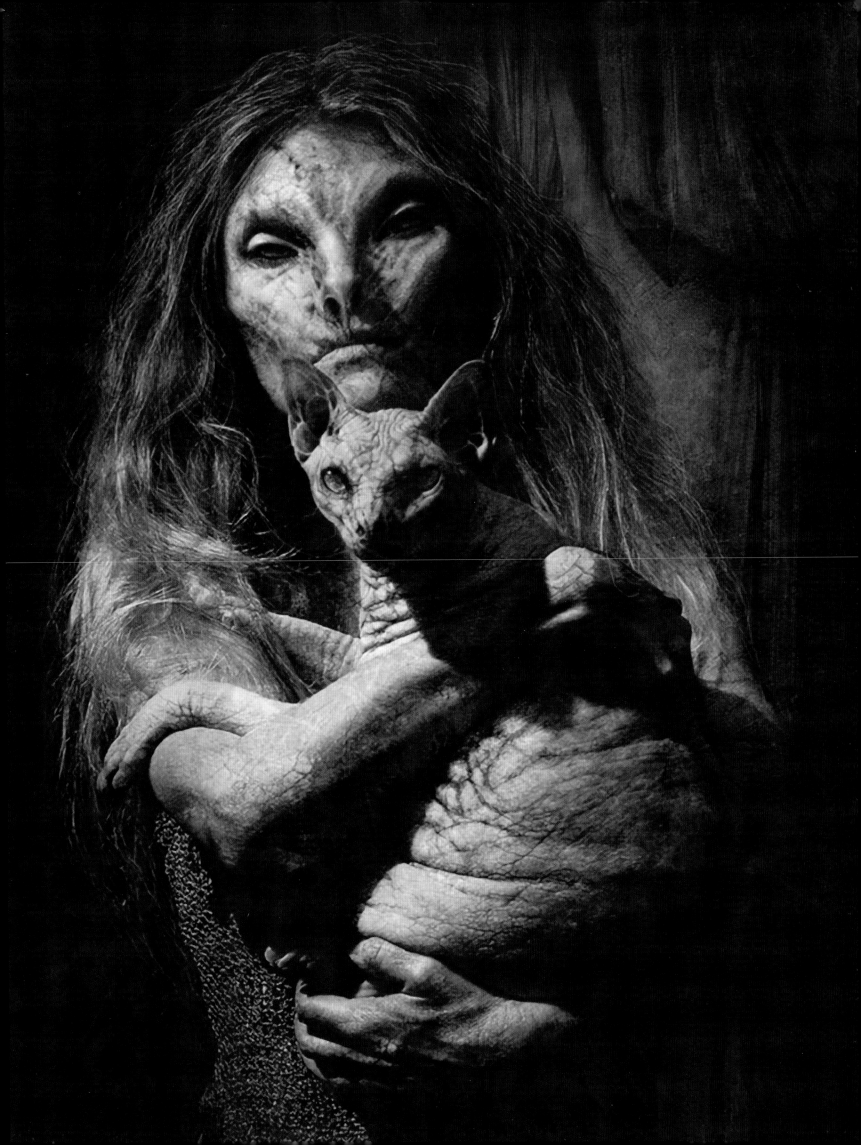

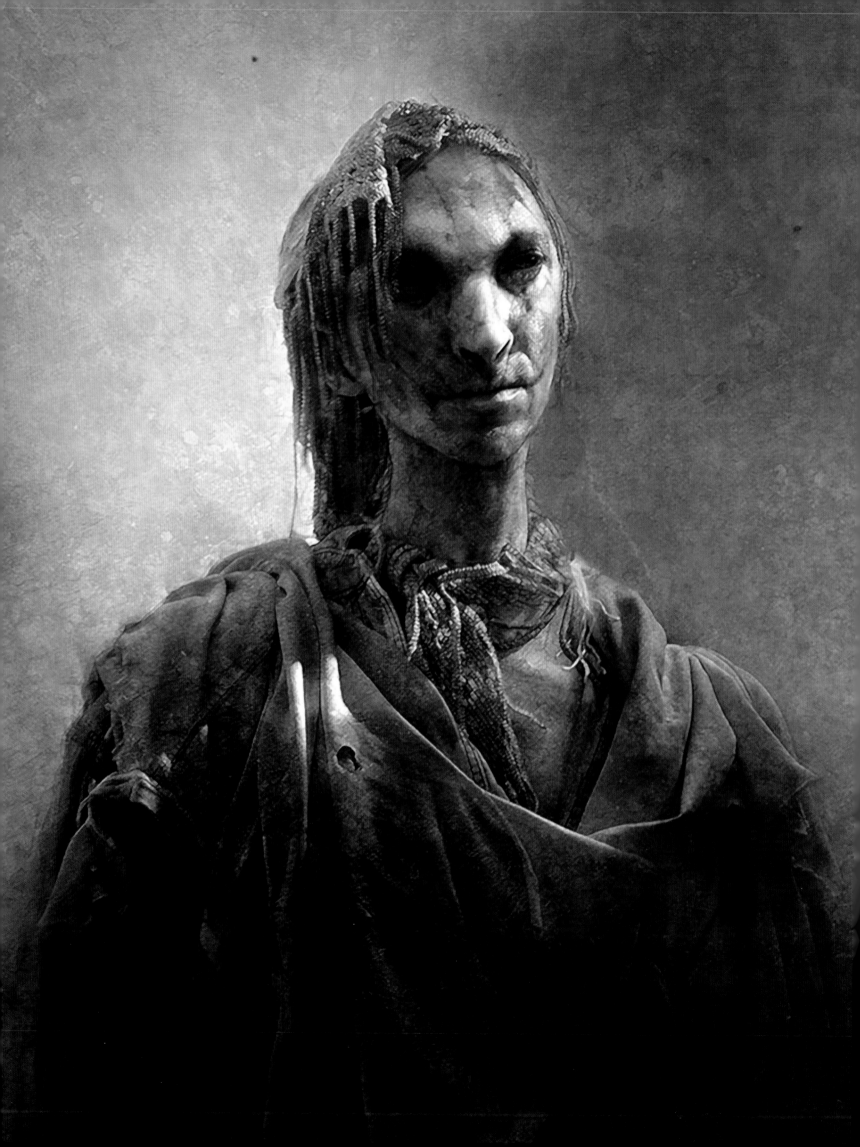

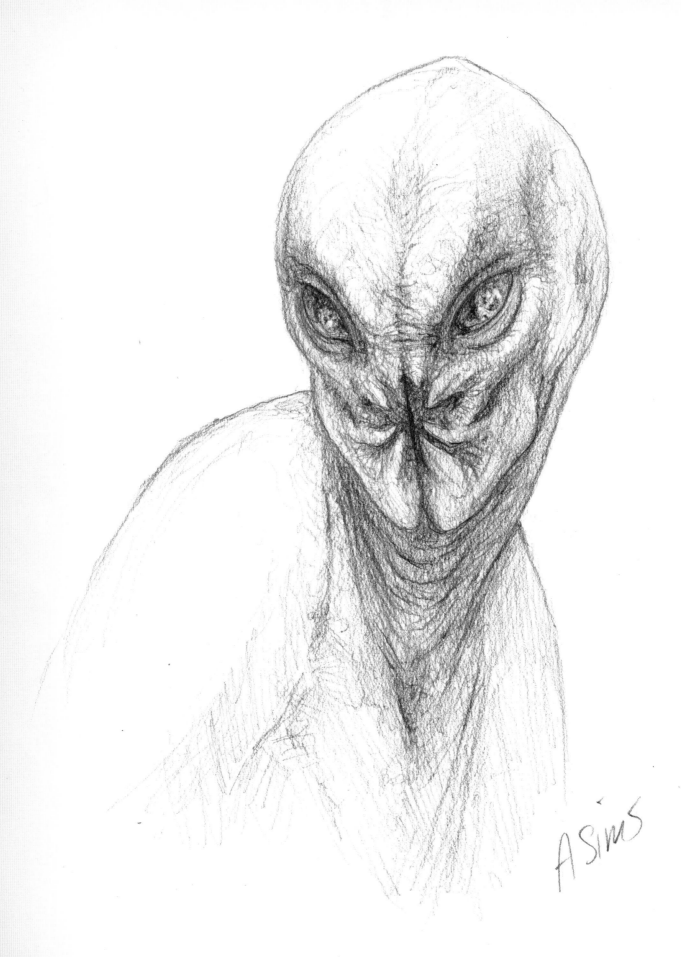

AIMÉE KUESTER

A IMÉE KUESTER IS A SELF-TAUGHT, SECOND-GENERATION painter and charcoal enthusiast. At first glance, one might notice the vivid color palette and dexterity in her oil paintings and the bold textural style of her charcoal work, but beneath the spirited subjects of her work hides a darker vision. Most of the themes in her work toy with the mysterious processes of how people evolve through decisions. Essentially, she is an observer of the cause and effect of human actions.

Aimée was raised near Albuquerque, New Mexico surrounded by tranquil desert in every direction. Immersed in the art culture of the Southwest, she had early exposure to gallery receptions, life drawing and plein air painting trips. Without much outside influence, she absorbed technical skill through observation and art books. It was apparent that drawing was her first language. Her parents mused, "It must be in the blood," as her obsession grew. She accepted her first national award at age six, enjoyed showing work by age eleven and won multiple awards for her first watercolor.

After selling at respected galleries in Santa Fe, New Mexico, she wanted to pursue her dreams in California. She has since become a "sketch theatre sweetheart" and exhibits in galleries all around California. Her paintings are included in numerous private collections worldwide.

Aimée has also done work as a fashion illustrator. Her fine art background allowed her to make an easy transition to conceptualizing costumes. Her infatuation with the female form coupled with her imagination drew the attention of stylists and opened the door to working with clients like Katy Perry and Shakira. She loves working in the concept stage where anything is possible, designing avant-garde pieces that are innovative and dynamic. Aimée's original custom designs are showcased in music videos, international performances, Nickelodeon, MTV, esteemed award ceremonies and more.

AIMEEKUESTER.COM

AIMÉE

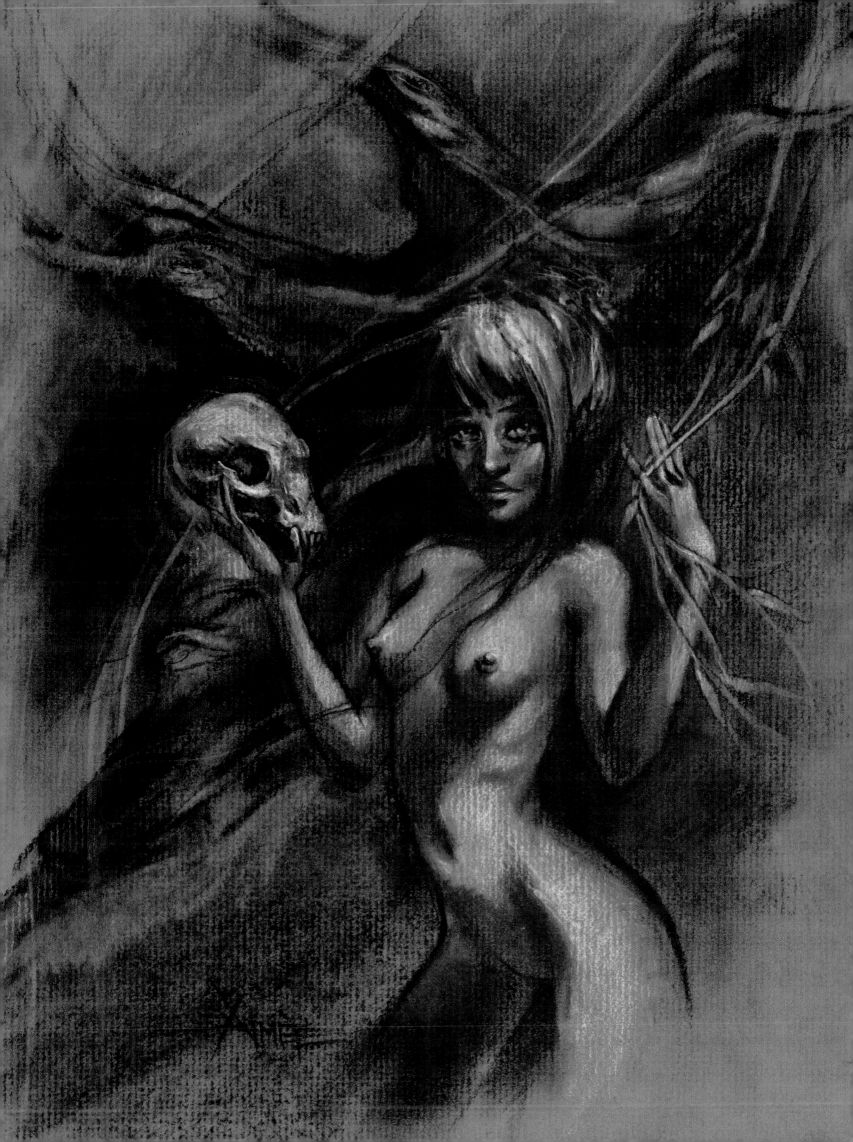

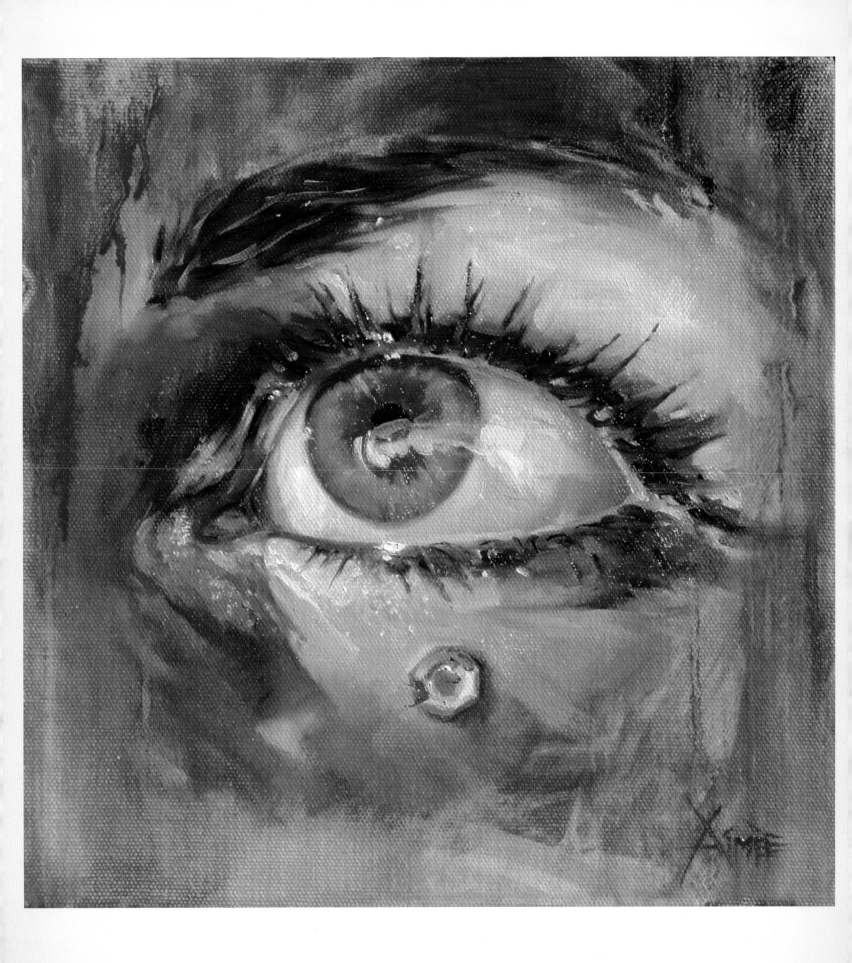

ALEX ALVAREZ

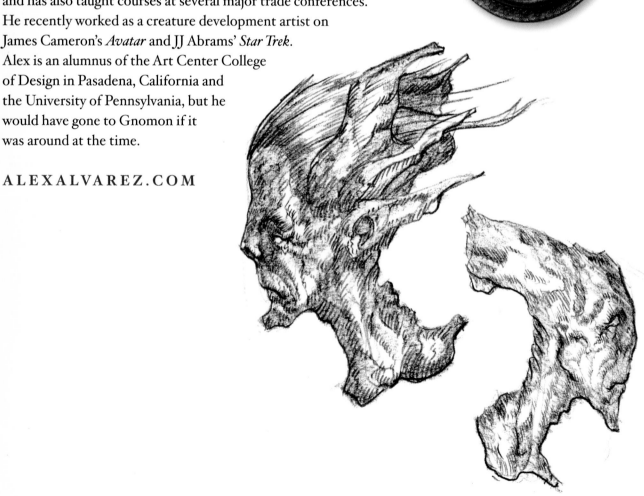

Alex Alvarez is the founder and president of the Gnomon School of Visual Effects in Hollywood, The Gnomon Workshop, Gnomon Gallery, Sketch Theatre, Gnomon Studios and the president/CEO of CG Channel. Having dedicated over a decade to educating students and professional artists around the world, Alex has helped change the face of computer graphics and design education.

Alex has been published in industry magazines, websites and books and has also taught courses at several major trade conferences. He recently worked as a creature development artist on James Cameron's *Avatar* and JJ Abrams' *Star Trek*. Alex is an alumnus of the Art Center College of Design in Pasadena, California and the University of Pennsylvania, but he would have gone to Gnomon if it was around at the time.

ALEXALVAREZ.COM

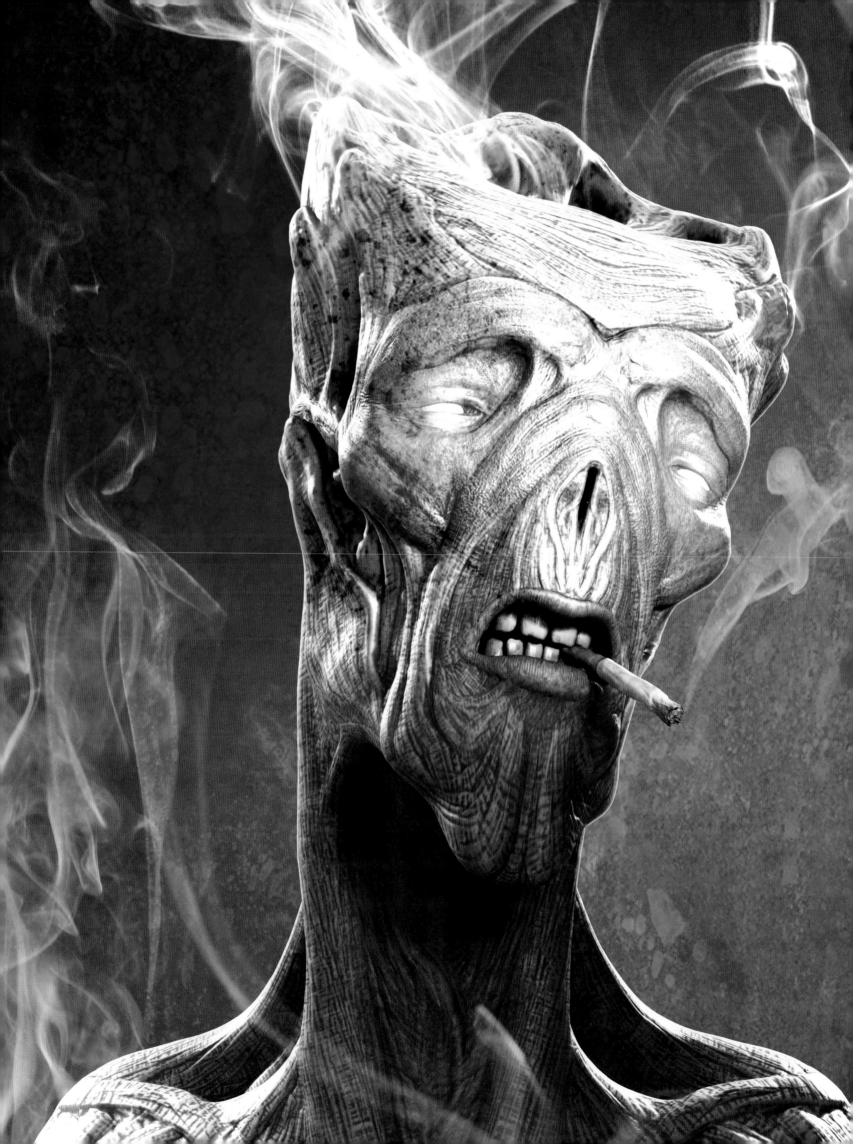

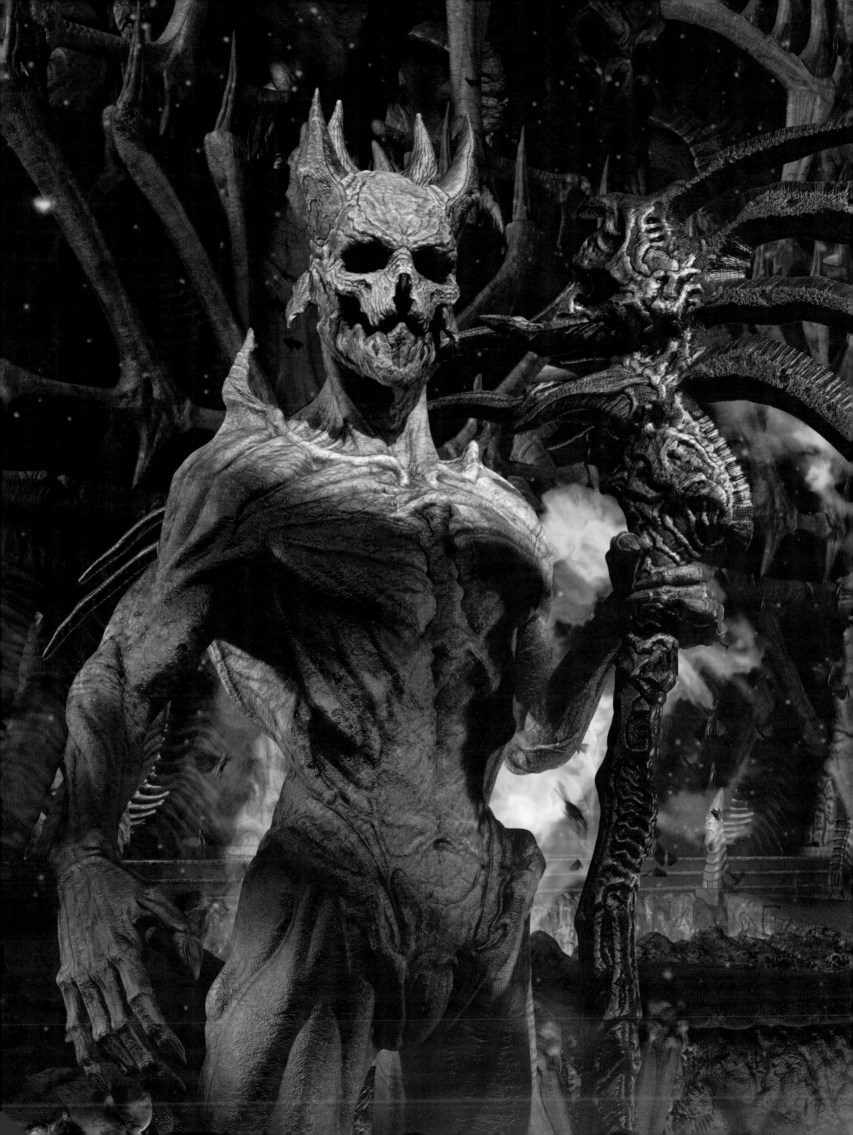

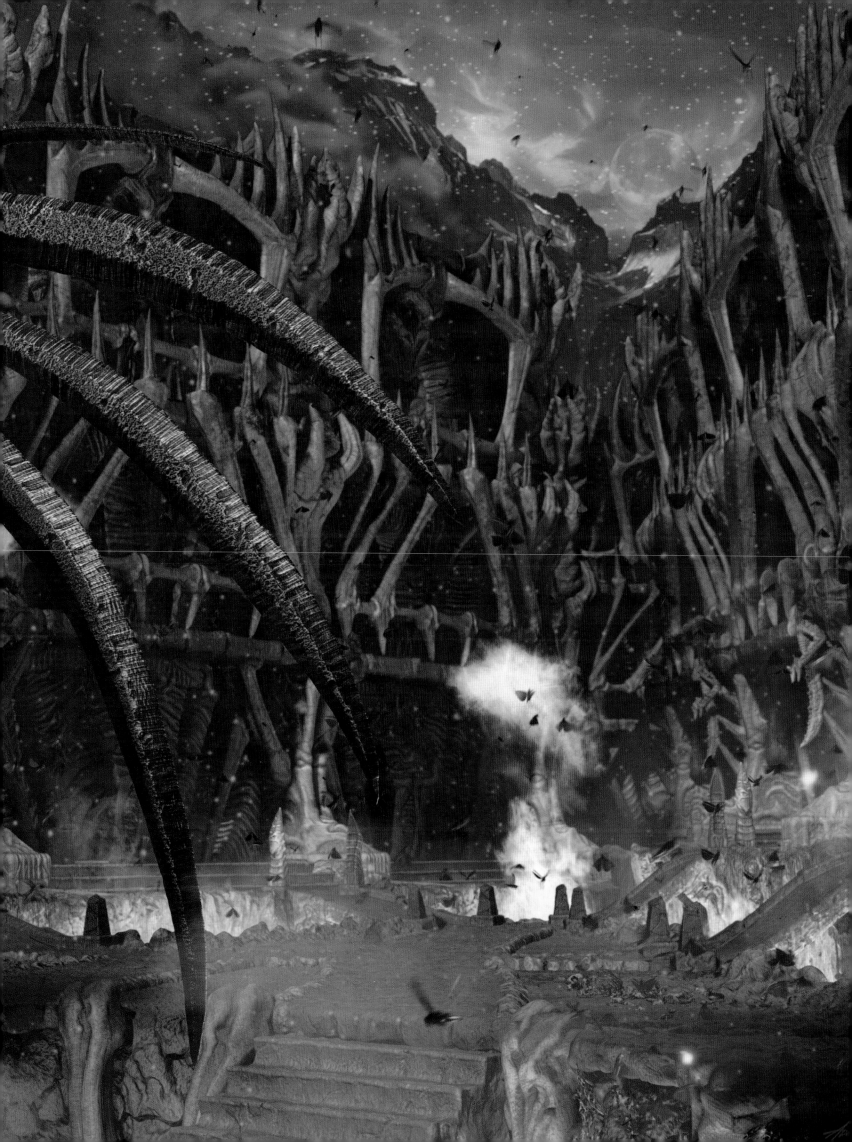

ALVIN LEE

I N 1997, ALVIN LEE BEGAN HIS COMIC BOOK CAREER AT THE
tender age of seventeen and is now a renowned veteran of the
industry. Alvin is one of the few North American-born comic
book artists who is still presently involved in the anime/manga
movement. He has worked with several comic book publishers,
including Marvel, DC/Wildstorm, Dreamwave Productions and
most recently, Udon Comics and Entertainment. Alvin's other titles
include *Deadpool, Agent X, X-Men: Age of Apocalypse, Gen 13* and most
notably his revival of the *Street Fighter* comic book series.

His talent has also led to the game art of two Capcom
videogame titles, *Capcom Fighting Jam* and
the re-release of *Street Fighter 2 Turbo*
for the Xbox 360.

ALVINLEEART.COM

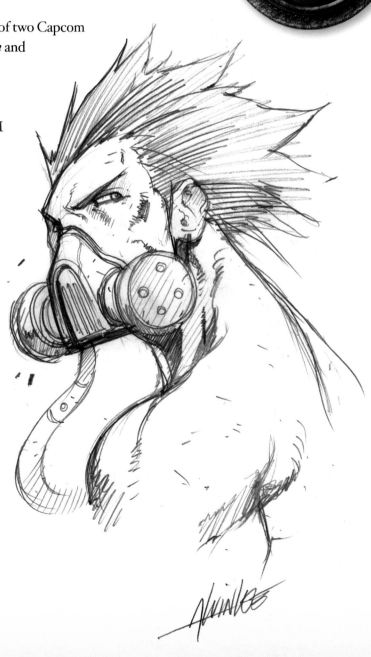

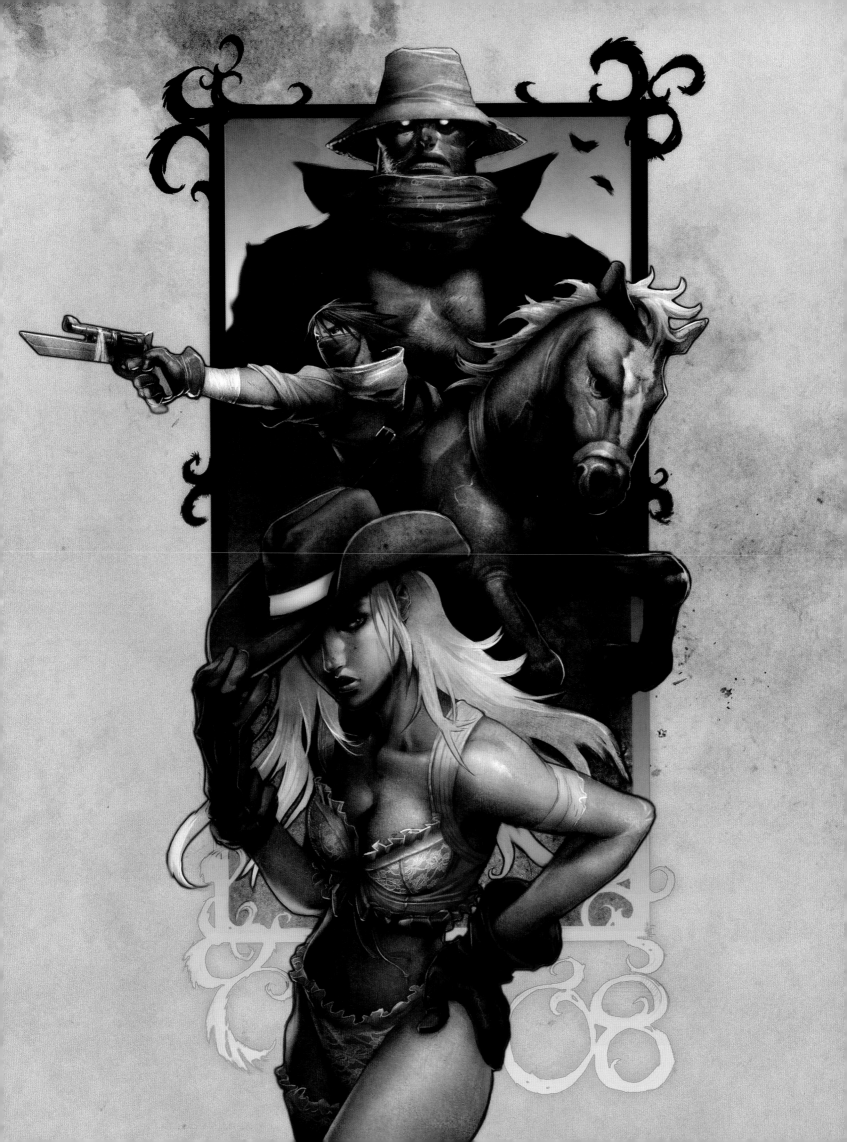

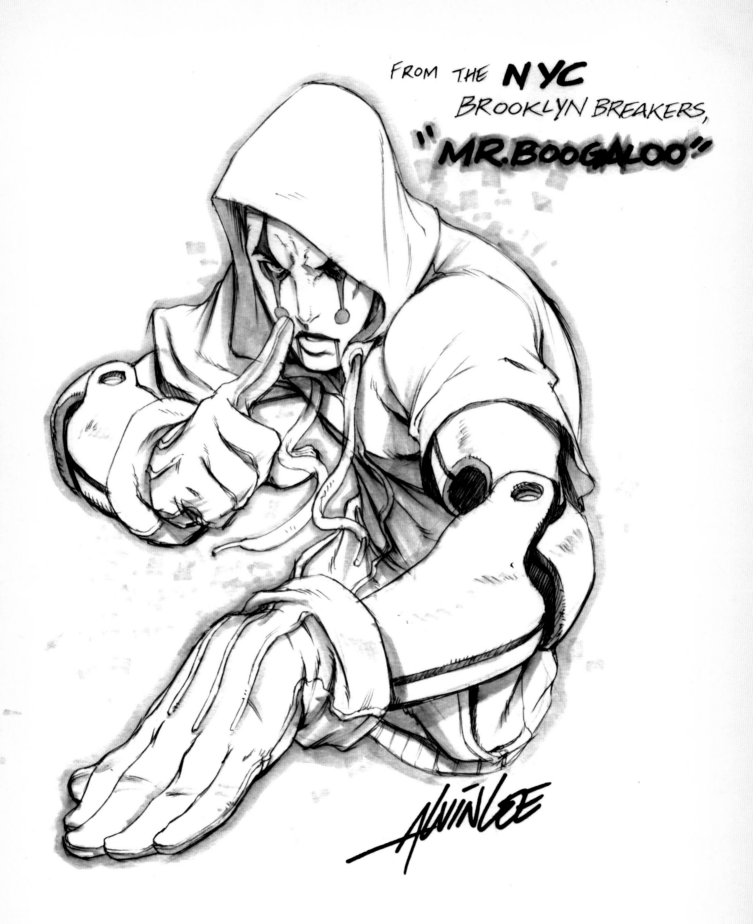

FROM THE **NYC** BROOKLYN BREAKERS, "**MR.BOOGALOO**"

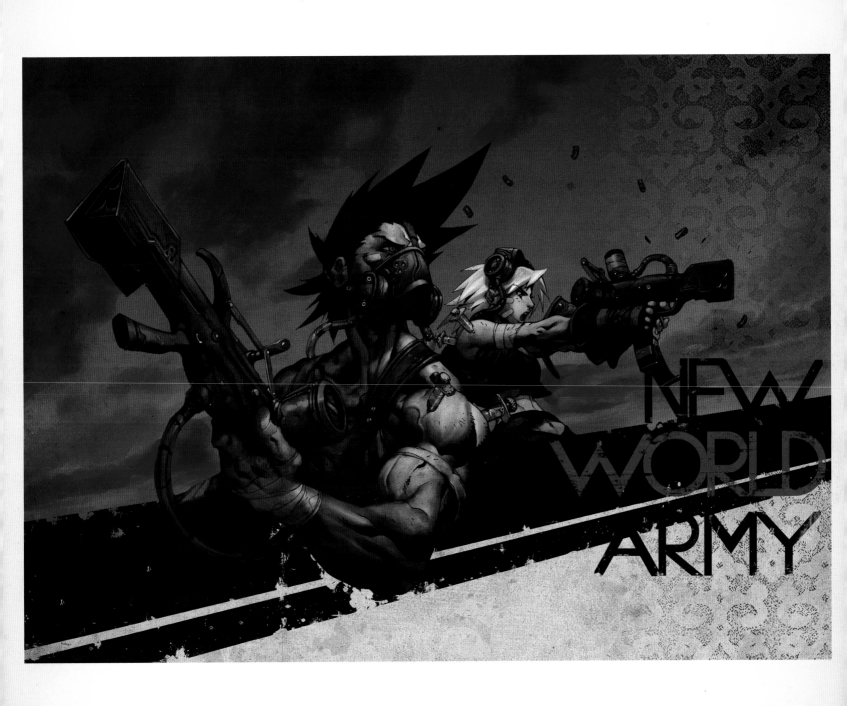

NEW WORLD ARMY

AMY BOTELLO

—————————◆—————————

"**I** LOVE TO PAINT. I HATE TO PAINT. I'VE DONE IT SINCE I WAS barely able to hold a crayon and draw on a placemat at a restaurant. It's a part of me, like it or not. As an only child, I entertained myself by drawing and painting all the silliness that came into my head. As a big child, I'm still doing the same thing. I'm either thrilled with what I create, or I hate it. It's a strange little beast, this creativity.

"I feel that I've been studying art my whole life. As a kid, Frazetta and comic books ruled my world. In high school, at the Los Angeles County High School for the Arts, I studied the old masters and experimented in many forms of visual art. At Associates in Art, I studied classical figurative painting and illustration and marveled at our modern day masters that continue to make me feel like an imposter. After working for ten years in the film industry, I feel that I am finding my creative voice once again, and it feels wonderful... and tortuous."

AMYBOTELLO.COM

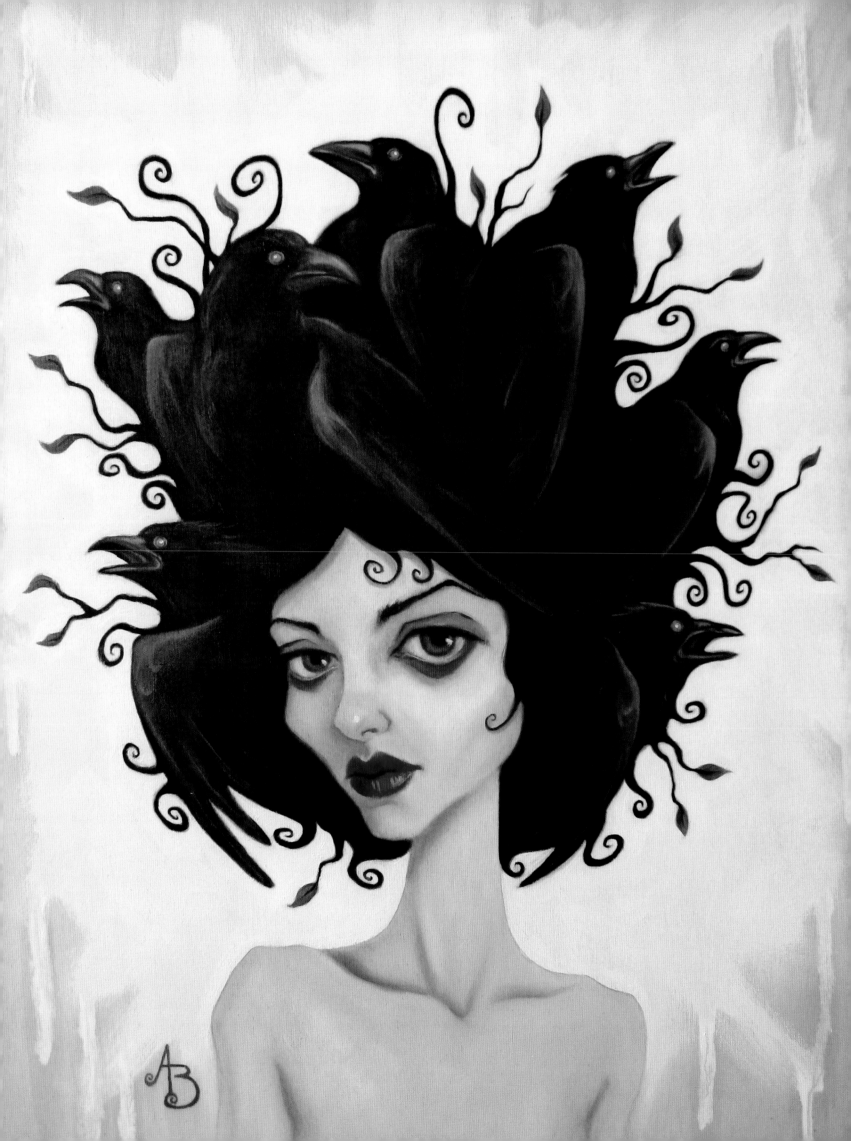

ANA BAGAYAN

Ana Bagayan was born in the capital of Armenia, Yerevan and moved to the United States when she was six years old. In Burbank, California, she frolicked amongst tall grasses and dancing bears until she entered the Art Center College of Design in Pasadena, California, where she earned her bachelor of fine arts in illustration.

Ana's work has been received internationally and has been featured in such publications as *Rolling Stone*, *Spin*, *GQ* and various others. She currently resides in Los Angeles with her boyfriend and their Yoranian puppy named Sushi.

ANABAGAYAN.COM

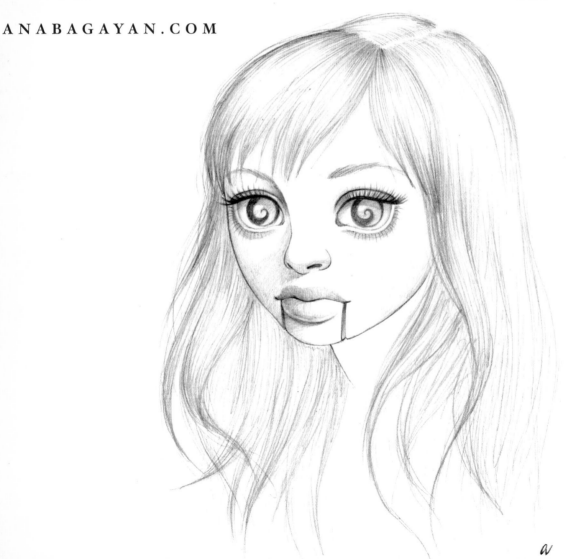

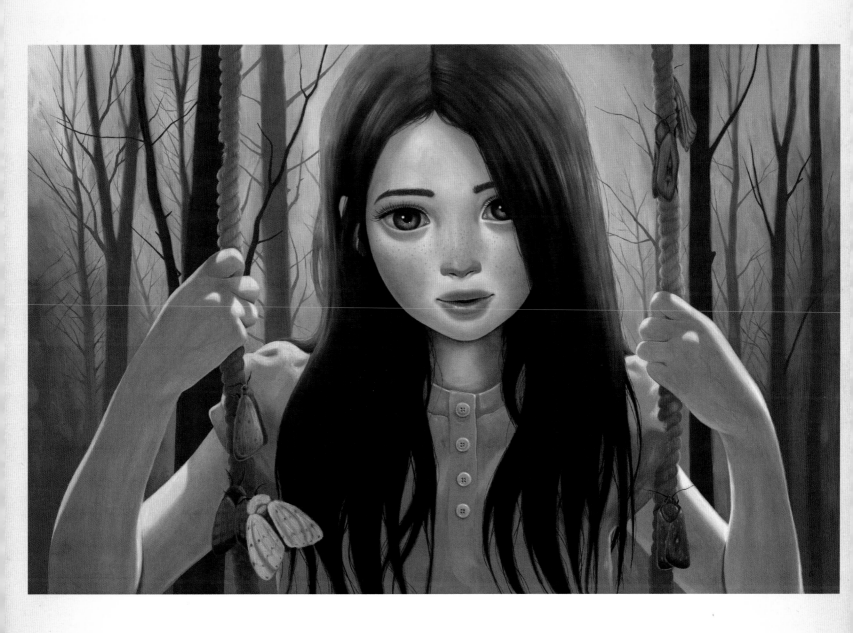

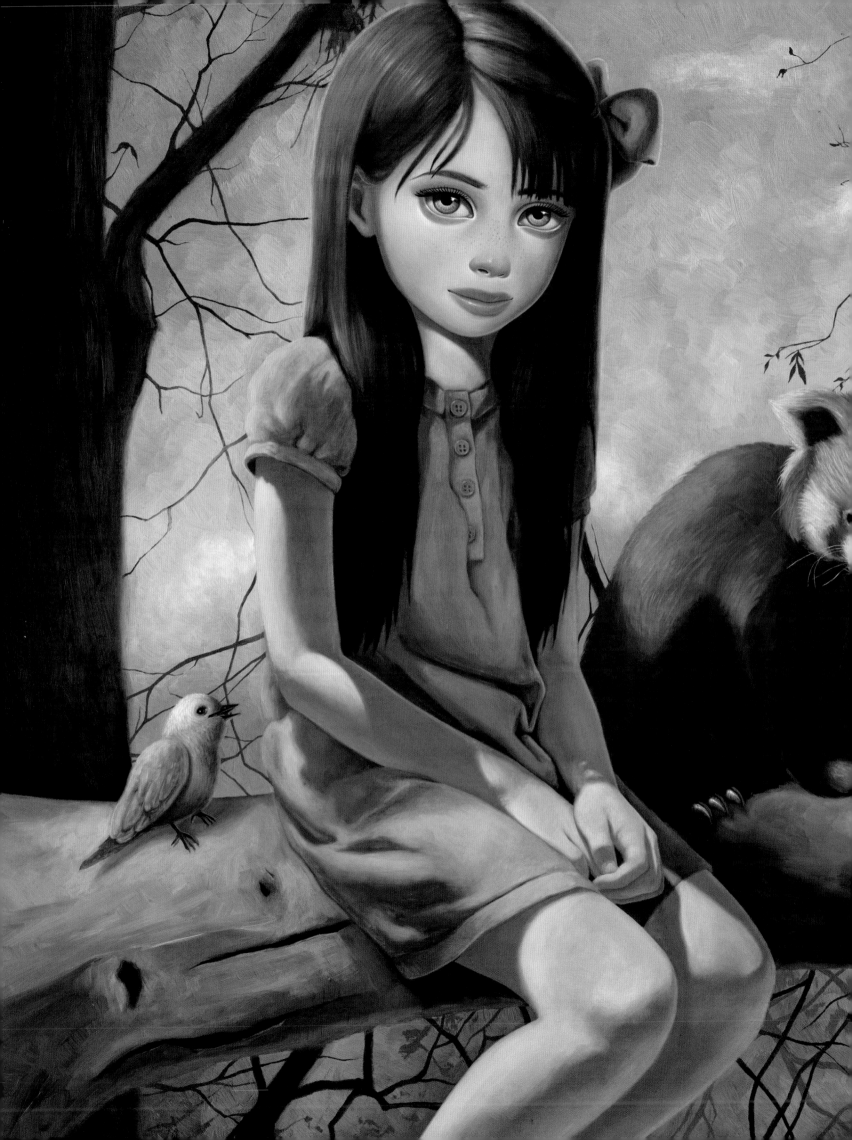

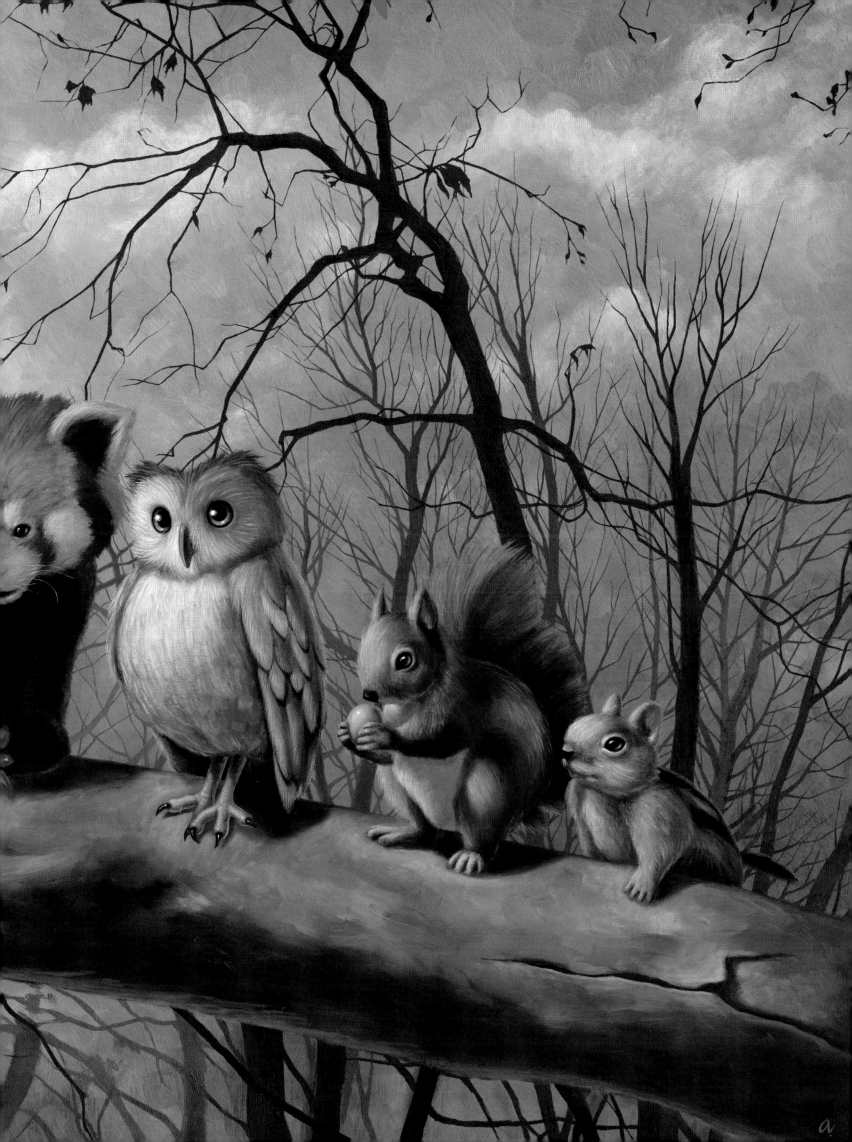

APRICOT MANTLE

APRICOT MANTLE CREATES HIS DRAWINGS WITH PRISMACOLOR pencils. His artwork is inspired by various sci-fi and horror movies, games and urban legends. It is his re-envisioning of the cheesy and kitsch aspects of these genres, fleshed out using vivid colors, strong cartoonistic realism and twisted perspectives.

Using a wide array of fabrication techniques, he builds his own unique, custom frames to continue the concept and theme of the piece beyond paper. He feels that conventional frames oftentimes limit art, restricting it to the confines of a simple rectangle. His work stands out from the wall and often resembles a sort of "art theme park."

The actual building process he uses mimics the same techniques that are used in designing and building props and sets for movies. He was taught by movie special effects engineer Rick Hilgner, who has been making special effects for movies for over twenty years. Apricot uses practical, movie making tricks and secrets in creating some of the finishes for the frames.

APRICOTMANTLE.COM

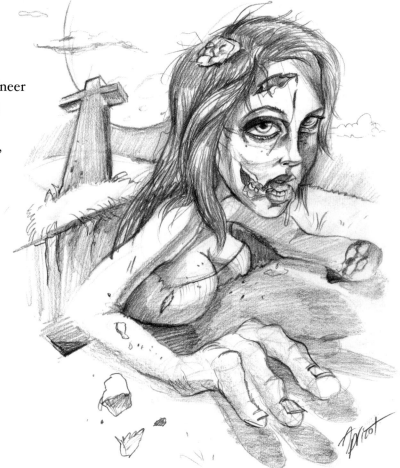

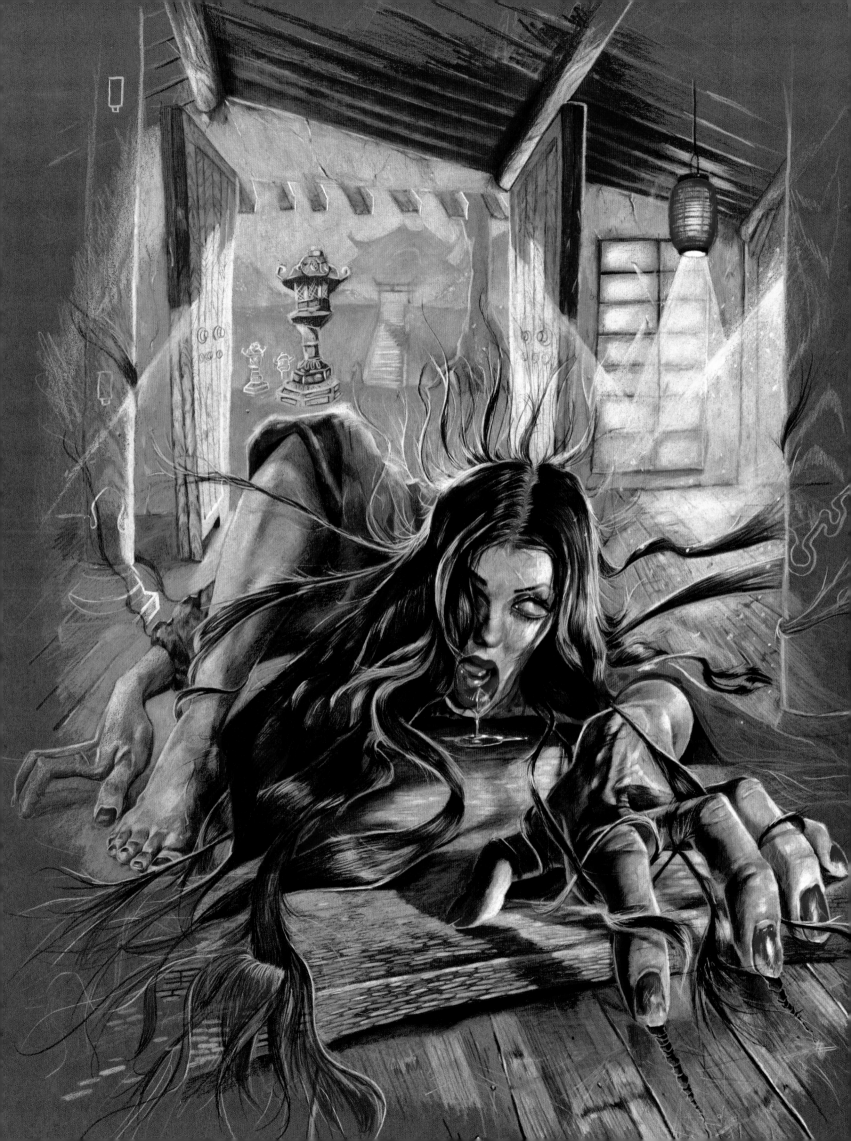

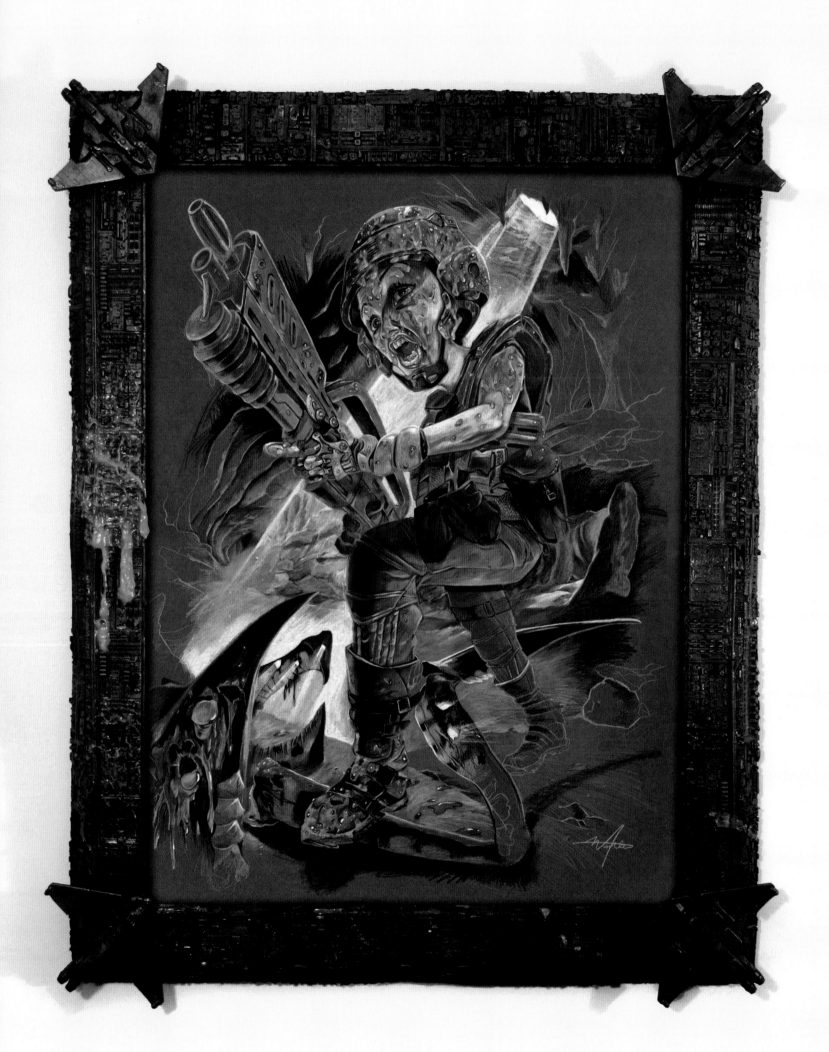

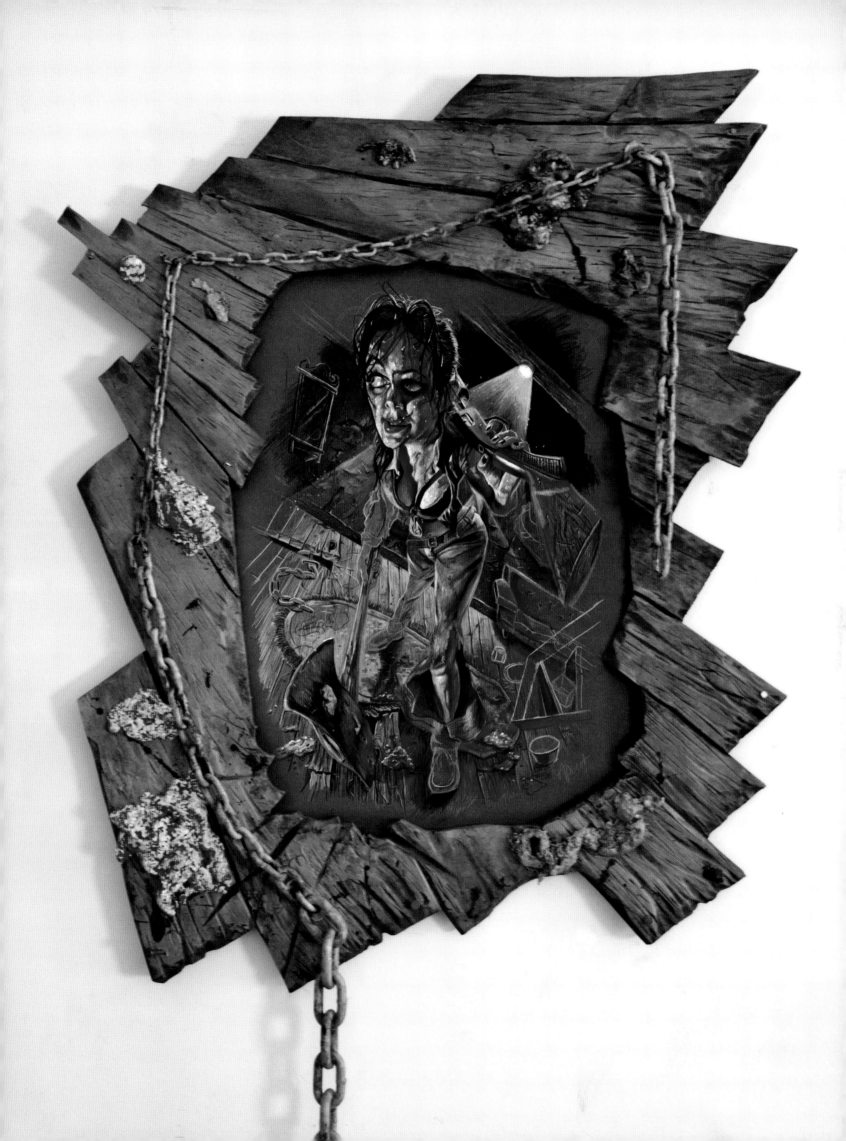

AXEL #13

Axel was born and raised in the greater Los Angeles, California area. He attended the Art Center College of Design in Pasadena, California and has been working professionally in the entertainment industry for fifteen years. He has worked with several companies, including Sony Pictures Animation, Nickelodeon, Midway Entertainment, Image Comics, Animax Entertainment, THQ, NBC and Hasbro, Inc.

Axel is currently working on freelance projects. He also teaches character design at the Gnomon School of Visual Effects. He always has a sketchbook at hand to do a doodle. He also has a thing for denim and sneakers.

LEYENDECKER13.BLOGSPOT.COM

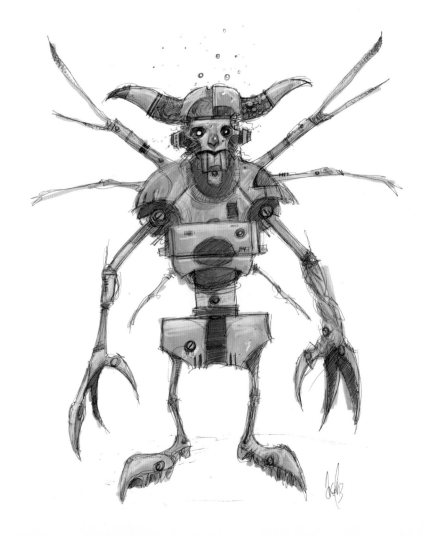

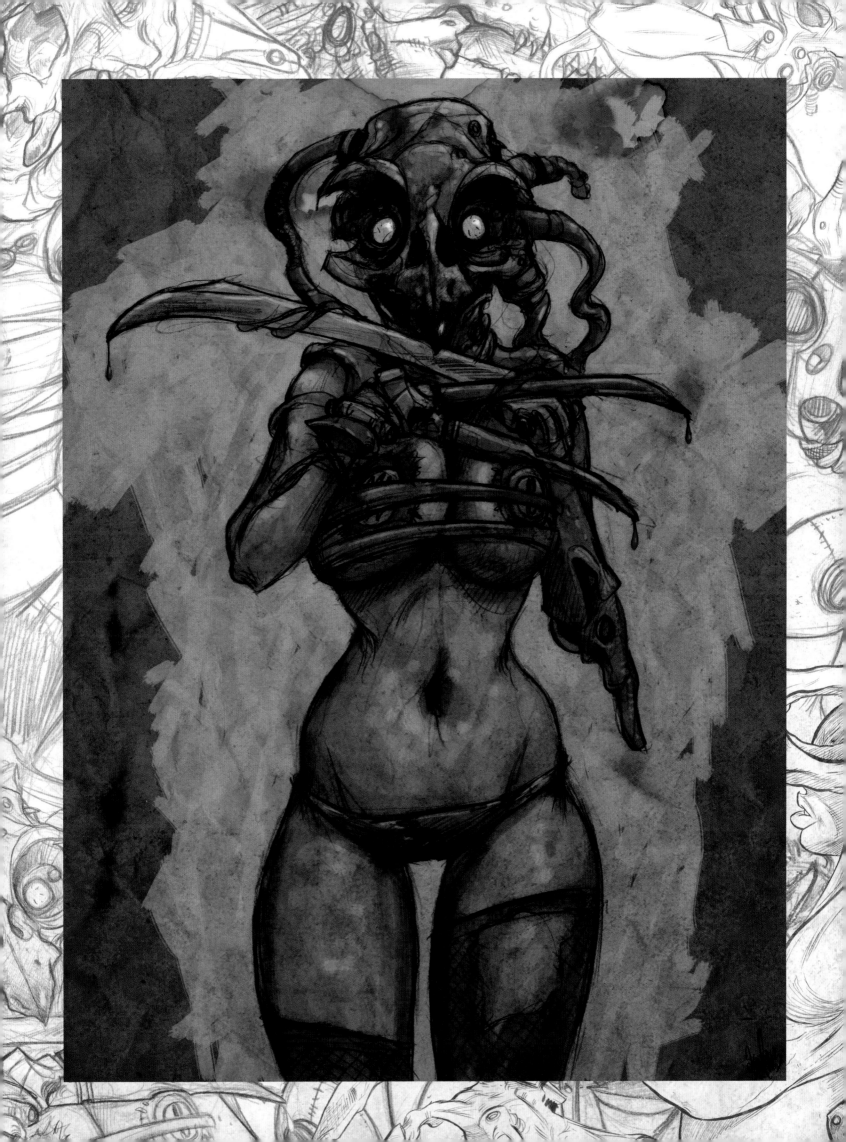

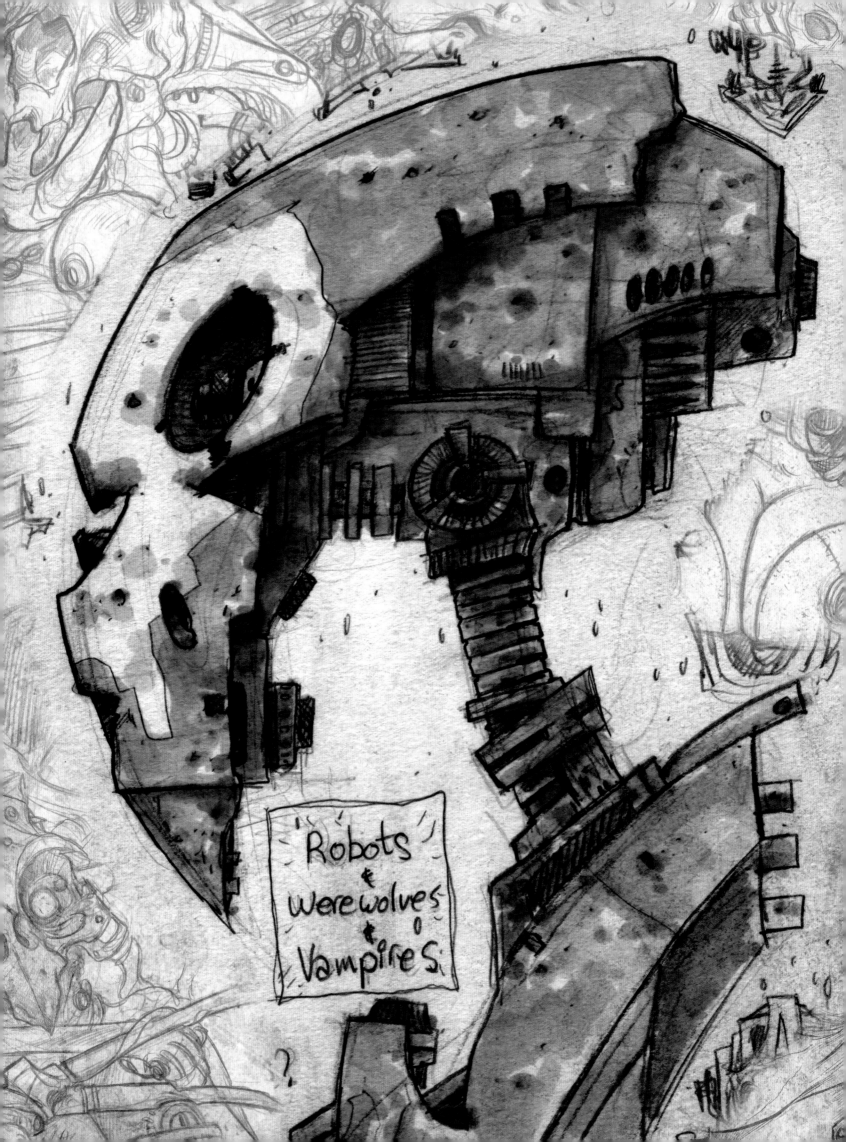

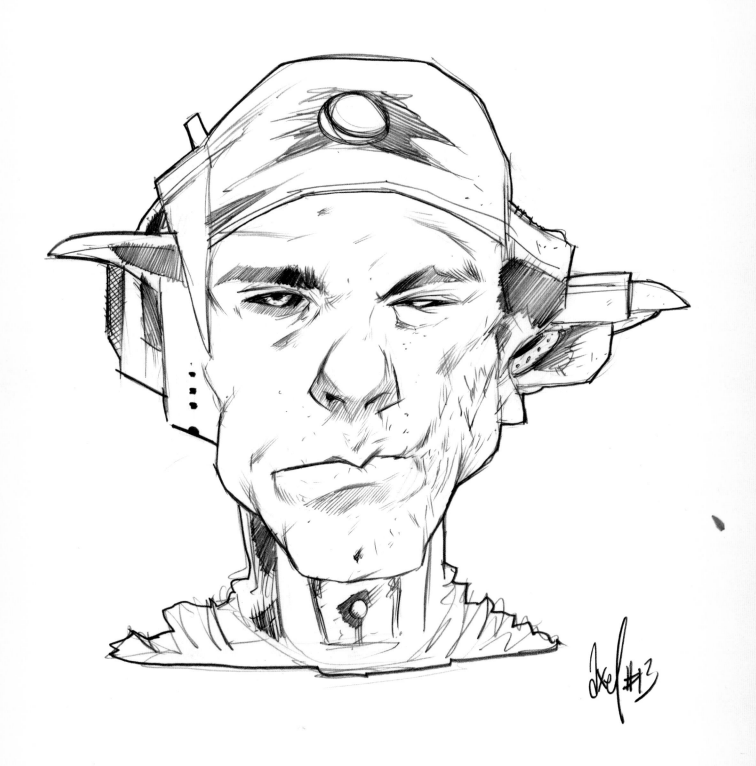

BRANDI MILNE

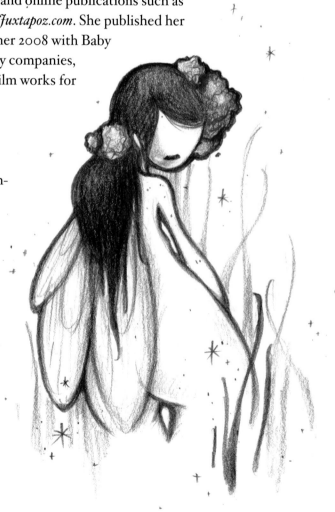

Southern California artist Brandi Milne was born in Anaheim, California in 1976. She grew up happily surrounded by a wealth of inspiration as a child, taking pleasure in classic cartoons, crayons and coloring books, Sid and Marty Kroft creations, toys, candies and the kitchy fabrics and notions of the times.

Self-taught and emotionally driven, Brandi's work speaks of love, loss, pain and heartbreak in the first person. She decorates it with a wink of humor and a delicious, candy-coat finish – a combination that can be considered highly addictive to viewers around the world. Brandi's work is celebrated and supported in fine art galleries across the United States and has been featured in both written and online publications such as *Hi- Fructose Magazine*, *Babyboss Magazine* and *Juxtapoz.com*. She published her first book, *So Good For Little Bunnies,* in summer 2008 with Baby Tattoo Books and has collaborated with many companies, including 686, Hurley, Billabong and Acme Film works for CVS Pharmacy.

Brandi is currently continuing her role as a featured artist for Hurley, as well as working on clothing designs, collaborating with a high-profile rock star duo and working on her next solo show for June 2010 at the Corey Helford Gallery in Culver City, California.

BRANDIMILNE.COM

♥ BRANDi

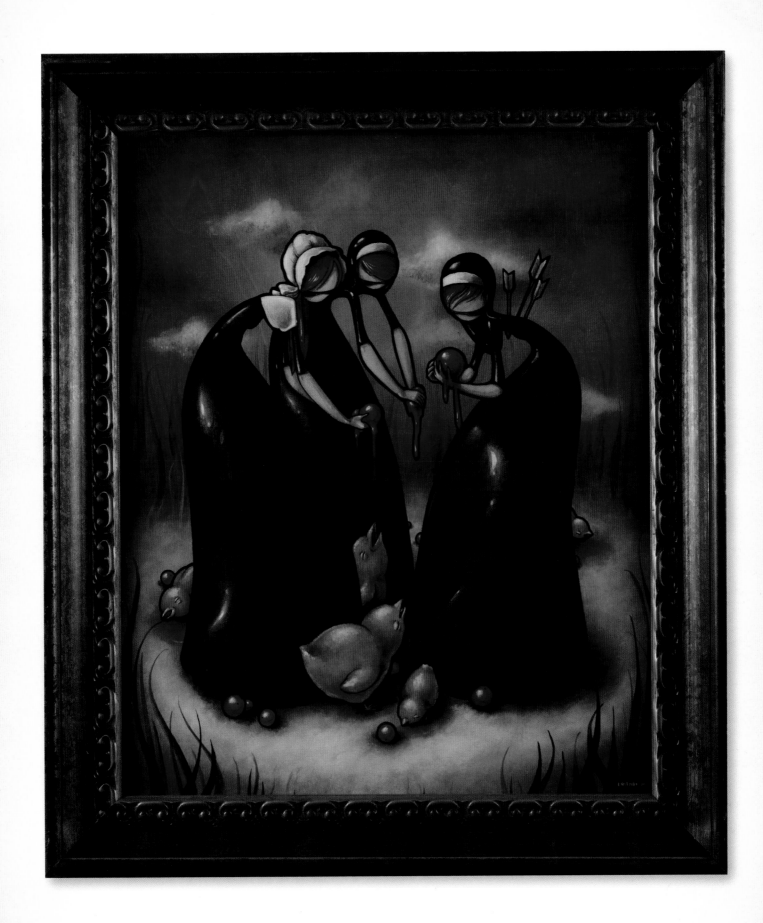

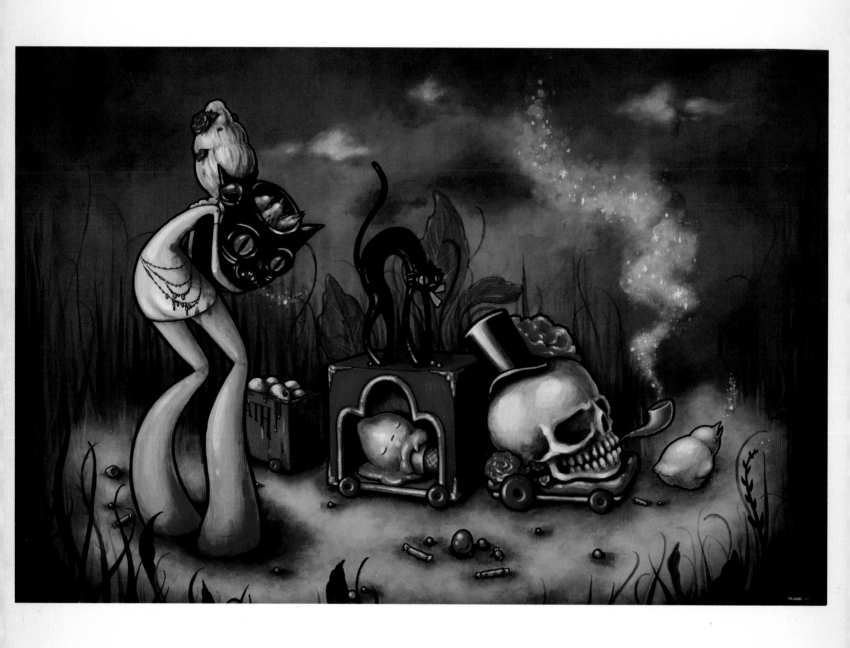

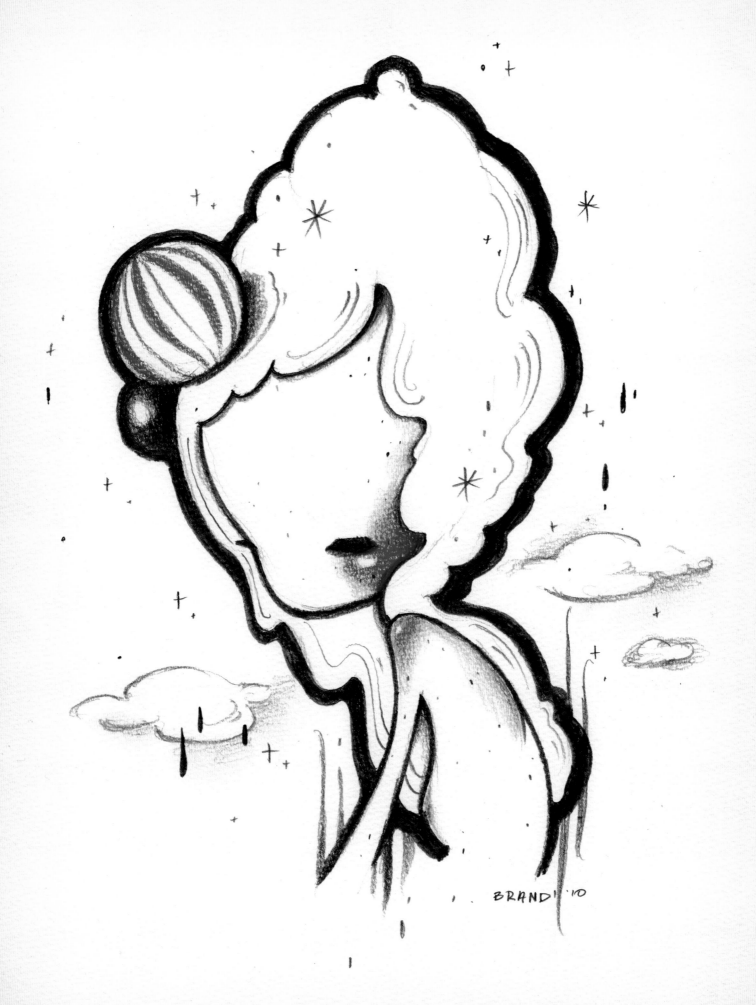

BRIAN SMITH

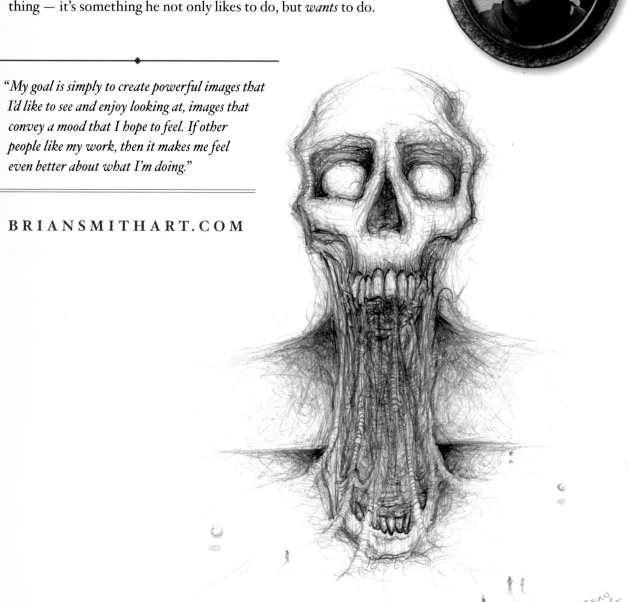

BRIAN SMITH IS A SELF-TAUGHT ARTIST BORN AND RAISED in Los Angeles, California. Although always interested in creating art, he waited until age thirty-five to do anything about it. He now paints and draws as much as possible to make up for lost time. He expresses that making art can be an extremely challenging and solitary undertaking. Every day, he questions why he's taken on a career in the arts. In the end, it boils down to one thing — it's something he not only likes to do, but *wants* to do.

"My goal is simply to create powerful images that I'd like to see and enjoy looking at, images that convey a mood that I hope to feel. If other people like my work, then it makes me feel even better about what I'm doing."

BRIANSMITHART.COM

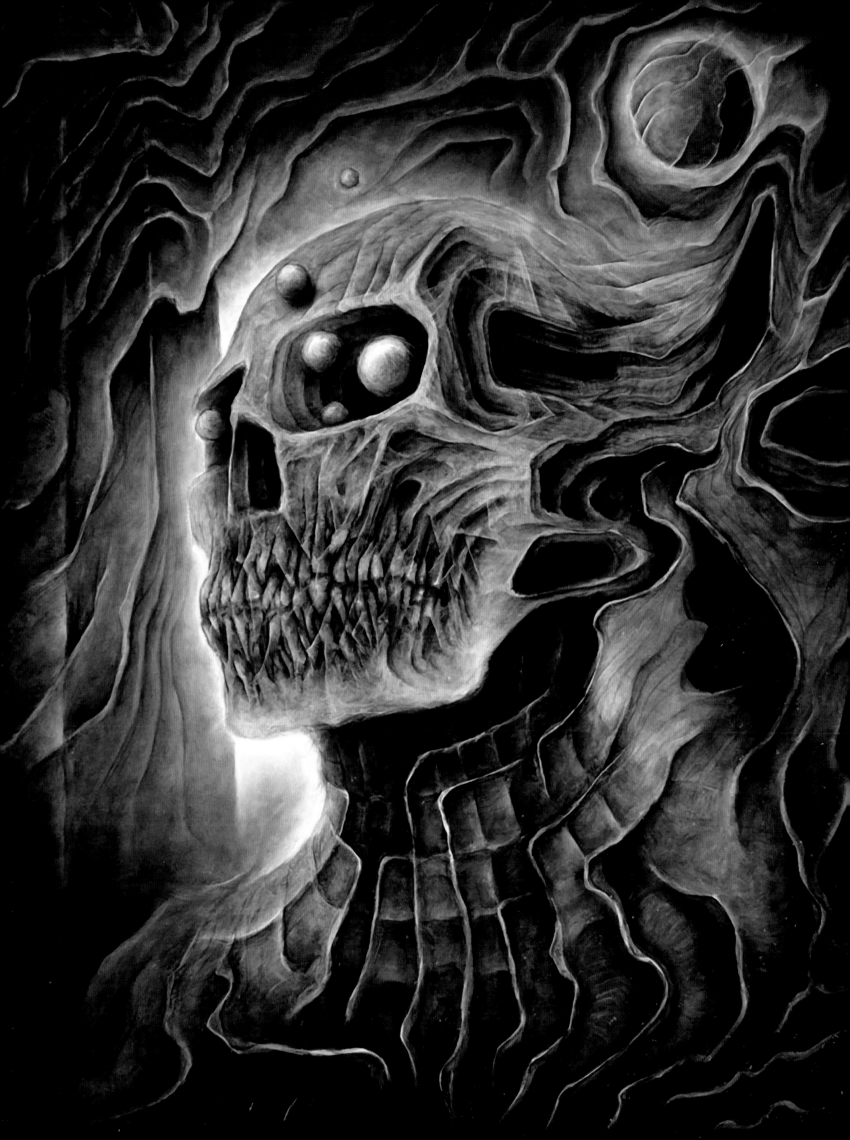

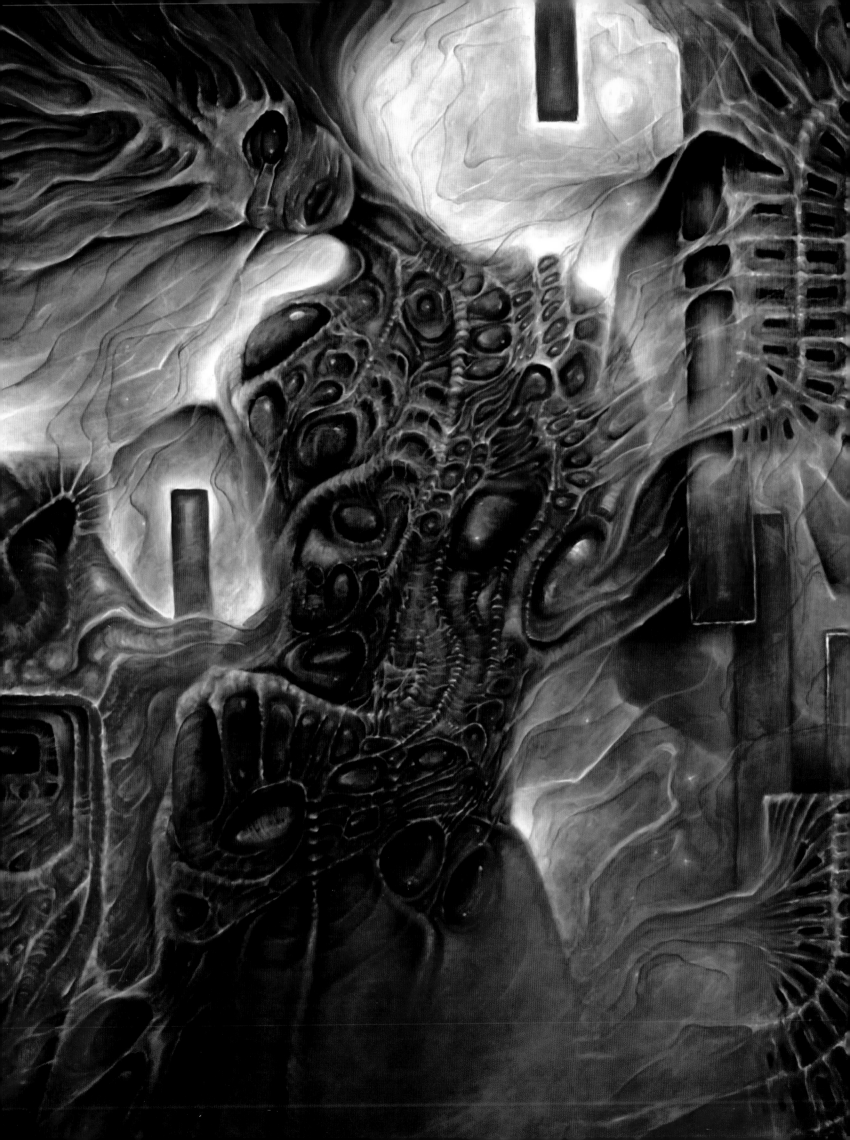

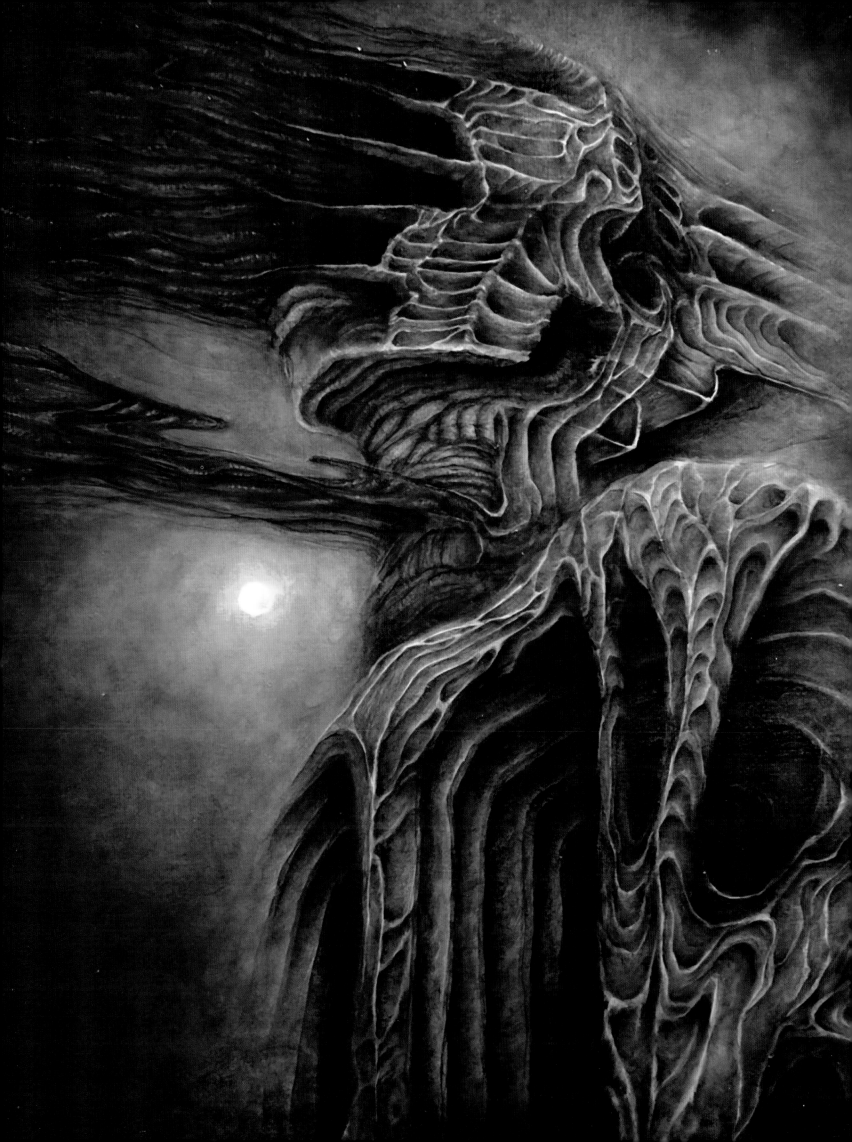

CAMERON DAVIS

BORN IN HILLSBORO, OREGON, CAMERON ATTENDED THE Rhode Island School of Design (RISD) and graduated with a BFA in illustration in 2005. After an invaluable internship at Design Studio Press, he was offered a job as a concept artist at Neversoft Entertainment, where he worked on such video game titles as *Tony Hawk* and *Guitar Hero*.

Cameron has worked with Activision, McFarlane Toys, Earache Records, Rhythm and Hues, Psyop Animation and Dreamworks Animation. He enjoys telling stories.

CDAVISART.COM

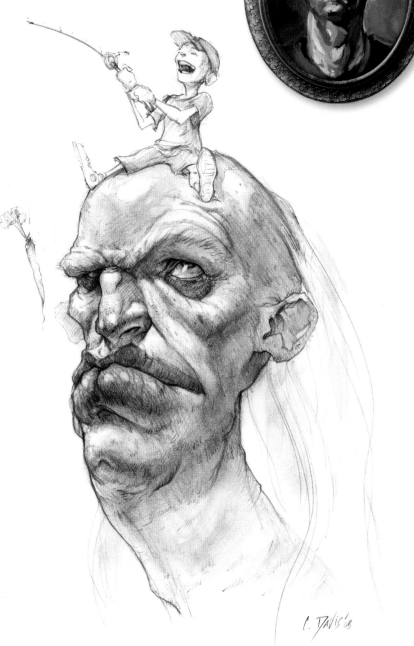

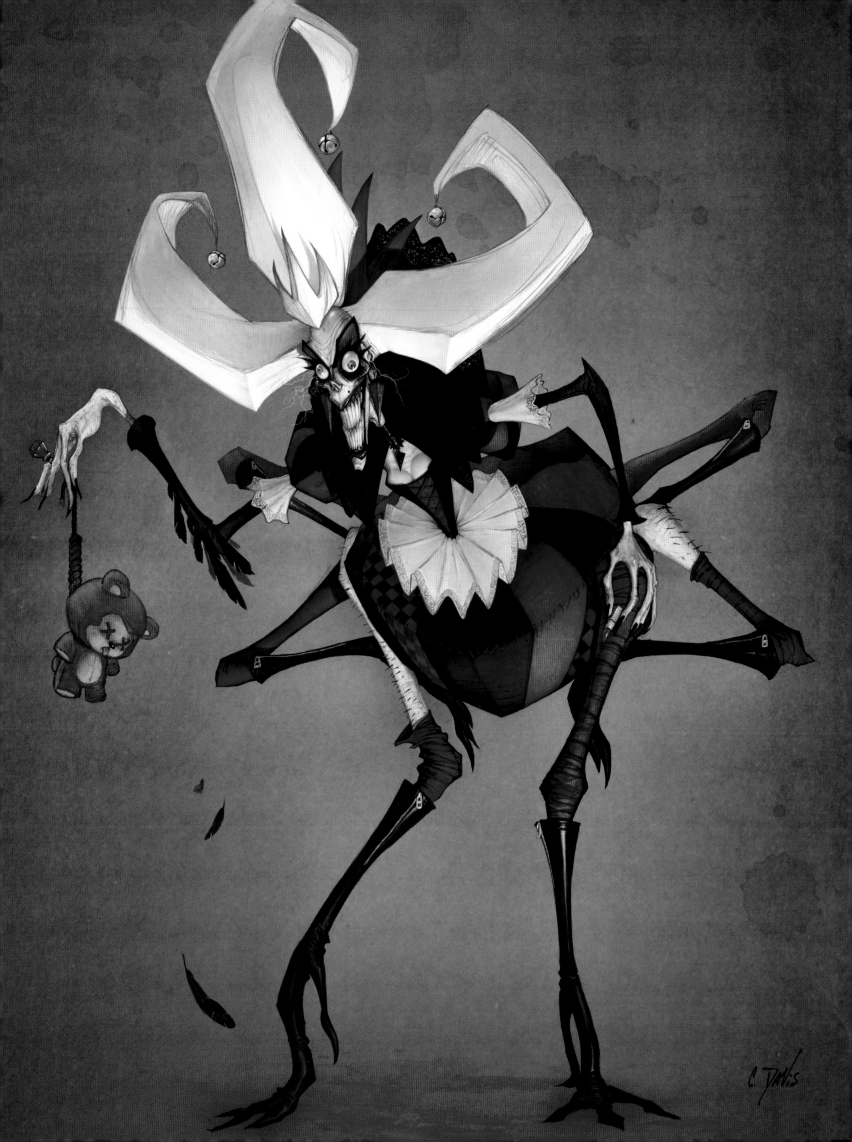

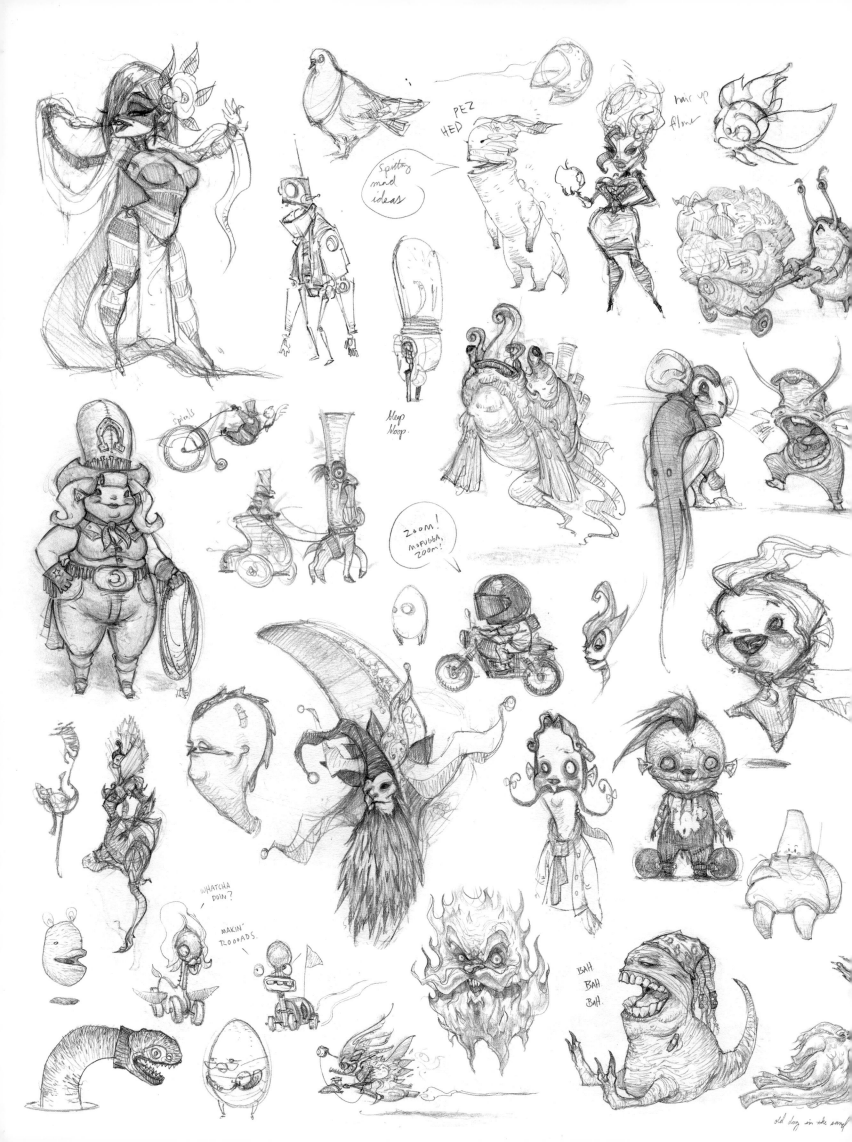

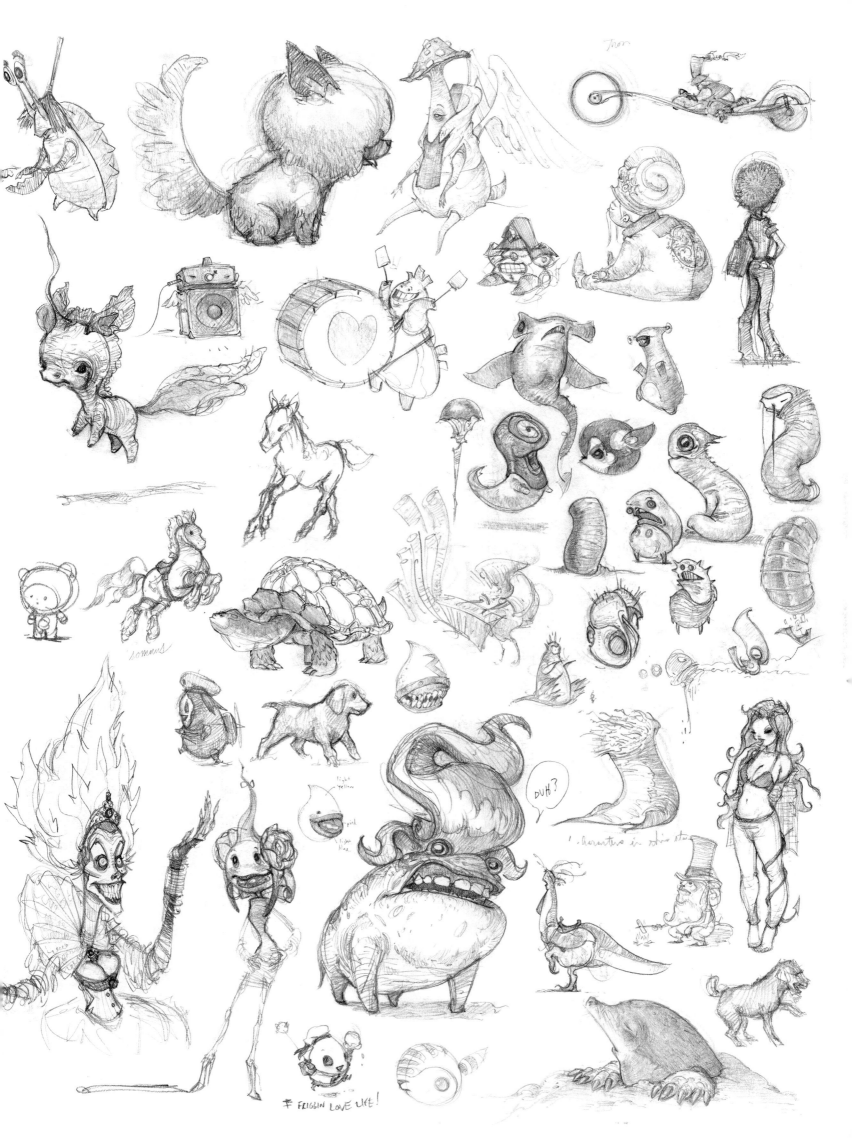

Thor

DUH?

somnus

FRIGGIN LOVE LIFE!

CHARLES HU

CHARLES HU IS A FIGURE PAINTER AND NOTABLE ART instructor. He has exhibited at Wendt Gallery in Laguna Beach, California. While still in school, he was hired by Associates in Art to teach figure drawing. Upon graduation, he began teaching drawing and painting at the Los Angeles Academy of Figurative Arts. Charles also teaches at the Art Center College of Design in Pasadena, California. He has a BA with a full scholarship from the Art Center College of Design and also taught at the Gnomon School of Visual Effects in Hollywood, California.

Most recently, Charles founded the 3 Kicks Fine Art Studio in Pasadena, California.

3KICKSTUDIO.COM

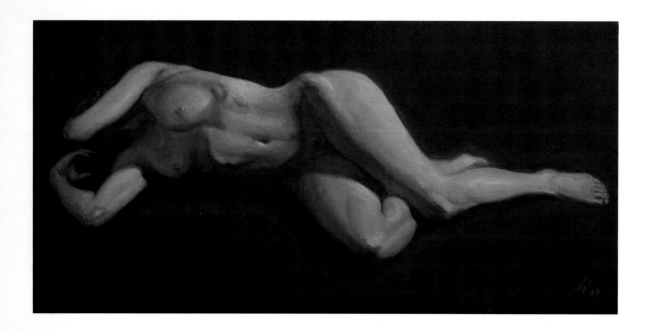

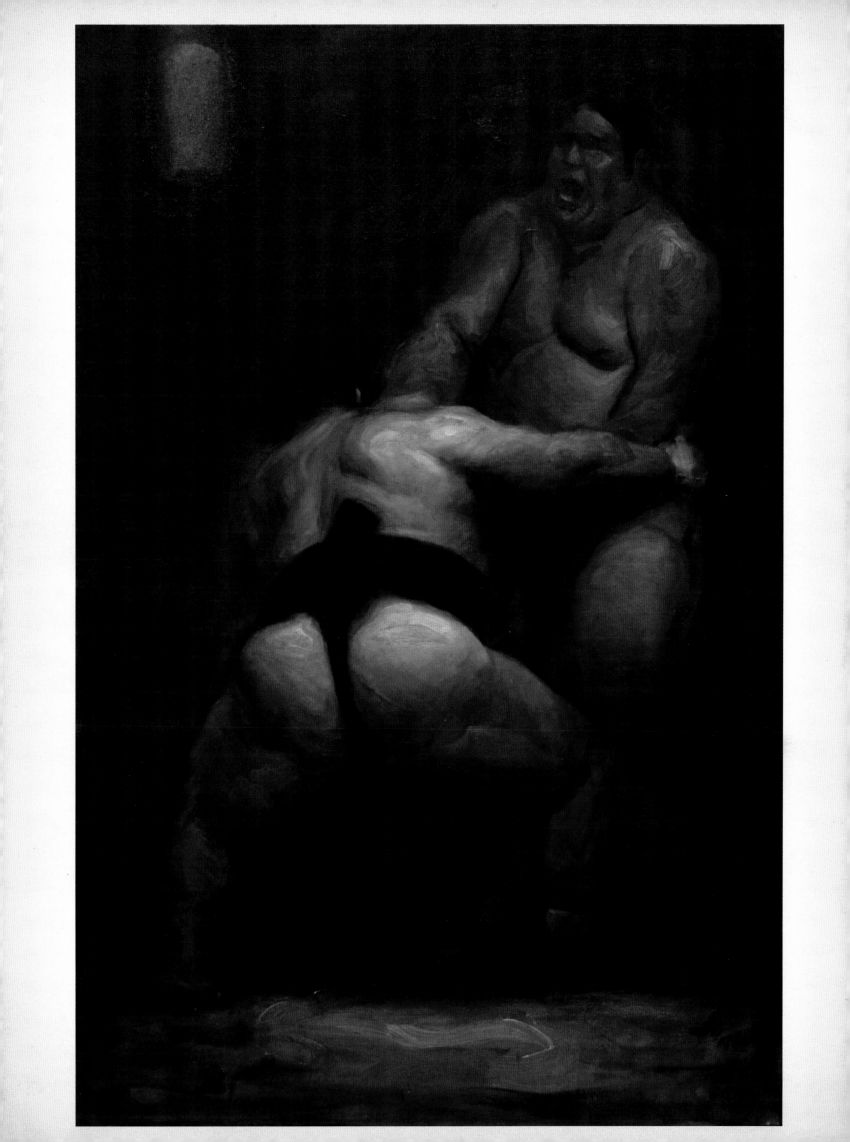

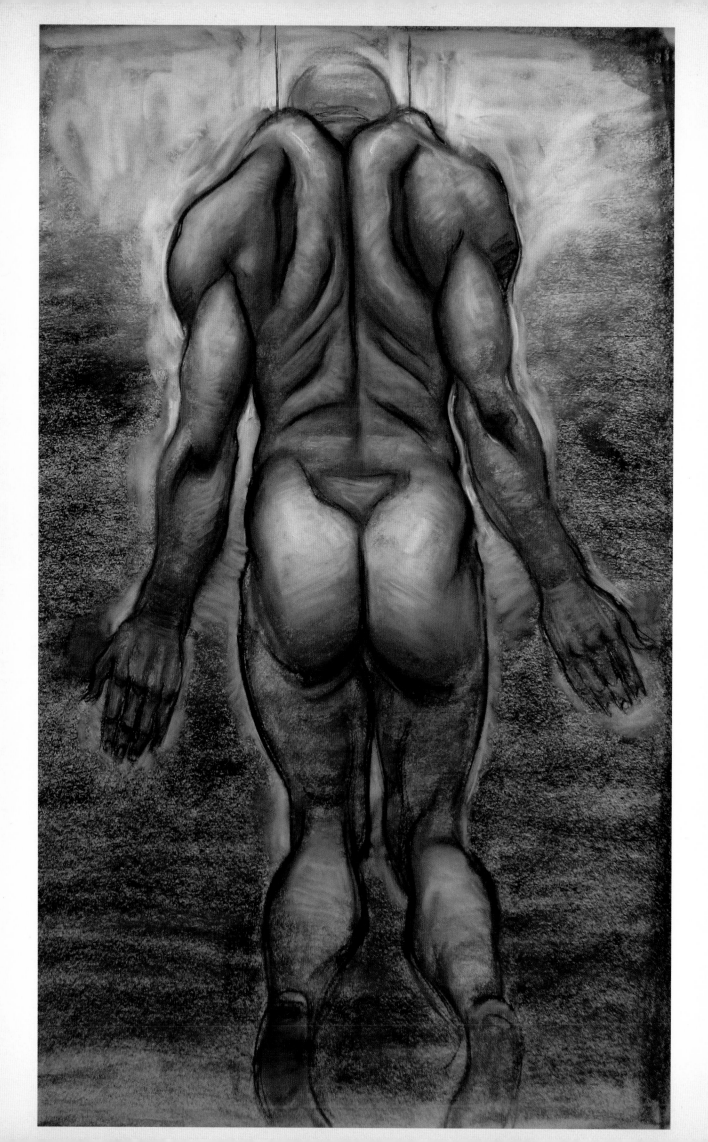

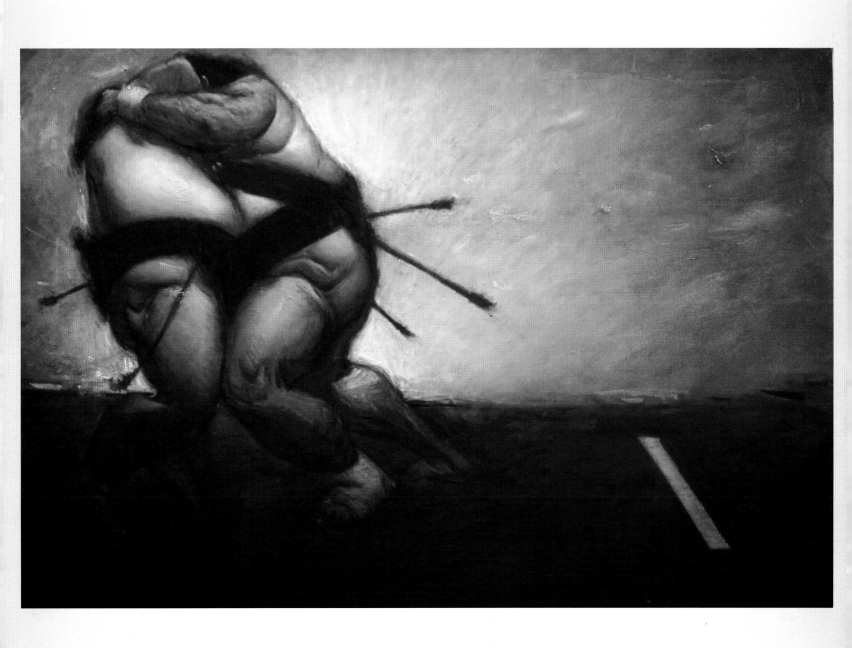

CHET ZAR

BORN ON NOVEMBER 12, 1967, IN THE HARBOR TOWN of San Pedro, California, Chet Zar's interest in art began at an early age. His parents were always very supportive and never put any limits on his creativity. His entire childhood was spent drawing, sculpting and painting.

Zar's interest in the darker side of art began in the earliest stages of his life. A natural fascination with all things strange fostered within him a deep connection to horror movies and dark imagery. He could relate to the feelings of fear, anxiety and isolation that they conveyed. These are the themes that permeated most of his childhood drawings and paintings and are reflected in his work to this day.

The combined interest in horror films and art eventually culminated into a career as a special effects makeup artist, designer and sculptor for the motion picture industry where he designs and creates creatures and makeup effects for such films as *The Ring*, *Hellboy I & II*, *Planet of the Apes* and the critically acclaimed music videos for the art-metal band Tool. Zar also embraced the digital side of special effects as well, utilizing the computer to translate his dark vision to 3D animation for Tool's live shows and subsequently releasing many of them on his own DVD of dark 3D animation, *Disturb the Normal*.

But the many years spent dealing with all of the politics and artistic compromises of the film industry left Zar feeling creatively stagnant. At the beginning of 2000 (at the suggestion of horror author Clive Barker), he decided to go back to his roots, focus on his own original works and try his hand at fine art, specifically painting in oils. The result has been a renewed sense of purpose, artistic freedom and a clarity of vision that is evident in his darkly surreal, and often darkly humorous, paintings.

His artistic influences include painter James Zar (stepfather and artistic mentor), Beksinski, H.R. Giger, Frank Frazetta, M.C. Escher, Bosch and Norman Rockwell — just to name a few.

"Chet's art is beautiful and scary. His style has a modern twist crashing into a classical approach. I think Chet is a master painter on his way to making a great mark in our little world. Wanna do something smart with your money? Invest in a Chet Zar painting." — Adam Jones (TOOL)

CHETZAR.COM

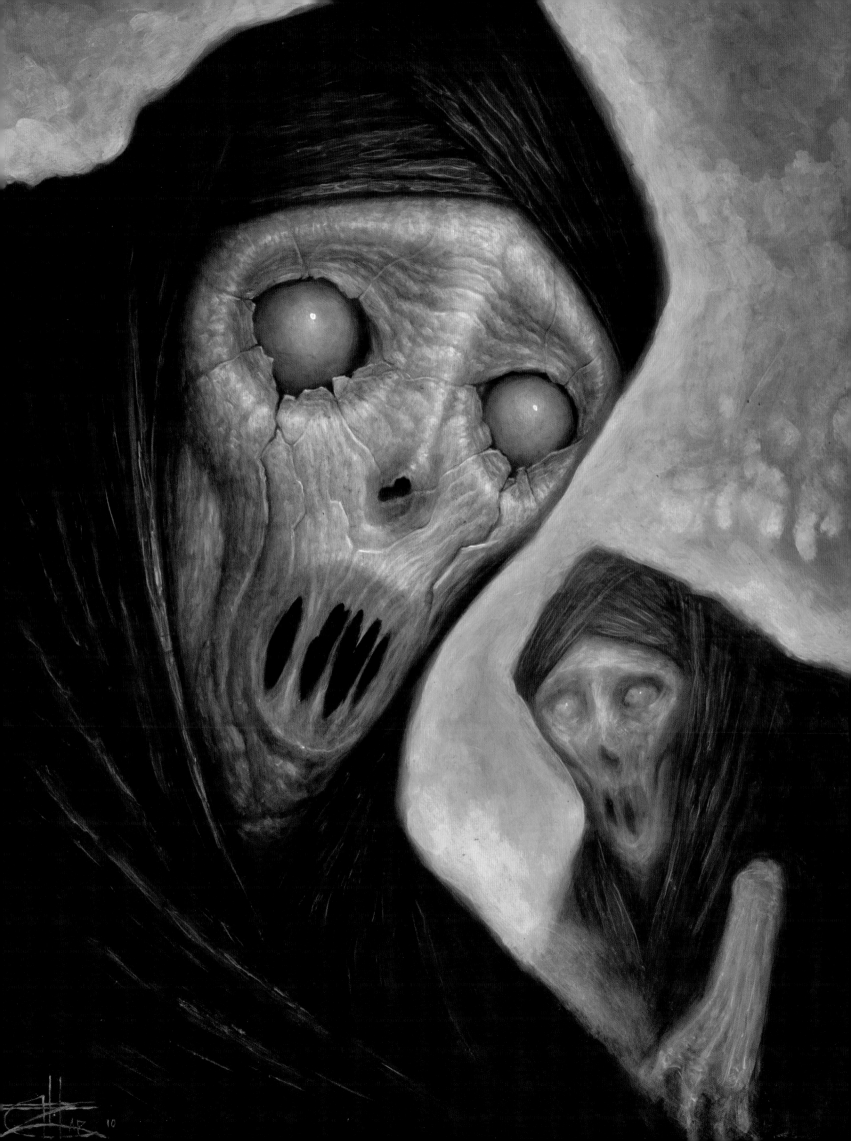

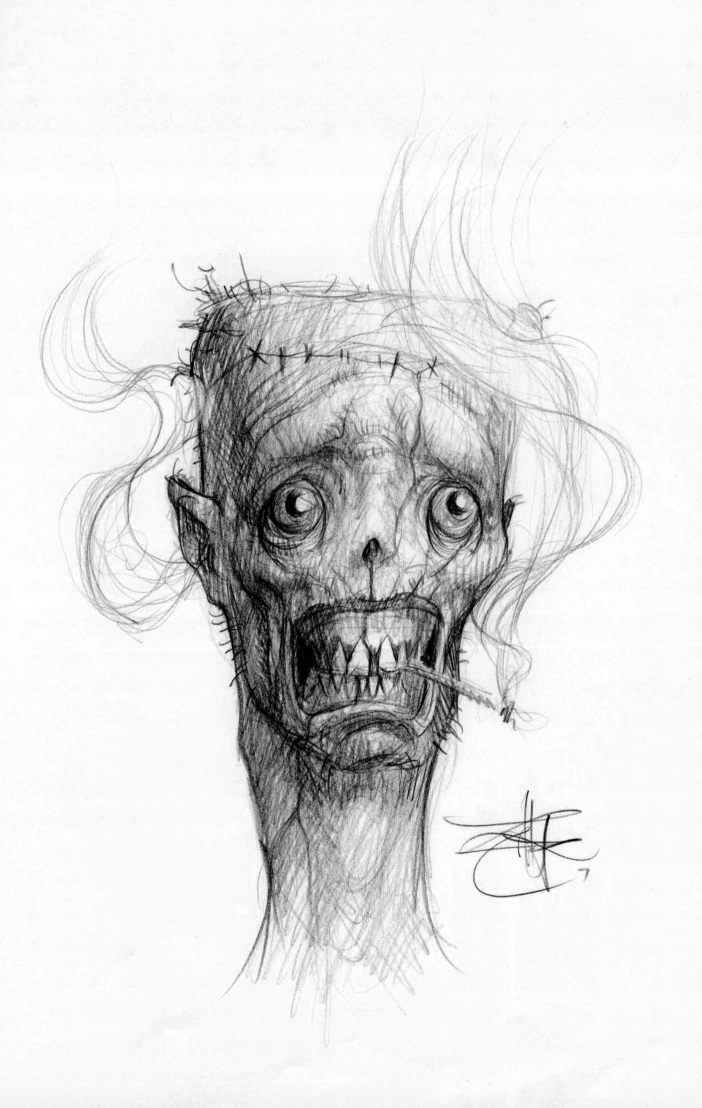

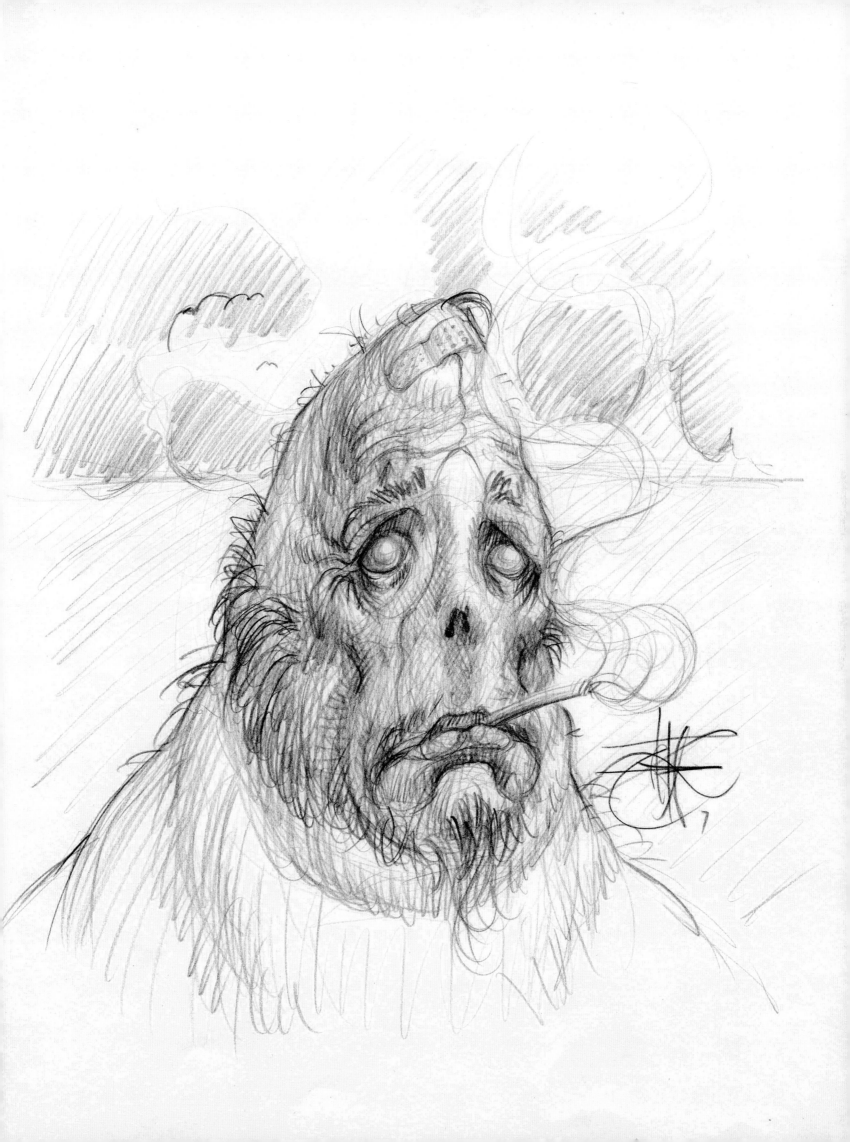

CHRIS RYNIAK

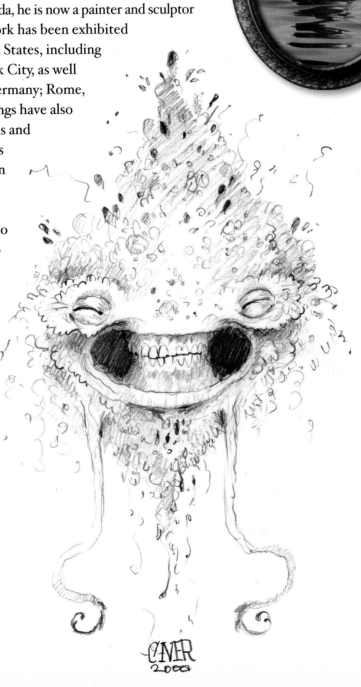

PAINTER AND SCULPTOR CHRIS RYNIAK WAS BORN IN 1976 in the suburbs of Detroit, Michigan. He spent his childhood basking in the warm glow of Saturday morning cartoons and flipping over rocks in search of insects, reptiles and ghosts.

Years later, a graduate and former instructor of the Ringling School of Art and Design in Sarasota, Florida, he is now a painter and sculptor of all manner of critters. Chris' work has been exhibited in galleries throughout the United States, including Miami, Los Angeles and New York City, as well as internationally in Hamburg, Germany; Rome, Italy and Tokyo, Japan. His paintings have also been published in numerous books and periodicals in the United States, as well as in Europe, Singapore, Japan and Australia.

Chris now resides in a coastal Ohio Dutch Colonial with his wife, two children, cat, dog, frog and fish. Sadly, no ghosts as of yet.

CHRISRYNIAK.COM

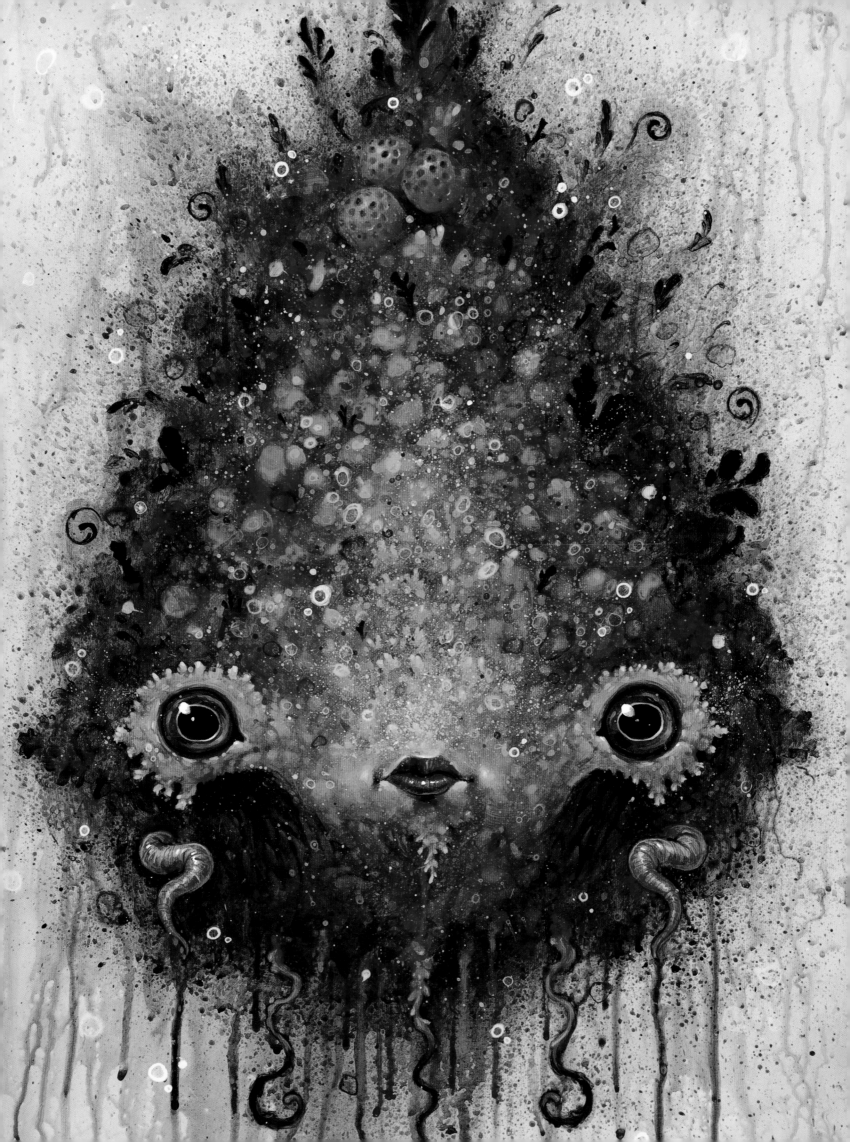

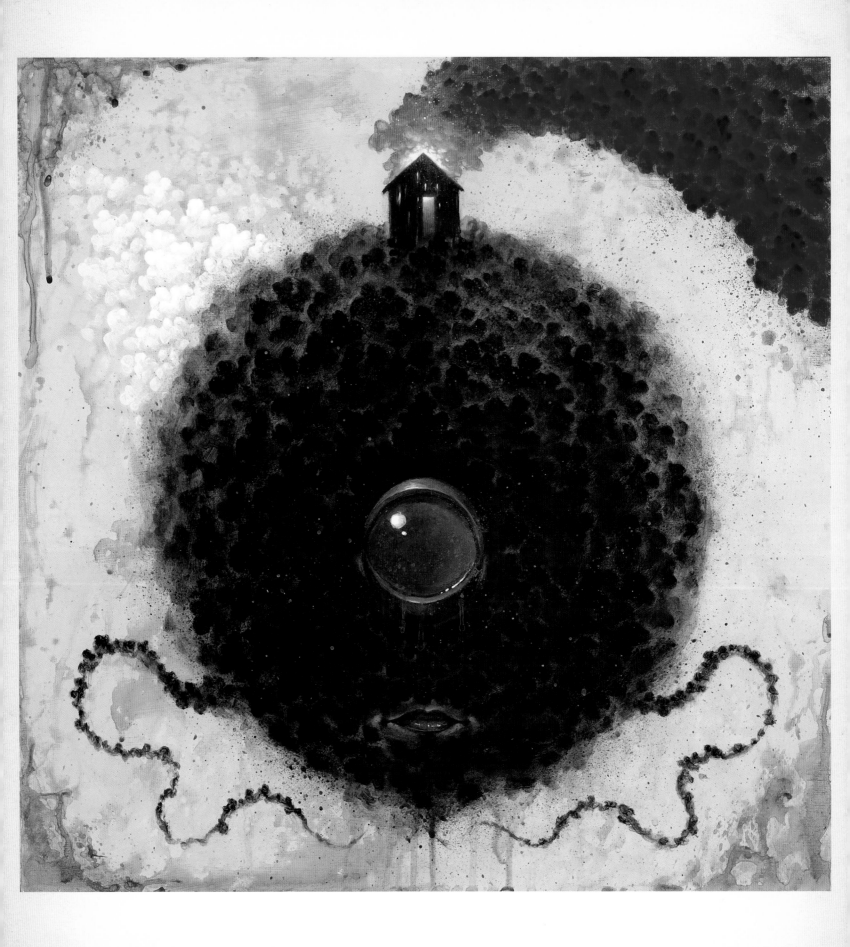

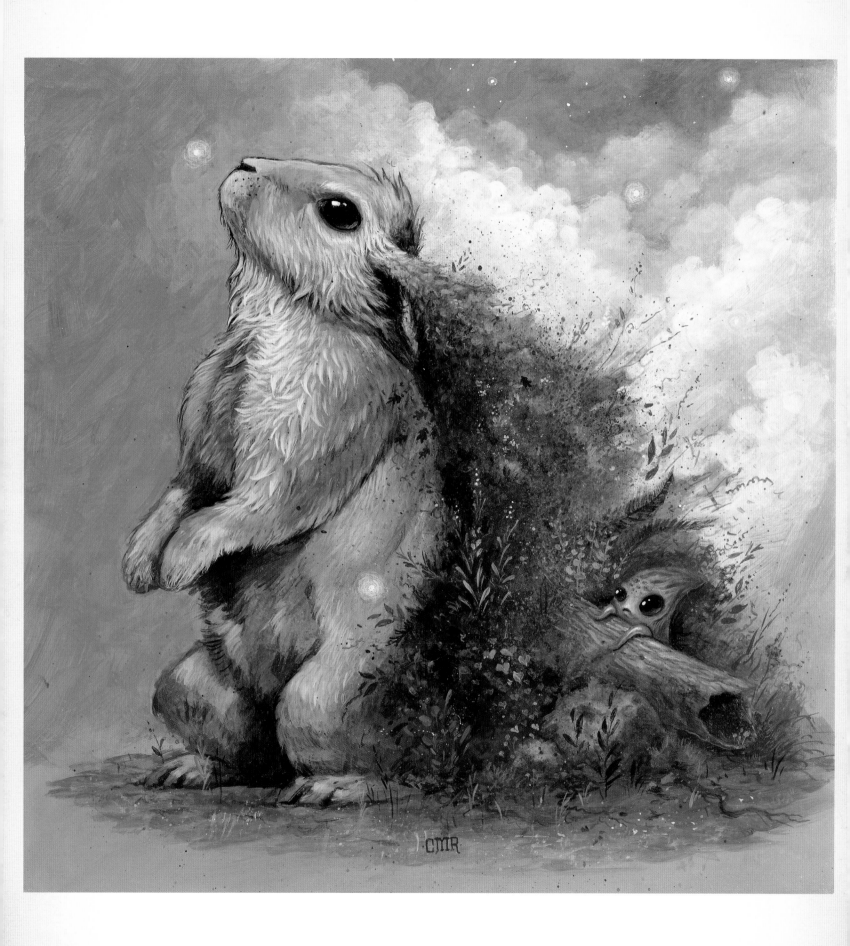

CHRISTIAN LORENZ-SCHEURER

Christian Lorenz-Scheurer has worked on some of the most innovative movies, games and theme parks of the past decade. His range of projects reaches from architectural design for movies such as *The Fifth Element* to concept art for *The Matrix* and *Titanic* to the fantastic dreamscapes of *Dark City*, *Final Fantasy*, *Animatrix* and *The Golden Compass*.

He was involved in the visual definition of video games such as EA's *Spore* and *Lord of Rings: Return of the King*, Mistwalker's *Lost Odyssey* and Square's *Final Fantasy IX*. Venturing into other artistic projects, Christian has lent his unique vision to international-themed resorts in Dubai and Doha, bestselling children's book covers and original intellectual property for animated films. His career has lead him from New York to Tokyo to Cape Town, and his work has been shown in presentations and expositions around the world.

In 2006, Christian released his first book, *Entropia: A Collection of Unusually Rare Stamps* (Design Studio Press), which he sold to a major Hollywood studio.

Christian also teaches at the Art Center College of Design in Pasadena, California. During his free time, he continues to fill sketchbooks and has recently returned to traditional painting and sculpting. He lives with his lovely wife and his little daughter Kiki in Topanga Canyon, California.

CHRISTIANLORENZSCHEURER.COM

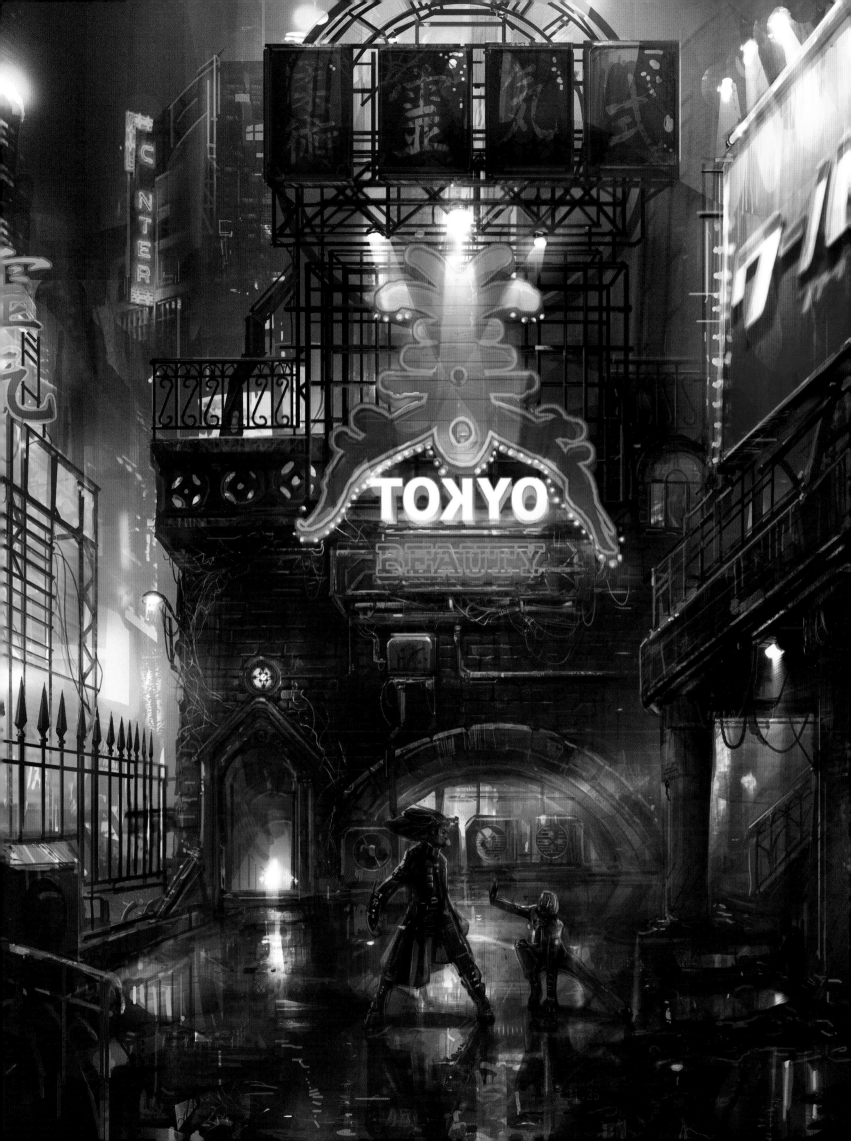

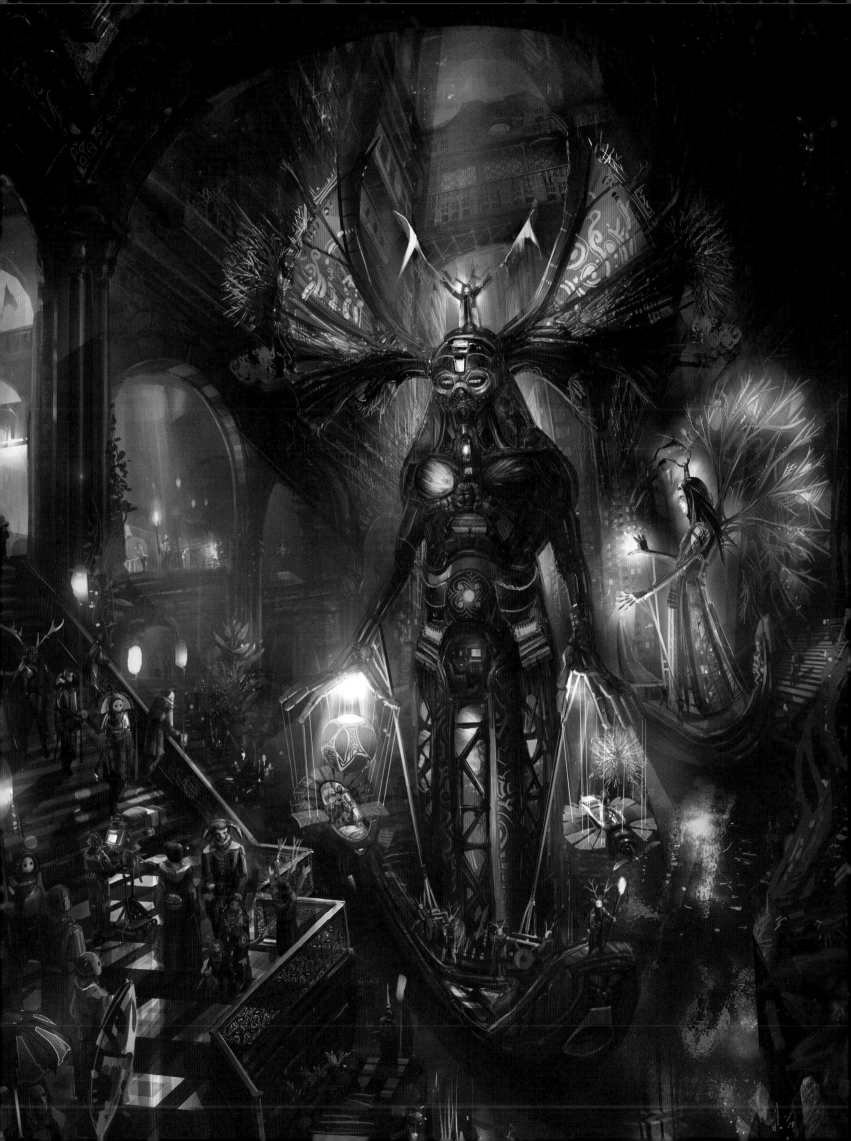

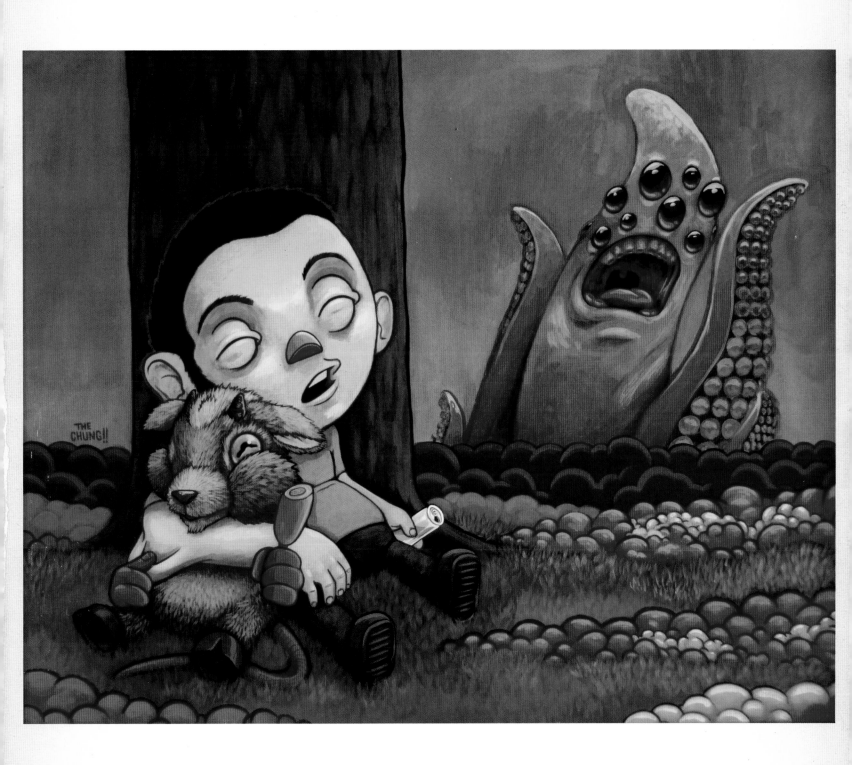

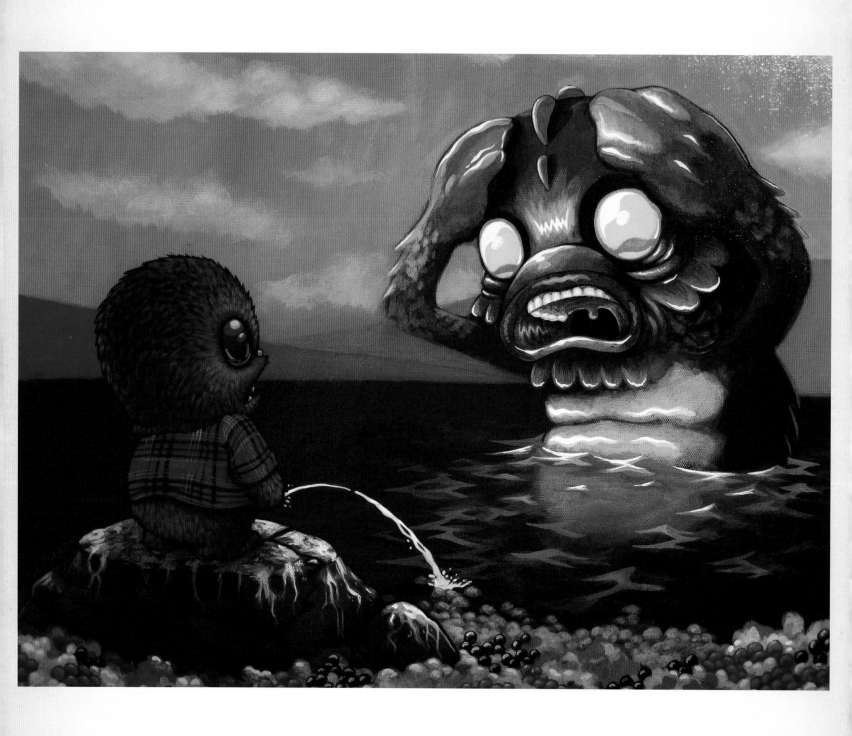

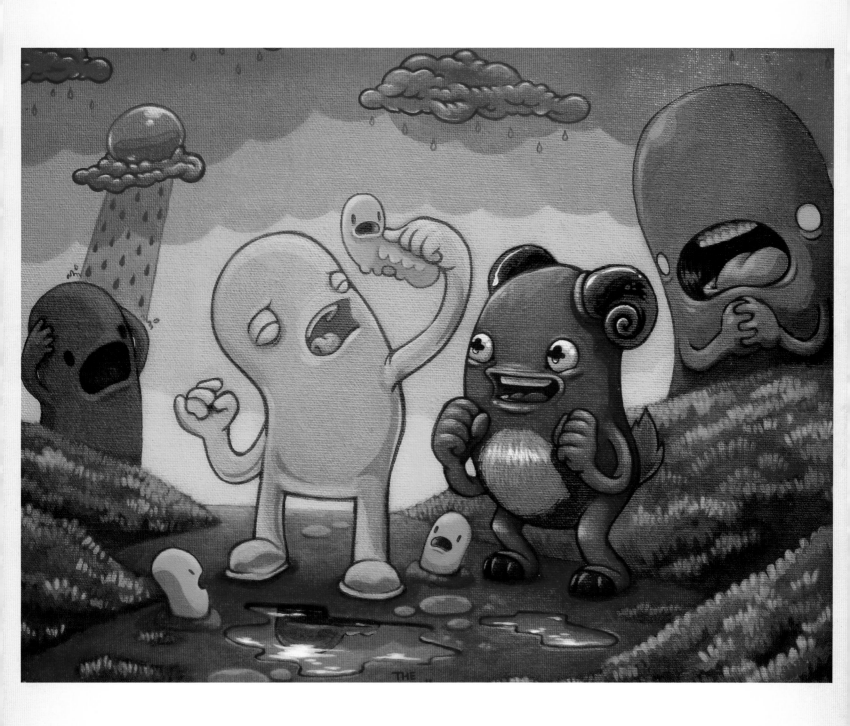

COREY MILLER

ASK PREMIER TATTOO ARTIST COREY MILLER HOW HE GOT into the tattoo business, and he will probably tell you it was "by hanging around the wrong people." And, if you have a sense of humor and you get it, he may tell you the real story.

In 1982, a fifteen-year-old Corey Miller was playing drums in a punk rock band when he decided he needed a tattoo. So, he carved out his first tattoo on himself using a needle with thread wrapped around it. This inspired Corey to build his own tattooing machine, which consisted of a fish tank pump motor, a bent toothbrush, the tip of a BIC pen and some guitar string as a needle. He used to carry his homemade contraption around in a Vans shoebox with a bottle of Pelican ink.

It wasn't long before he was on his way...many years in between (which you may read in full detail when you visit Corey's bio online), unforgettable stories, legendary mentors and countless hours of persistence and experience developed Corey into the master tattooist we know today.

Looking back on his formative years, Corey feels lucky to have experienced the best and the worst of the tattoo business. He never had a formal apprenticeship, as many tattoo artists do, but instead got his education by "going on my own and falling on my face and doing it all again on my own terms."

His career has run the gamut from the street shop of Fat George's to the "Kustom Klass" of Good Time Charlie's Tattooland and everywhere in between.

Every tattoo Corey Miller designs, whether for customers famous or unknown, is itself a unique and timeless work of art. In addition, he continues to break new ground by engineering cutting-edge tattooing tools. He has seen a lot of changes during his more than twenty years experience in the business. Looking into the next millennium, the sky is the limit for Corey Miller and his house of original tattoo design, the Six Feet Under Tattoo Parlor.

SIXFEETUNDER.COM

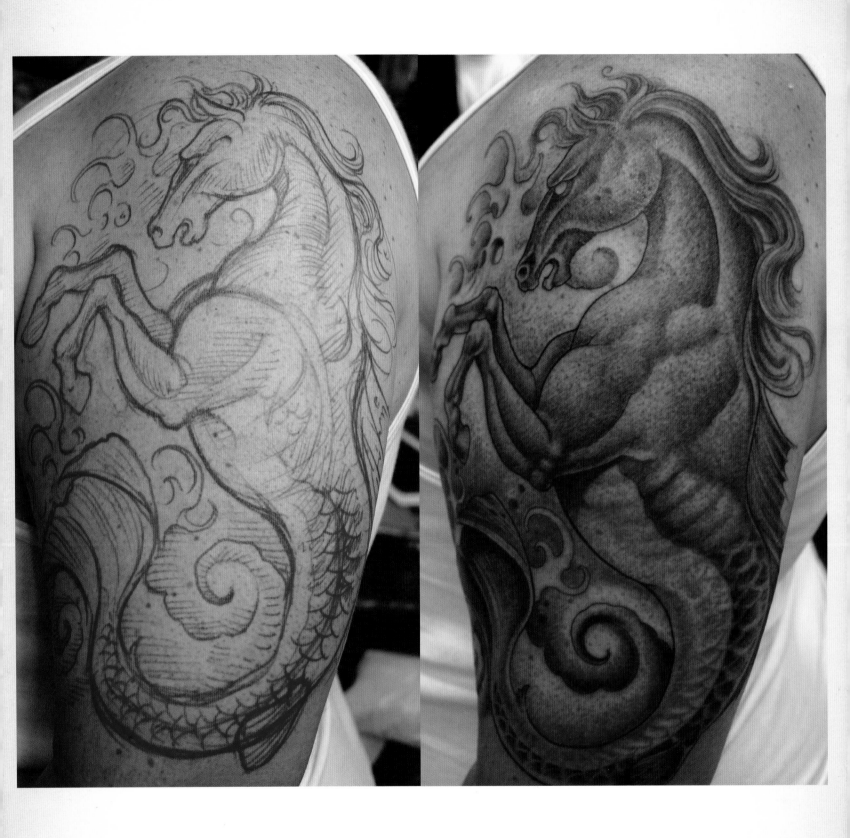

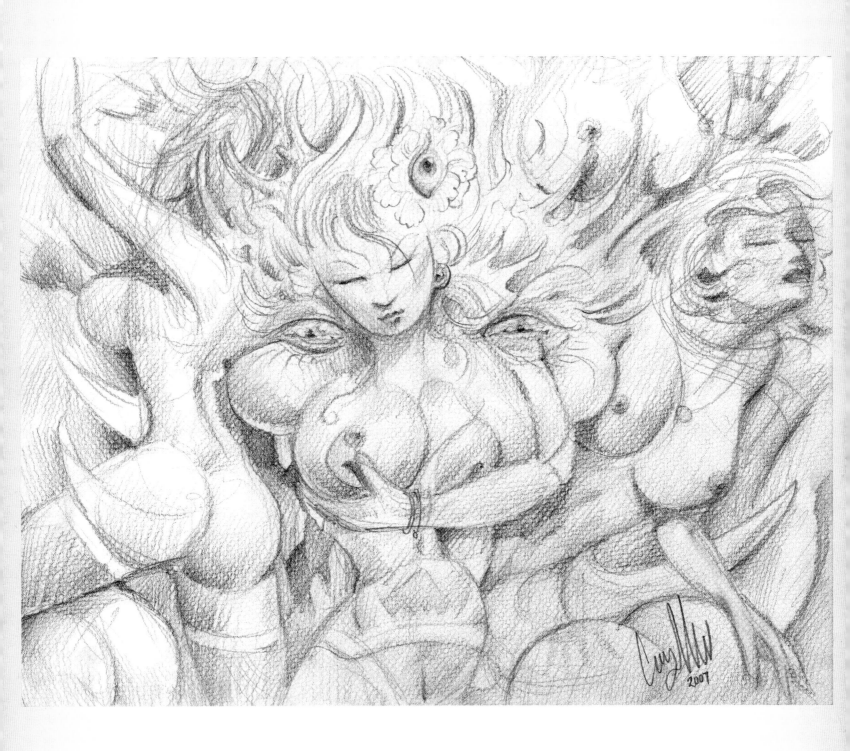

DAPHNE YAP

Daphne Yap is a freelance artist working in the Los Angeles, California area as a concept artist and illustrator. She came to Los Angeles to attend the Otis College of Art and Design and majored in toy design. She does concept art for films and has worked on such projects as James Cameron's *Avatar*, Tim Burton's *Alice* and Kenneth Branagh's *Thor*. She is currently working on other film projects. She likes to dabble in this and that and all sorts of bits and pieces. She also has a sketchbook, *Daphne01*, by Design Studio Press out now.

DAPHNEYAP1.BLOGSPOT.COM

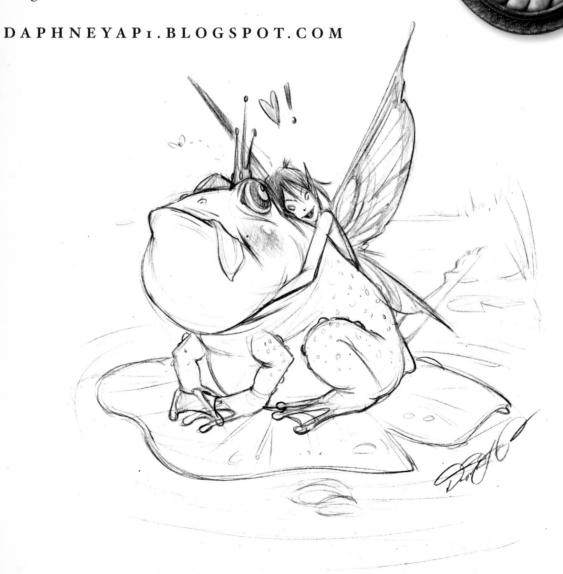

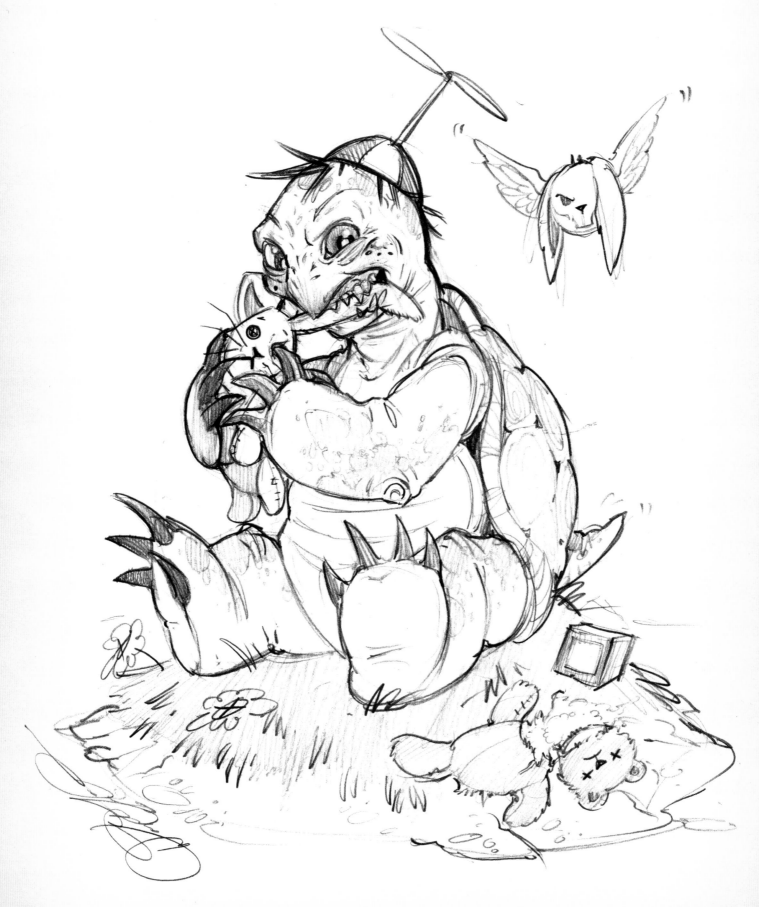

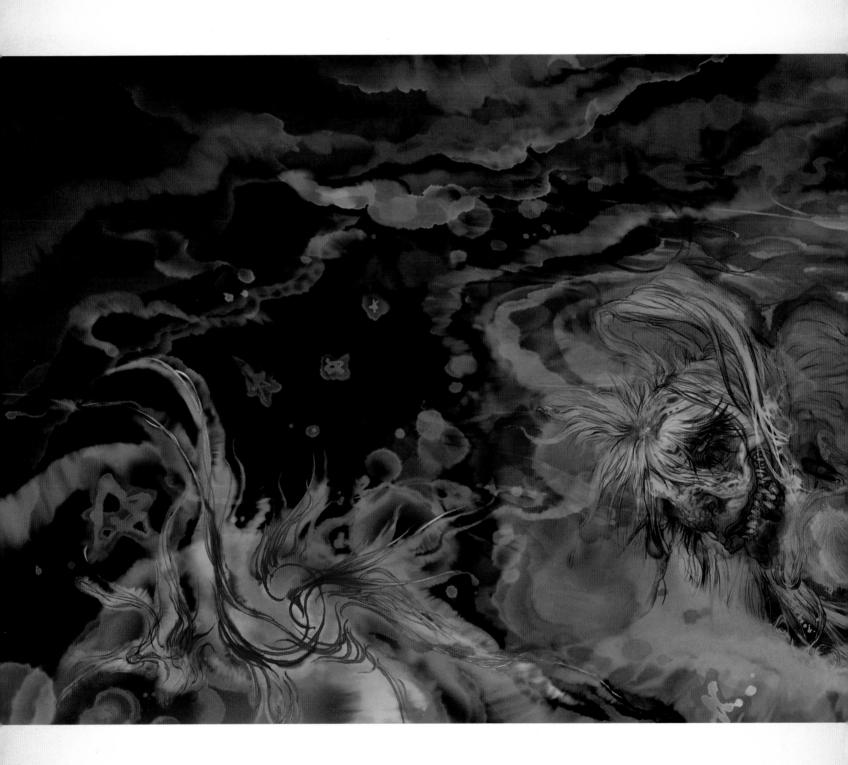

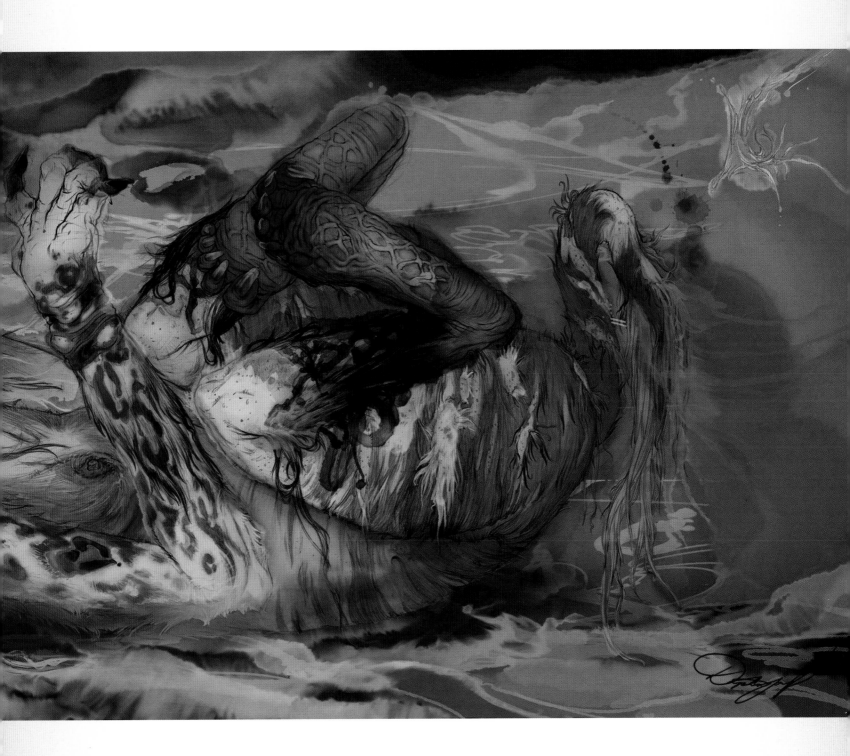

DAVE DORMAN

EISNER AWARD-WINNING ARTIST AND AIR FORCE BRAT Dave Dorman has lived and traveled around the world, which has noticeably influenced his diverse body of work. Dave attended St. Mary's College in Maryland and the Joe Kubert School of Cartoon and Graphic Art before leaving to teach himself oil painting. Minus an instructor's influence, Dorman experimented and adapted unorthodox, often imitated techniques, many of which he explains in his Gnomon Workshop DVDs.

Dorman's first big break was a cover for *Heavy Metal Magazine* in 1982. He followed that up with extensive work on *Indiana Jones*, *Star Wars* (fans voted him the #1 Star Wars Artist), *Alien, Predator, AVP, Batman, Spiderman, G.I. Joe, Magic: The Gathering, World of Warcraft, King Kong, Star Trek, Lord of the Rings, Harry Potter* and his own critically acclaimed project, *The Wasted Lands.*

DAVEDORMAN.COM

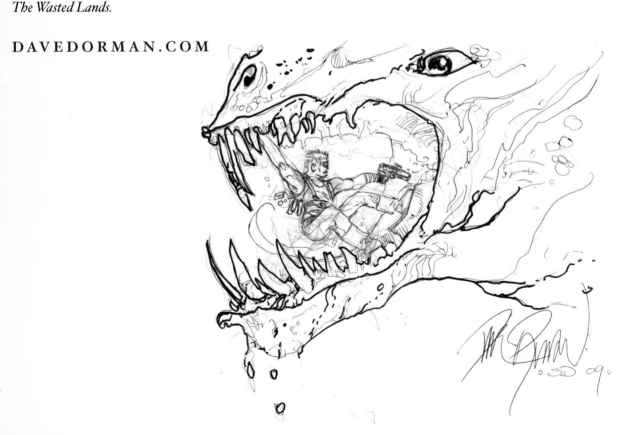

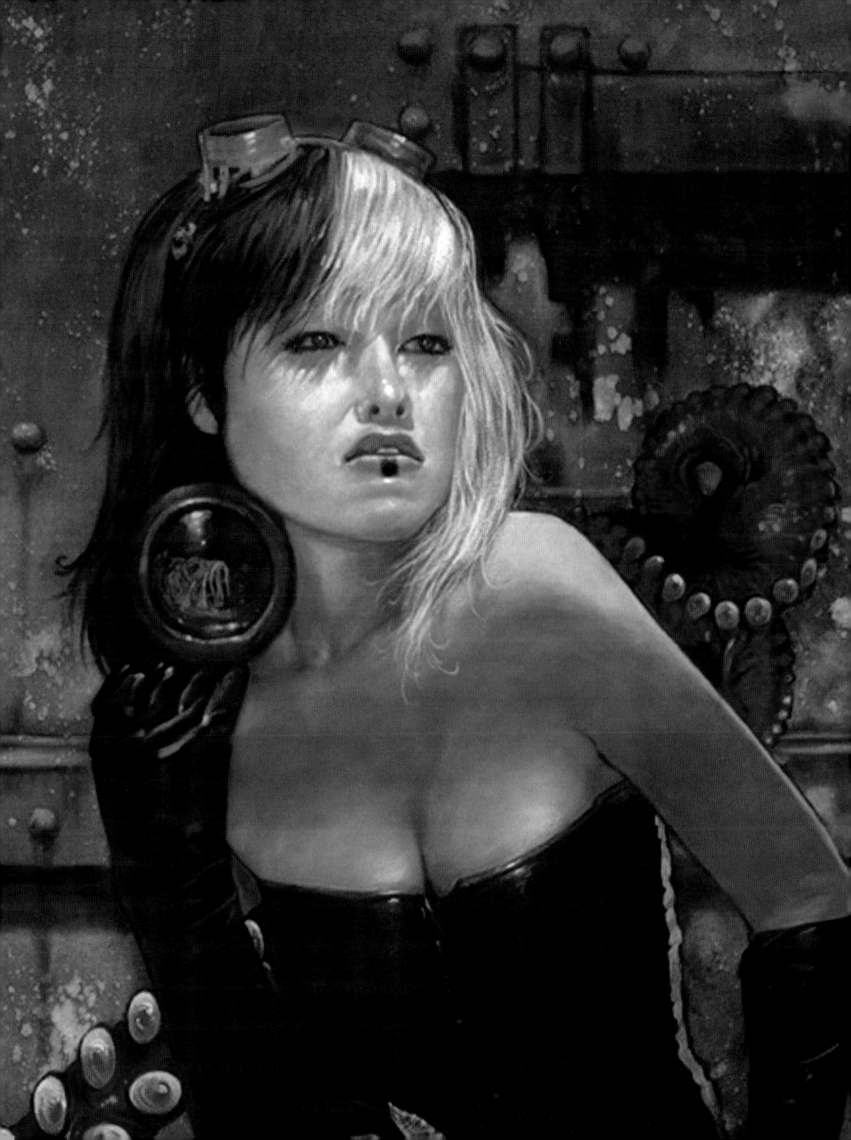

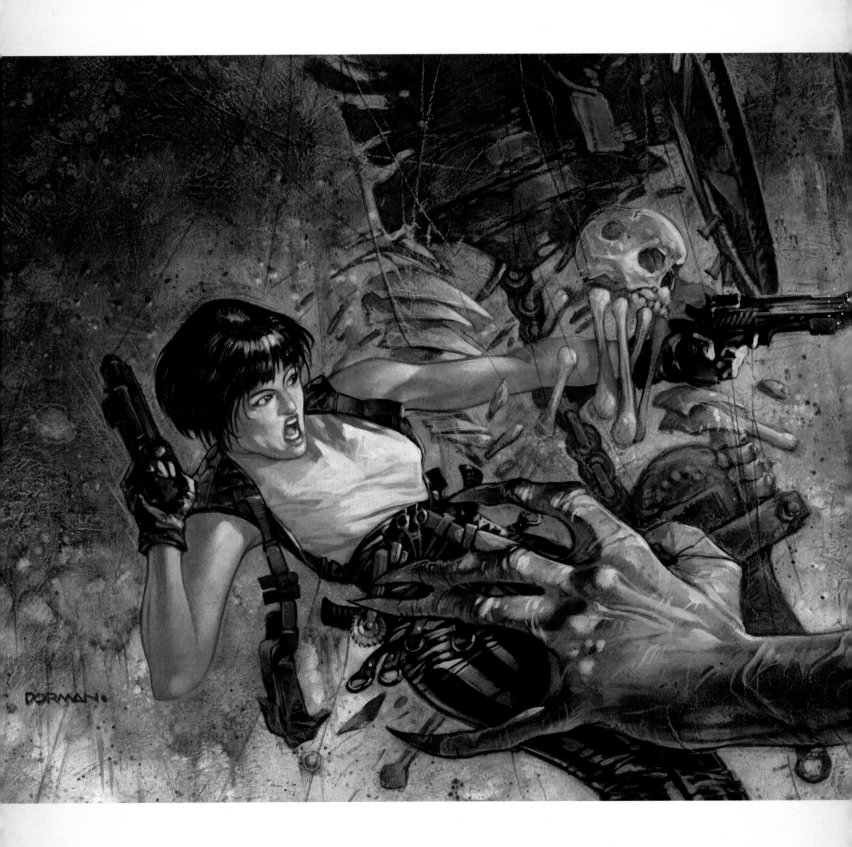

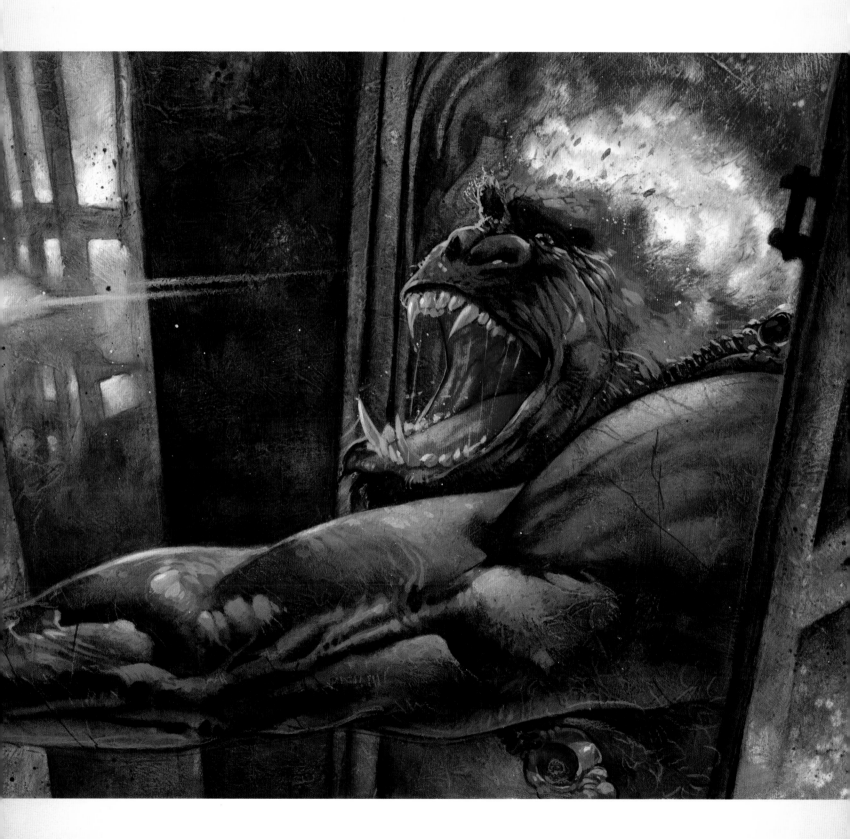

DAVE HILL

DAVE HILL WORKS PRIMARILY IN PEN AND INK DOING large-scale pointillism pieces. Interested in art his entire life, he was largely inspired at a young age by the works of Dali. His work has shown in Los Angeles, New York and France. Dave does commissioned work and designs images for *Spinal Cord*, a lifelong labor of love.

He shares his studio with a hairless rat (Flurp) and a raven (Fester), and he shares his life with an extremely tolerant wife, Angel, and two nutty brats, Acey and Zane.

DRHILL.BIZ

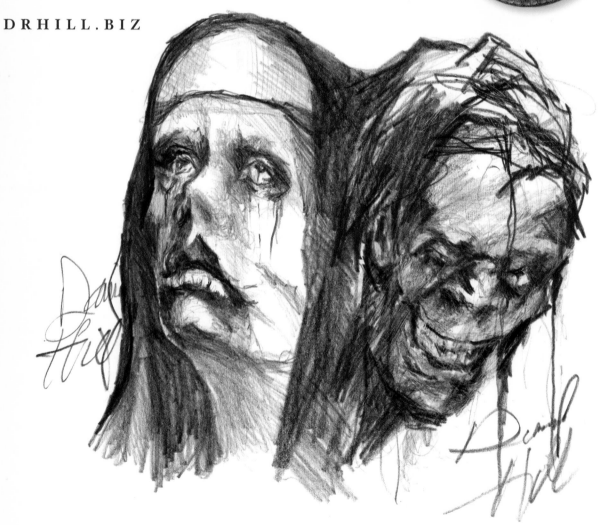

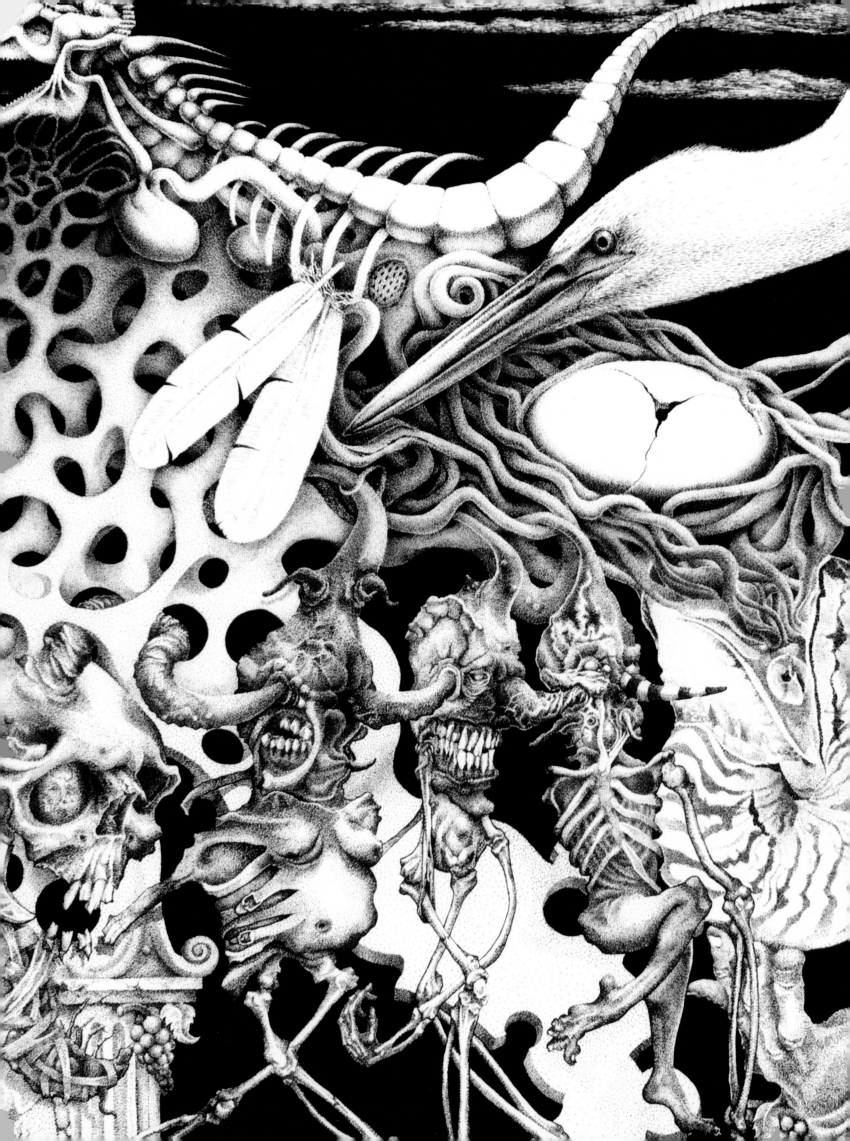

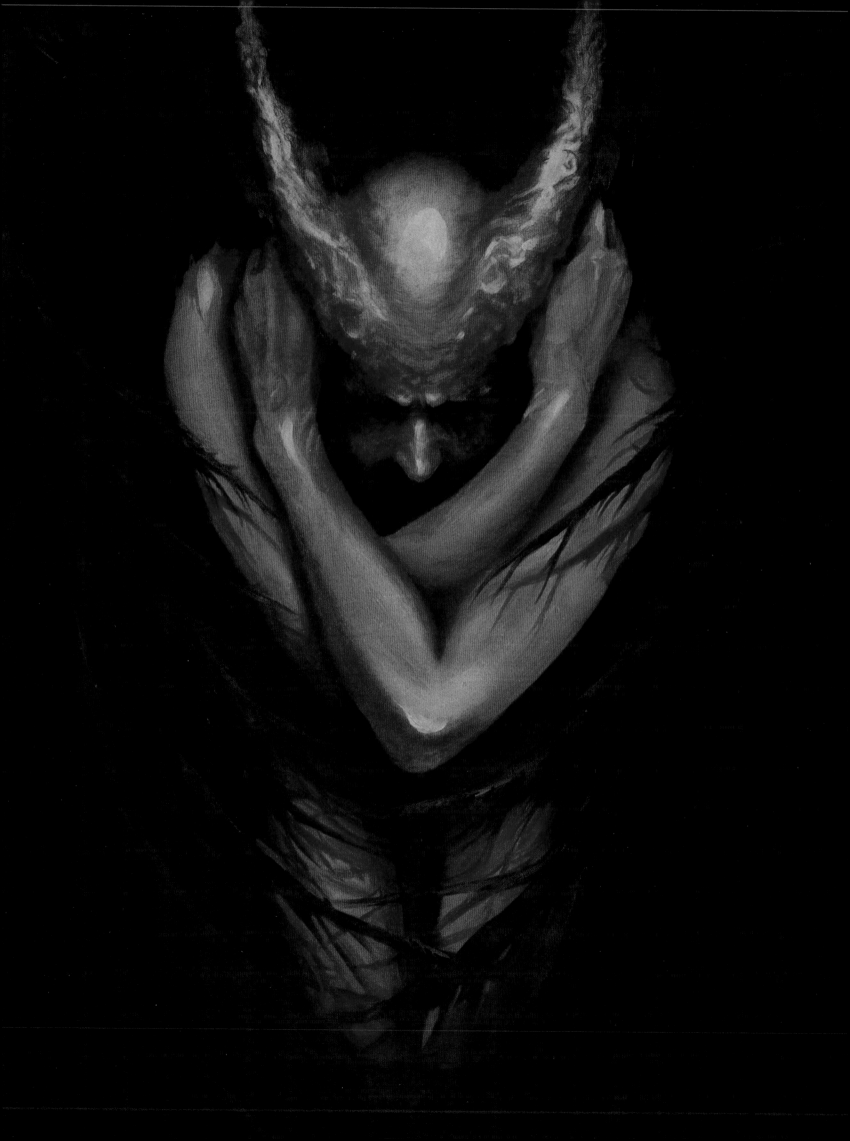

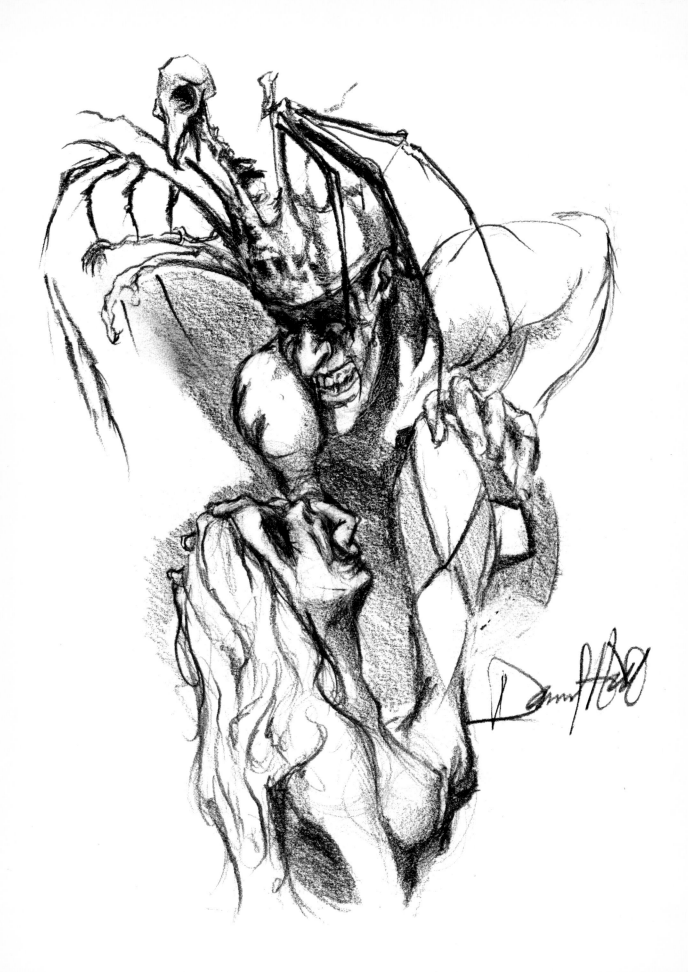

FRED HARPER

FRED HARPER'S LIFE GOAL AT THE AGE OF FOURTEEN WAS to be a caricature artist in a carnival or amusement park. Fred achieved this lofty goal at the of age nineteen with a summer job at Cedar Point Amusement Park in Sandusky, Ohio. Time to make new goals! Fred graduated with a BFA in painting from the Columbus College of Art and Design and painted hundreds of murals for *The Limited Express* until he got his pencil in the door at Marvel comics. He painted posters, pin-ups and covers as well as drew interiors for titles such as *Conan*, *Spiderman* and *Doctor Strange*.

Fred has shown his work at CBGB's 313, The Museum of American Illustration and Banning and Low galleries in Washington D.C. (two solo shows!). Fred's work is in the private collections of the rich and powerful... not that he could call in any "favors". His illustrations have appeared in such great publications as *Time*, *The Wall Street Journal*, *The New York Times*, *Playboy*, *The Village Voice*, *Sports Illustrated* and just about every issue of *The Week* magazine.

Fred makes appearances at high schools and colleges, such as Collegiate in New York City, McDowell High School, Brooklyn School of Technology, The Pratt Institute and Syracuse University. The National Caricaturist Network gave him the "Best Color Award" in 2008 and invited him to guest teach a color seminar at their annual convention. He also painted the key art for the tenth anniversary of Ozzfest 2005. When you see that kid in the black concert t-shirt with the Ozzy demon sitting on the crapper, think of Fred...boy, that didn't sound good, did it!?

Fred lives in New York City with his cat named Buzzard.

FREDHARPER.COM

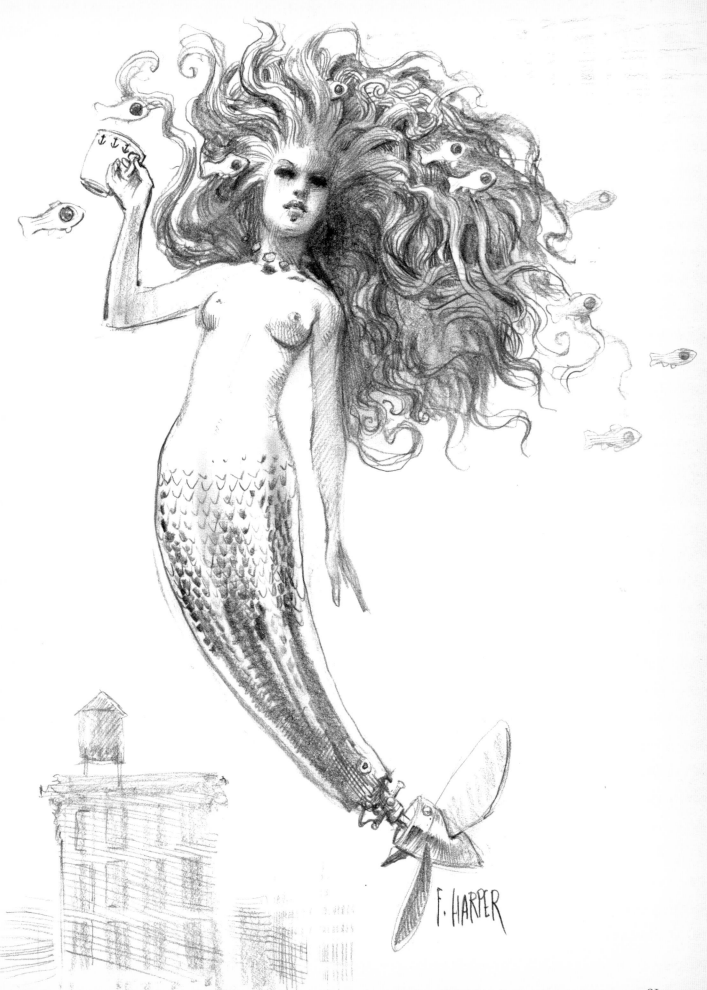

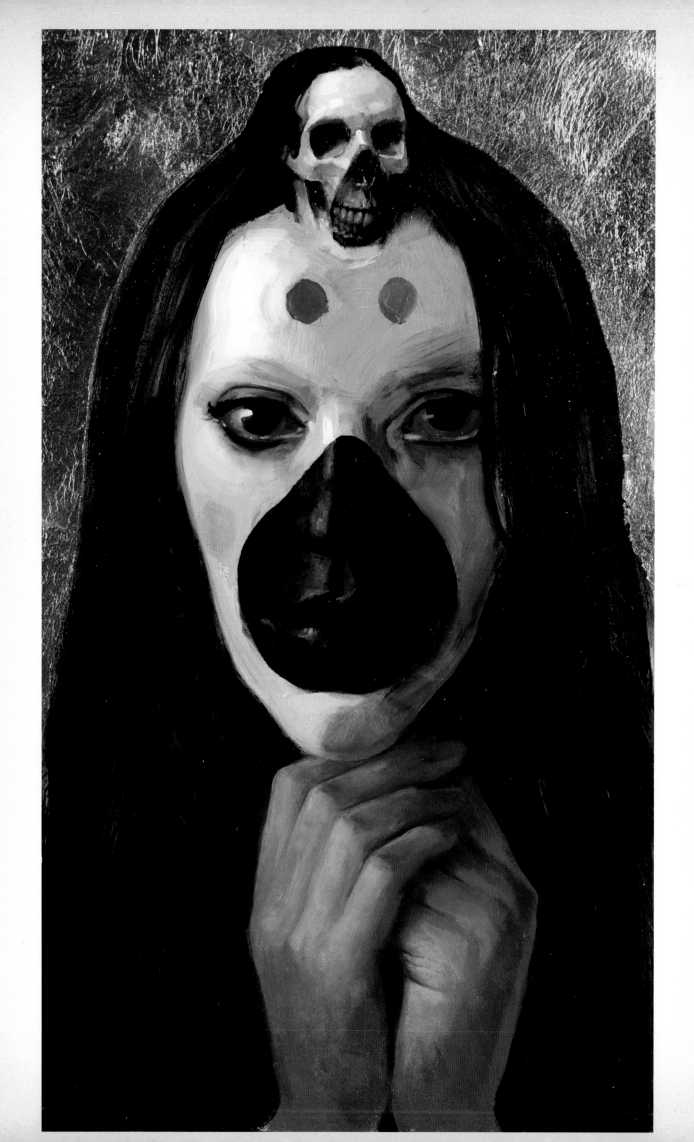

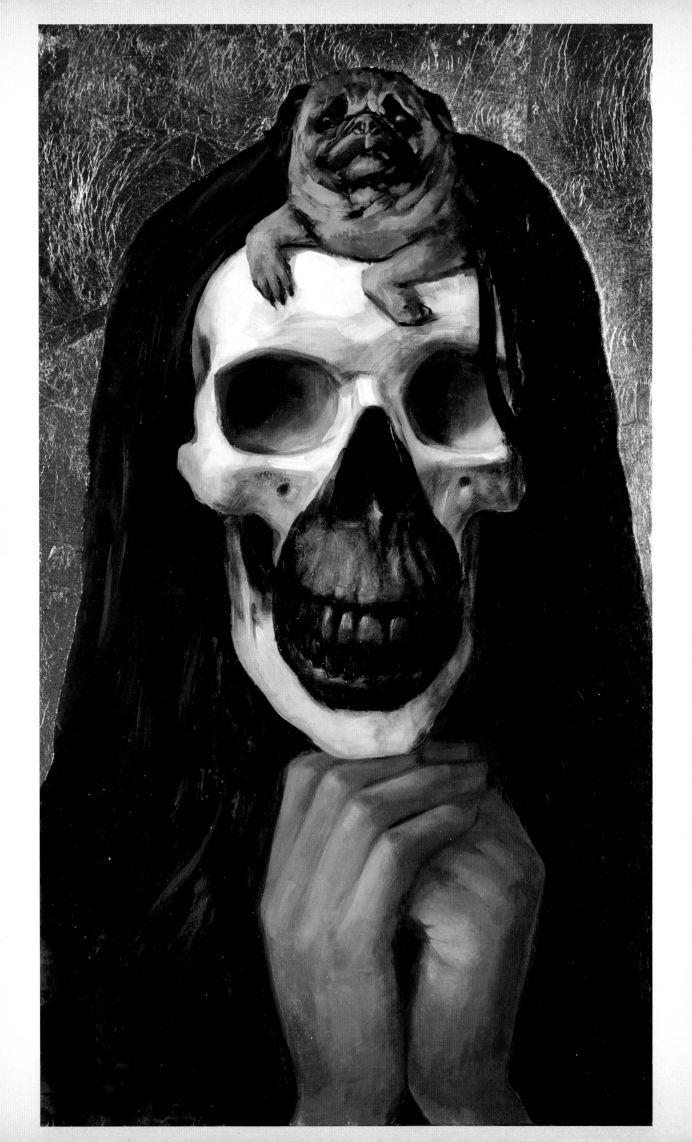

GENE GUYNN

GENE GUYNN WAS BORN AND RAISED IN FORT WORTH, Texas and from a very young age was immersed in the world of art. With a painter for a mother and a musician for a father, his world was always one of creativity and expression. He began painting in college courses during high school, and in fall of 2004 began his BFA at the Academy of Art University in San Francisco, California.

Gene takes inspiration from the thriving urban, outsider and lowbrow art cultures of San Francisco, Los Angeles and New York City and combines it with a fine art sophistication, especially taking influence from contemporary masters such as Jenny Saville and Lucian Freud. After graduating with a BFA in painting in 2008, Gene moved from San Francisco to the Los Angeles area, where he continues to paint, further evolve his personal style and exhibit in galleries all over the world.

GENEGUYNN.COM

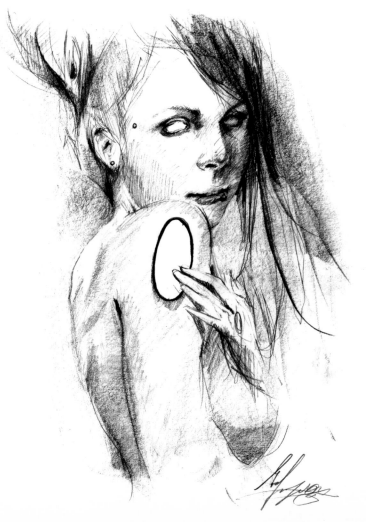

94

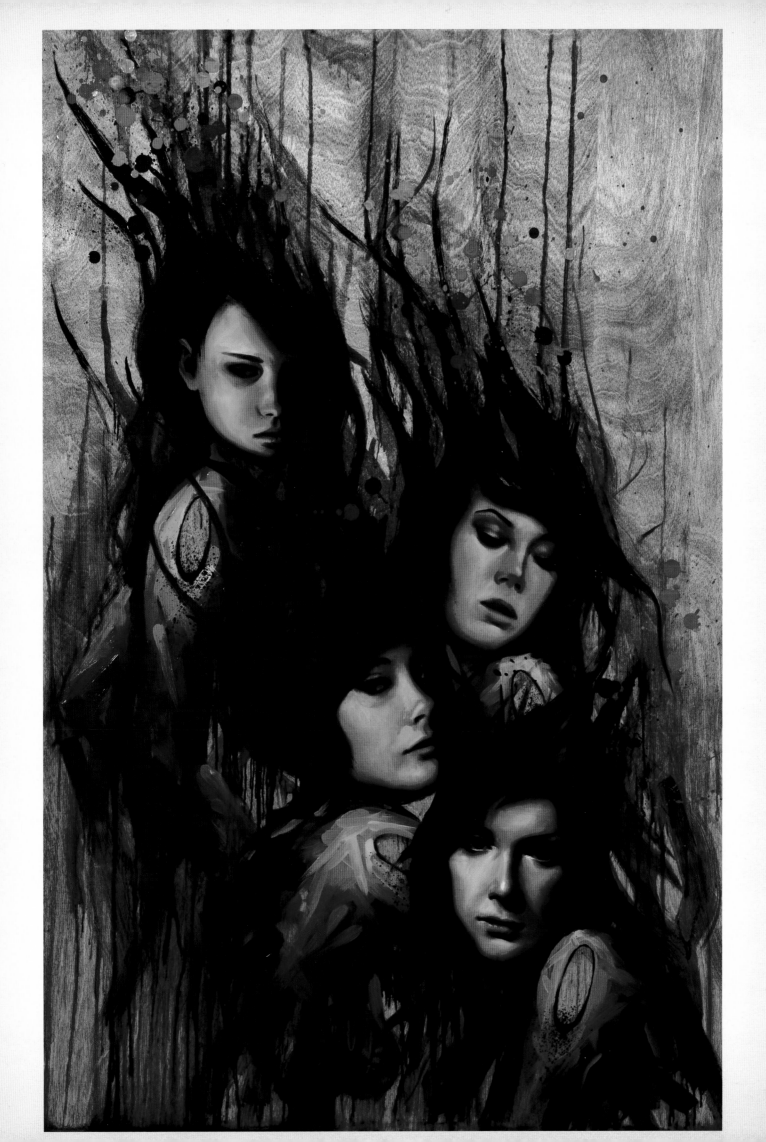

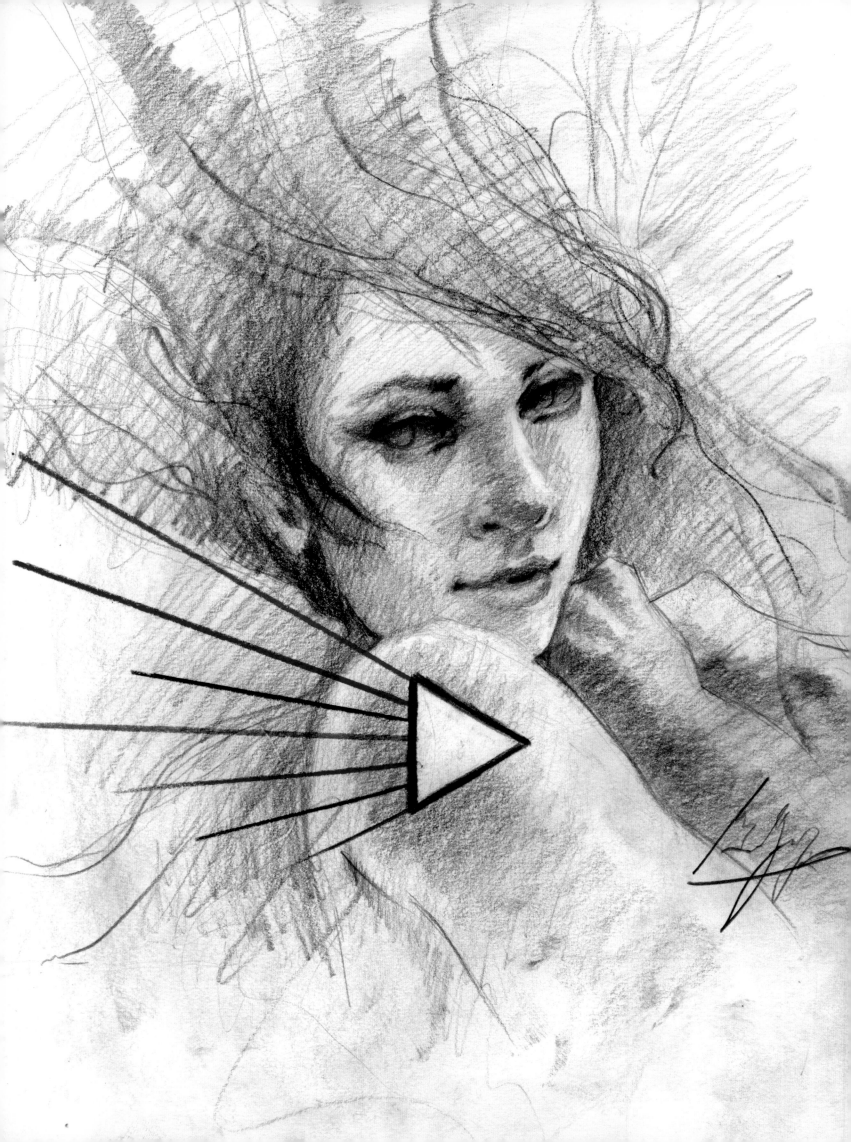

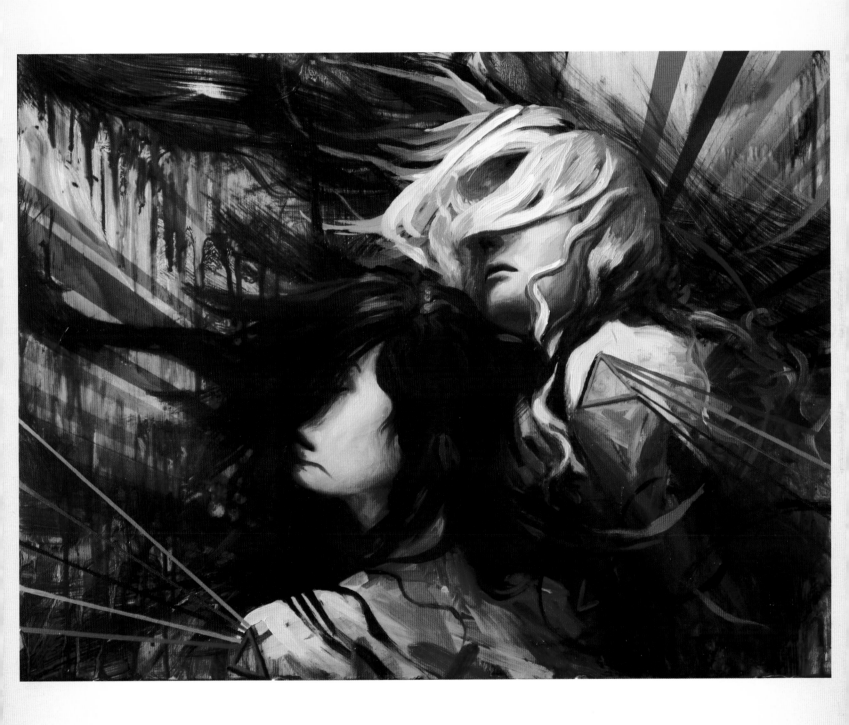

GREG "CRAOLA" SIMKINS

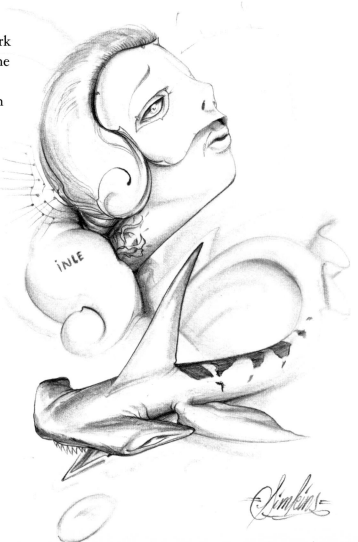

GREG "CRAOLA" SIMKINS' PAINTINGS PROPEL THE VIEWER into curious realms never seen and are full of curious characters ready to be introduced to the viewer's imaginations. Old cartoons, books, animal documentaries and music become the inspiration for Simkins' surreal world. Greg Simkins was born and raised in Torrance, California, just south of Los Angeles. His interest in art began upon his discovery of crayons and cartoons at a young age.

Simkins' artistic career started to develop after being introduced to spray paint in 1993, where he took on the name "Craola." It was through spray paint that his style transitioned into the use of acrylic paints, leading him to create the color combinations and blending techniques he is infamous for.

It was also his obsession with the artwork he would see in museums growing up, the books and magazines he would collect and the many hours of sitting alone with his sketchbook as his only outlet that formed the subplots to we world we see in Greg's paintings today.

IMSCARED.COM

98

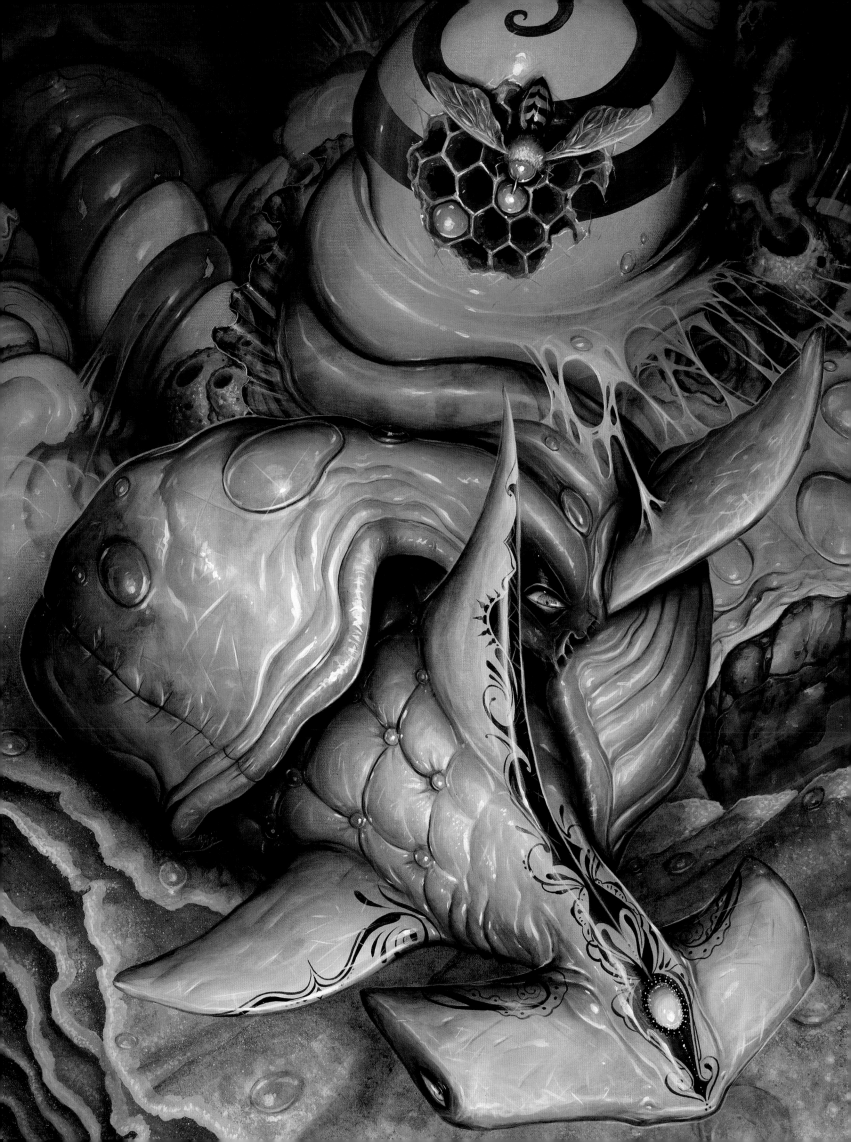

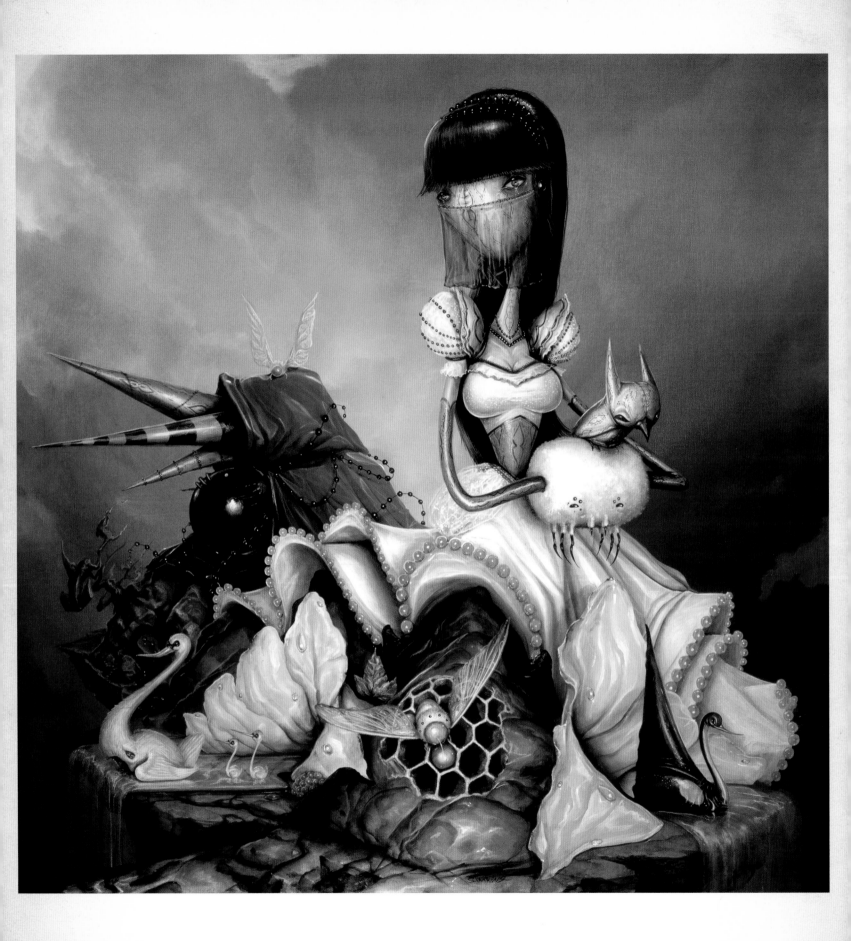

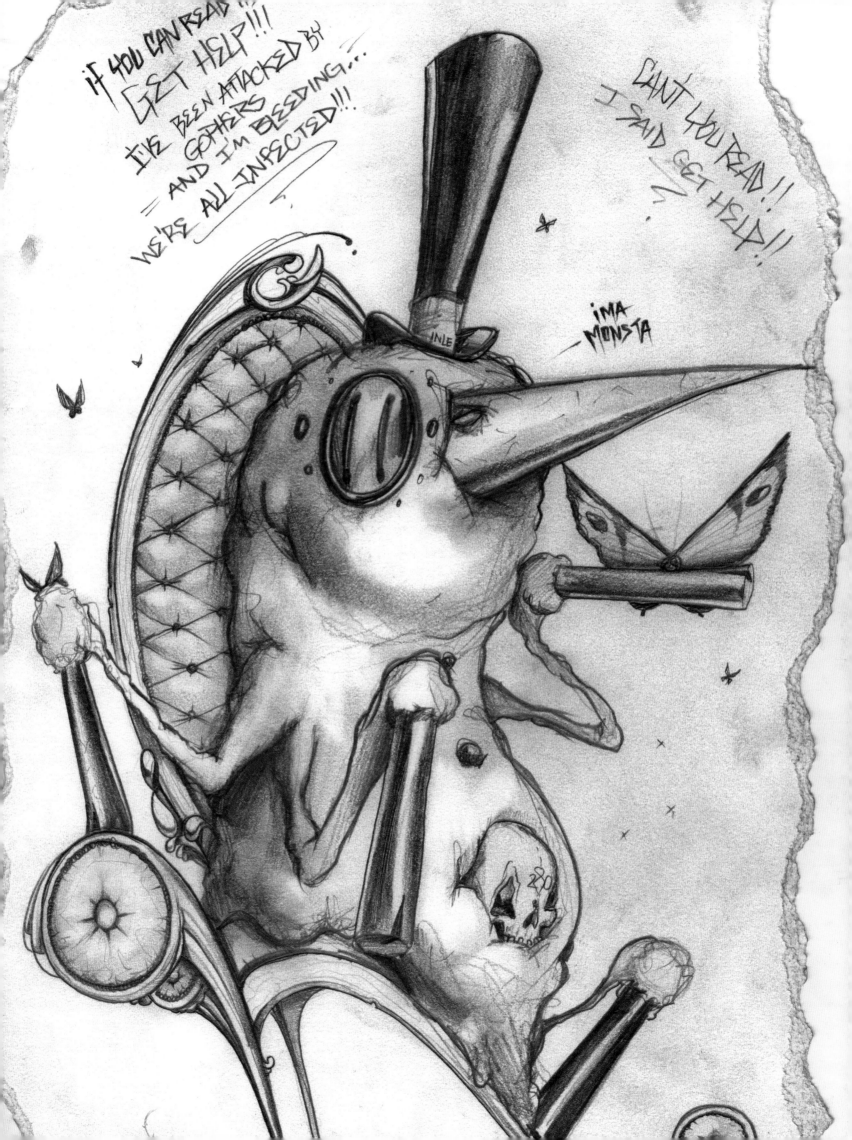

GRIS GRIMLY

GRIS GRIMLY CAN BE BEST DESCRIBED AS A STORYTELLER. For more than a decade, his distinctive style and wide selection of mediums have captivated a variety of loyal fans worldwide. Originally recognized for his dark yet humorous illustrations for young readers, Grimly has transcended beyond the realm of picture books through writing, gallery art and film.

Grimly's illustrations can be appreciated in over a dozen best selling books, including *The Dangerous Alphabet* with author Neil Gaiman, his own personally scribed *Little Jordan Ray's Muddy Spud*, the *Wicked Nursery Rhymes* series and the highly anticipated release of *Frankenstein*. Along with writing and illustrating books, Grimly has ventured into moving pictures as the director of the demented and humorous independent featurette, *Cannibal Flesh Riot!* He has worked with cult sensation Elvira, directing the opening to her show *Elvira's Movie Macabre* and a music video featuring the Mistress of the Dark. He is currently working on his second featurette, *Wounded Embark of the Lovesick Mind,* and has signed on to direct the stop motion feature *Pinocchio*, produced by Guillermo Del Torro.

As a storyteller Gris Grimly delivers, without boundaries or apologies, a madhouse of imagination to those who seek to be taken into his world. He is the one and only "mad creator".

MADCREATOR.COM

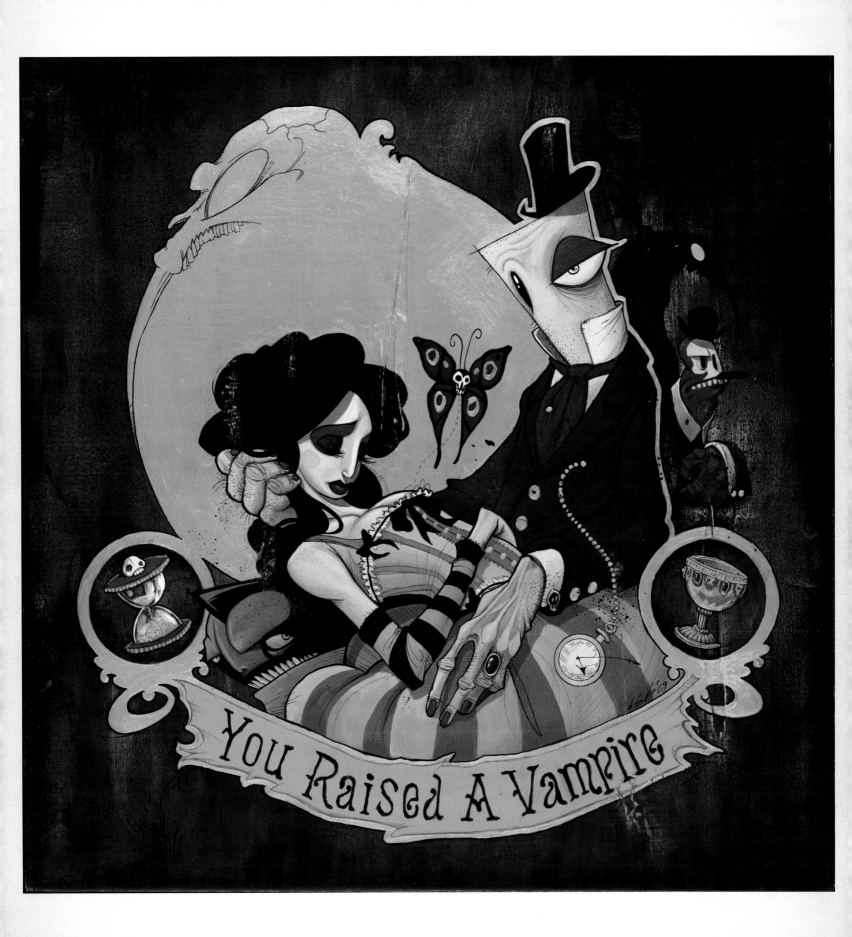

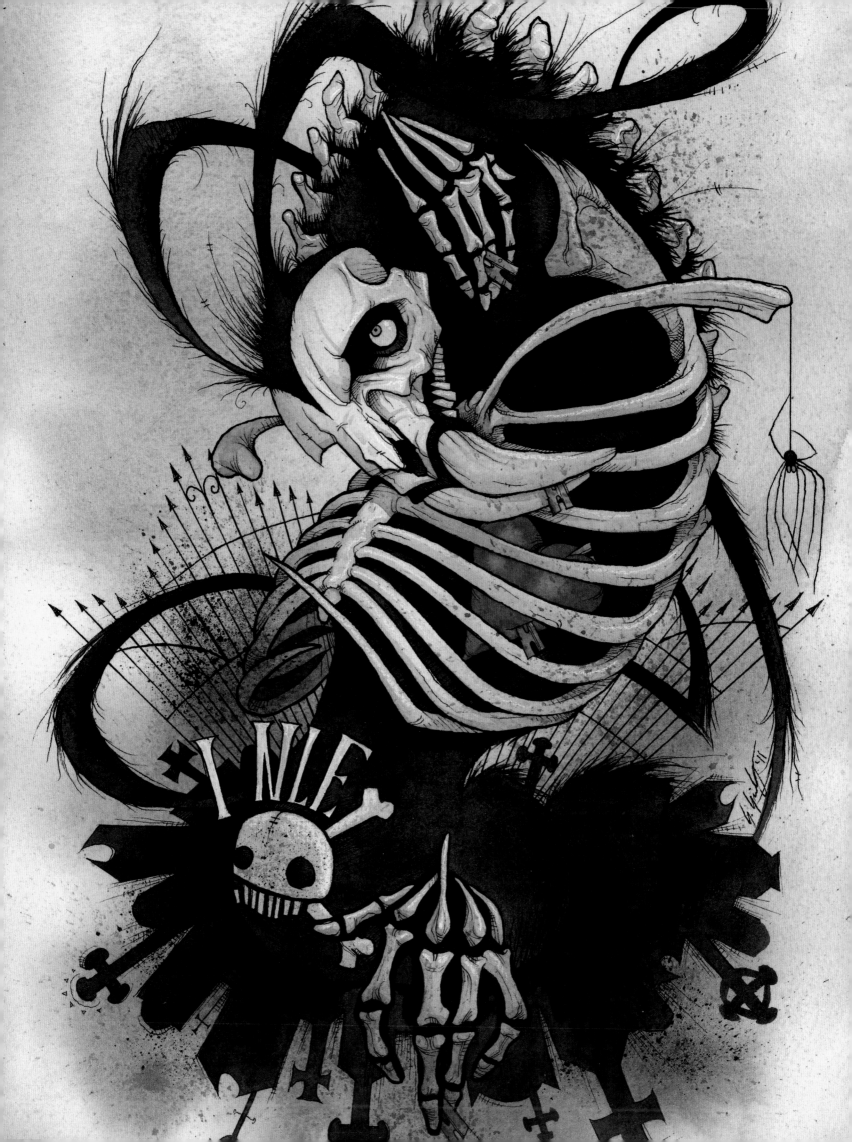

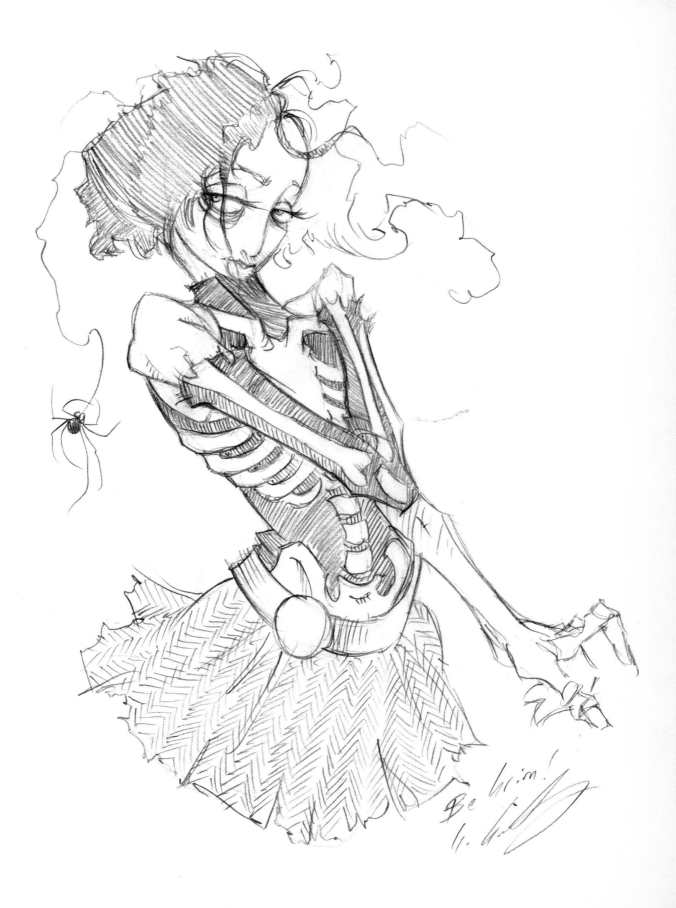

JEFF MCMILLAN

JEFF McMILLAN WAS BORN IN OCTOBER OF 1977 AND GREW UP in San Jose, California. McMillan's influences lie heavily in '80s pop culture. The artist proclaims that this decade boasted the best television programming, cartoons, toys and movies. It was also a decade of imagination and creativity, during a time when the world was changing so drastically on all levels.

He attended the Art Center College of Design in Pasadena, California from 2001 to 2004 and received a BFA in illustration. He now lives and works in Long Beach, California, with his wonderful wife, Liv, and a disobedient Siamese cat.

JEFFMCMILLAN.COM

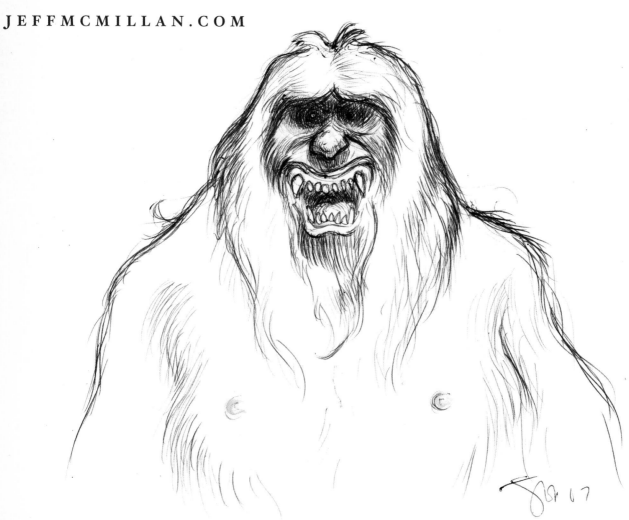

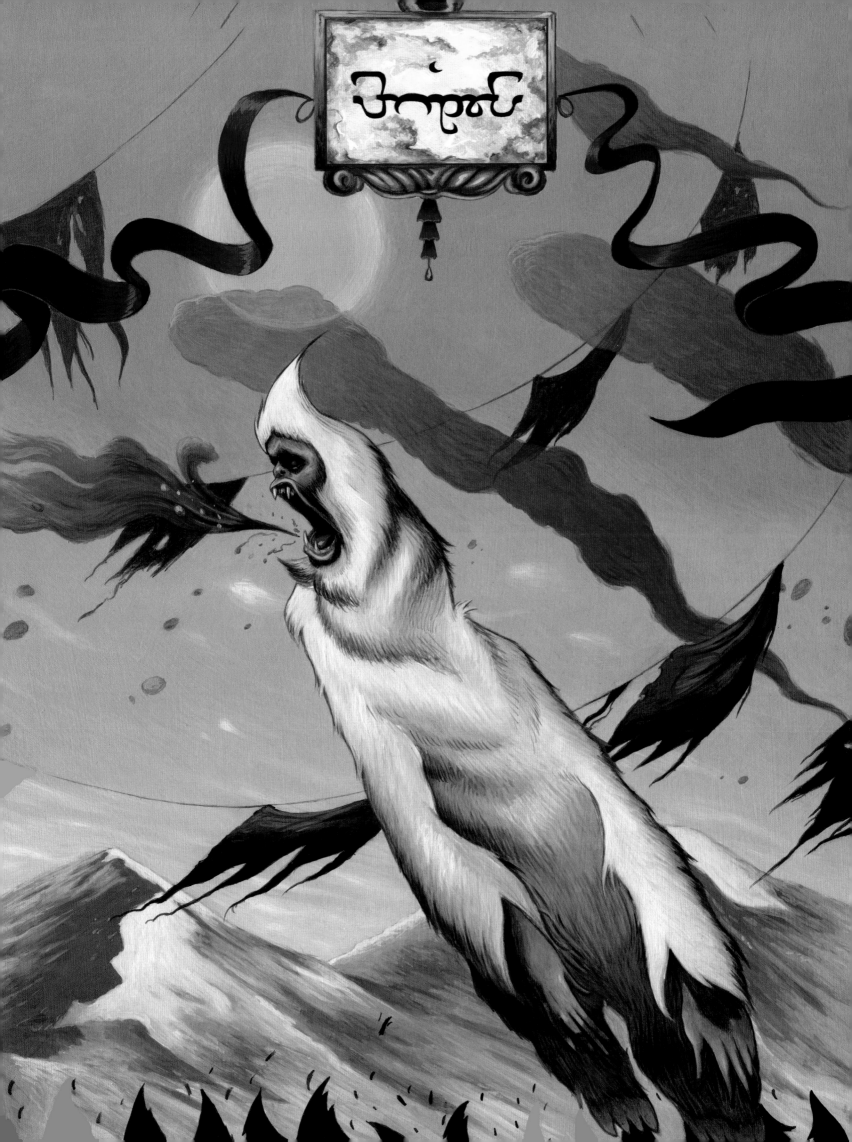

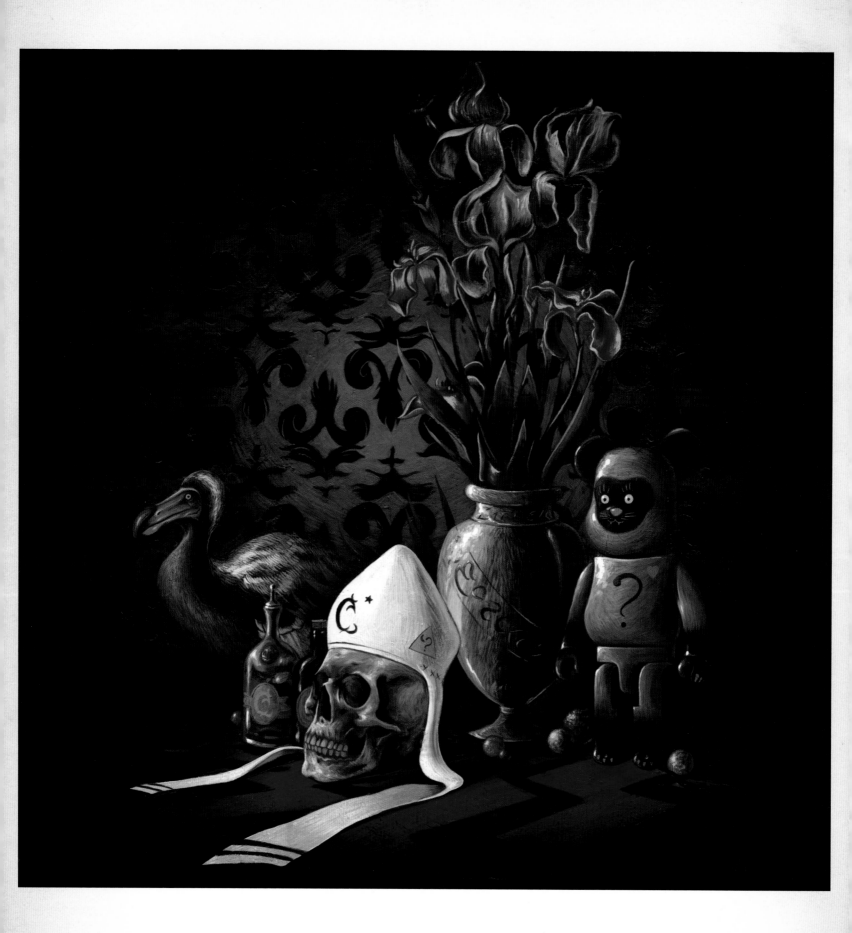

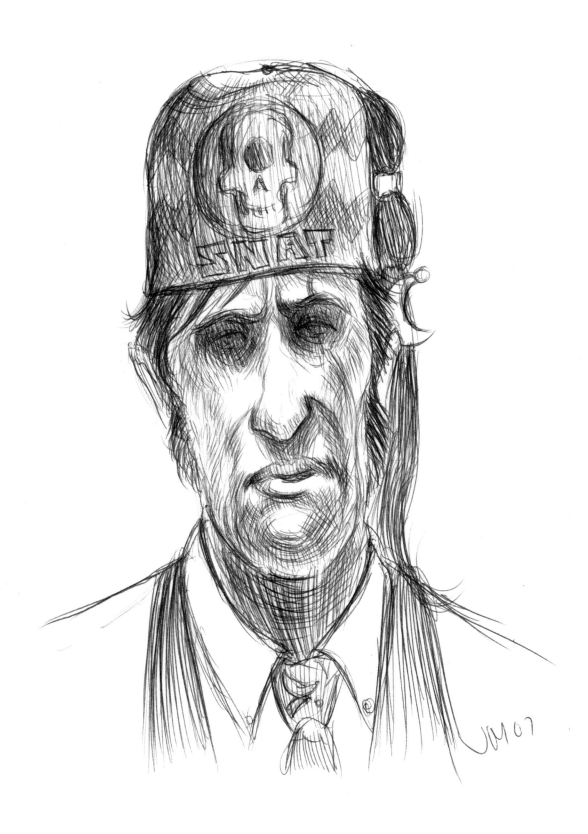

JESSICA WARD

Jessica Ward is a contemporary, figurative, pop-surrealist artist who began exhibiting her work in 2008. Born in Agana, Guam in 1982, she moved and traveled around the world as a child because her father was an Air Force officer. As a child, Ward could always be found sketching and drawing, and she aspired to become a professional artist when she grew up. She attended the Kendall College of Art & Design in Grand Rapids, Michigan and received a bachelor's degree in fine art-drawing with a minor in illustration.

Ward's artwork is inspired by eating disorders, which she herself has struggled with since adolescence. She uses graphite, color pencil, chalk pastel and water color on paper or board.

Jessica currently lives in Los Angeles, California with her husband, Apricot Mantle. She had her first gallery show in 2008 and has been exhibiting her work internationally since then.

"Jessica's beautifully macabre artwork will seize your attention in an instant. The message that runs behind her depictions of dual-limbed temptresses that snack on their coiffures is much deeper than what meets the eye. Her graphite charm uncovers ugly truths in the realm of eating disorders and body dysmorphia. Every spiral, skeleton and string of hair represents something different in her ward of mysterious mistresses."
— The Hive Gallery & Studios

"Guam-born artist Jessica Ward is not about to glamorize being a teenage girl with lip gloss and mini-skirts. Her vivid graphite and color drawings of female figures with detached limbs and incomplete bodies are a visual reminder that hidden neuroses can pop up in the prettiest of places. Exposing the paranoia of eating disorders and teens, Ward's subjects become more monster than teen and illustrate a storybook of inner delusions where hair is a girl's worst enemy and cats become accepting protectors and symbols of escape."
— L'etoile Magazine

JESSICAWARDART.COM

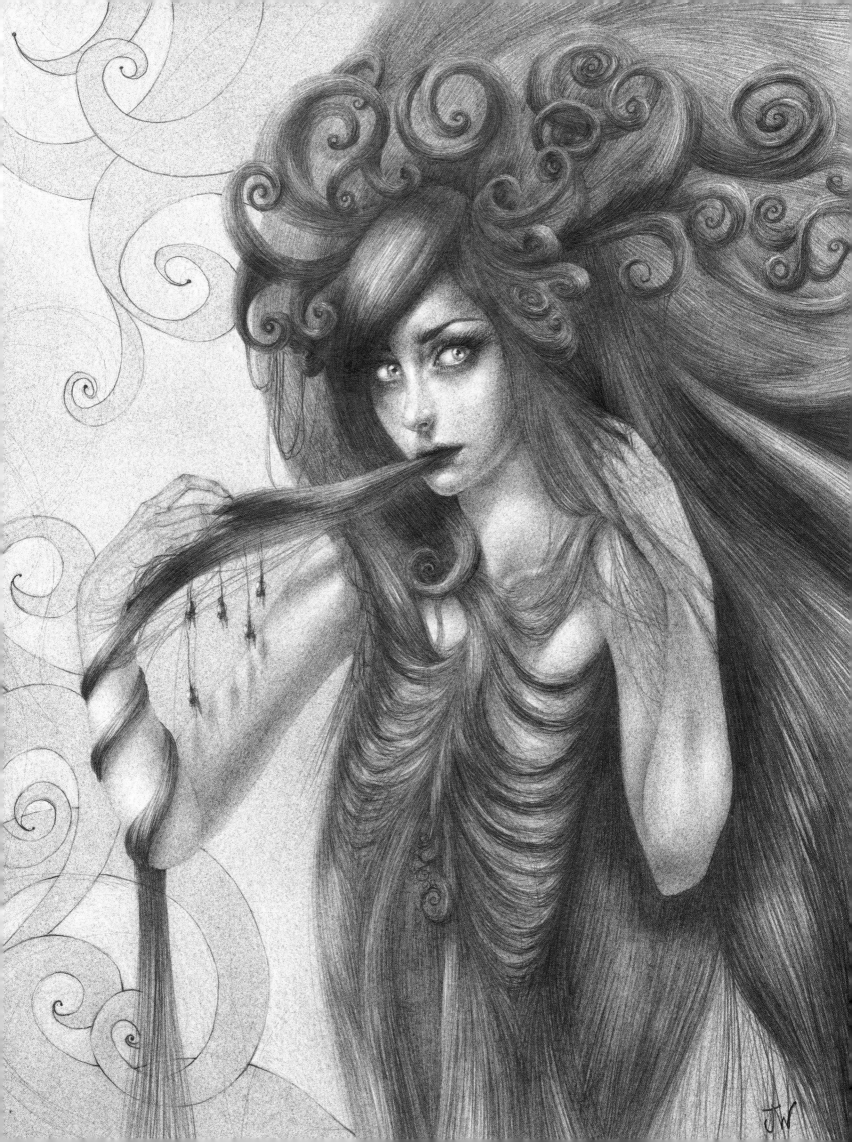

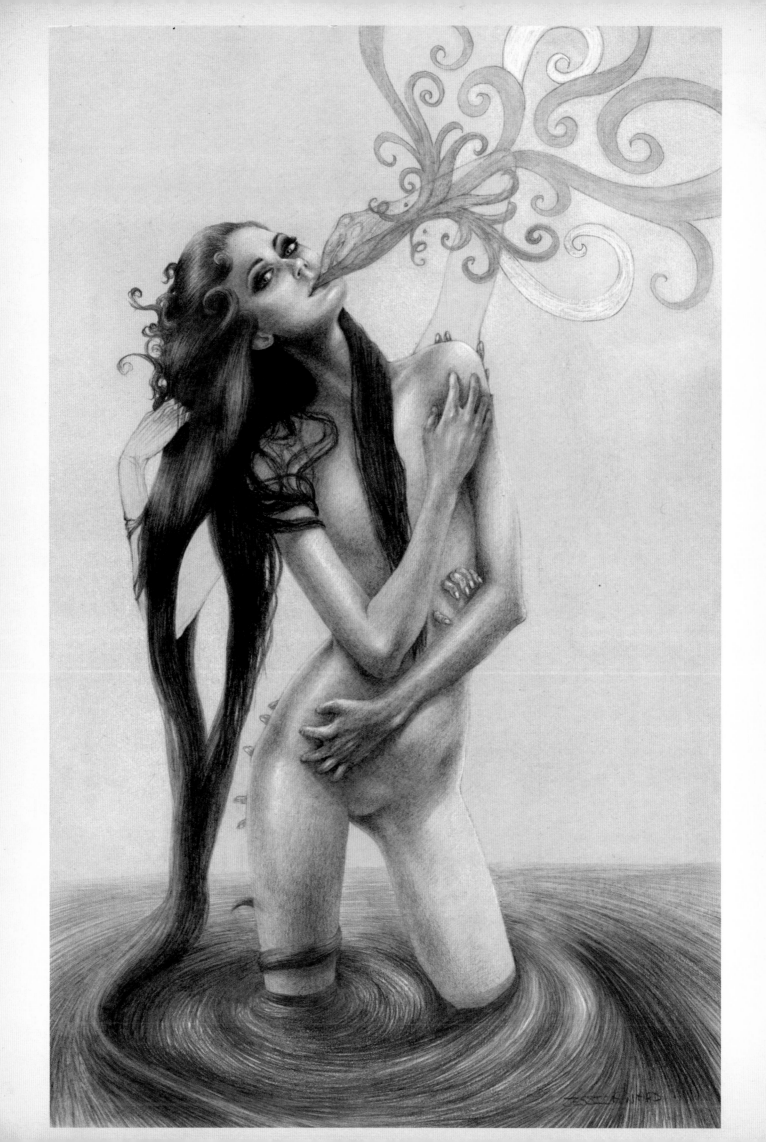

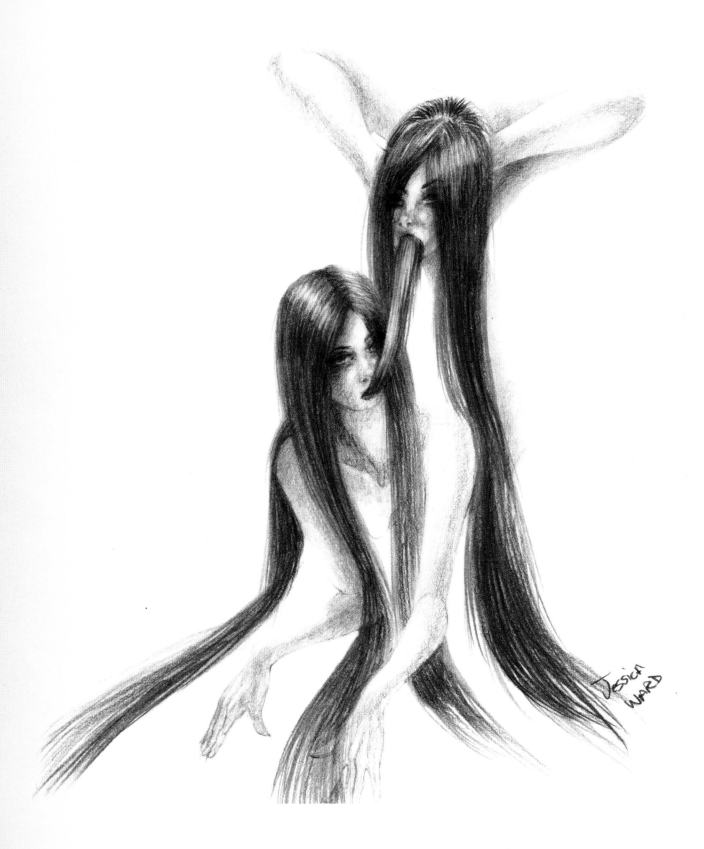

JON BEINART

Jon Beinart is a visual artist, best known for his Toddlerpedes (doll sculptures) and detailed graphite and ink drawings. He also publishes art books focusing on the artwork and artists featured in the beinArt collective.

As a child, Jon was lost in his imagination and preoccupied with the lives of ants, snails, spiders and mice. This fascination with small worlds continued through his life, often blocking out the larger world around him, and this interest is apparent in his art. Drawing is Jon's oldest outlet, an obsession that is deeply rooted and has become fundamental to his well-being.

"At the age of four, an eccentric friend of my family often babysat me. She made black and white woodcuts of anthropomorphic snakes with sagging breasts. They were often pregnant and wore nooses around their necks. She told me on many occasions that I was destined to be an artist when I grew up and that one of her snakes, which held a paintbrush and palate, was in fact a picture of me.

"When I asked her about the rope around my neck and why I had boobs, she said it was also a self-portrait! I found this very confusing. She was a bit crazy, but her encouragement contributed to my development as an artist."

BEINART.ORG

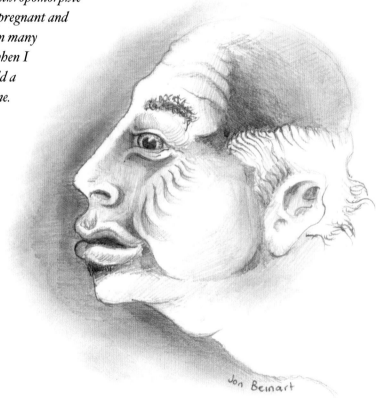

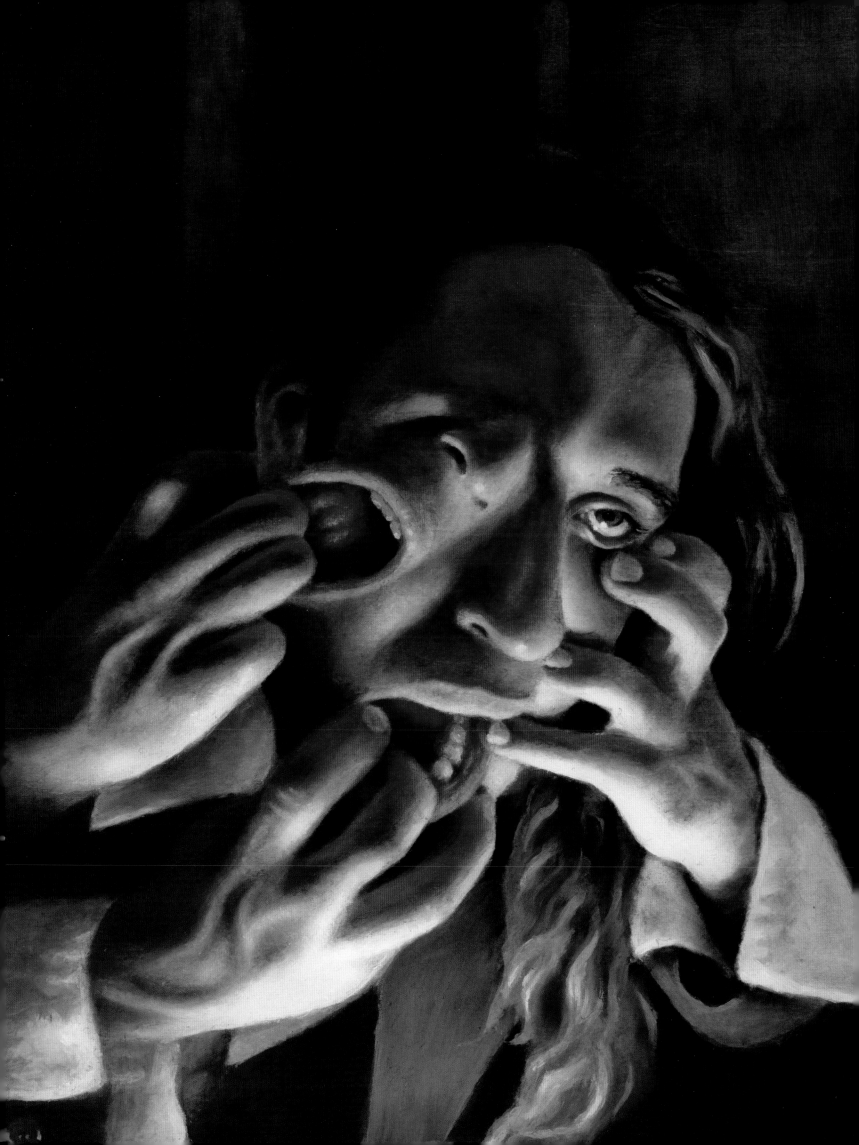

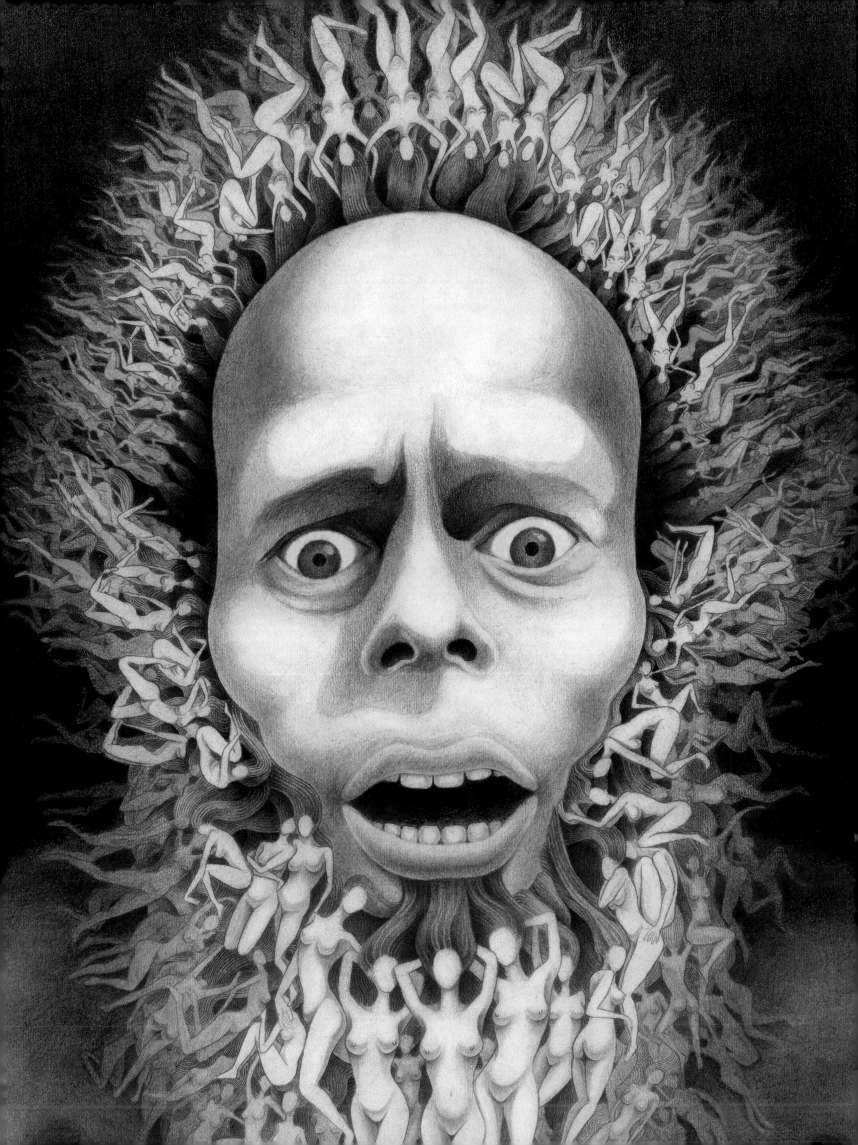

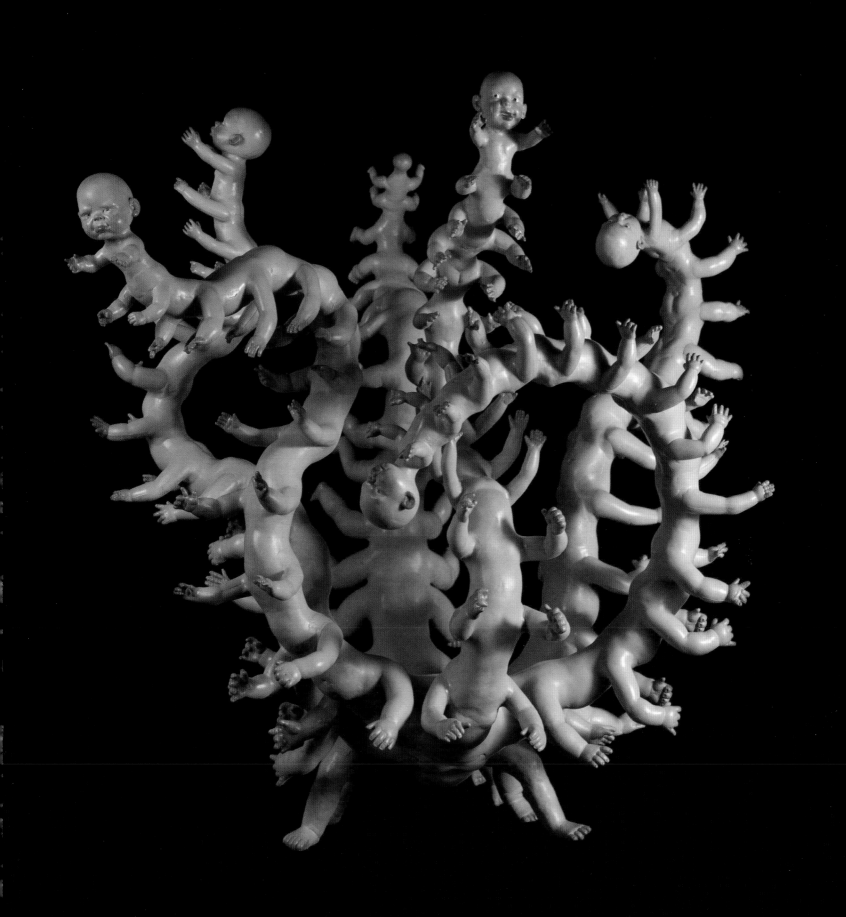

JON SCHNEPP

Jon Schnepp graduated from The School of the Art Institute of Chicago, Illinois. In the past, Jon has directed episodes of *Upright Citizens Brigade*, edited episodes of *Space Coast: Coast to Coast* and designed the *Aqua Teen Hunger Force* home. Jon has made original programming for Cartoon Network, FX, Nickelodeon and Comedy Central.

Currently, Jon has directed and produced the Adult Swim animated series *Metalocalypse*, where he created the character designs for the cartoon band Dethklok. Along with directing three seasons of *Metalocalypse*, Jon recently co-directed episodes of *The Venture Bros.* and *The Black Panther*. Schnepp also directed over fifteen music videos for the Dethklok concert tour.

Jon loves science fiction, horror, comic books and all things nerd.

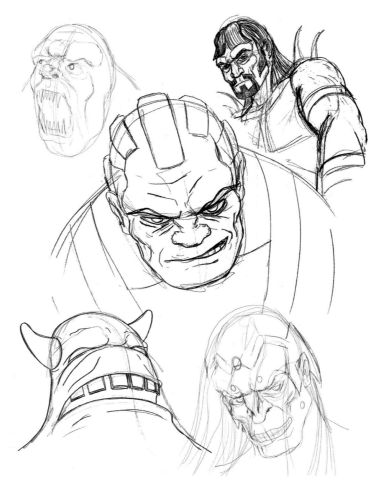

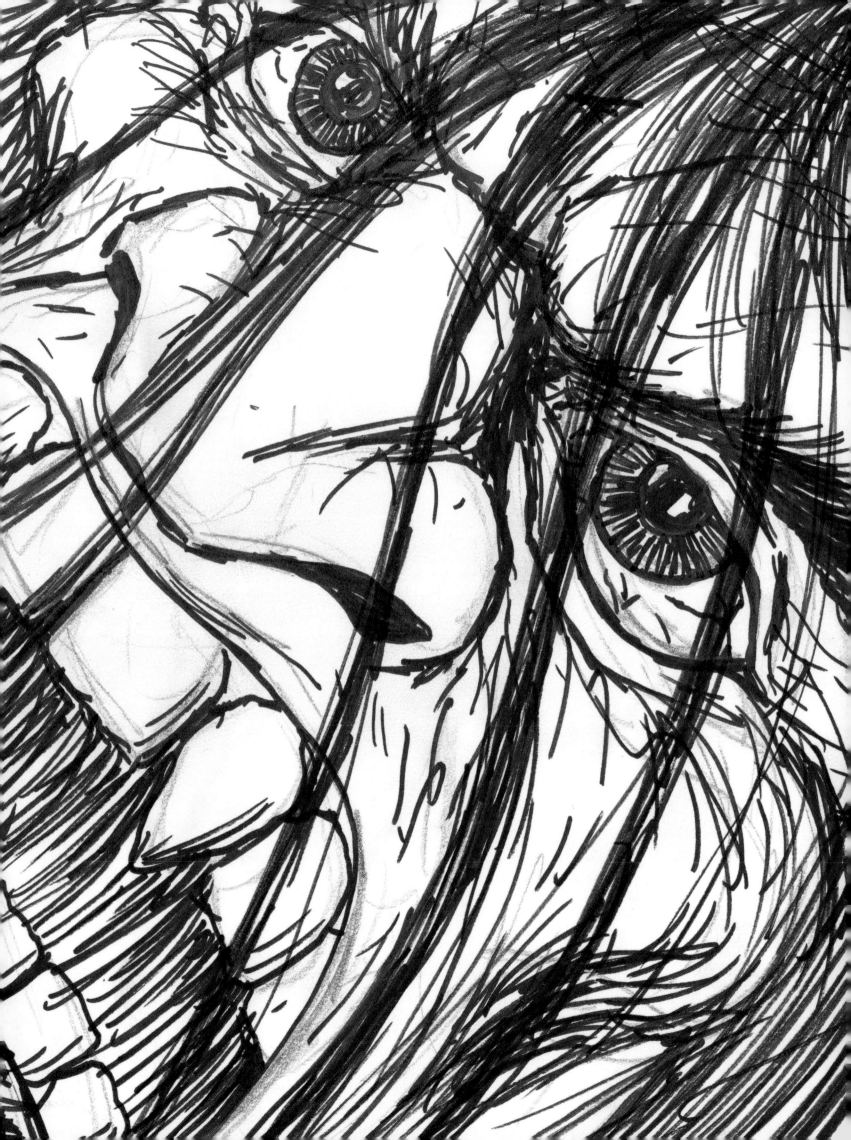

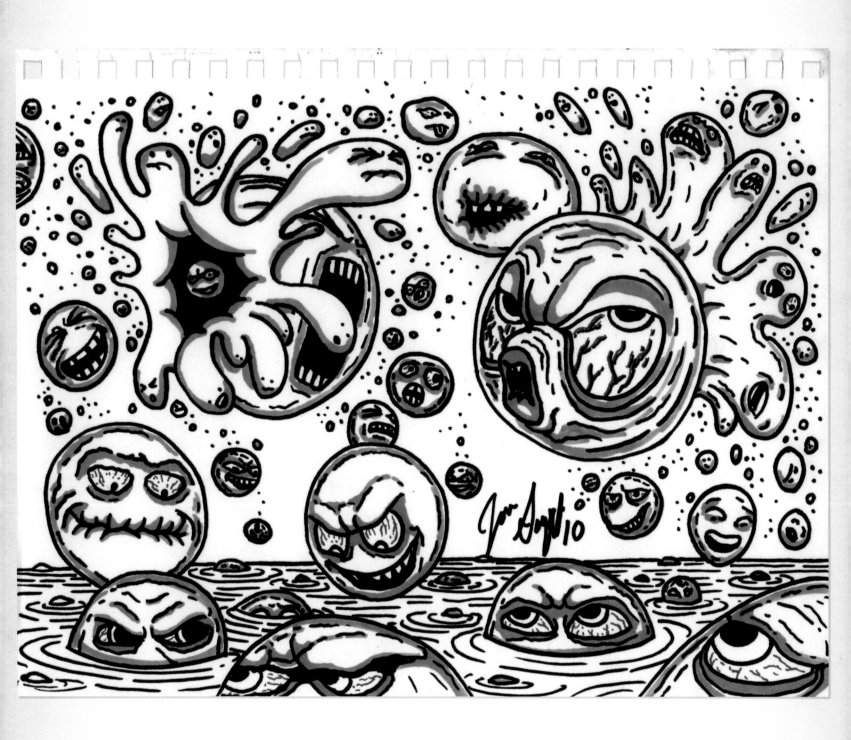

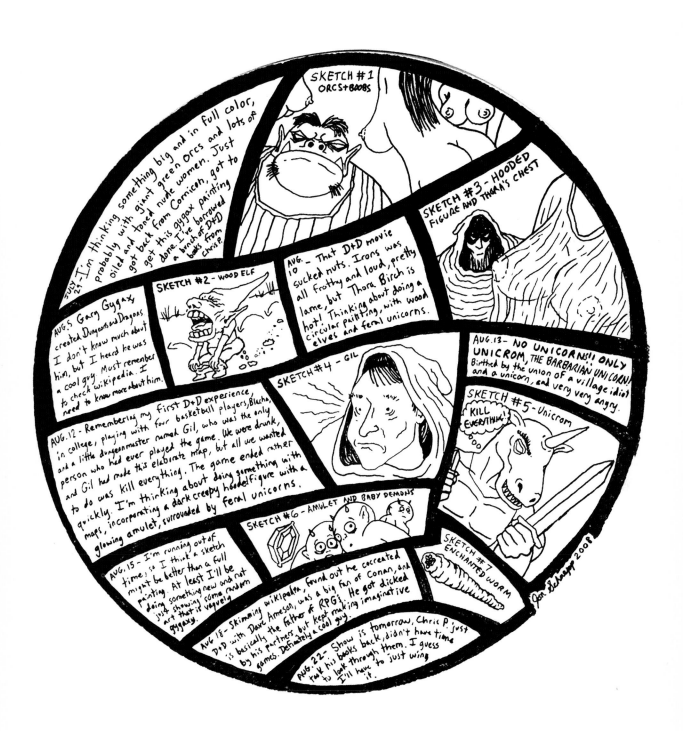

JORDU SCHELL

JORDU SCHELL IS A CREATURE AND CHARACTER DESIGNER WITH over twenty-three years in the film, television, toy and video game industries. He designed the characters for the film *300*, was key character supervisor for James Cameron's *Avatar* and has contributed countless creatures and monsters to films such as *Men in Black*, *Alien: Resurrection*, *The Chronicles of Narnia* and *The Mist*.

He has art in the collections of Steven Spielberg, Rick Baker and Richard Taylor. He has taught sculpture and design at Tippett Studio, Industrial Light and Magic, Blizzard Entertainment and Weta Workshop in New Zealand. His passion for the craft of fantasy design is evident in his bizarre creations, and he tremendously enjoys sharing this passion with others.

SCHELLSTUDIO.COM

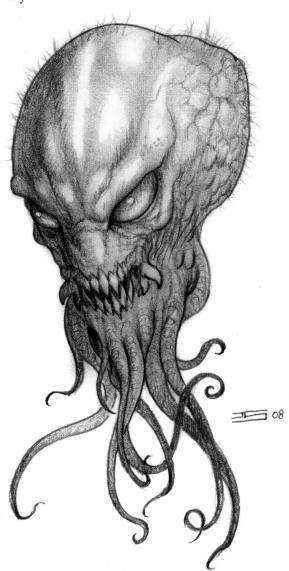

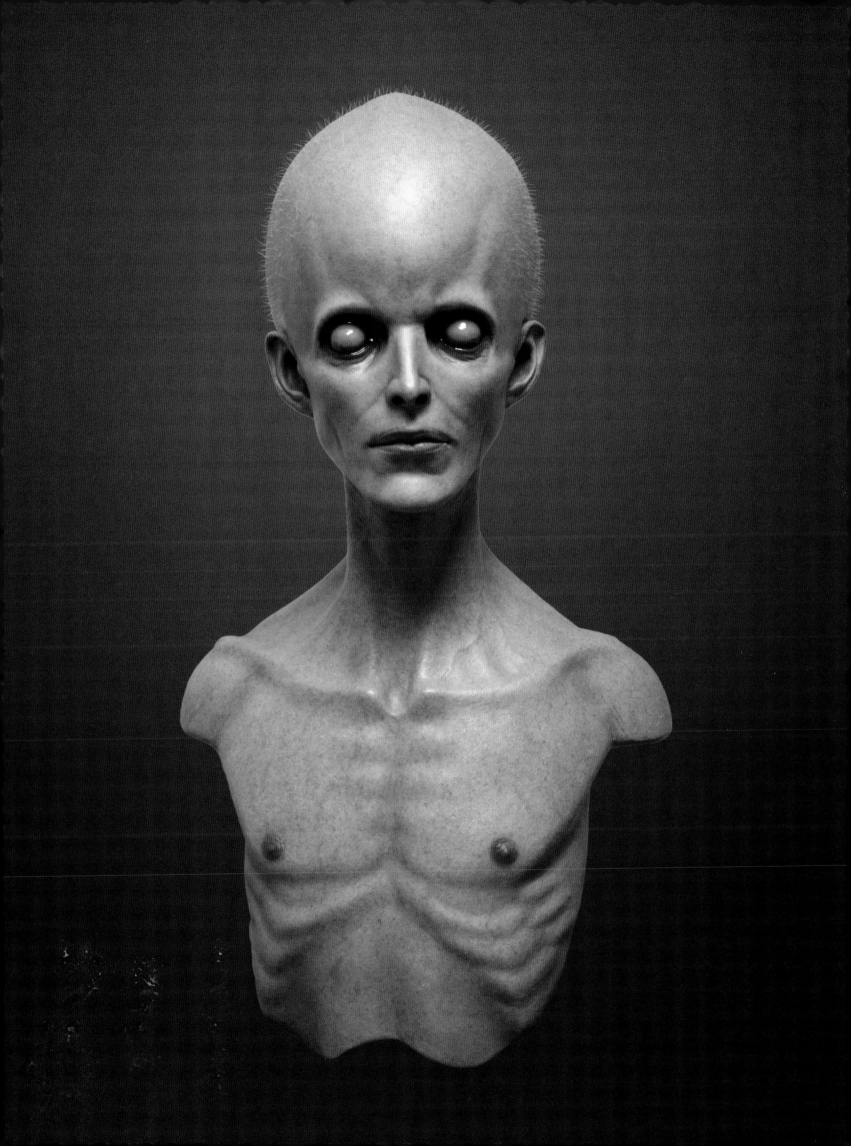

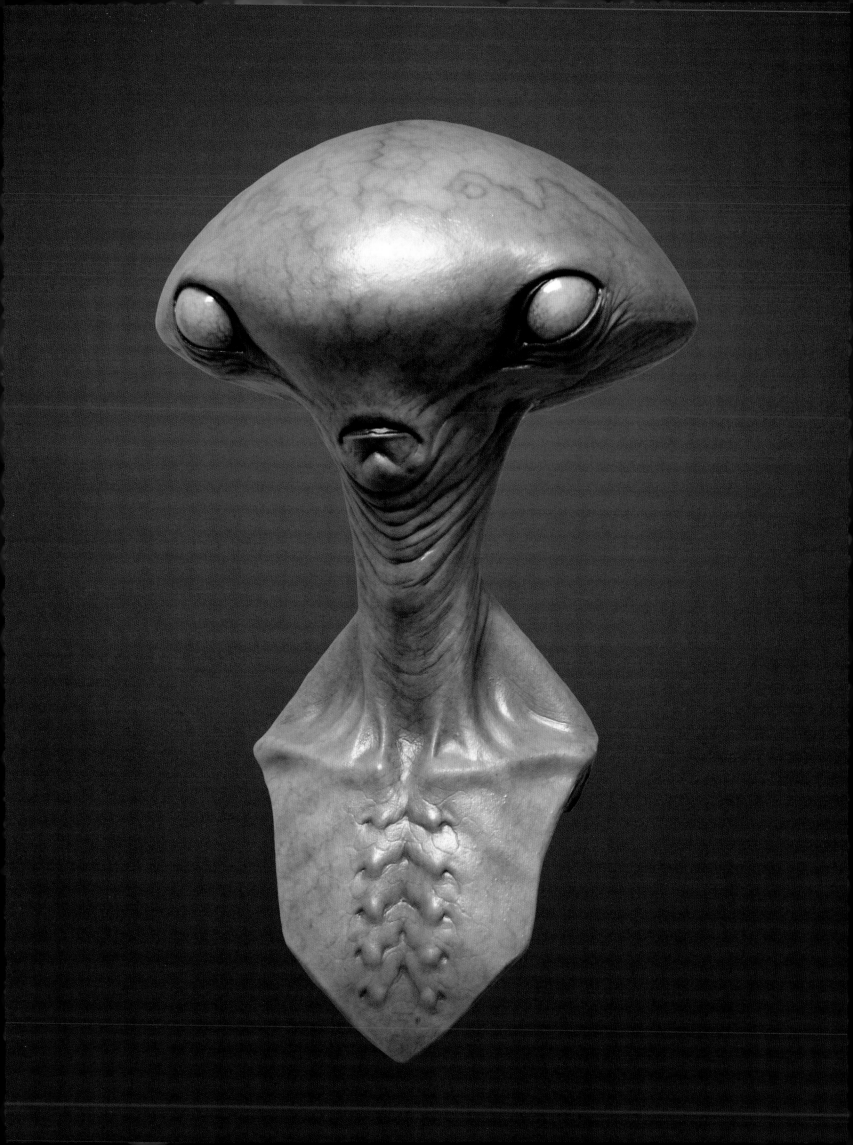

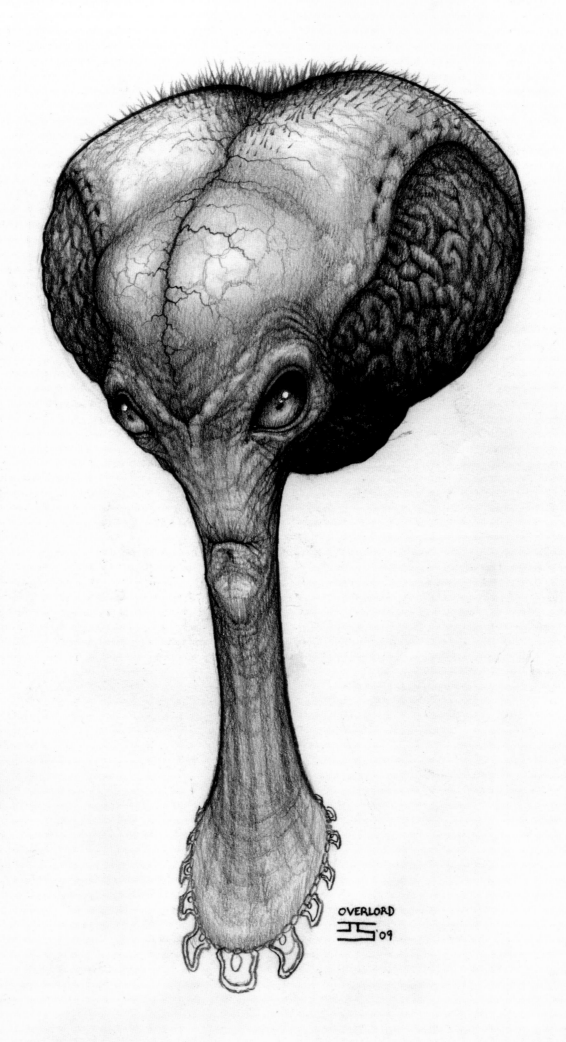

OVERLORD

KALI FONTECCHIO

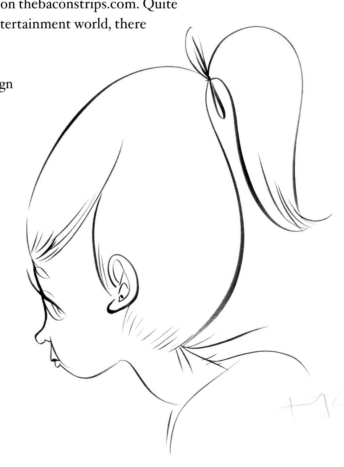

JUST BEGINNING HER CAREER IN ANIMATION, KALI HAS WORKED for Disney Television Animation, Warner Bros. Animation, Six Point Harness, Wildbrain, Bento Box and more. She honed her skills for the industry, working with seasoned pro John Kricfalusi on conceptual art for film, television, and the internet.

Although animation is her career, she is not limited to that title alone. In the past few years, she has contributed artwork to magazines, newspapers and books. Her first children's book illustrations were recently published in *Dorotea and Friends Visit The Hospital*. Her art has been included in various Los Angeles art shows, including Sweet Streets II. Kali also recently participated on an animated short for Channel 101 for the first time. Coming soon, the *Yo! Gabba Gabba Comic Anthology* is her first self-published, written and illustrated comic. Also debuting soon is her bimonthly comic *Maude Macher*, which will be showcased on thebaconstrips.com. Quite determined to make her mark in the art and entertainment world, there will be no slowing down.

Kali attended the Otis College of Art and Design in Los Angeles, California and received a BA in Digital Media.

"Kali is the latest young cartoon prodigy. In an era where classic drawing and cartooning skills seem to be vanishing, Kali takes her influences from the great cartoons and comics of the past. Look out for her to be one of the next movers and shakers in the cartoon business." — John K.

KALIKAZOO.BLOGSPOT.COM

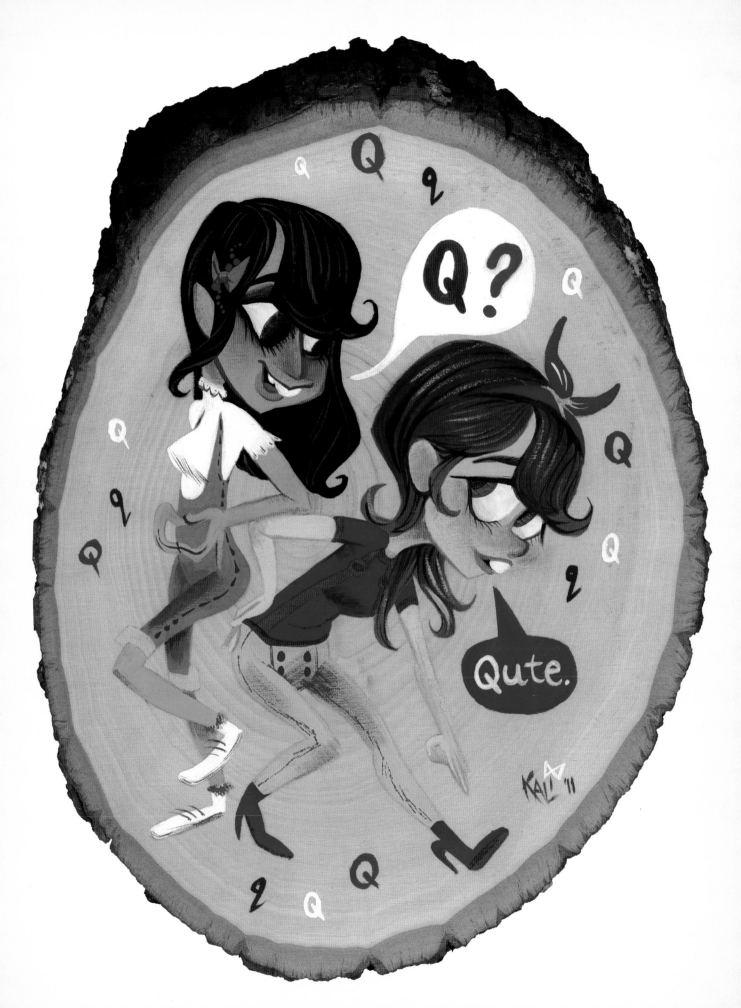

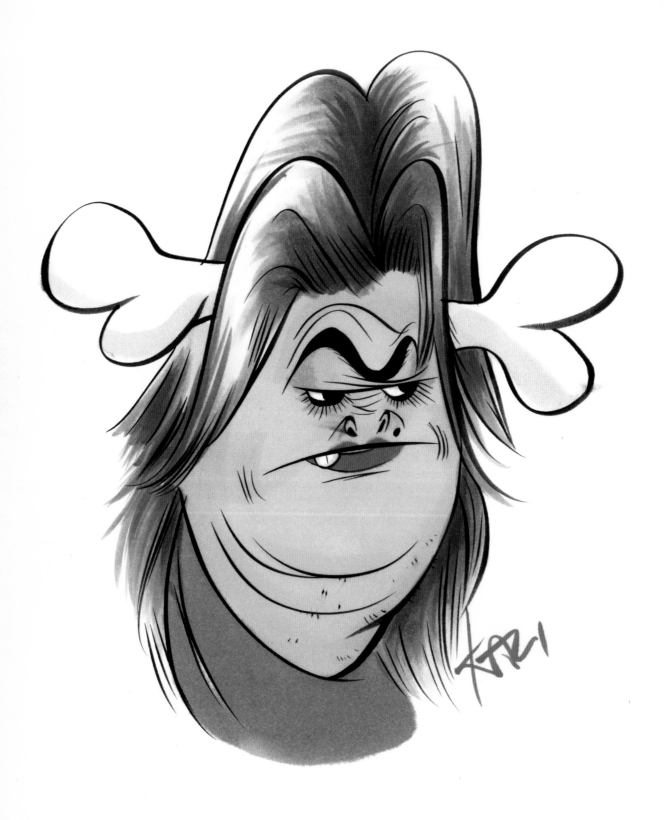

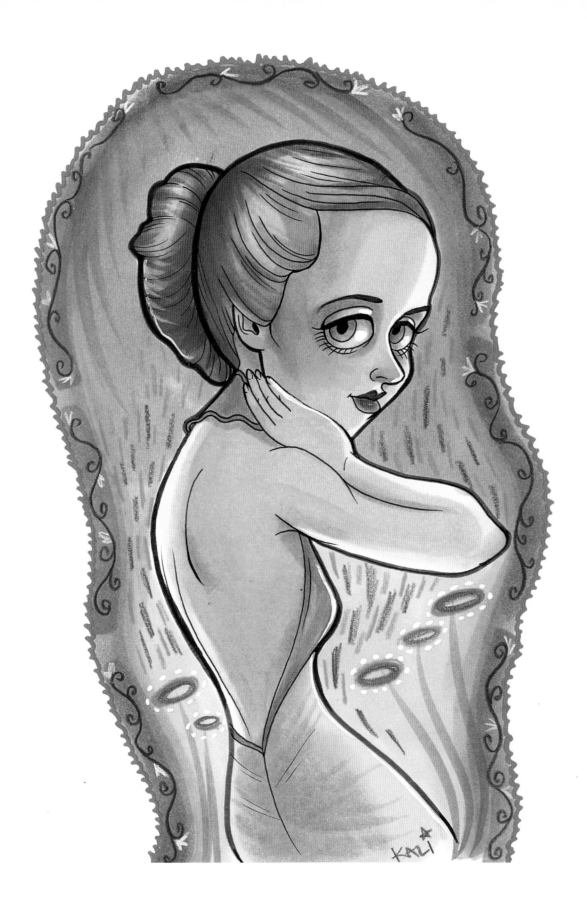

LOLA

"LIFE IS EXACTLY WHAT YOU MAKE OF IT. MY NAME IS LOLA, and I am a dreamer. I was born in 1975, but my age does not define me. My past has molded me into a genuine soul. I believe very strongly all things are for a reason. College was uneventful, yet taught me that I had the ability to find my own techniques and expression. My experience as a tattoo artist in the late-90's was incredible, yet only fulfilled nine out of ten of my necessary reasons to live as an artist. And it demanded too much time out of my studio. I like to invent, imagine and execute a place full of space where the world can evolve into a magical, copacetic machine, sparing the disintegration of our earth and harm to innocent creatures and beings.

"If not for the ability to paint, my voice might become just another static, white noise. We need harmony, lyrics and a visual escape from reality because reality has become somewhat of a nightmare — war, genocide, hunger, death, disaster and political disappointment.

"I paint to start a positive dialog amongst strangers. And I paint because it is my most precious gift in life. I sing through my brushes the way a song might touch your heart and knock you off your feet, so that you might feel for one moment and forget how the media desensitizes you and holds you in its grips with fear tactics. Of all my childhood memories, the ones that stick with me most are from pure imagination. If I can bring you back to your own early memories for even one minute as you gaze upon what has become my life's work, you just might recognize a not too distant feeling of pure emotion, as you were once so innocent. I wish upon a star that this feeling might have a domino effect, ease a day and bring a smile. Because a smile is infectious, and if our hearts are happy, nothing can stop us."

LOLAFINEART.COM

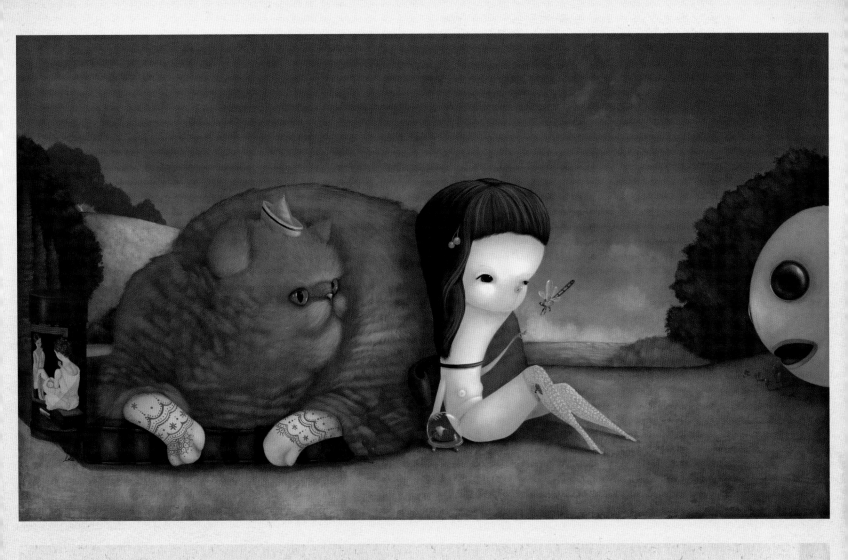

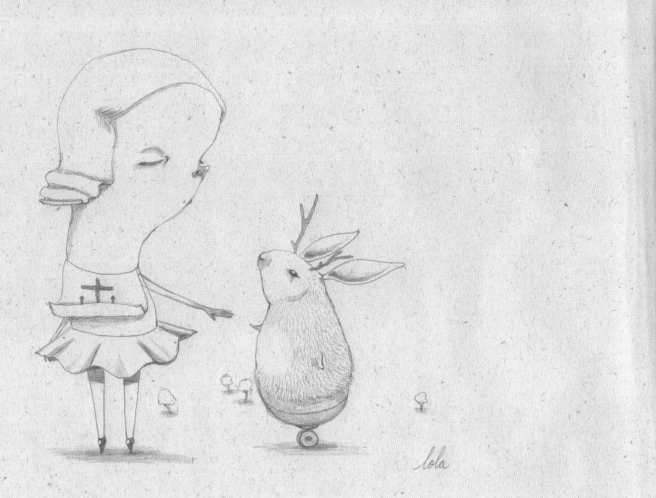

lola

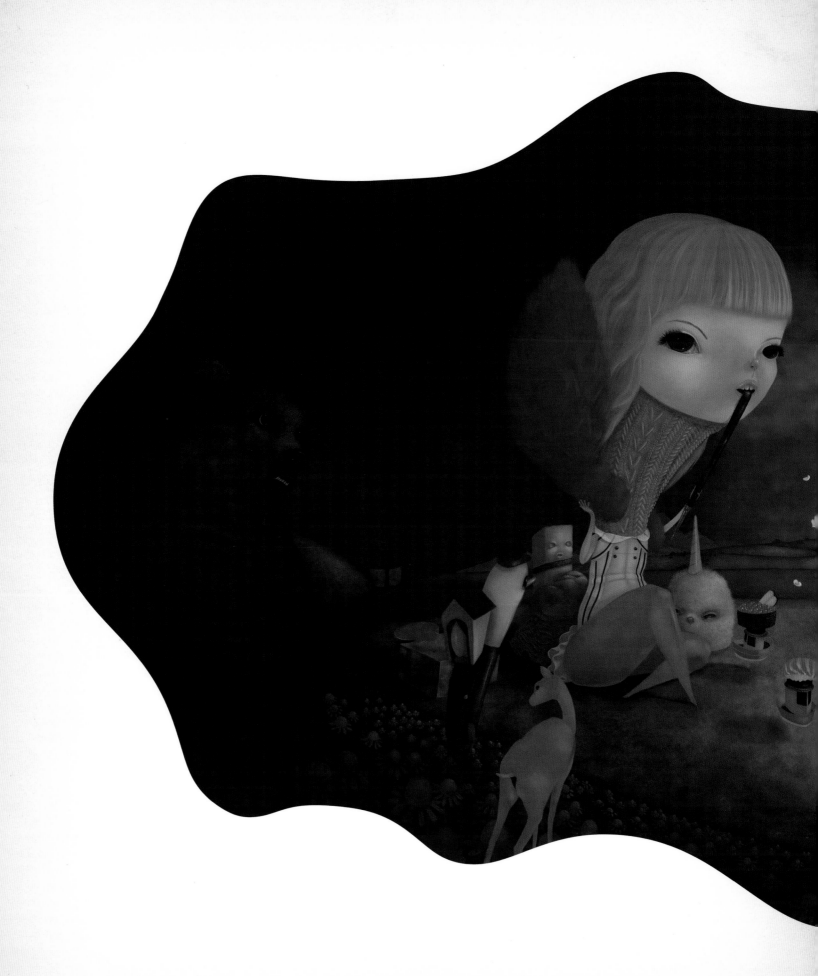

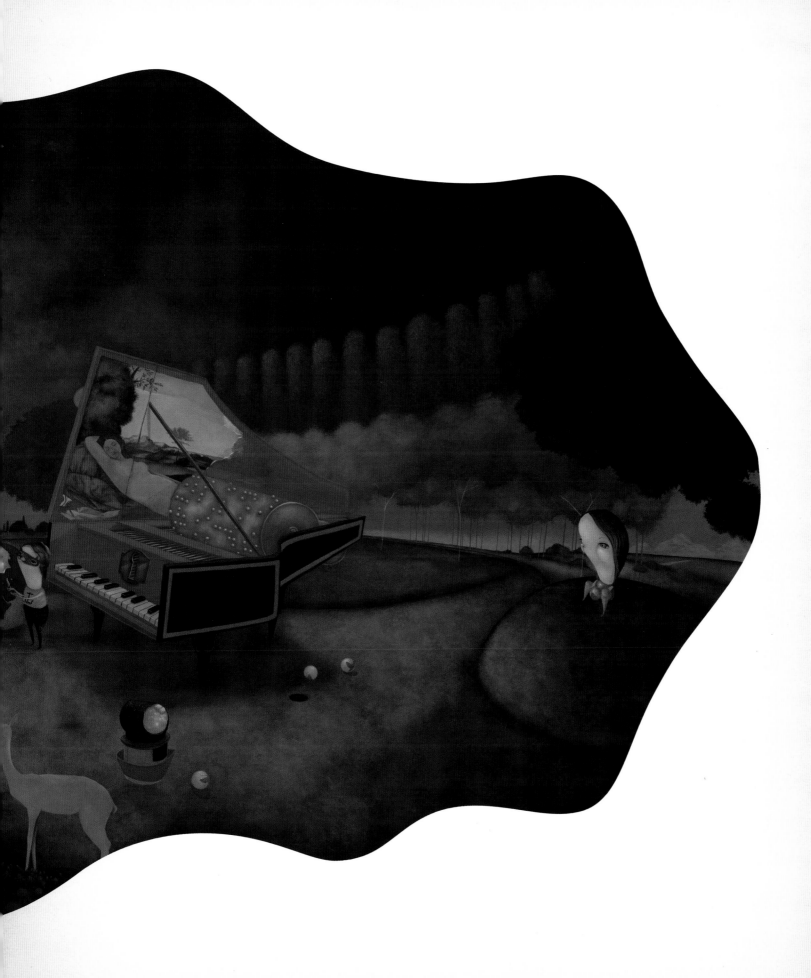

LUKE CHUEH

Born in Philadelphia but raised in Fresno, california, Luke Chueh (pronounced CHU) studied graphic design at California Polytechnic State University in San Luis Obispo, California where he earned a BS in art and design (graphic design concentration). He was employed by the Ernie Ball Company, working in-house as a designer/illustrator, where he created several award-winning designs and was featured in the design annuals of *Communication Arts* and *Print Magazine*. Meanwhile, he also created, produced, wrote, designed, edited and published *E.X.P.*, a zine dedicated to the "Intelligent Dance Music (IDM)" genre.

In 2003, Chueh moved to Los Angeles, California to further pursue a career in design. However, a lack of employment opportunities left him resorting to painting as a way to keep busy (a hobby he picked up while attending Cal Poly). He got his start when the Los Angeles underground art show, Cannibal Flower, invited him to show at their monthly events. Since then, Chueh has quickly worked his way up the ranks of the Los Angeles art scene, establishing himself as an artist not to be ignored. Employing minimal color schemes, simple animal characters and a seemingly endless list of ill-fated situations, Chueh stylistically balances cute with brute, walking the fine line between comedy and tragedy. Chueh's work has been featured in galleries around the world and some of his paintings have also been reinterpreted into vinyl toys.

LUKECHUEH.COM

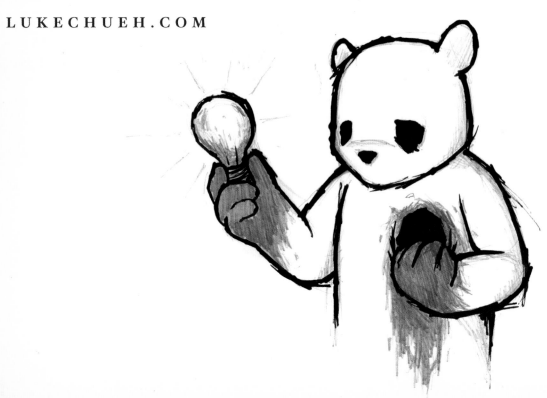

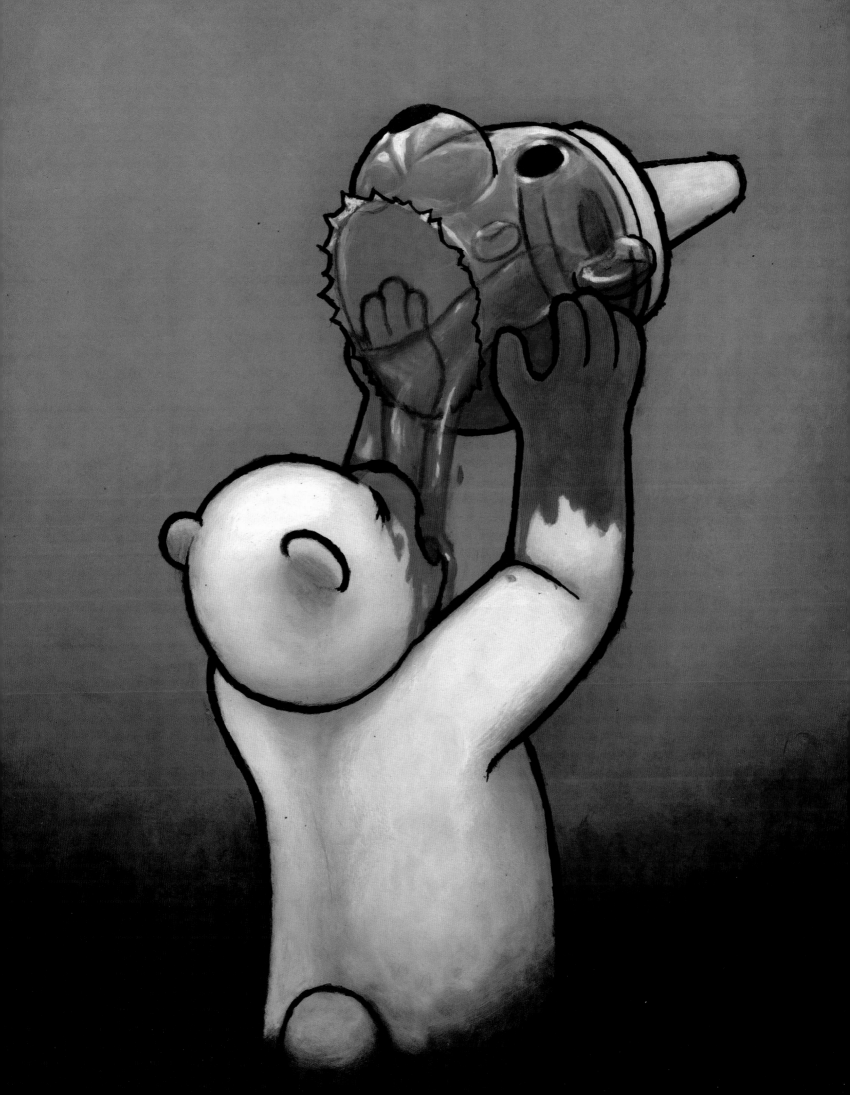

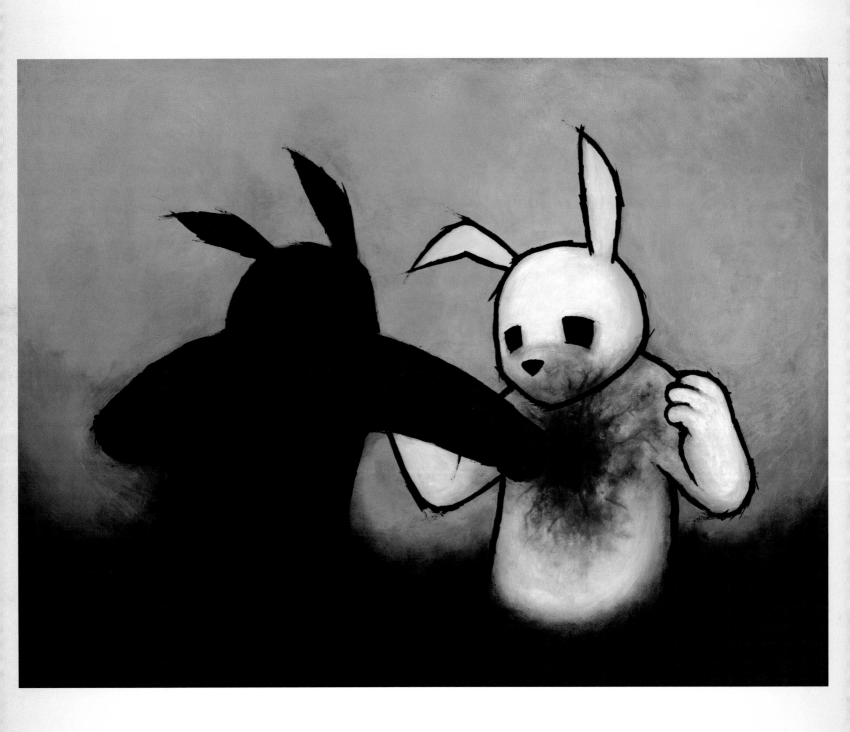

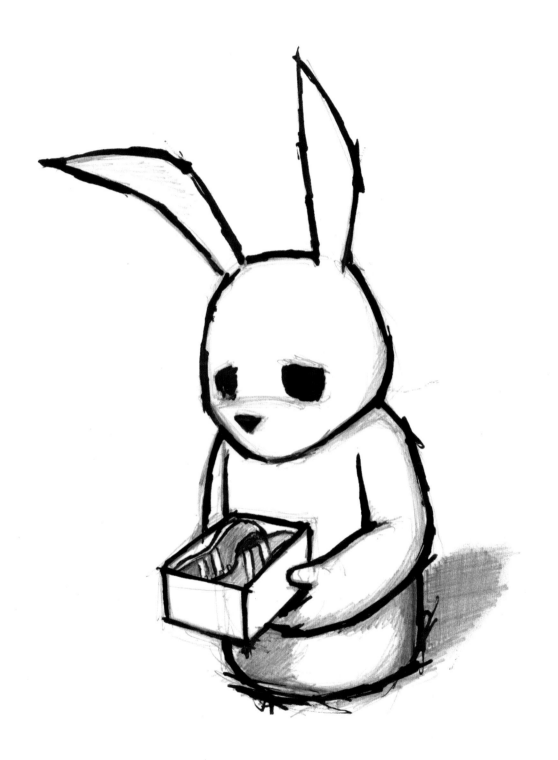

MARC GABBANA

MARC GABBANA IS AN ILLUSTRATOR AND CONCEPT ARTIST who works in the advertising, gaming, publishing and motion picture industries.

Marc studied architecture at the Lawrence Institute of Technology (LIT) in Southfield, Michigan for a year before enrolling at the Center for Creative Studies (CCS) in Detroit, Michigan. He graduated in 1990 and earned a bachelor of fine arts degree in illustration. His school assignments always had a heavy emphasis on technical accuracy as well as imaginative subject matter, whether it was a fifty-foot-tall robot intercepting kids throwing snowballs or strange creatures lurking in the shadows.

His freelance career began during his third year of school when he started to do projects for various local advertising agencies. By the time he graduated the following year, he had a full roster of clients. Early jobs required Marc to paint a lot of shiny cars for Detroit's ad agencies, where he incorporated portions of his imaginative backgrounds at every opportunity. His client base soon reached beyond Detroit and included such companies as Nintendo, Scholastic and Hasbro, as well as Image Comics and Dark Horse Comics, to name a few.

There were also various magazines and renowned advertising agencies that commissioned Marc to create fantastic images for their publications and advertising campaigns. For the next few years between advertising jobs, Marc began to create an extensive body of work with an emphasis on architectural, vehicle, creature, character and environmental design–works that would reflect his own unique vision.

Film credits include *Star Wars: The Phantom Menace* and *Attack of the Clones*, *Matrix Reloaded* and *Revolutions*, *Cyberworld*, *The Polar Express*, *Hellboy*, *War of the Worlds*, *Beowulf* and *A Christmas Carol*. He drew storyboards and designed environments, vehicles and alien technology, ranging from sketches to finished illustrations.

His creative passion is to bring to life the myriad creatures and monsters crawling around in his head.

MARCGABBANA.COM
MARCGABBANA.BLOGSPOT.COM

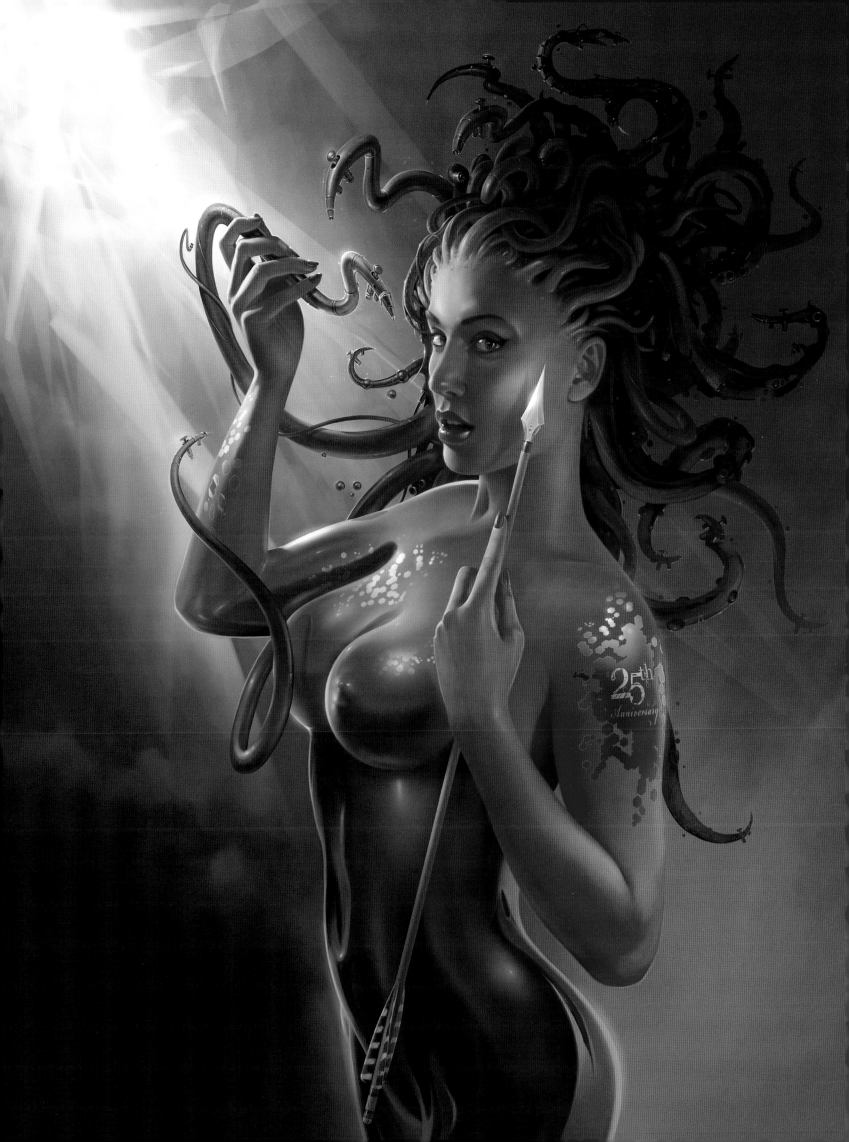

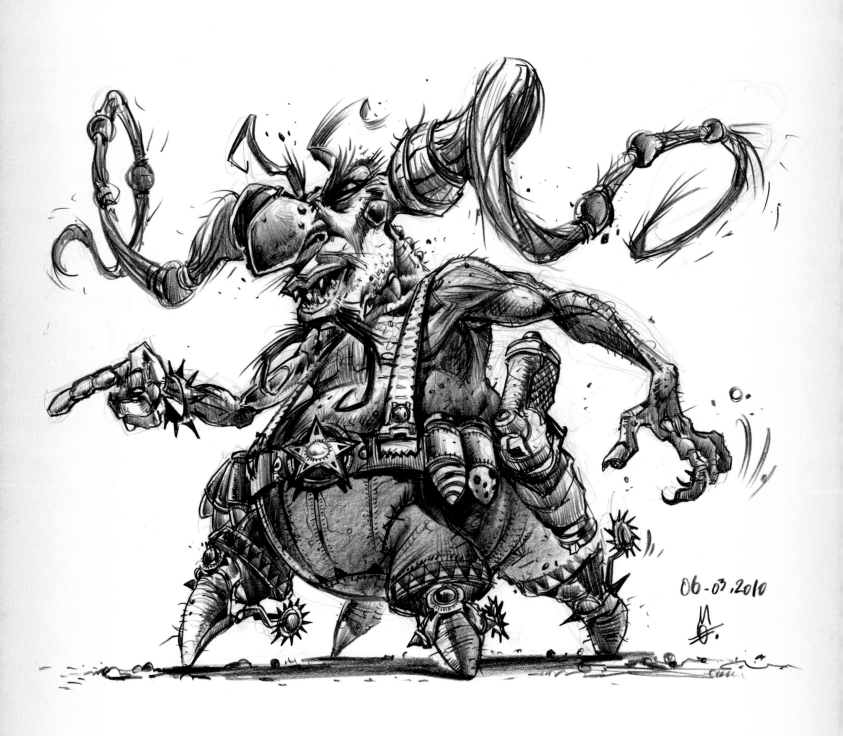

06-03.2010

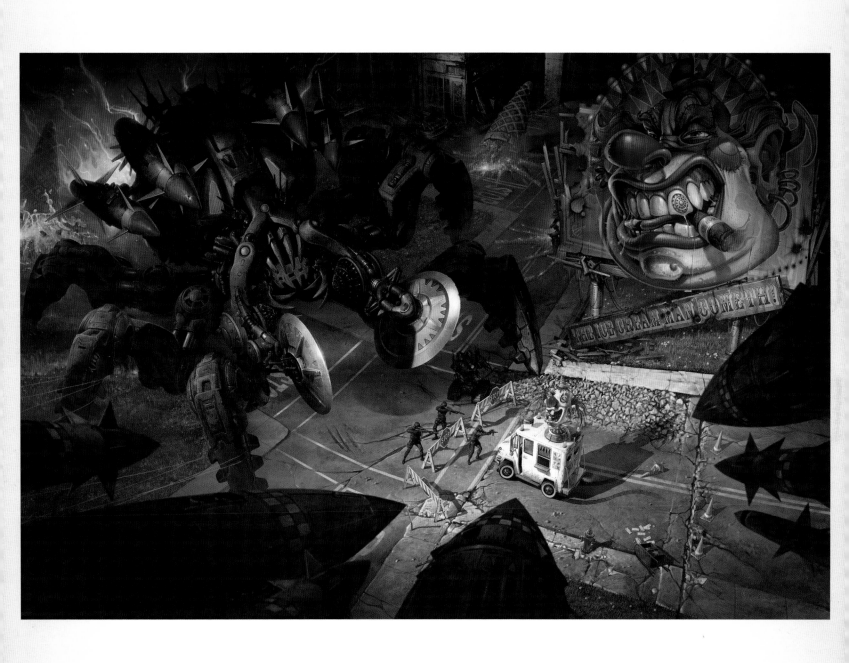

MARI INUKAI

MARI INUKAI WAS BORN IN NAGOYA, JAPAN. IN 1995, Mari came to the United States to pursue her studies in art. She first attended Santa Monica Community College (mentor program) in Santa Monica, California, then Associates in Art in Sherman Oaks, California and finally the California Institute of the Arts in Valencia, California, where she received her BFA in character animation in 2004.

Her professional clients include Walt Disney, Sanrio Co. LTD, Cartoon Network, Nickelodeon, Nylon Motion Inc., Oishii Productions and NGTV.

Her short animated film, *Blue and Orange*, has been an official selection at numerous national and international film festivals, including the Sundance Film Festival in 2003, and was the Japanese Grand Prix winner at the Short Shorts Film Festival EXPO in 2005. Besides her animation work, Mari regularly exhibits her paintings and drawings and designs clothes, ceramic toy figures and other fun products. She lives in Beverly Hills, California with her daughter, Sena.

MARIINUKAI.COM

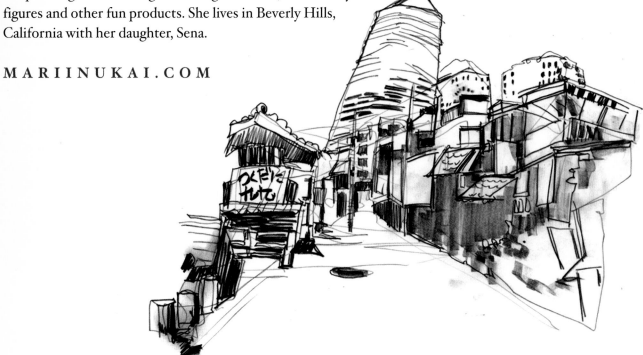

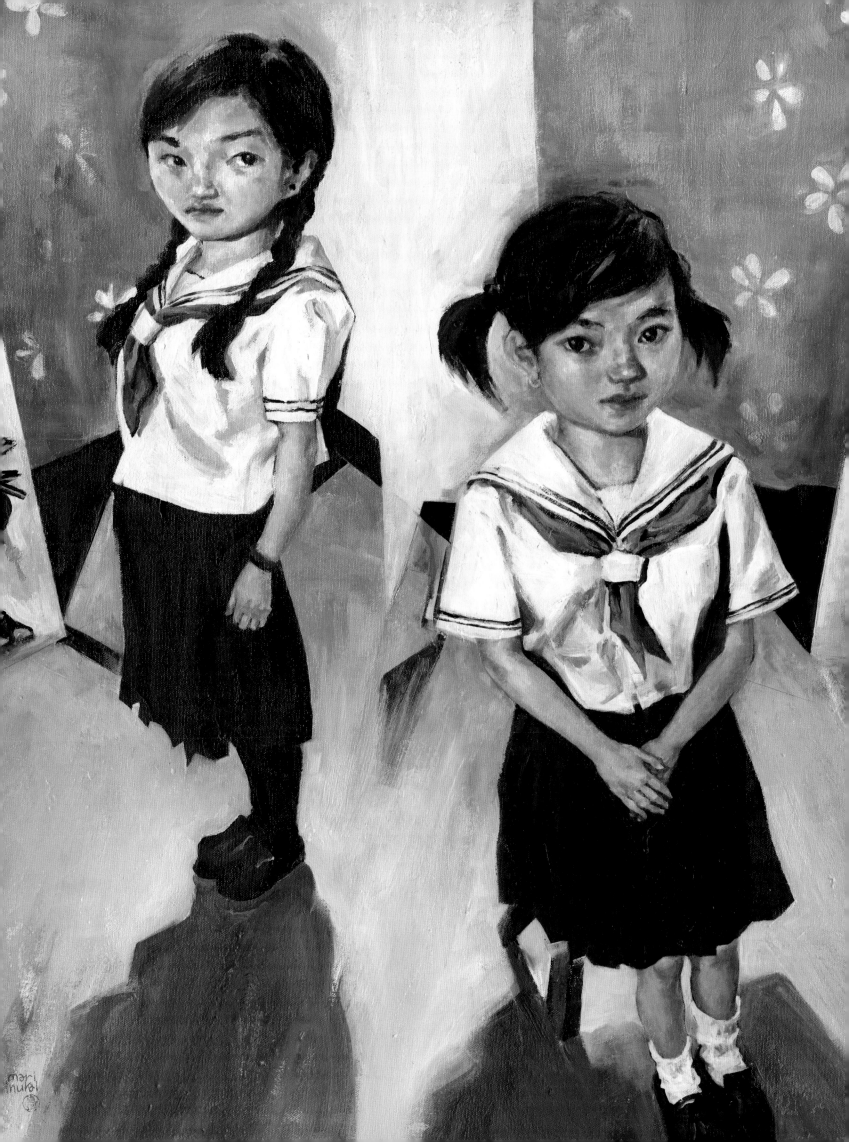

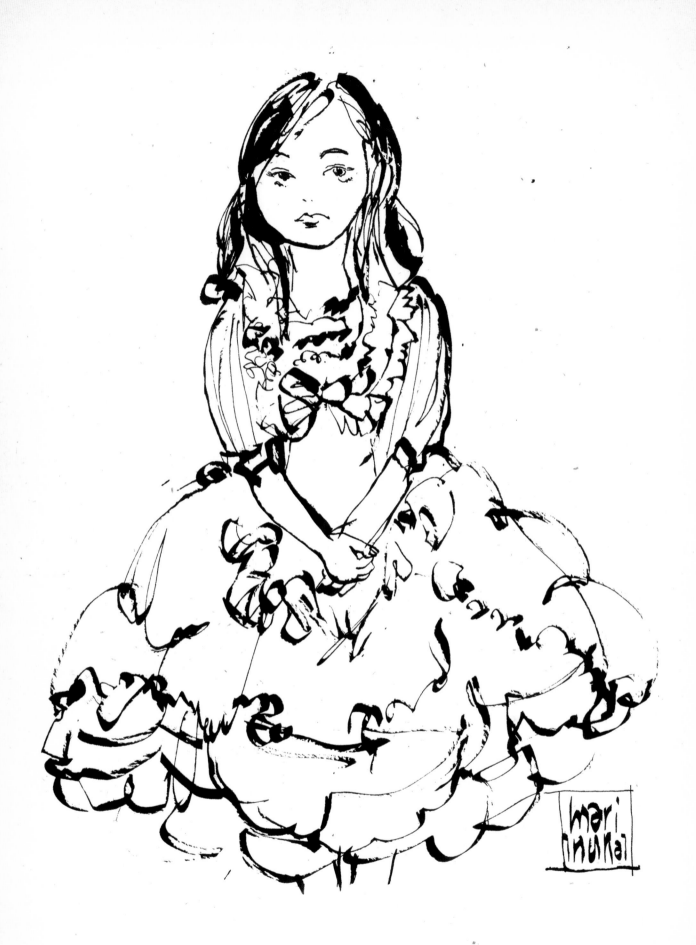

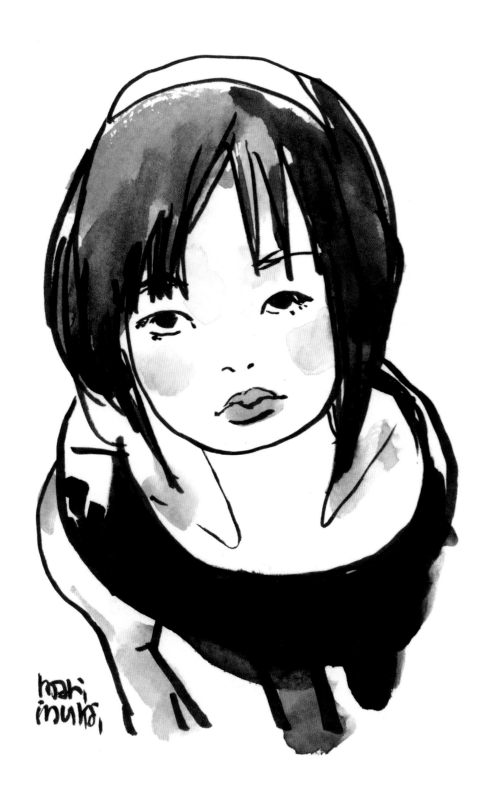

MARSHALL VANDRUFF

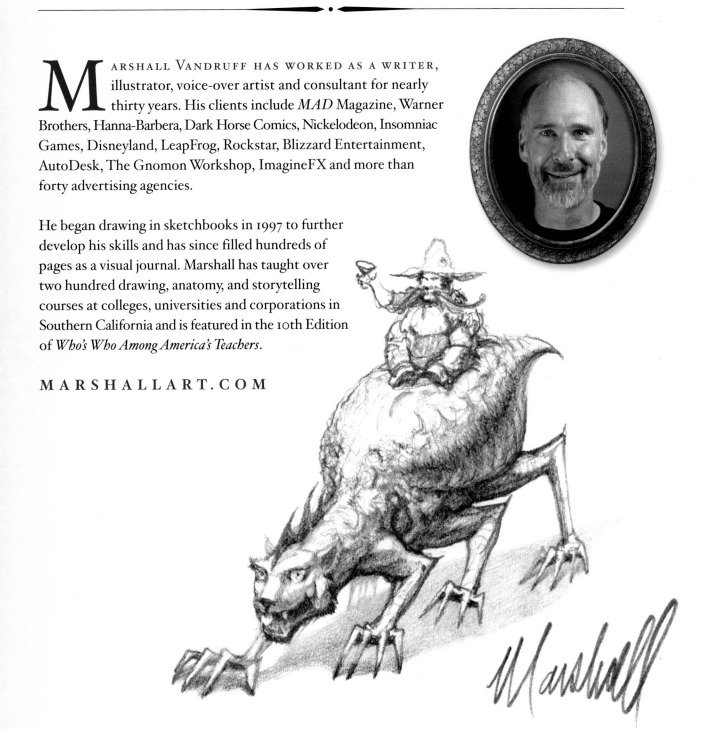

MARSHALL VANDRUFF HAS WORKED AS A WRITER, illustrator, voice-over artist and consultant for nearly thirty years. His clients include *MAD* Magazine, Warner Brothers, Hanna-Barbera, Dark Horse Comics, Nickelodeon, Insomniac Games, Disneyland, LeapFrog, Rockstar, Blizzard Entertainment, AutoDesk, The Gnomon Workshop, ImagineFX and more than forty advertising agencies.

He began drawing in sketchbooks in 1997 to further develop his skills and has since filled hundreds of pages as a visual journal. Marshall has taught over two hundred drawing, anatomy, and storytelling courses at colleges, universities and corporations in Southern California and is featured in the 10th Edition of *Who's Who Among America's Teachers*.

MARSHALLART.COM

4.5.03

NO FREE RORSCHACH TESTS!

"Welcome to Greca-Penumbra, Heartland of the Dead Coyotes" (rock group)

"THE ARTISTIC ANCHOVY Wrinkle Machine"
GOD'S MACHINATIONS

"Weasels Again" Natural Rantings
It all fell apart— Two days ago tomorrow.

ANY SHARDS?

ONE PAGE WONDER
SLUGBUCKETS & YOU

The Gargantuan slugbucket Fiasco

The Guy with the overheating head

The Tortured Sole

The Gene Autry Museum and Breakfast Cereal Manufacturing Corporation Headquarters

"THE FACE OF GLORY"

Starbucks should have multiple colored coffees to match your wardrobe so you can spill without worrying.

Other than in the museum, Why don't you observe.

Watercolor is "Making the best of an emergency" —Sargent as quoted at LACMA 5.3.02

The Gene Wilder Parallelogram & Artificial Insemination Clinic.

Robt. Tunks' "ALL BALL-BEARING ANTI-RESTITUTION MACHINE"

5.5.03

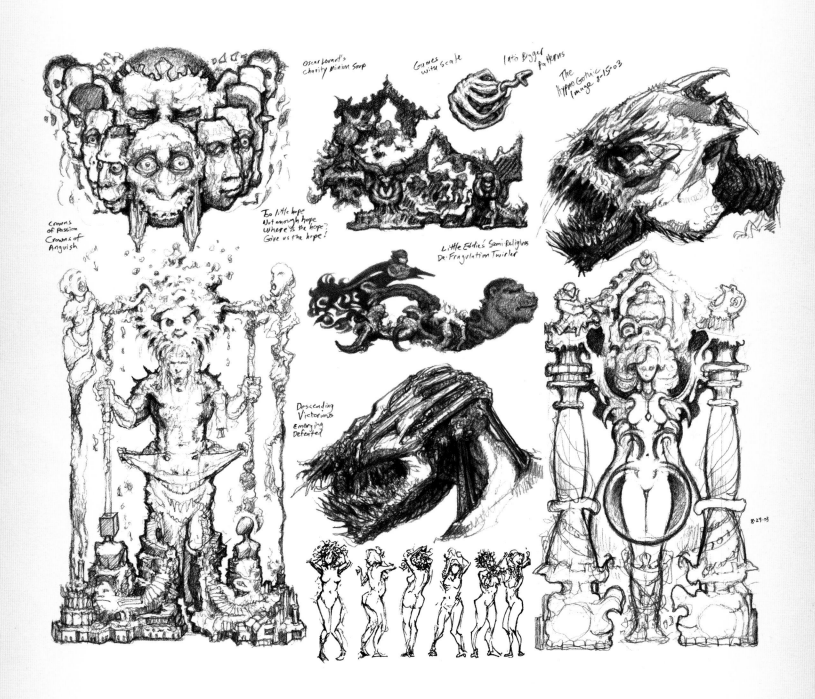

Oscar Levant's charity Minion Soup

Games with scale

Into Bigger patterns

The Hypno Gothic Image 8-15-03

Crowns of Passion
Crowns of Anguish

Too little hope
Not enough hope
Where is the hope?
Give us the hope!

Little Eddie's Semi-Religious De-Fragulation Twirler

Descending Victorious emerging Defeated

8-29-03

149

MEATS MEIER

MEATS MEIER IS CURRENTLY A FREELANCE ILLUSTRATOR and animator living in downtown Los Angeles, California. He taught the first ever ZBrush course at the Gnomon School of Visual Effects and is the author of the very popular *Introduction to ZBrush* training DVD produced by the Gnomon Workshop. Meats is also an award-winning digital artist (including two Exposé Master awards) with over a decade of experience in a wide range of artistic fields.

Meats' feature film credits include *Sky Captain and the World of Tomorrow* and *Hellboy* as a technical director and compositor. He has also worked as an airbrush artist, lead artist at a video game studio (Beyond Games) and has had a successful career as an independent artist and illustrator. Meats' artwork is on the cover of numerous books, magazines and web sites, and he was honored with the prestigious "Maya Master" title by Alias at SIGGRAPH in 2003. In 2006, Meats helped with the stereoscopic graphics for the cover of the TOOL album *10,000 Days* and now continues to work on animations along side Chet Zar and Camella Grace for their live touring concerts.

"Meats Meier hasn't put a pencil down since the time he drew Superman when he was two. Creating art that pulls you inside a world of complex forms and shapes, Meats communicates a strange universe of comingled mechanics and organics. By using Maya, ZBrush, and Photoshop, he has the freedom to explore infinite variations of his vision in multiple dimensions. With themes that include nature, toys, childhood and vision, he allows us to look at the world around us with entirely new eyes." — Jill Smolin

3DARTSPACE.COM

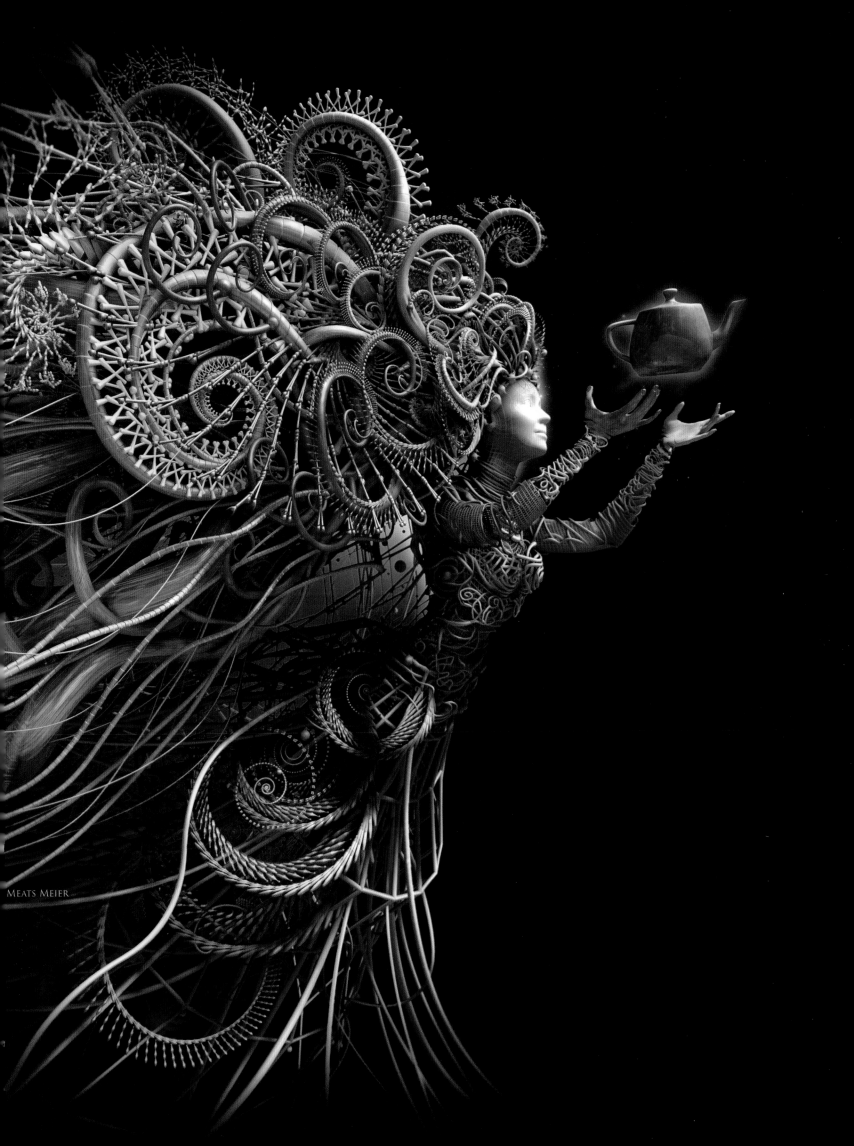

Meats Meier

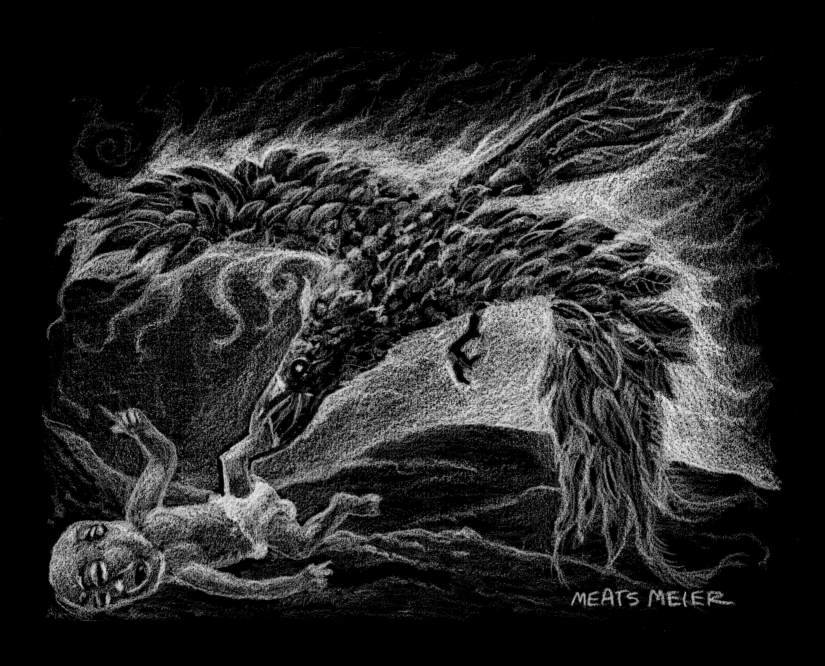

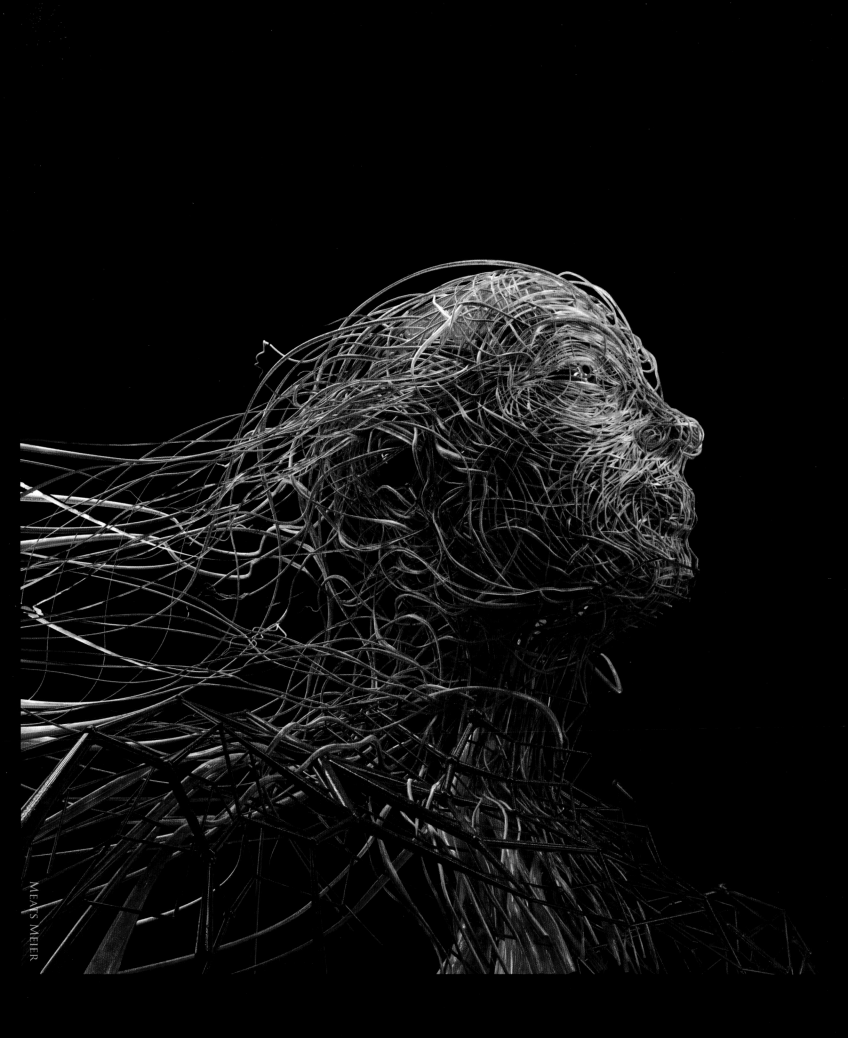

MICHAEL BROOM

COMING FORTH FROM THE SWAMP-RIDDEN COASTS OF the South, artist Michael Broom has screamed with an artistic voice that's hard to ignore.

After being raised on a steady diet of monster movies and gothic horror novels, working as an artist at Walt Disney World in Florida's panhandle and dabbling in the comic book industry with terrifying adaptations of gruesome horror films like Lucio Fulci's *Zombie* and *Phantasm*, Michael has recently begun to carve a niche in the Hollywood system designing monsters for film and television. His design sense and attention to quality got noticed quickly, and word has slowly been spreading as he continues to work alongside some of the most talented artists in the film industry.

He commonly uses Frankenstein-like techniques, combining the traditional mediums of painting and photography with the likes of more recent digital technologies like Photoshop and ZBrush to bring his characters and creatures to life.

HAITISWORST.DEVIANTART.COM/GALLERY

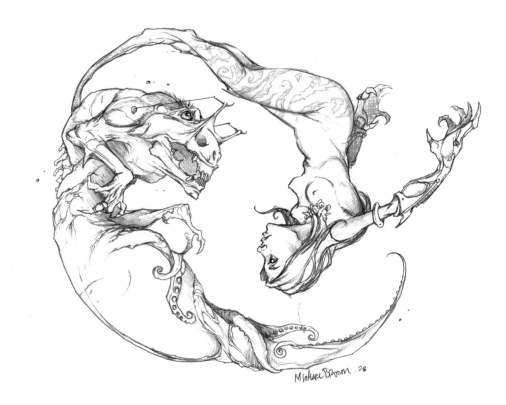

BLUE
HUNTING DOG

IGOR.

MANGED, DICSED,
tattoos.

SCARS.
Cuts.

TWisted, hit by a
lorry.

MICHAEL BROOM

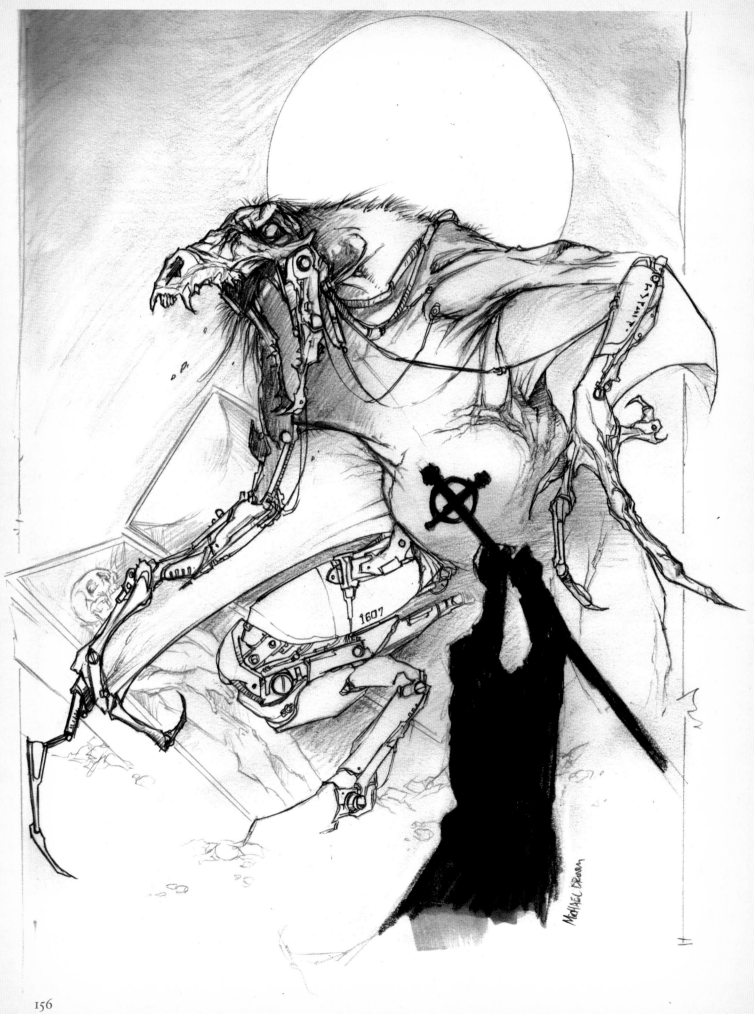

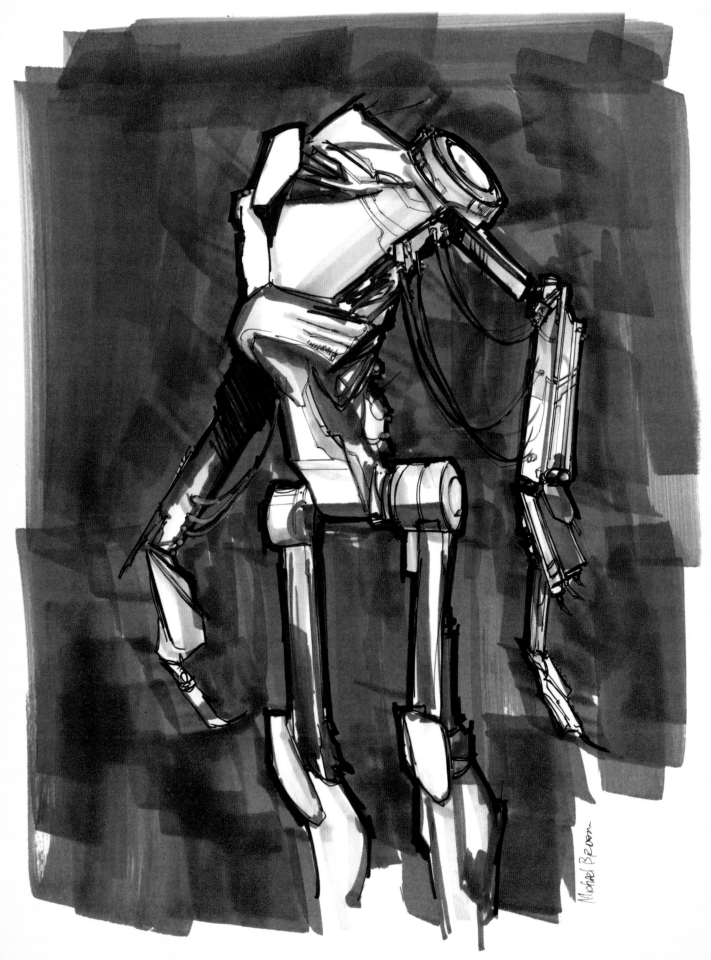

MICHAEL HUSSAR

MICHAEL HUSSAR IS AN AMERICAN FINE ARTIST WHO creates remarkably meticulous oil paintings using modern masters' techniques. His work focuses on provocative aspects of the human form and psyche. He is one of a handful of realist painters who are regarded as pioneers of the alternative art movement. He has a degree from the Art Center College of Design in Pasadena, California, where he taught portrait painting for nearly ten years.

He currently teaches workshops in the United States and Europe and shows his art internationally. His original paintings are in many prestigious collections. It is common knowledge that he enjoys Jägermeister, but insiders know he prefers Maker's Mark.

MICHAELHUSSAR.BIZ

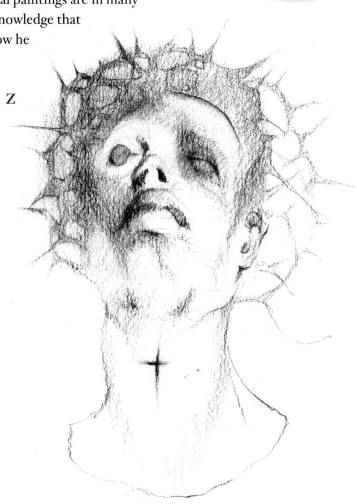

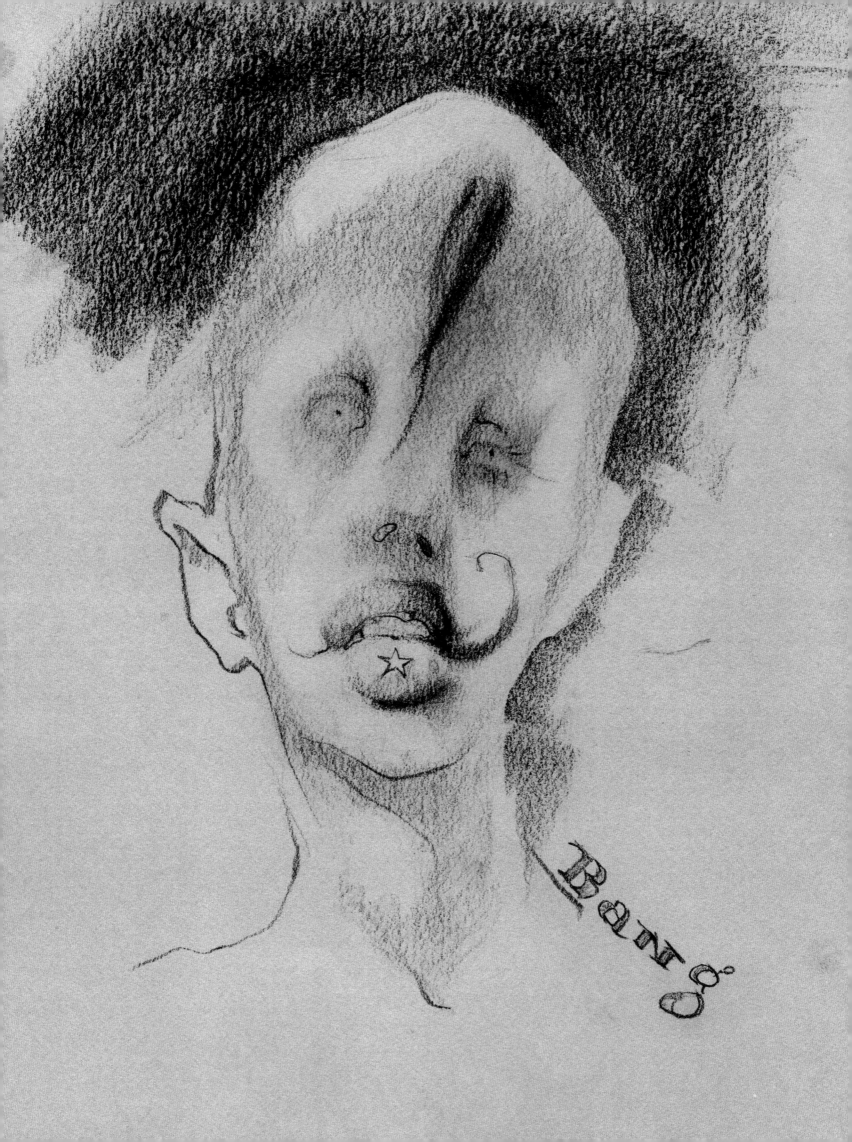

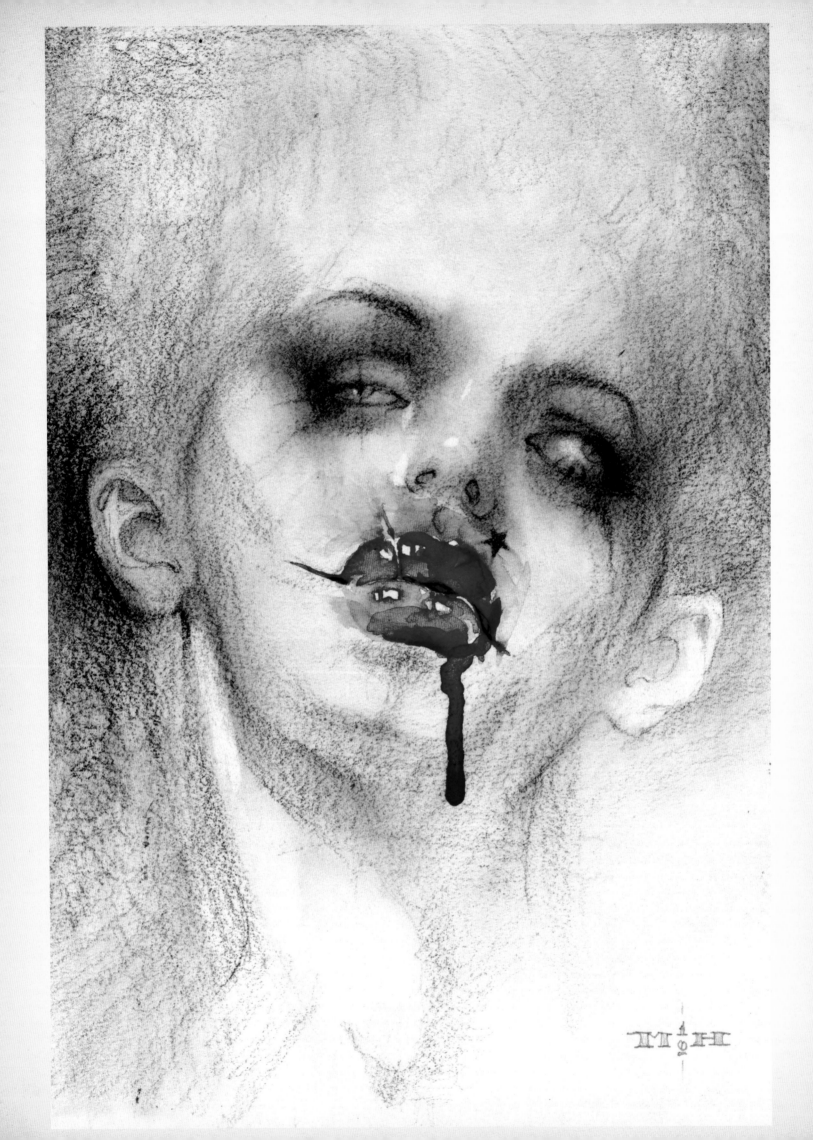

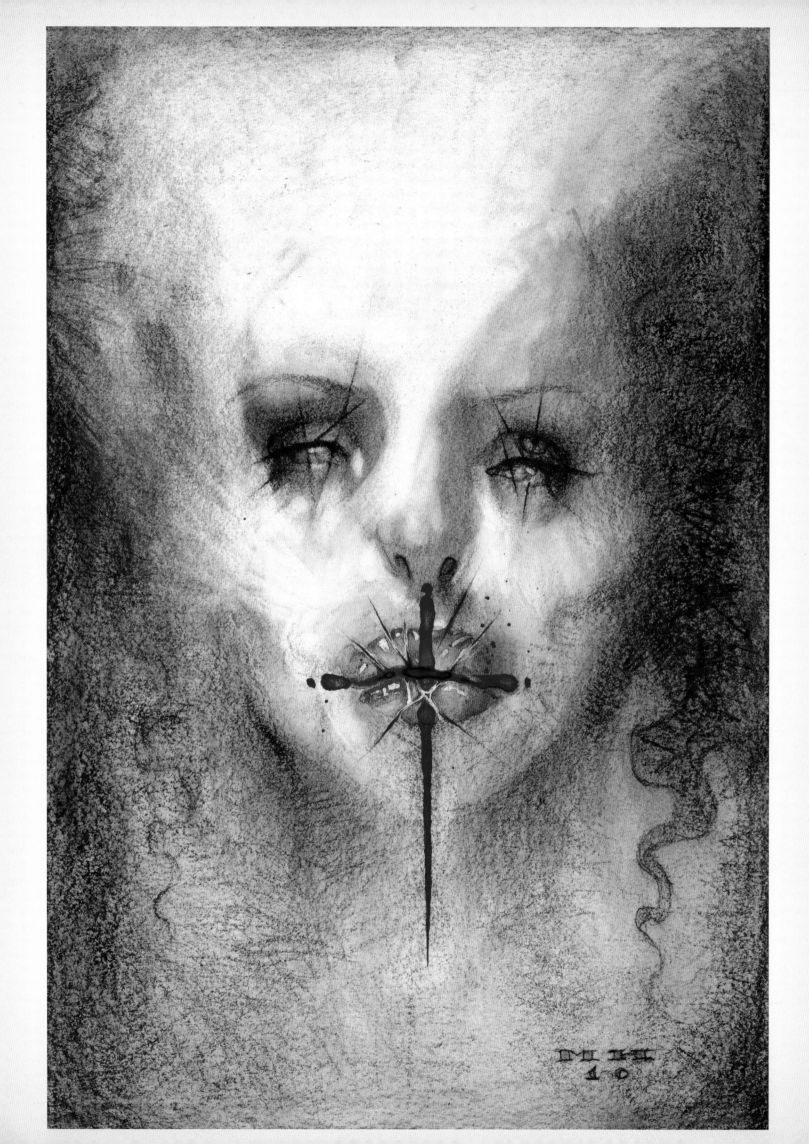

MISS MINDY

MISS MINDY LOVES TO EXPLORE MOOD, EXPRESSIONS and bizarre humor. Her work consists mainly of woodcut paintings and dioramas, in addition to fluid ink-work drawings and sketches. Her stories involve girls and imps, fairies and troublemakers of a most endearing yet bizarre sort. Her narratives find leads in precarious and naughty little circumstances, with other players helping along the tales of mishaps and silly shenanigans.

Miss Mindy was born into a family of artists and designers. Her grandmother worked as an inker and painter at Disney in the 1930s, while the other side of her family were illustrators, muralists and puppeteers. Her sister, CJ Metzger, has been a collaborator and muse. In addition to her fine art, Miss Mindy is an accomplished illustrator, concept and product designer for such clients as Hard Rock Cafe, House of Blues, Zippo, Warner Brothers and Nickelodeon.

Miss Mindy has written and illustrated two books with Baby Tattoo Books — *Miss Mindy's Sassy Paper Doll Bonanza* and *Teenie Weenie Tales,* which can be found in the *Artists Sisters: Box of Stories* book set.

She's also dabbled in the vinyl toy realm, creating a little doll named "DINK." Her artwork can be found in private collections throughout the United States and abroad and at various galleries around the world.

MISSMINDY.COM

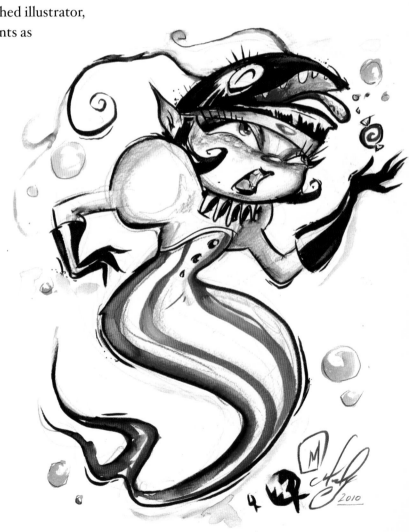

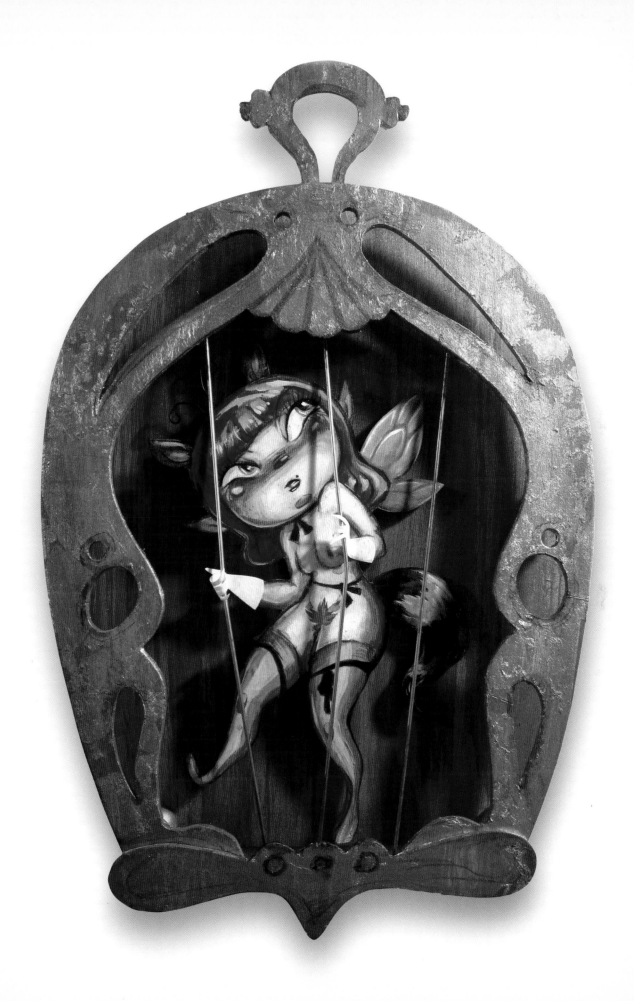

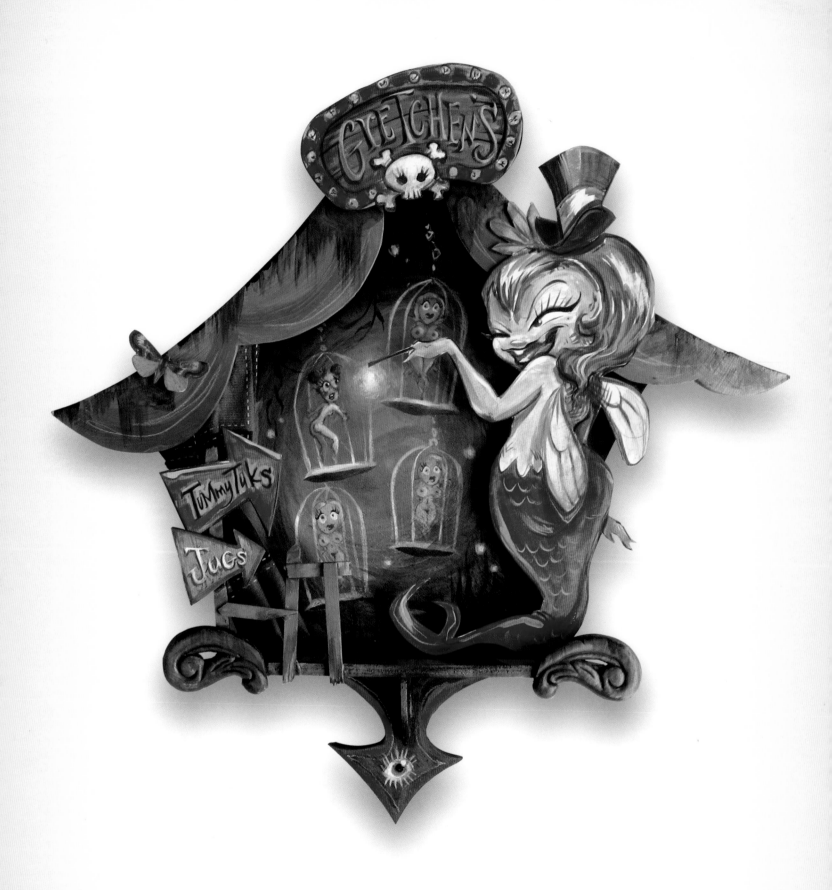

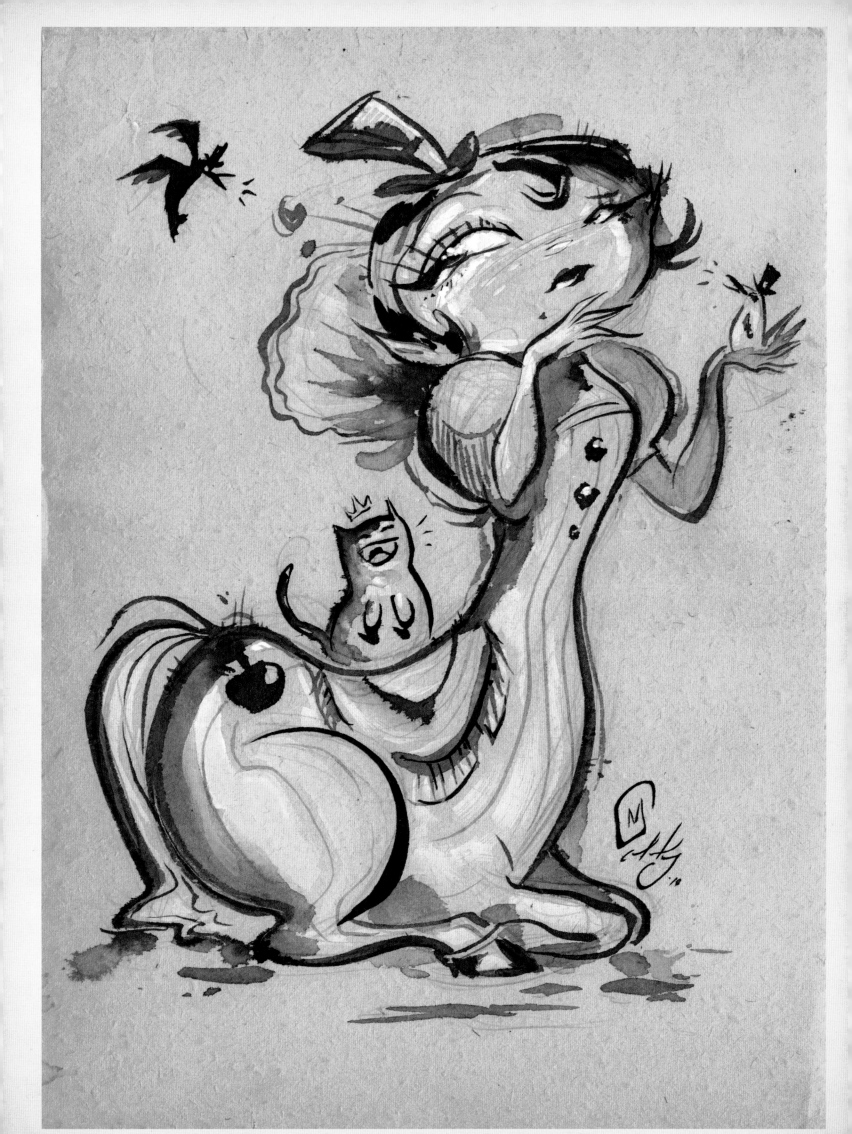

MOLLY CRABAPPLE

MOLLY CRABAPPLE IS AN AWARD-WINNING ARTIST, AUTHOR and the founder of Dr. Sketchy's Anti-Art School. Molly learned to draw in a Parisian bookstore. She later drew her way through Morocco and Kurdistan, and once into a Turkish jail. She developed her trademark Victorian style based a fascination with ambition and artifice. Remember, the devil's in the details.

Molly is the co-creator of *The Puppet Makers*, an original web series for DC Comics. She's drawn for *Marvel Comics*, the *New York Times* and *The Wall Street Journal*. She's also turned her talents to giant theatrical backdrops, parade installations, burlesque posters and gallery shows around the world.

Molly is also the creator of Dr. Sketchy's Anti-Art School, an international chain of alt.drawing salons that takes place in over a hundred cities on five continents. A business case study and media darling, Dr. Sketchy's has received hundreds of media profiles and changed the way life drawing is done.

MOLLYCRABAPPLE.COM

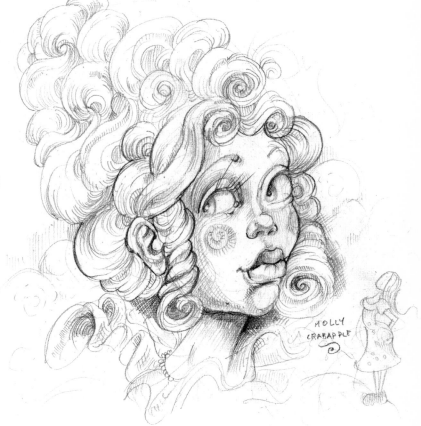

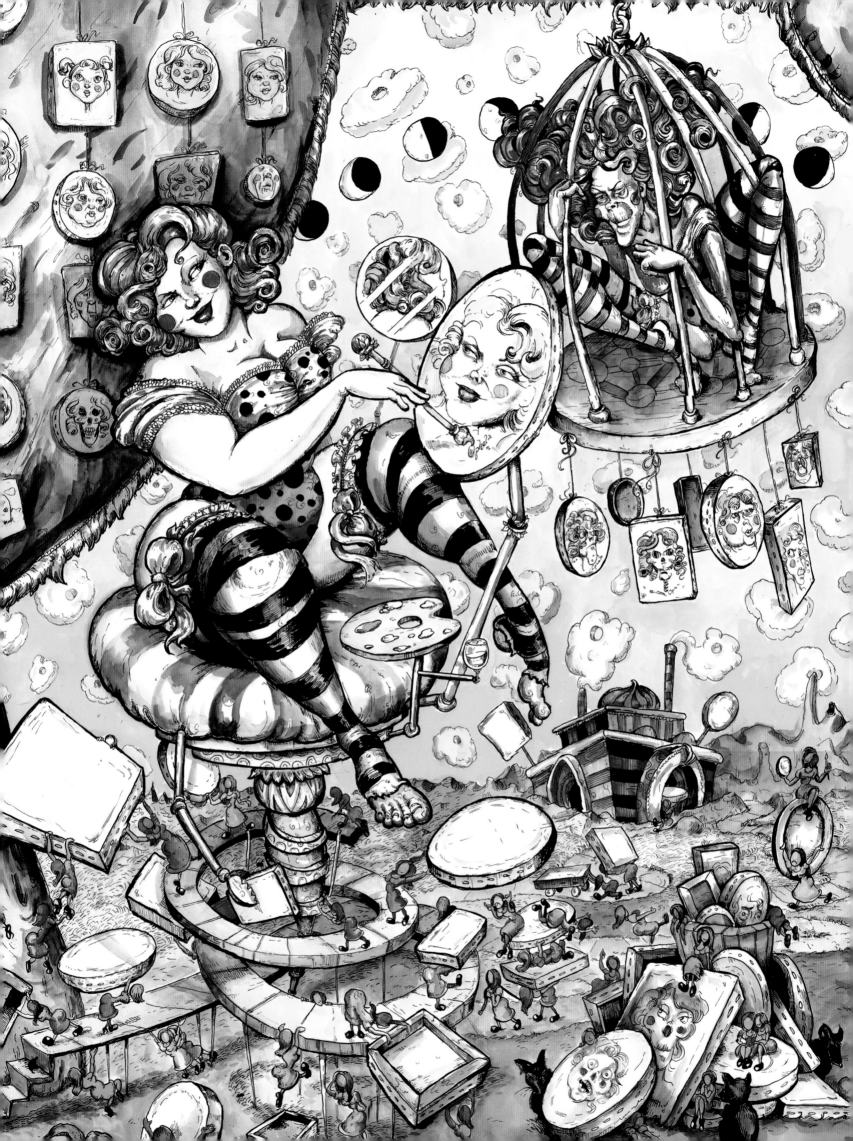

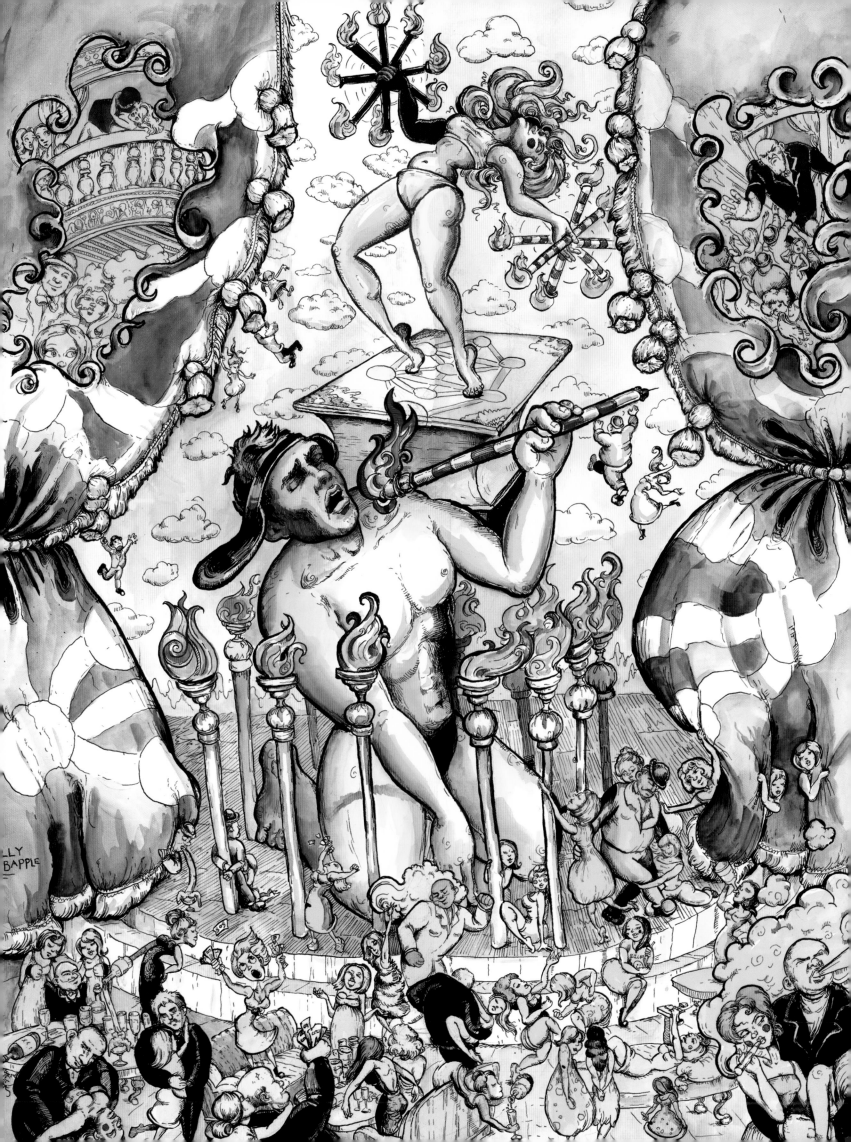

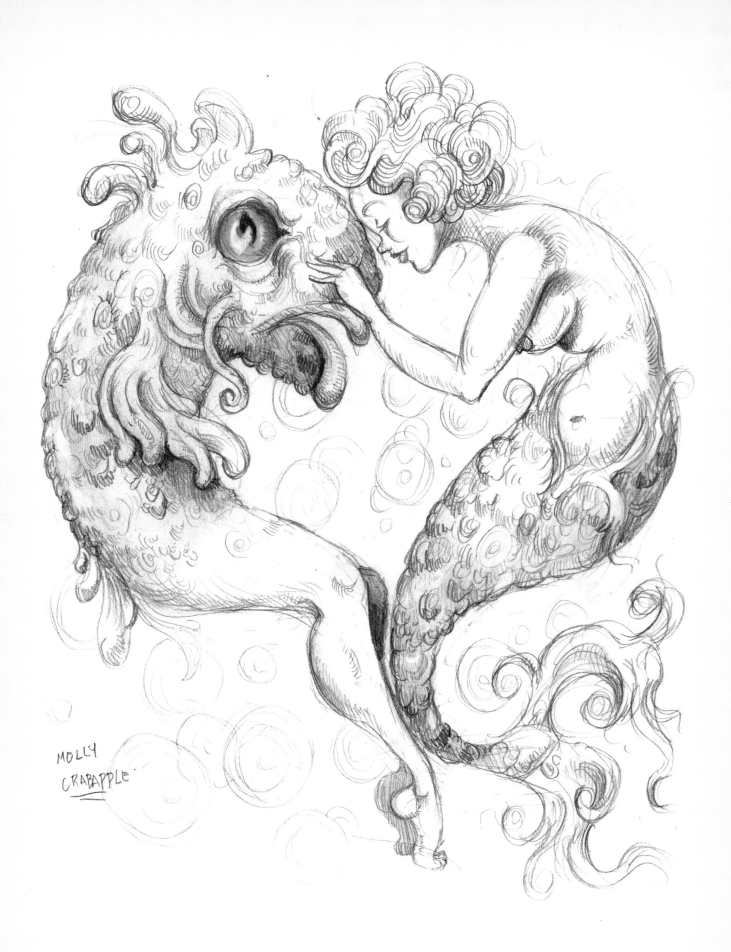

MUNK ONE

MUNK ONE, AKA JOSE A. MERCADO, IS A CONTEMPORARY American illustrator and fine artist, known for creating artwork for bands like Avenged Sevenfold, Bullet for my Valentine, Korn and My Chemical Romance. He is also known for working with world-renowned brands, recognized for their artwork and creativity. These include Upper Playground, Tribal Gear, True Love & False Idols and more. His fine art has also gained much attention, with no signs of slowing.

His style can seem very dark and serious at first glance, filled with undertones of politics, religion, personal experiences and emotions. Alternately, much of his work can also be bright, beautiful, fun and positive. These elements seem to coexist throughout much of his work. Proficient in both traditional and computer media, he is comfortable using whatever methods his projects call for.

After many successful years of working full-time in the apparel and merchandise industries as an employee, much of his knowledge and technical expertise has been gained from hands-on experience. In 2006, Munk One decided to focus on creating his own brand of art, while using his website munkone.com as the vehicle to share his creativity with the world.

During the 2008 election, Munk One created a striking portrait of the then presidential candidate Barack Obama. It was seen at bus stops all over the state of Pennsylvania and was also used for stickers, t-shirts and limited edition, signed and numbered poster runs. He also created a second, very popular design entitled "YES WE CAN" for a limited edition sticker run available through his website, with proceeds going directly to the Obama election campaign.

In 2009, Munk One was featured in *Juxtapoz* Art Magazine (issue #96).

MUNKONE.COM

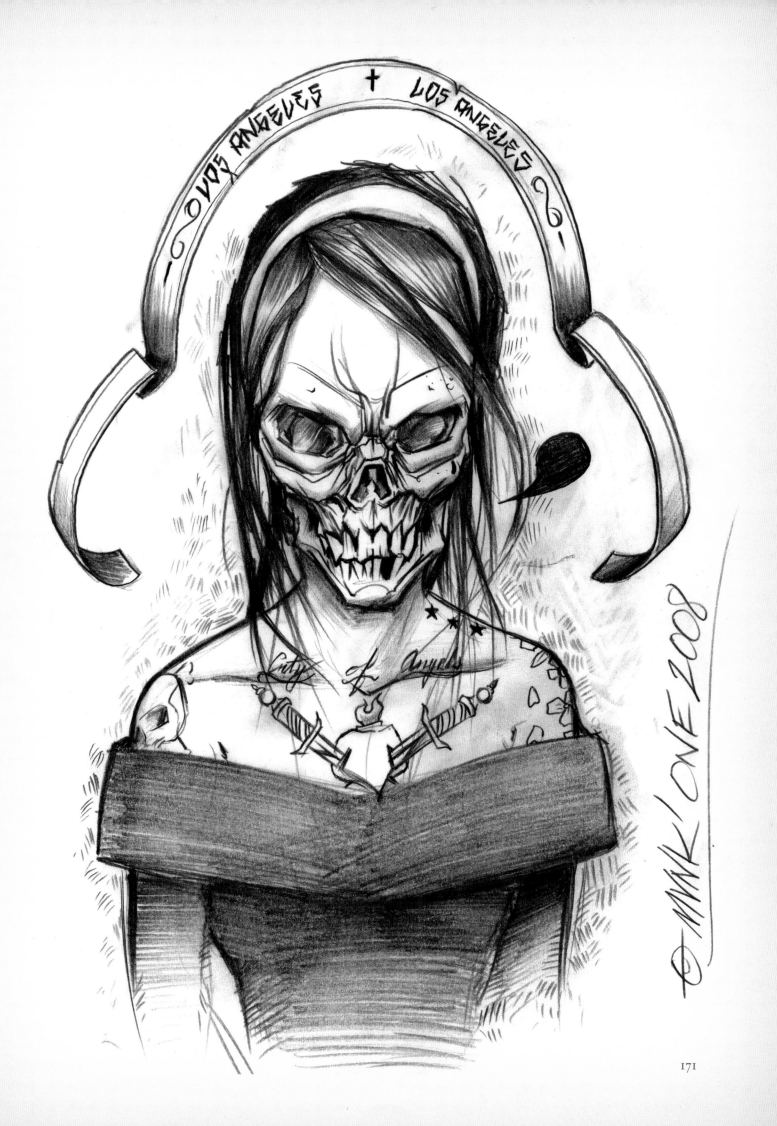

171

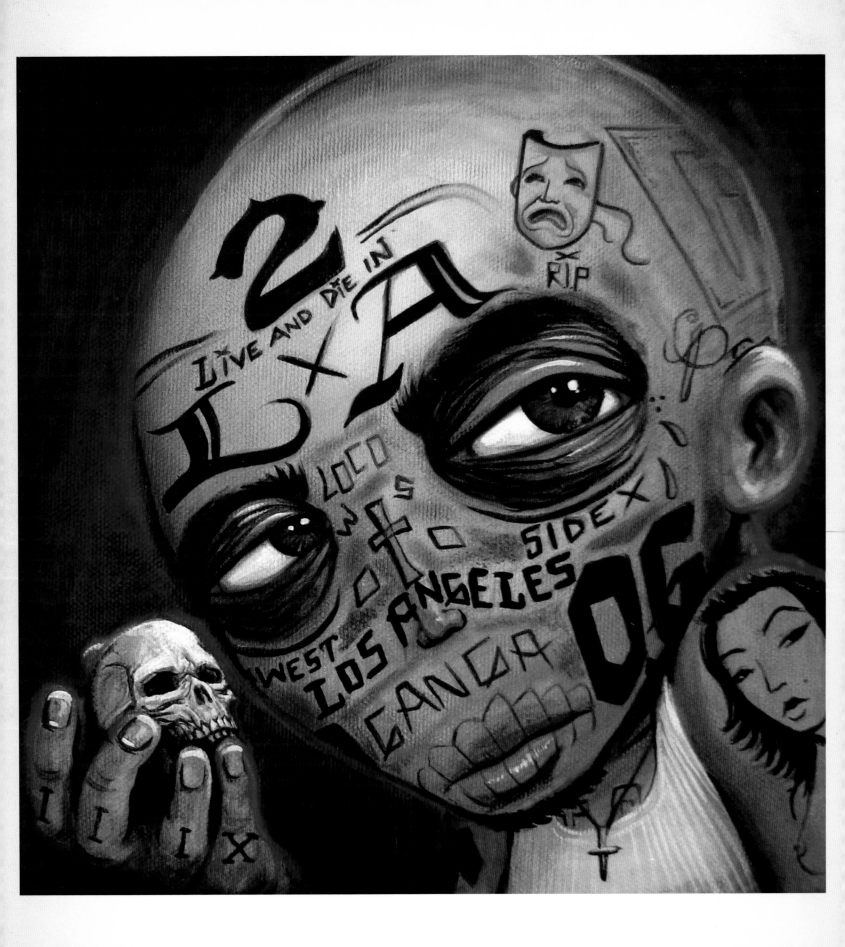

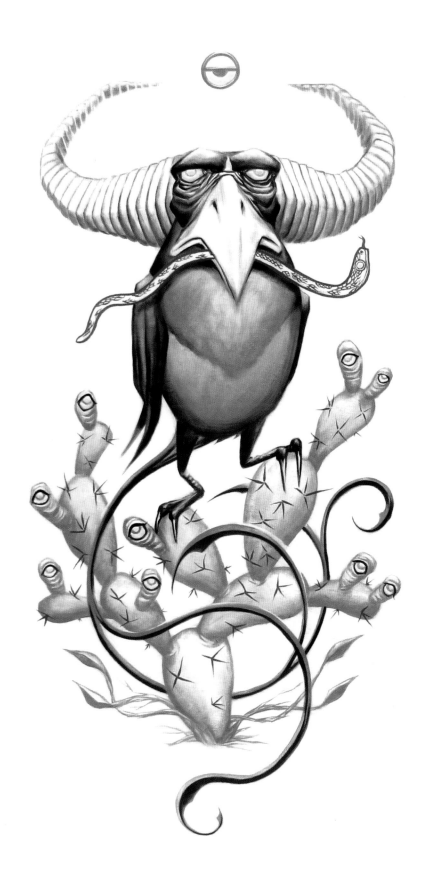

NAT JONES

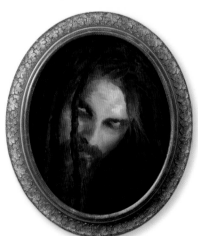

For more than a decade, Nat Jones has worked with or for nearly every major comic book publisher in the industry, including Dark Horse Comics, Image, IDW and Fox Atomic. Nat began his professional art career while he was still in high school, working with many of the day's top independent comic book publishers as well as illustrating *Looney Tunes* books for Warner Bros. At the age of twenty-three, Nat gained widespread acclaim as an artist on Todd McFarlane's *Spawn: The Dark Ages*, working alongside horror writer Steve Niles.

After working on numerous other books, Nat once again found himself in the spotlight, working with musician/director Rob Zombie on the Dark Horse Comic *The Nail*. This highly acclaimed work of horror garnered attention throughout the media, including stories in *Rolling Stone Magazine* and mentions on MTV and VH1. Nat then went on to collaborate once again with writer Steve Niles on his immensely successful *30 Days of Night* series before returning to *Spawn*, where he designed the first ever She-Spawn to appear in comics. Nat also worked alongside actor/director David Arquette to create a comic adaptation of his film *The Tripper*.

In 2006, Nat and fellow artist Jay Fotos founded Frazetta Comics. In a collaborative effort with writer Joshua Ortega, Nat and Jay created the No. 1 selling Image Comics title for the year 2007 — Frank Frazetta's *Death Dealer: Shadows of Mirahan*. Co-written by Nat, *Death Dealer: Shadows of Mirahan* tells the first and only *Death Dealer* story fully approved by legendary fantasy artist Frank Frazetta. *Death Dealer* holds Image Comic's record for the fastest sellout for a series issue No. 1.

Not limited to just the comic medium, Nat also works in other creative media, ranging from animation and album art to TV, movies and toy design, including work on the *28 Weeks Later* DVD and conceptual art for director Rob Zombie on his films *The Devil's Rejects* and the upcoming *Tyrannosaurus Rex*.

Nat is currently working on several projects, including a soon to be announced comic with acclaimed writer Joe Hill and the film *The Captured Bird* with director Jovanka Vuckovic and producer Guillermo del Toro.

Nat currently lives and works in Los Angeles, California.

NATJONES.COM

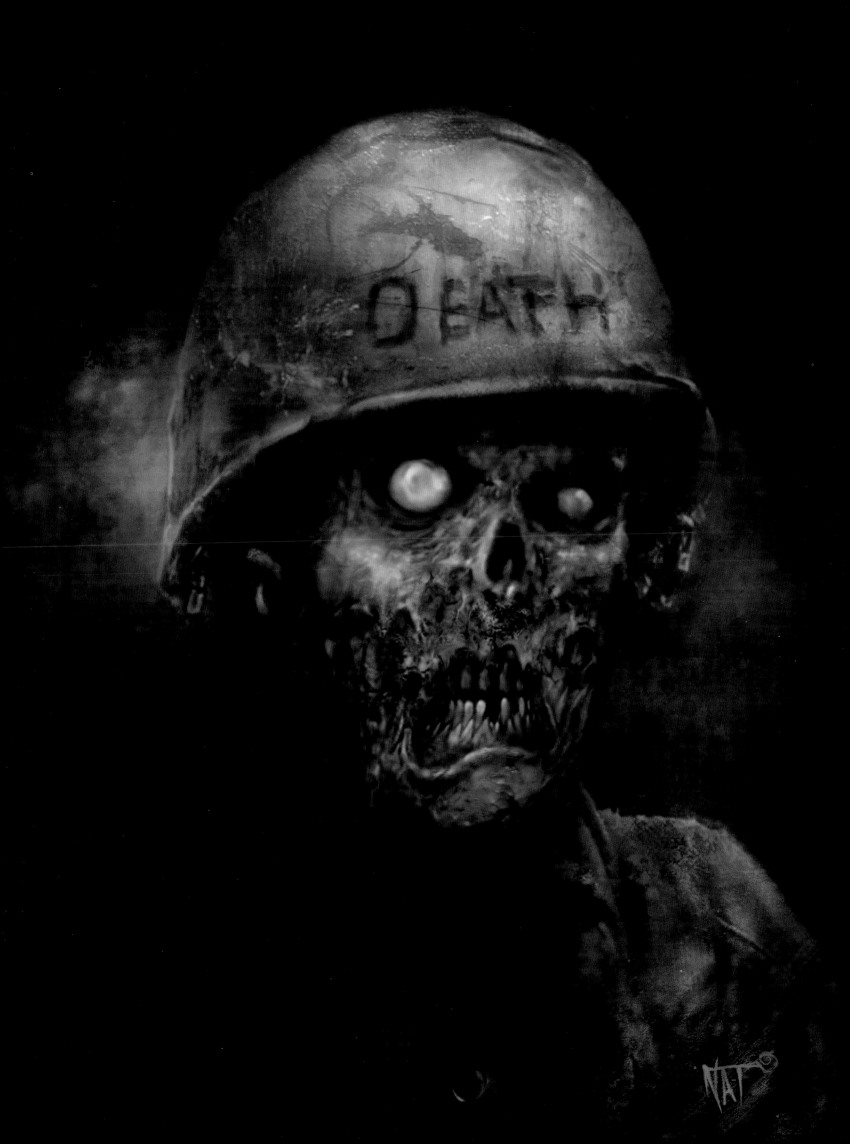

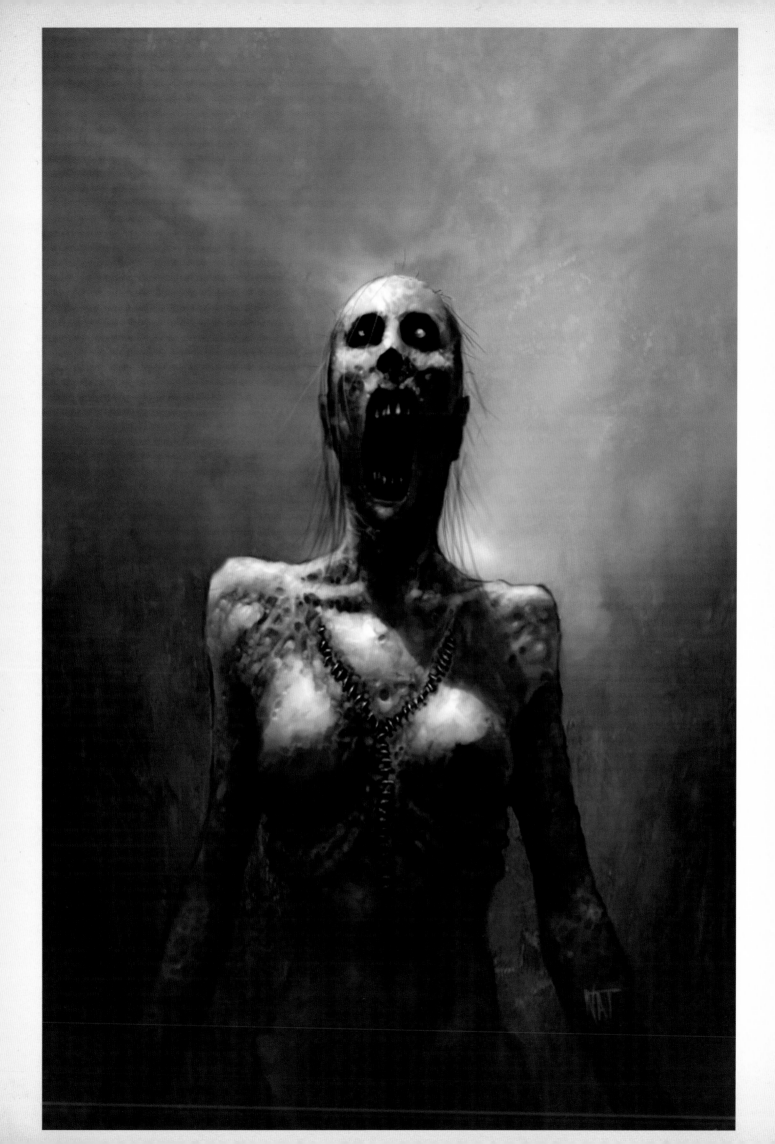

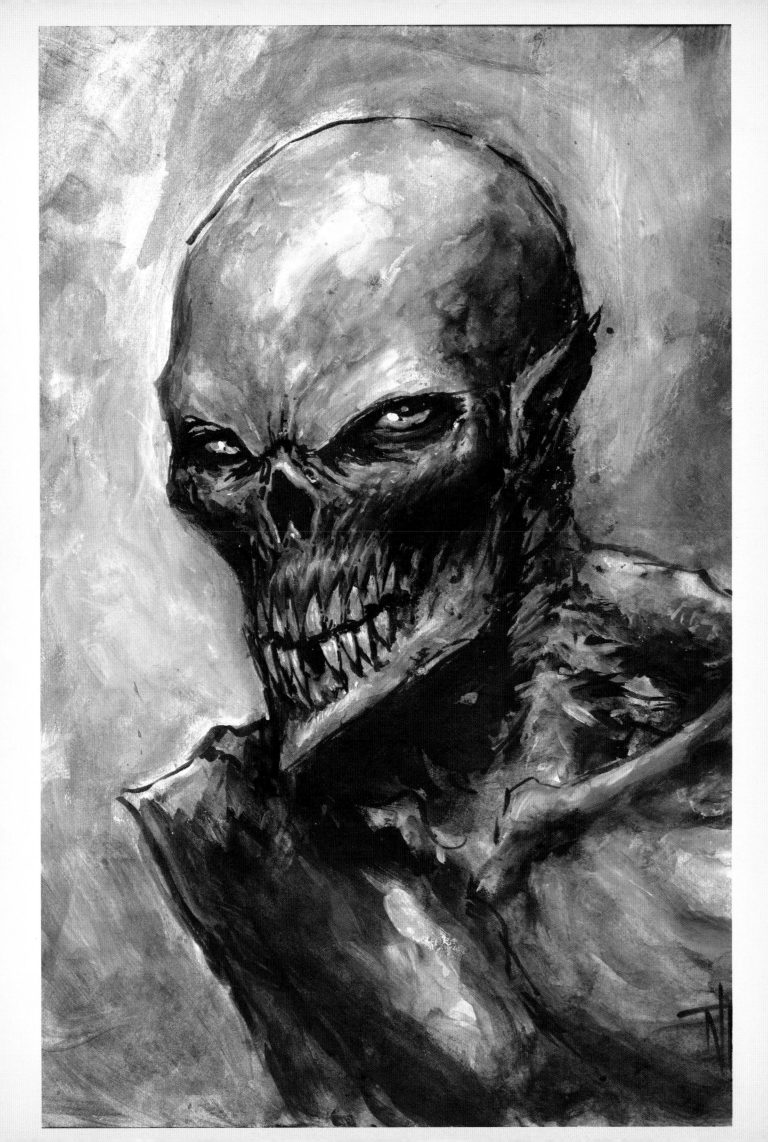

NATE FRIZZELL

Nathan Frizzell is a Southern Californian through and through. Raised in Riverside, California Nate took up residence in Los Angeles, California to pursue a professional art career. All the while, the Golden State's influence can be seen reverberating through his work. Using realistic rendering techniques juxtaposed with flat, iconographic shapes, Nate creates a playful tapestry which dances around the line between commercial art and gallery work.

NATEFRIZZELL.COM

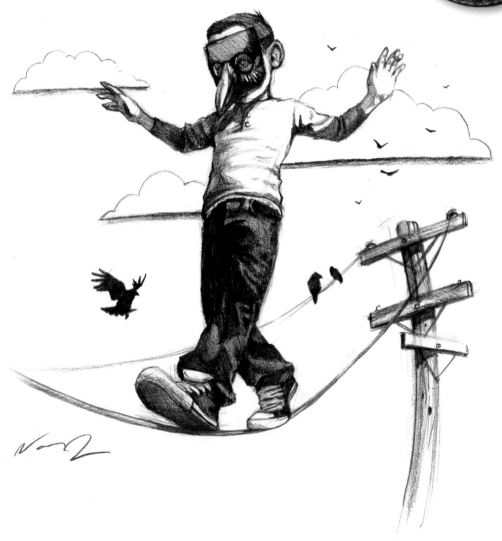

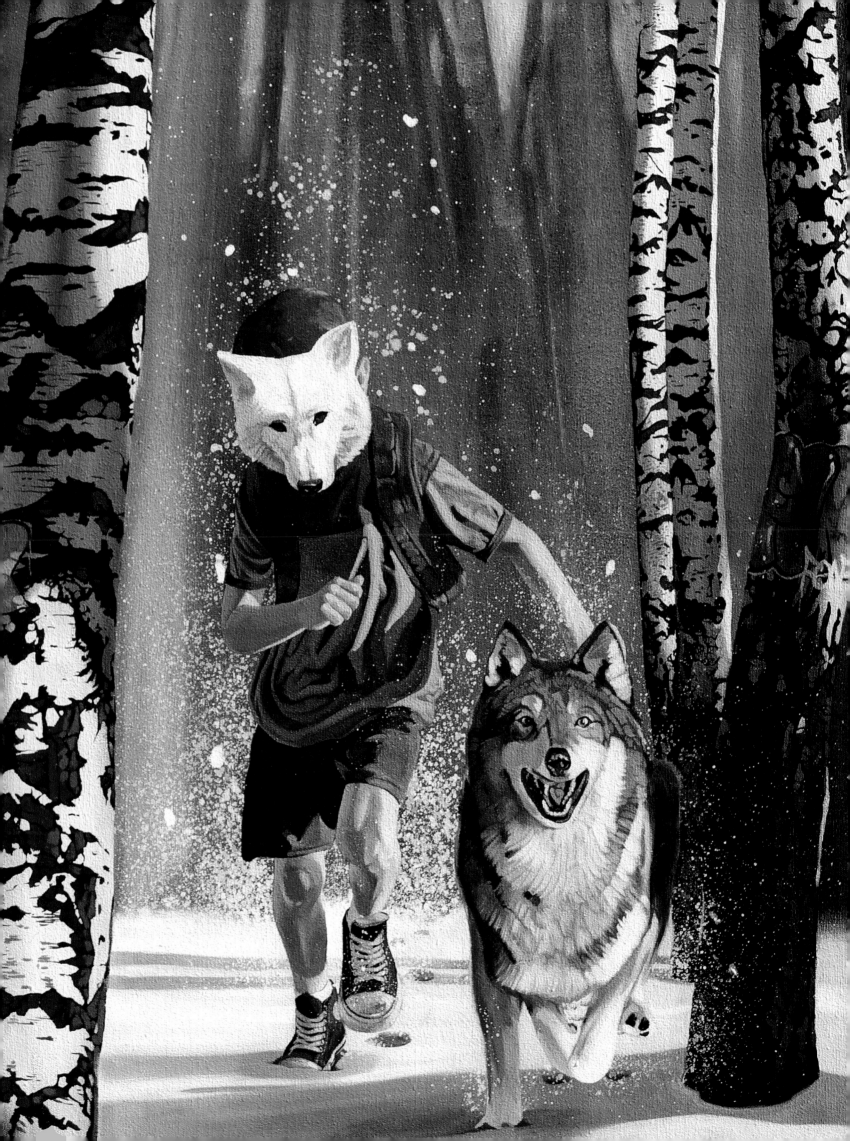

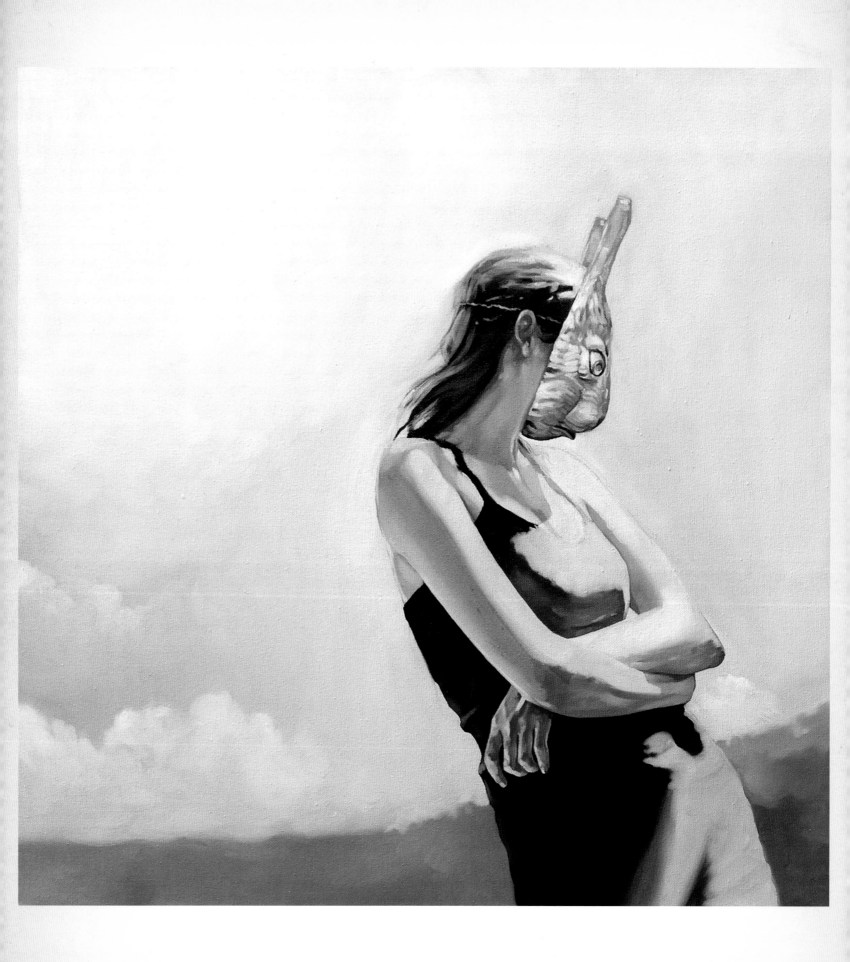

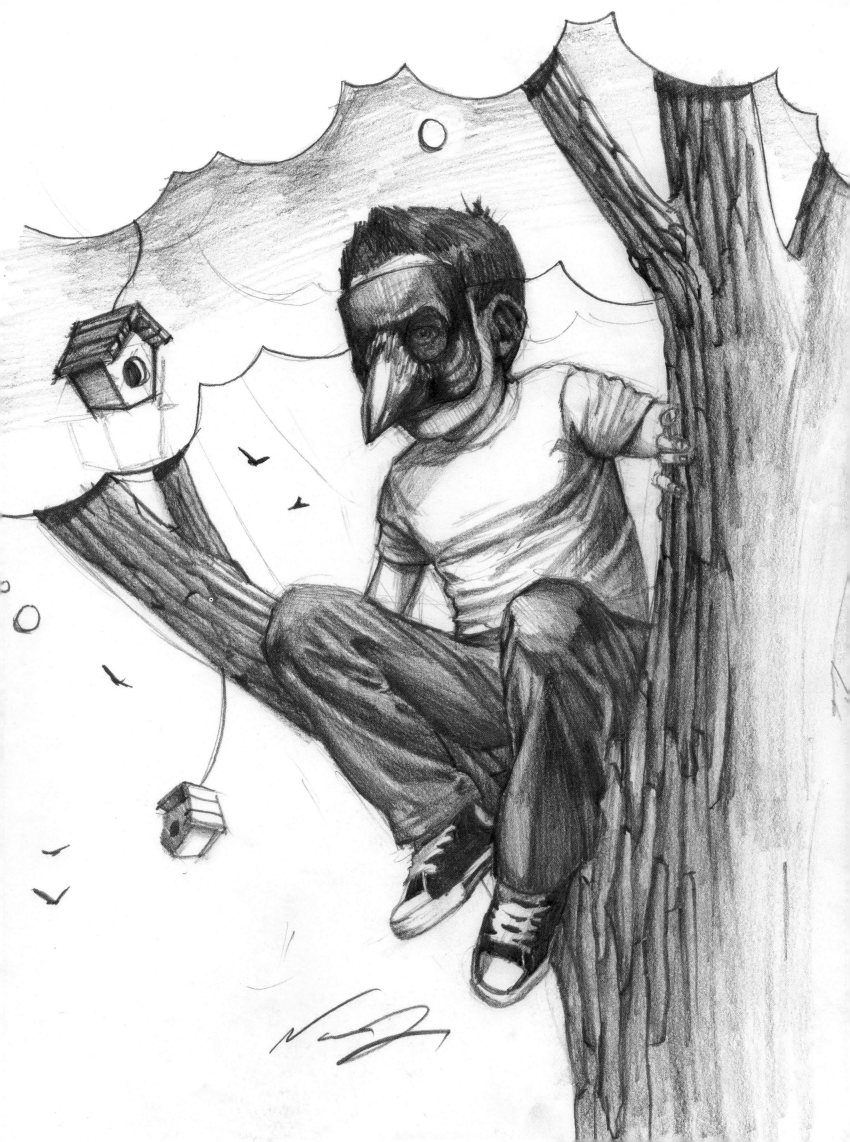

NICK BAXTER

NICK BAXTER WAS BORN IN 1981 IN NEW HAVEN, Connecticut and remained in the New Haven area until 2008, when he relocated to Austin, Texas. Following a life-long passion for creative self-expression, as a high school senior he was granted placement in the visual arts department at the Educational Center for the Arts, a magnet school in New Haven, Connecticut.

He then attended the Paier College of Art in Hamden, Connecticut (Dean's List), where he learned the basics of sharp focus still life painting in the classical trompe l'œil style. Nick then began a career in tattooing, while continuing to develop and pursue his interest in other fine art mediums, such as painting, mixed media collage and photography.

Now tattooing almost ten years, Nick has gained international acclaim in the body art community for his thought-provoking, innovative motifs and has become widely recognized by others in the tattoo industry for his combination of fine art and technical tattooing skills. He has been featured in every major tattoo art magazine in the world as well as other publications and books.

Nick has shown fine art works in several group exhibitions each year since 2003. Nick's technically demanding painting style dwells somewhere in between traditional sharp focus still life and modern photorealist styles, while bringing in elements of symbolism and surrealism. Visually, the work tends to center around close-ups of skin and visceral bloody macro-scapes. Thematically, Nick's work bridges elements of psychology, postmodern thought, anarchist theory and interpretations of ancient Buddhist teachings with personal symbols to investigate the nature of suffering, hope and transformation.

Inspired by a sincere concern for the human condition and a deep appreciation of the natural world, his aim is to question familiar assumptions and pierce the surface appearances of what we often take for granted, to create a space in which emotional certainties waver and taste loses its bearings, so that deeper truth and spiritual understanding may be uncovered.

NICKBAXTER.COM

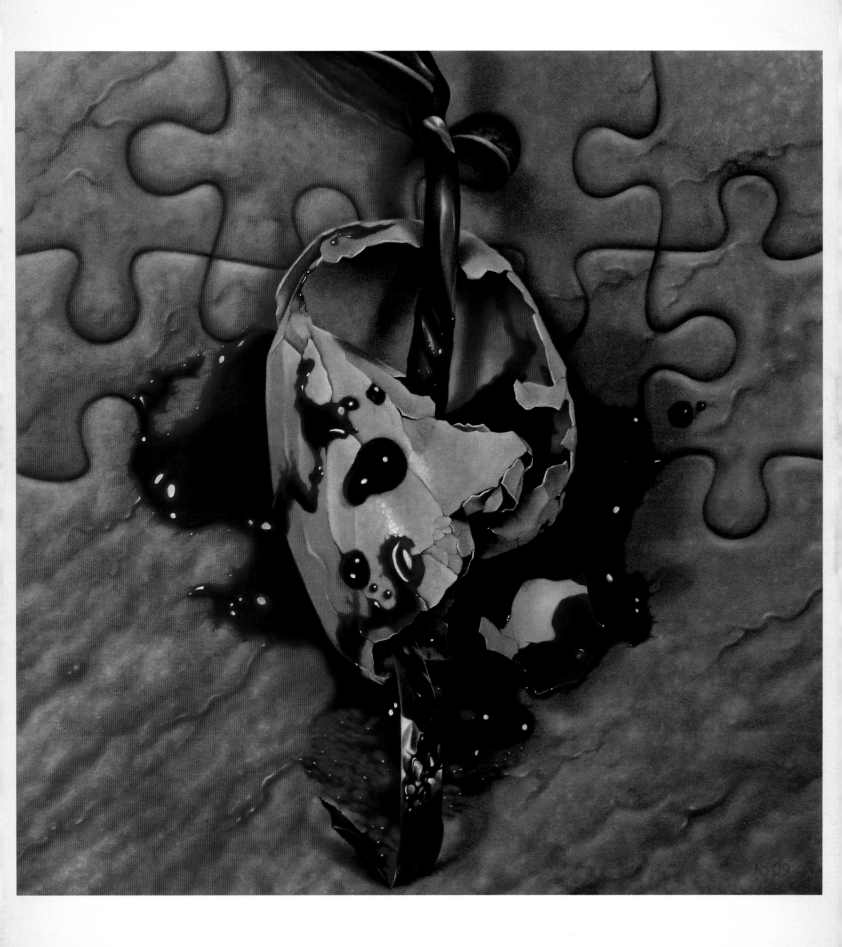

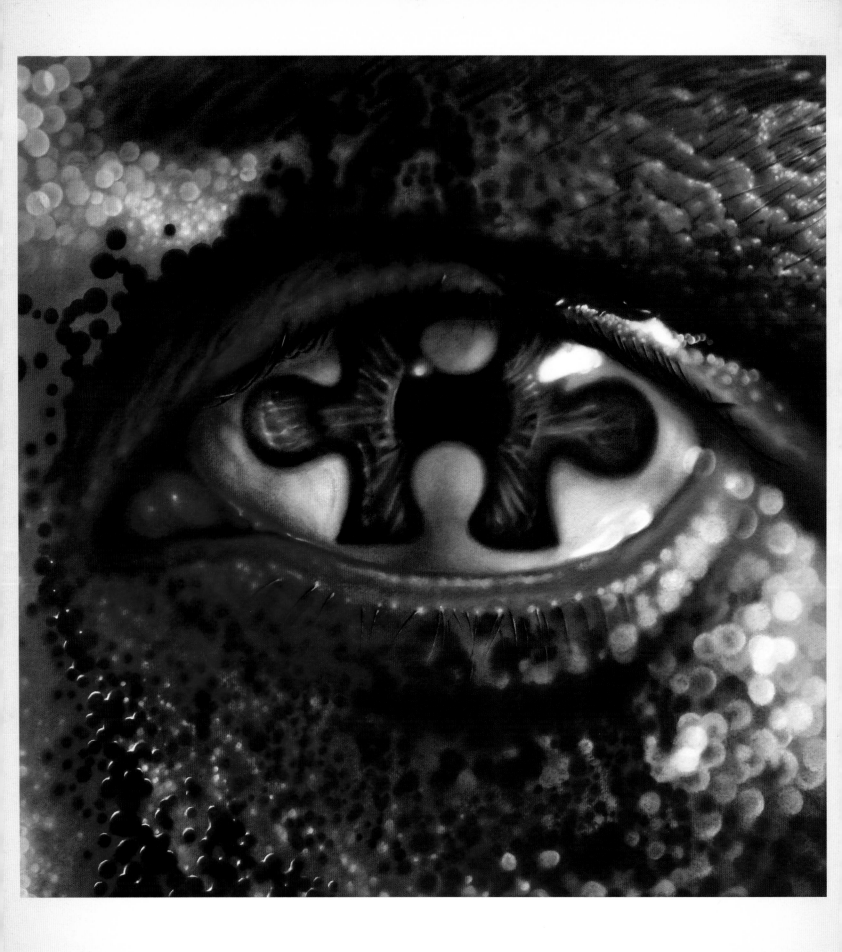

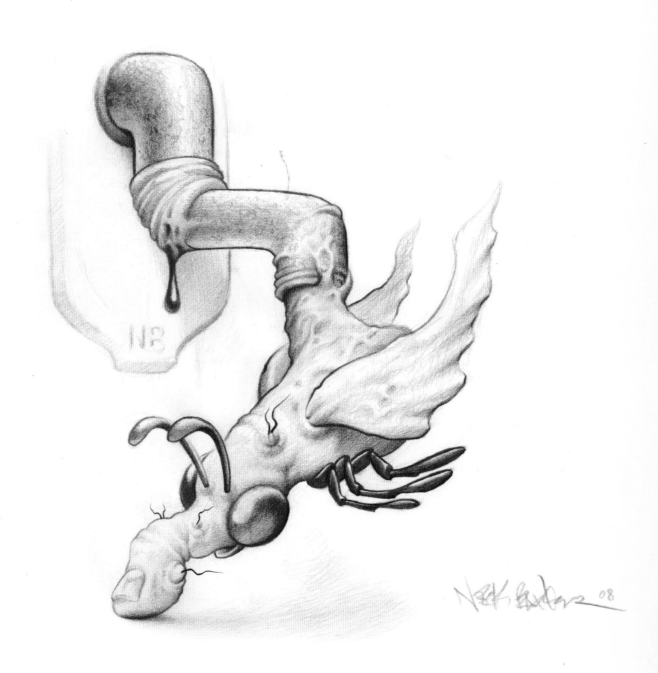

NICOLAS VILLARREAL

Nicolás P. Villarreal was born and raised in La Plata, Argentina. He studied at the Escuela of Animacion y Cinematografía de Avellaneda, where he earned a degree in 2D Animation. While studying animation, he was taken under the wing of Miguel Alzugaray, a well-known fine artist from Argentina. He continued studying animation and fine art painting until he entered the master's program at the Academy of Art University in San Francisco, California.

Nicolás graduated with honors in the spring of 2002, and since then he has worked as a 2D animator, character designer, sculptor and visual development artist for films and video games, including projects for Walt Disney Studios. He also wrote and illustrated his own children's book called *The Aces*.

Currently, Nicolás works as a freelance designer and teaches for the animation department at the Academy of Art University in San Francisco. Aside from drawing and painting, he also enjoys playing soccer and spending time with his friends.

NICOLARTS.COM

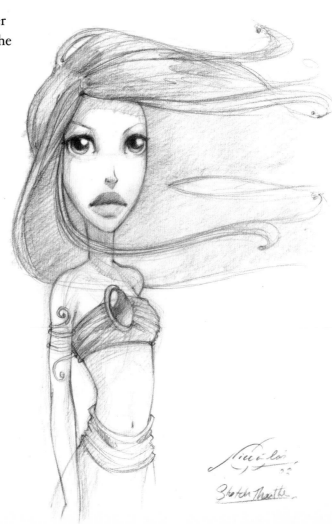

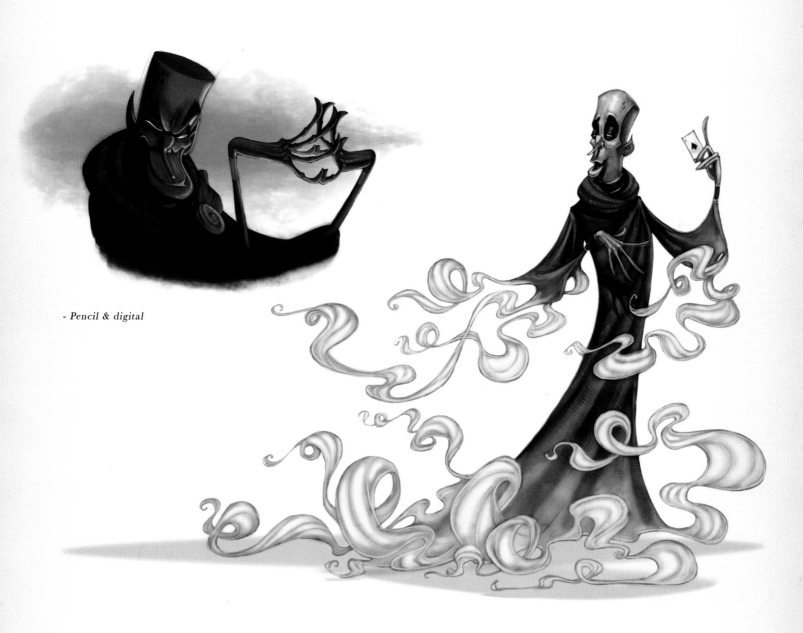

- *Pencil & digital*

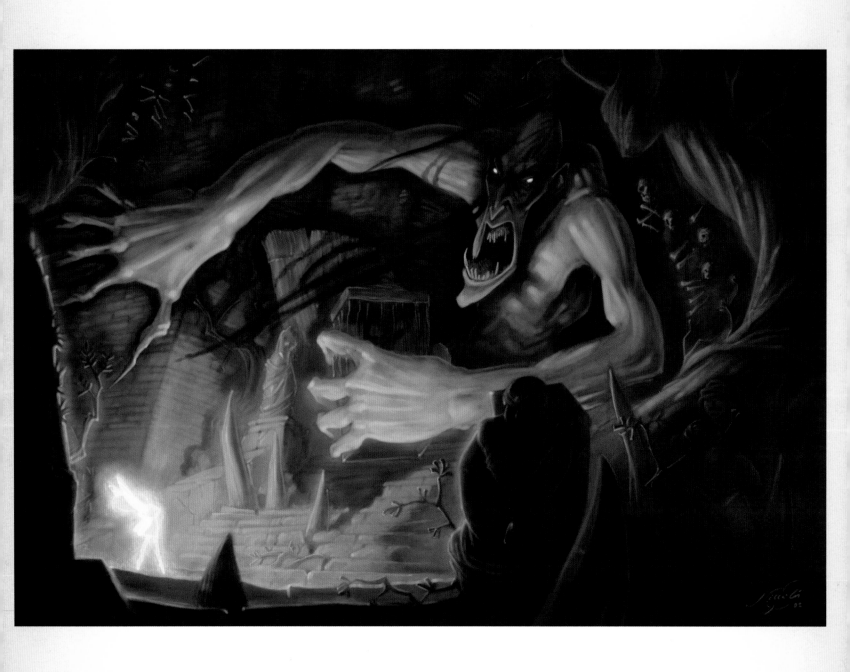

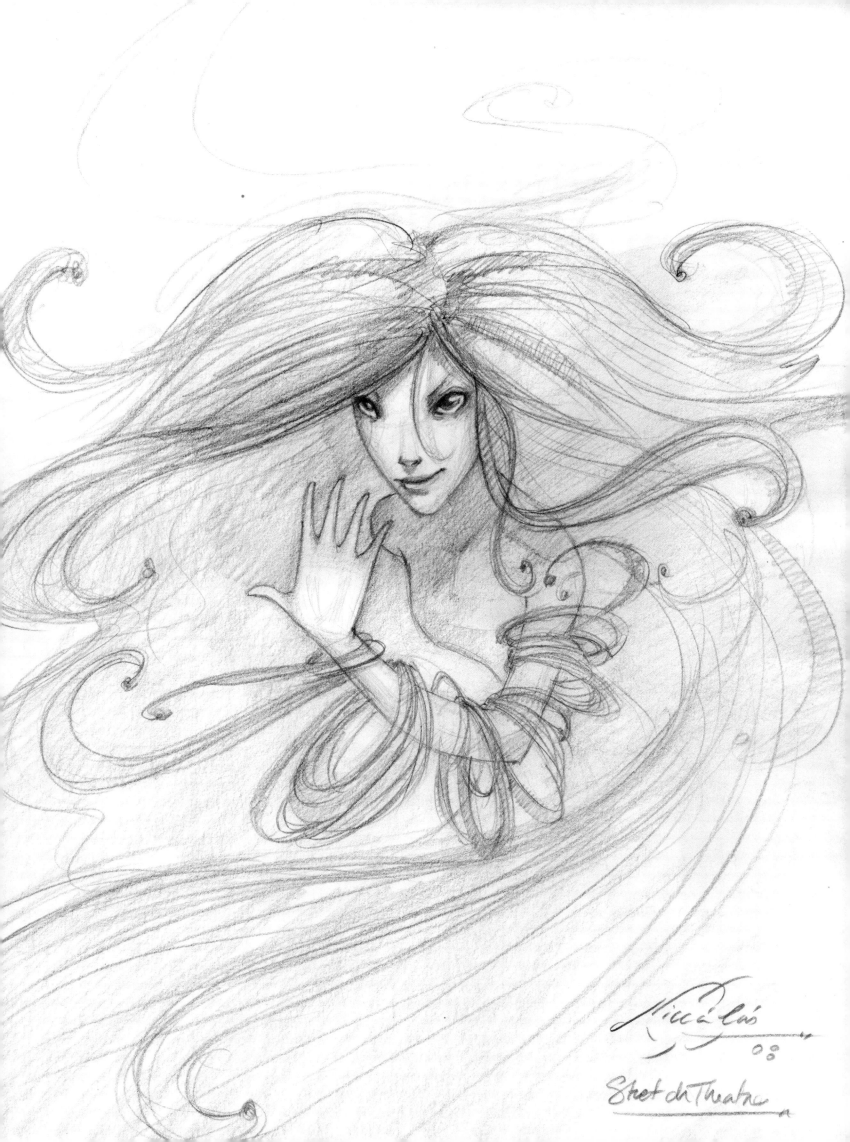

Nicolás
Sketch Theatre

RICK O'BRIEN

RICK IS A VISIONARY CREATOR WHOSE DISCIPLINES SPAN paint, clay and film. An accomplished designer, painter and property maker, he is one of Hollywood's one-man art departments. Pooling this menagerie of creative mediums has infused Rick's fine art to unique levels, allowing the artist to explore humanity fearlessly.

"It is the knowledge and understanding that behind every movement, decision, idea and aesthetic, there are forces at work constantly shaping, adjusting and defining them. It is acknowledging that truth lies beyond the surface, and a reminder that has helped clarify in my own mind a philosophy that continues to dominate my work."
— Counterweight, The Art and Concepts of Rick O'Brien

RICKOBRIENTMP.BLOGSPOT.COM

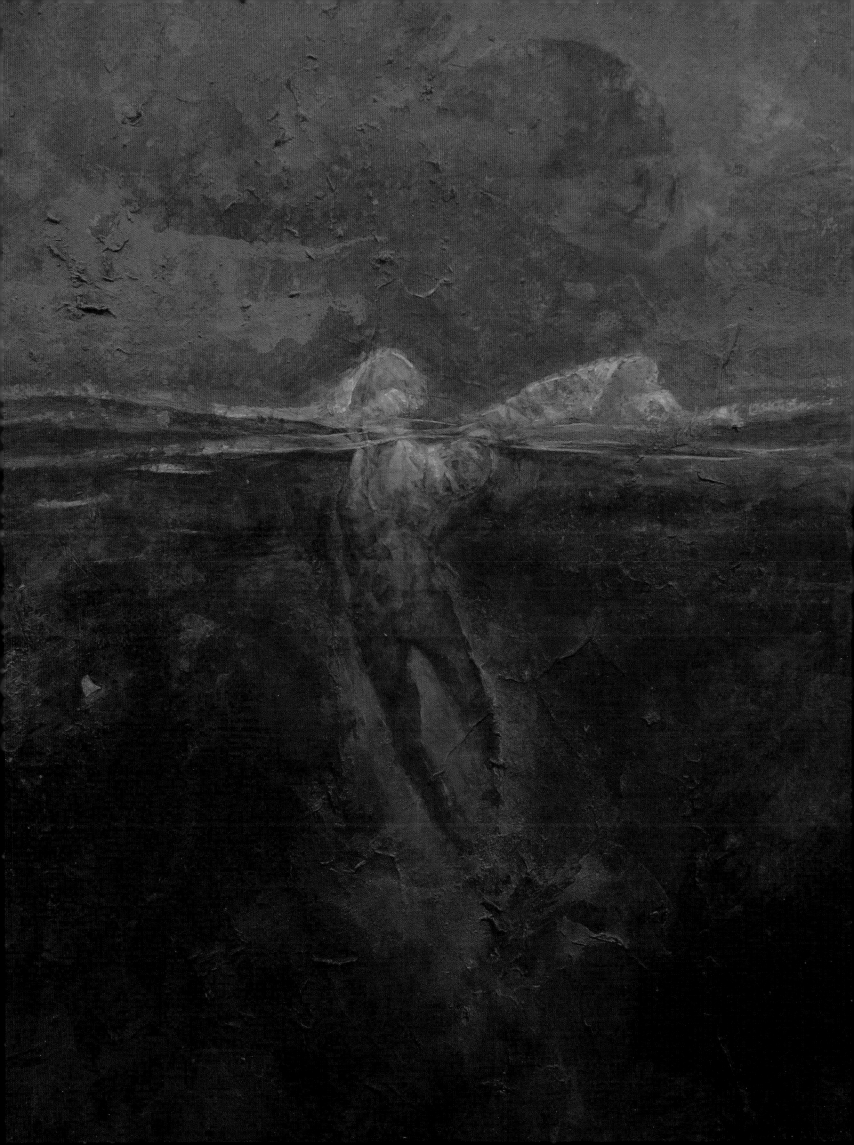

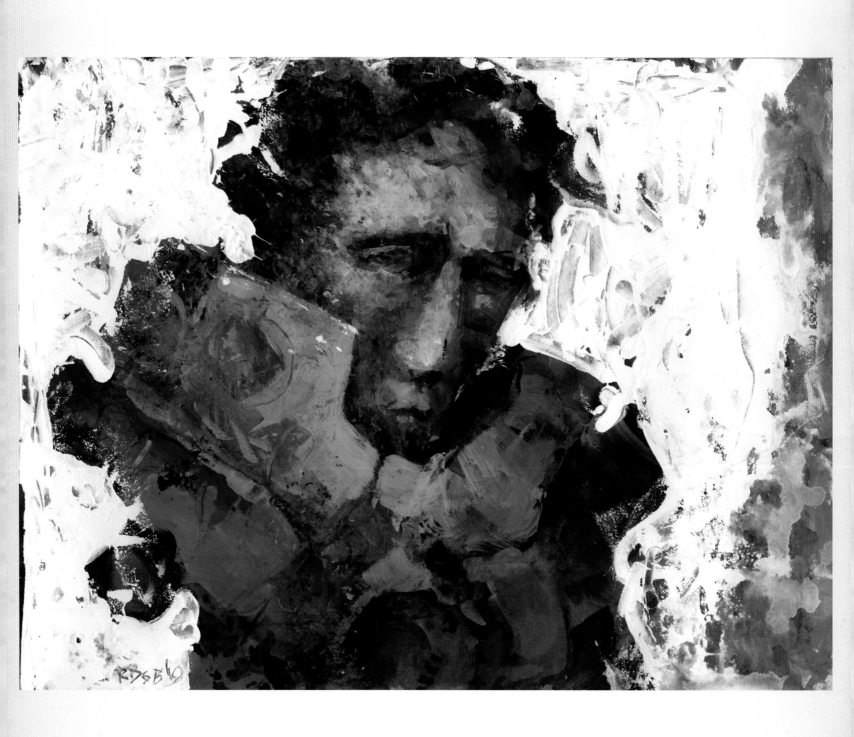

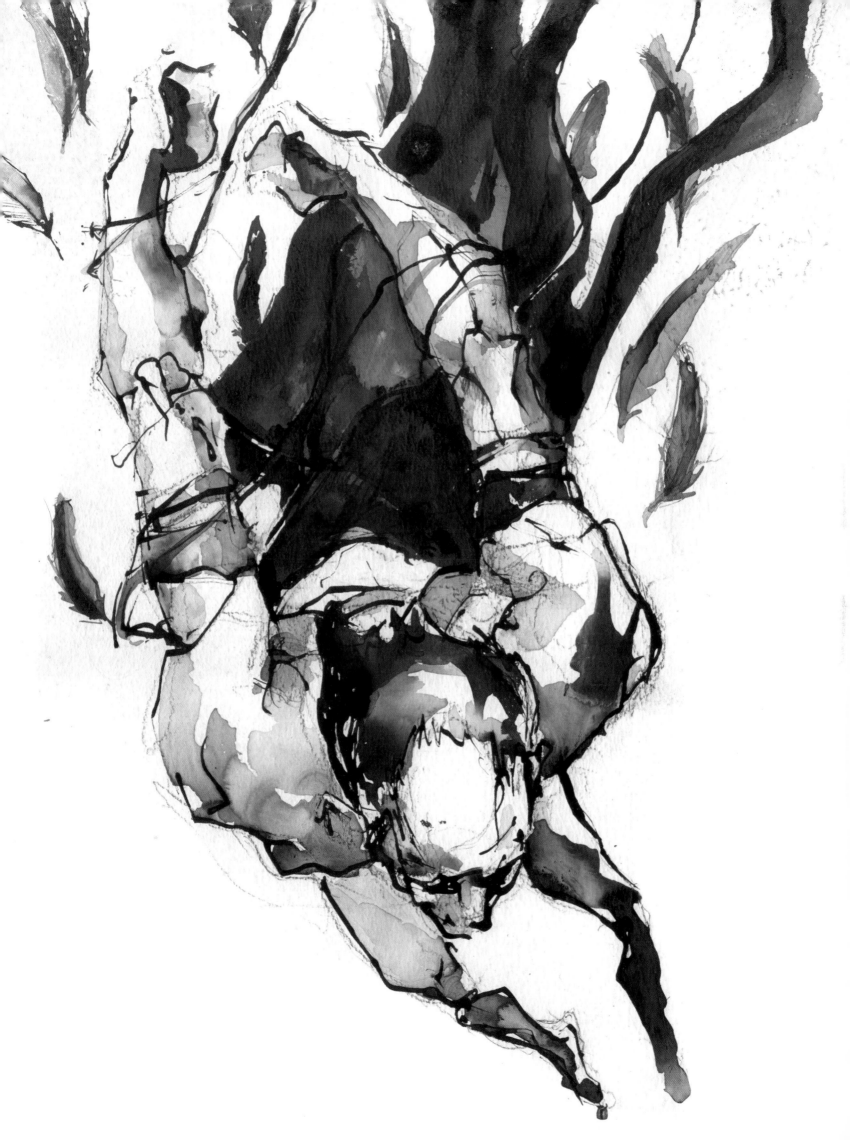

RON ENGLISH

ONE ASPECT OF RON ENGLISH'S WORK INVOLVES "LIBERATING" commercial billboards with his own messages. Frequent targets of his work include Joe Camel, McDonalds and Mickey Mouse. Ron English can be considered the "celebrated prankster father of agit-pop," who wrangles carefully created corporate iconographies so that they are turned down, used against the very corporation they are meant to represent. Ron English is considered one of the fathers of modern street art and has initiated and participated in illegal public art campaigns since the early 1980s. Some of his extralegal murals include one on the Berlin Wall's Checkpoint Charlie in 1989 and one on the Palestinian separation wall in the West Bank in 2007, with fellow street artists Banksy and Swoon.

Ron English has also painted several album covers, including The Dandy Warhols album cover *Welcome to the Monkey House,* and some of his paintings are also used in Morgan Spurlock's documentary *Super Size Me*. During the 2008 presidential election, he combined the features of Barack Obama and Abraham Lincoln for a widely-distributed image entitled "Abraham Obama."

Songs In English is the world's first blog-as-you-go recording project. It is based on the lyrics of world-renowned Brooklyn songwriter Jack Medicine. The project is being arranged and produced by the high-energy rock stylings of Velvet Rut. English has also collaborated with Daniel Johnston and Jack Medicine in the *Hyperjinx Tricycle* project.

P O P A G A N D A . C O M

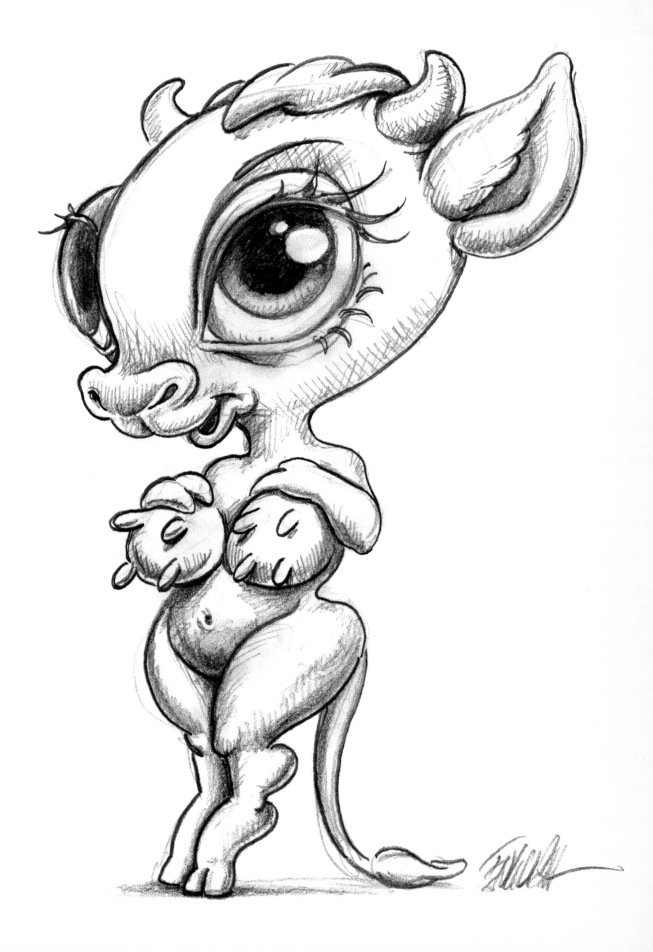

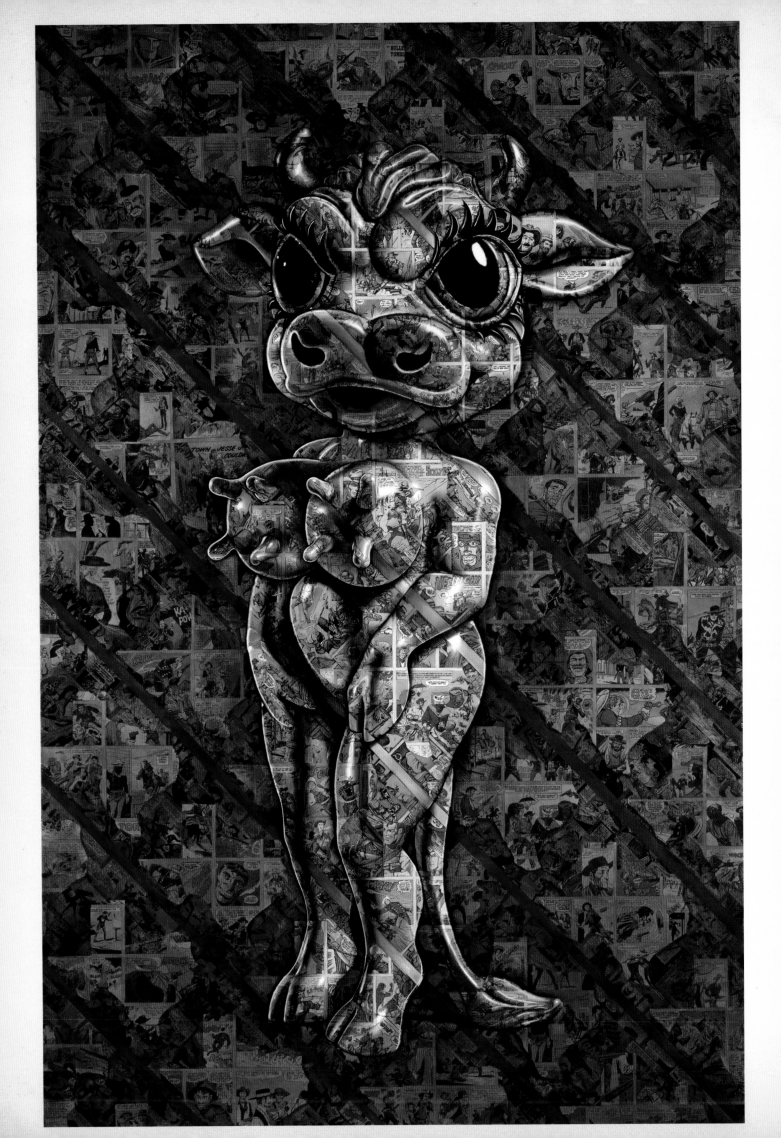

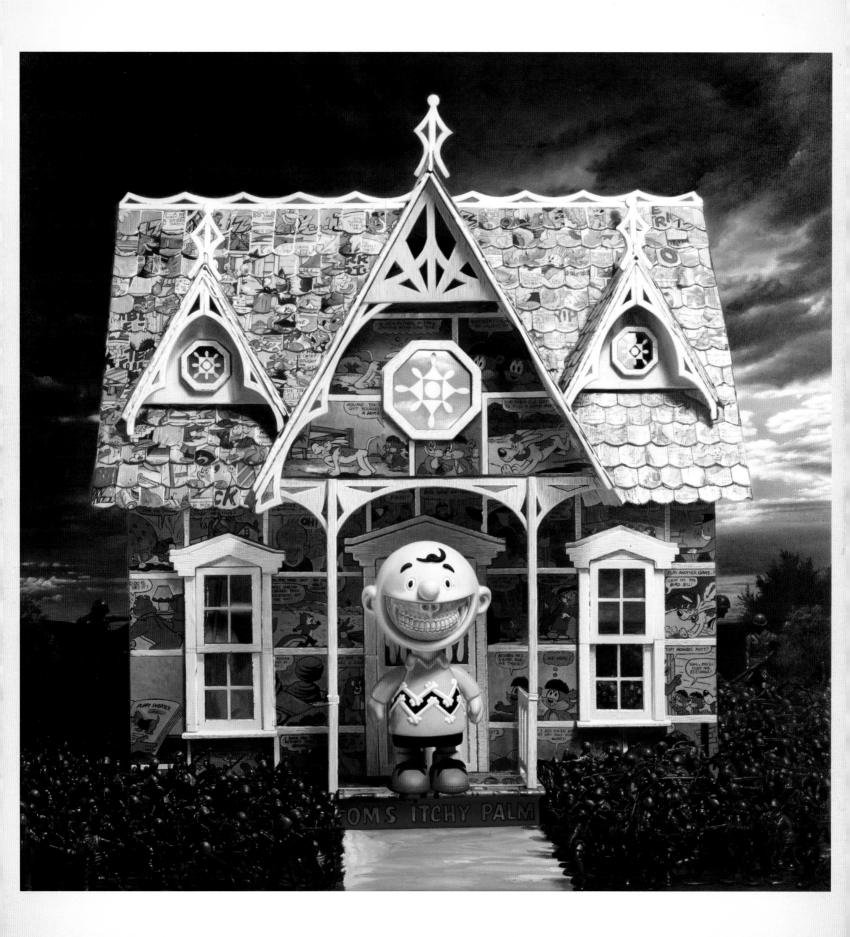

S. FISHER WILLIAMS

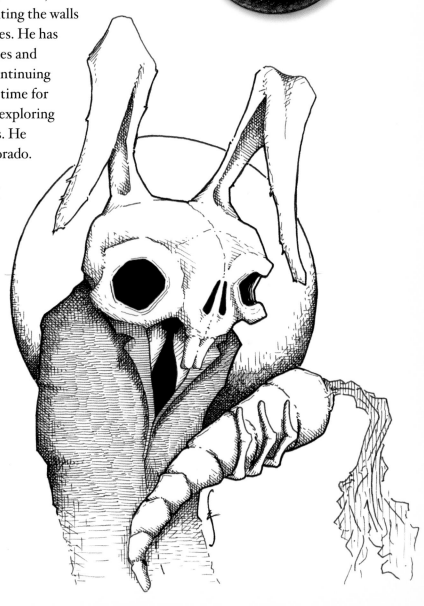

S EAN FISHER WILLIAMS GREW UP ON A STEADY DIET OF cartoons, comics, horror movies, toys and exploring Martian landscapes with imaginary friends. Drawing his entire life, his recognizable style didn't take shape until his early adult life, where these childhood influences were folded into the Southern Gothic voice of the years spent living in Louisville, Kentucky. Together they create images that are both tragic as well as humorous, static slices of untold narratives, lost lullabies or forgotten fairy tales.

Fisher's work has appeared on rock posters, albums, alternative newspapers and magazines, as well as haunting the walls of small venues and galleries in several states. He has published two books of illustrated storylines and over a dozen of short-run mini-comics. Continuing to draw every single day, Fisher still makes time for cartoons, comics, horror movies, toys and exploring Martian landscapes with imaginary friends. He does so now from his home in Denver, Colorado.

AQUALABSTUDIOS.COM

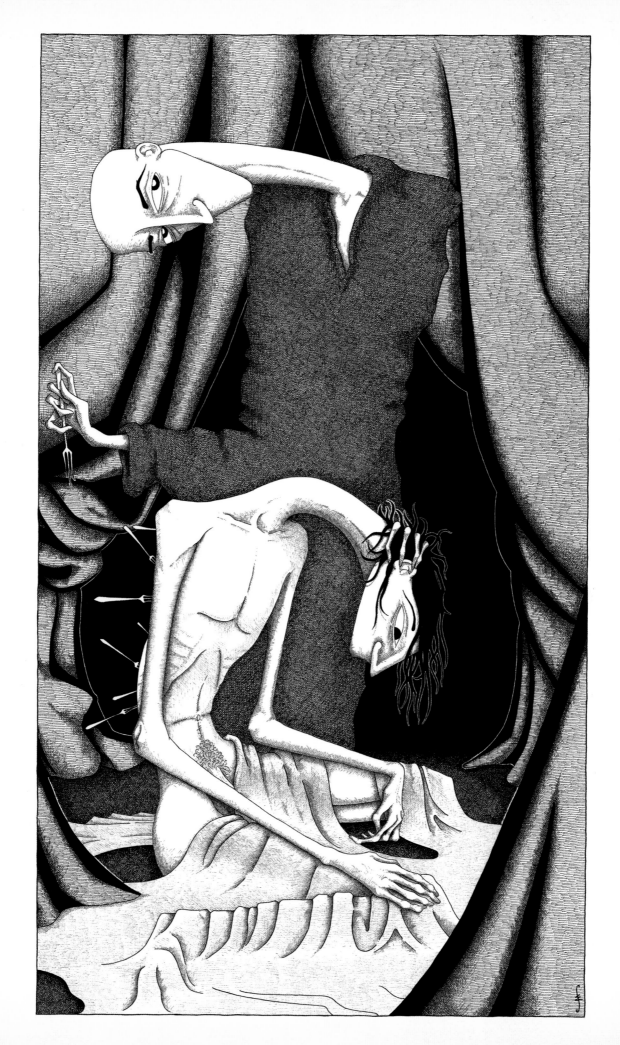

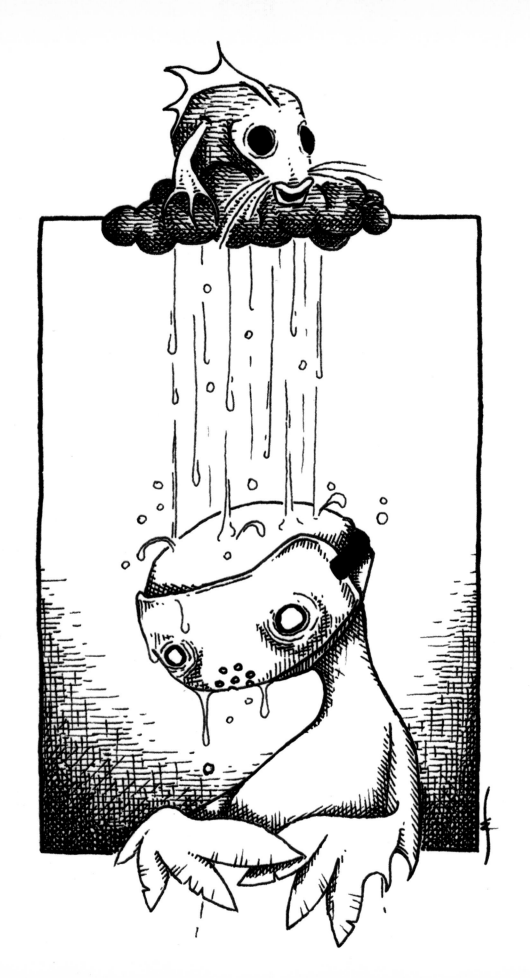

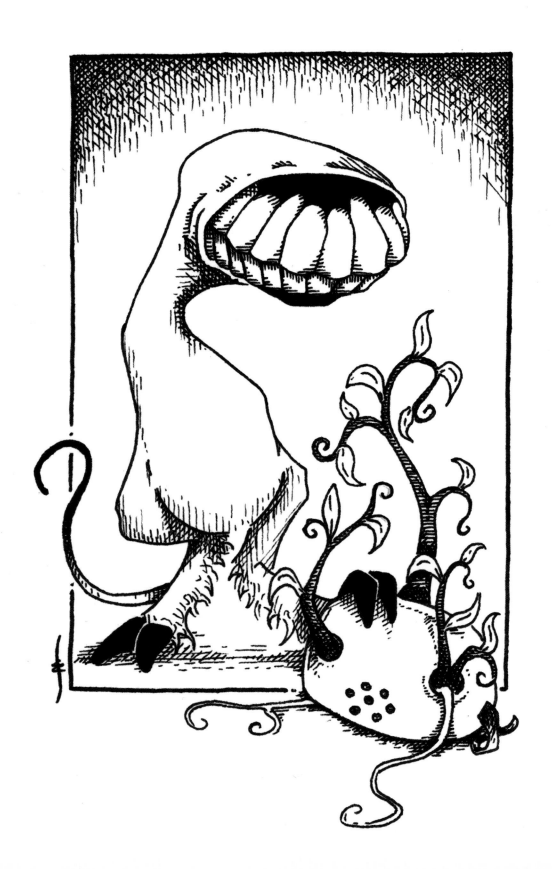

SAM SHEARON

S AM SHEARON, ALSO KNOWN UNDER THE PSEUDONYM
"Mister-Sam," is a dark artist originally born in Liverpool,
England in the United Kingdom. Specializing in horror and
science fiction, his work often includes elements inspired by ancient
cultures, the occult, industrial/art/revolution-eras and the supernatural.

Sam studied at the University of Leeds in the College of Art & Design
in West Yorkshire, England. He was awarded a bachelor of arts degree
with honors in 2000 for visual communication. Shortly after, he went
on to become a qualified art teacher, gaining a post graduate certificate
in education from Huddersfield University in West Yorkshire, England.
His first solo exhibition entitled, "A Walk On the Darkside," boasted forty-five
pieces of his original artwork, including six-foot-tall demonic statues, biomechanical monsters and
giant canvases depicting images of horror and the macabre. The exhibition was featured in various
national newspapers, including *The Daily Telegraph,* as well as *BBC Radio ONE* and live interviews on
BBC Radio Leeds North—resulting in the show being extended to six weeks due to popular demand.

Mister-Sam has created dark artwork for a variety of rock and metal music related clients,
including Jason Charles Miller, Godhead: Edge of the World, Keith Caputo, Dass Berdache, Ryan
Oldcastle, HIM, Iron Maiden, Cradle of Filth, Black Water Rising and Rob Zombie. Sam's dark
artwork can also be found in the form of graphics on the bodies of guitars, as well as on various
types of musical equipment and apparel including carry cases, drum skins and merchandise.
Clients include Coffin Case and ESP Guitars.

MISTER-SAM.COM

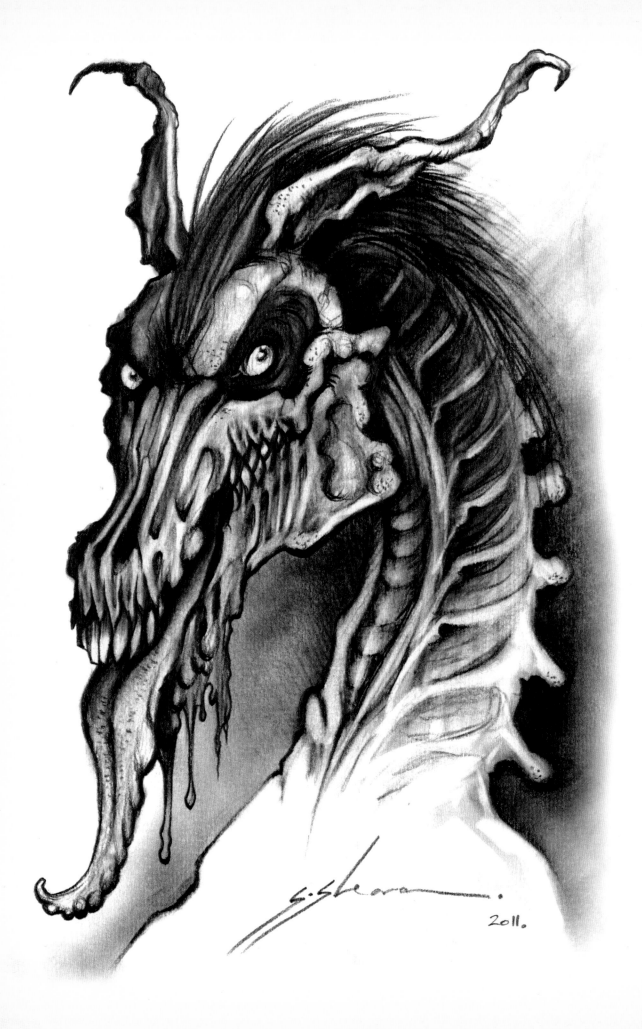

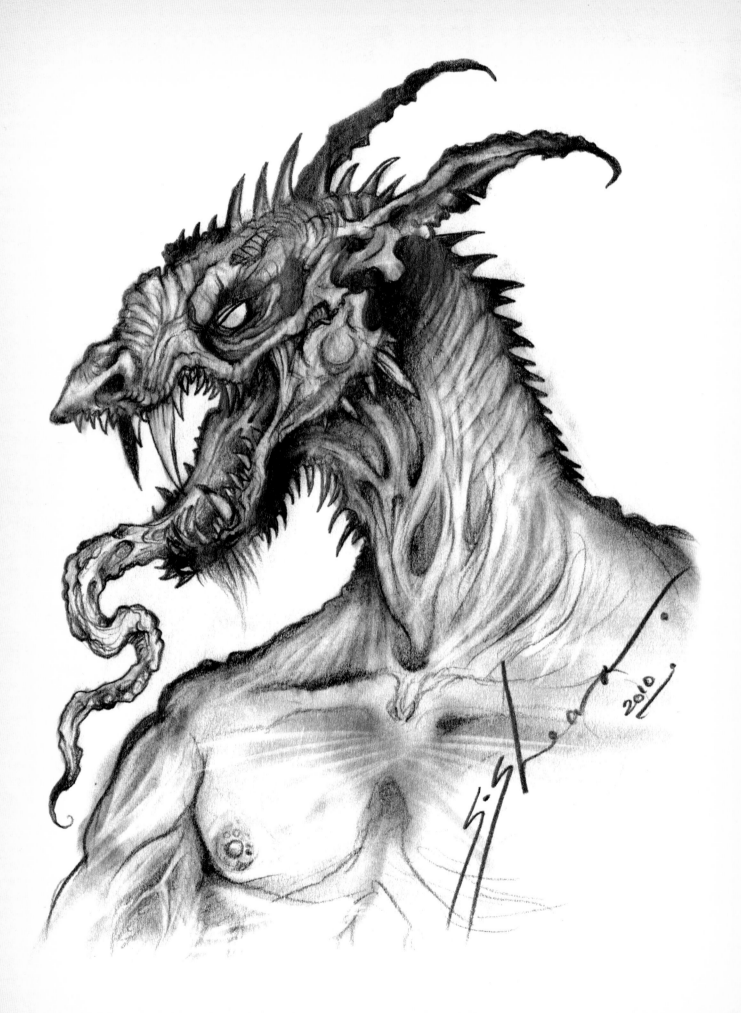

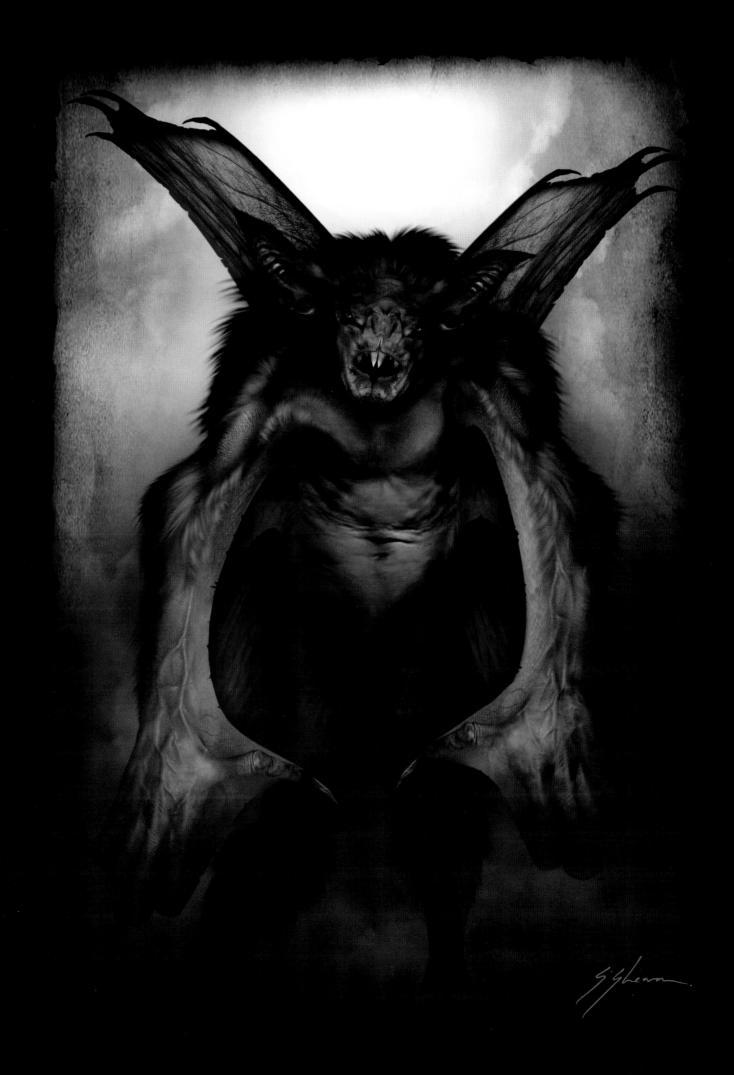

SHAWN BARBER

S HAWN BARBER'S BODY OF WORK FOCUSES PRIMARILY ON painting, portraiture and documenting contemporary tattoo culture. Barber's intimate renditions of tattooed individuals balance both meticulous brush strokes and loose energy. Figurative in nature, these large paintings take on abstractions with explosive colors, meandering lines and paint dripping down the canvas.

Barber earned his BFA from Ringling College of Art and Design in Sarasota, Florida in 1999 and has paintings held in private collections throughout the United States, Canada, Asia, Europe and Australia. His paintings have been exhibited in diverse solo and group venues, including the Joshua Liner Gallery, Billy Shire Fine Arts, The Shooting Gallery, Mesa Contemporary Arts Center and University of Houston. His first published book of art, titled *Tattooed Portraits,* was published by 9mm Books in March of 2006, followed by his second tome, *Forever and Ever*, a 256 page hardcover book dedicated to the *Tattooed Portraits* series.

Among his extensive achievements, he has taught drawing, painting and the business of art for ten years at various art schools throughout the country. After years of documenting the art of tattoo, it was a logical progression to pick up the tattoo machine and add tattooist to his resume. When he is not traveling or painting, he can be found working at Memoir Tattoo in Los Angeles, California.

SDBARBER.COM

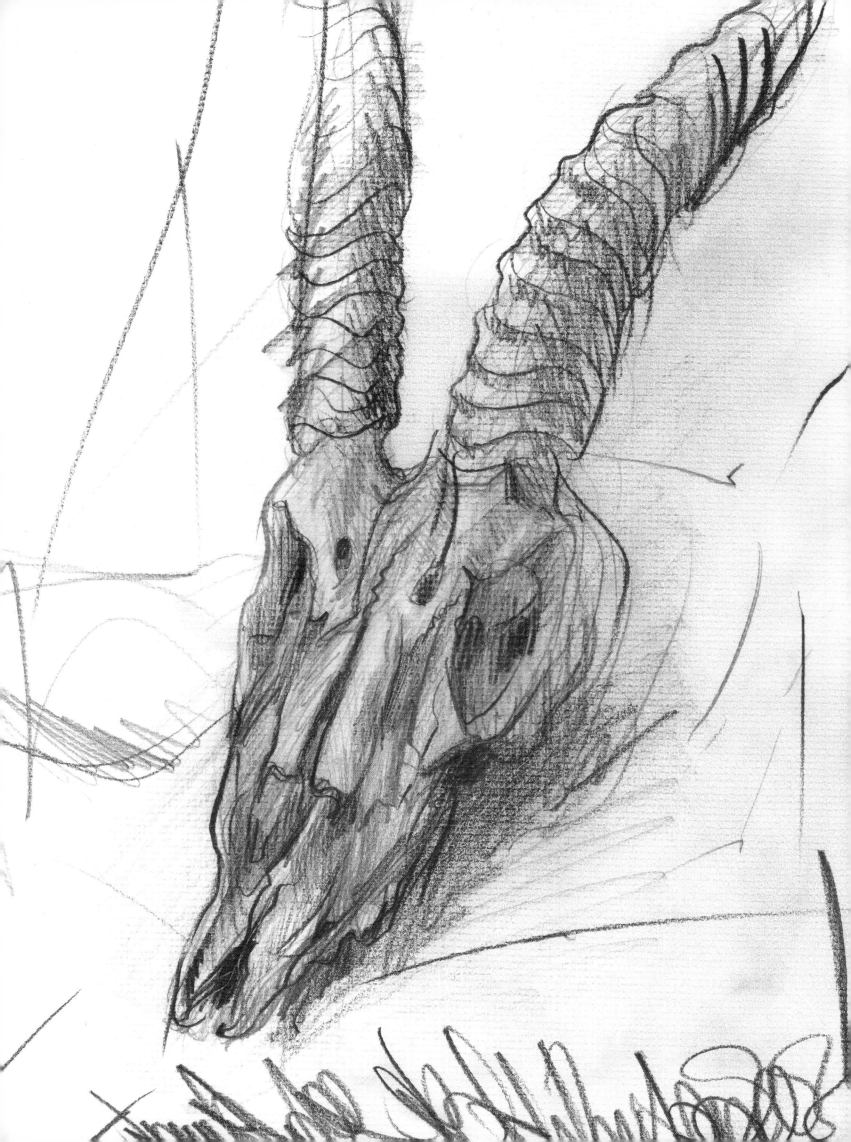

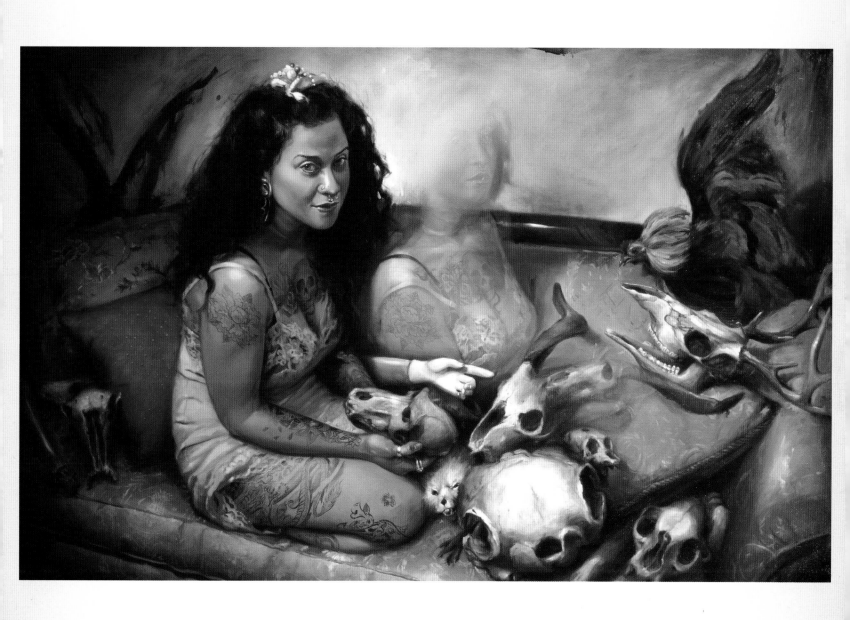

STEVEN DAILY

STEVEN JAMES DAILY INCORPORATES THE WONDER OF NEW vision with the transformative detail of a mature mind. His journey has allowed him to witness key elements in the American artistic landscape and stand shoulder to shoulder with both the brutal and the benign.

Born in Southern California in 1973, Daily's career in the visual arts was placed on a set of polyurethane wheels and given the neon-baked smog-scape to stoke the initial fire of creativity. Daily later relocated to the southern United States, where his imagination was given free reign to explore the dilapidated corners of the American Dream. Busted rail spurs lead to careful consideration of brushwork and technique. Abandoned houses become the focus for the energy of old masters, who create fervor for that which is ancient and useful. Ghosts spill from the eyes of Daily and suffuse canvases and physical forms with a style that is simultaneously mature and provocative, providing a glimpse a glimpse into a spidery, parallel world where hearts beat backwards as Rembrandt meets entropy under a magenta moon.

Daily has painted a ribbon of bows and a track of scars across the North American continent, working with thousands of interesting human beings in the process. Some of the astonishing entities that have withstood the physical presence of our intrepid explorer of dreams and nightmares include Disney, Sony, Slave Labor Graphics and HBO. All those who retain the steady hand and fine line of Steven James Daily for purposes related to commerce or art find as much satisfaction in the result as Daily does in the craft. Every piece staves off decay, while adding new layers to the compost of culture, creating updrafts of creativity that reach far beyond the space in which you view the art. A broad landscape of modern culture and the wreckage of the ghosts of history; this is what the eyes of Steven James Daily have seen, and this is what his works reflect.

STEVENDAILY.COM

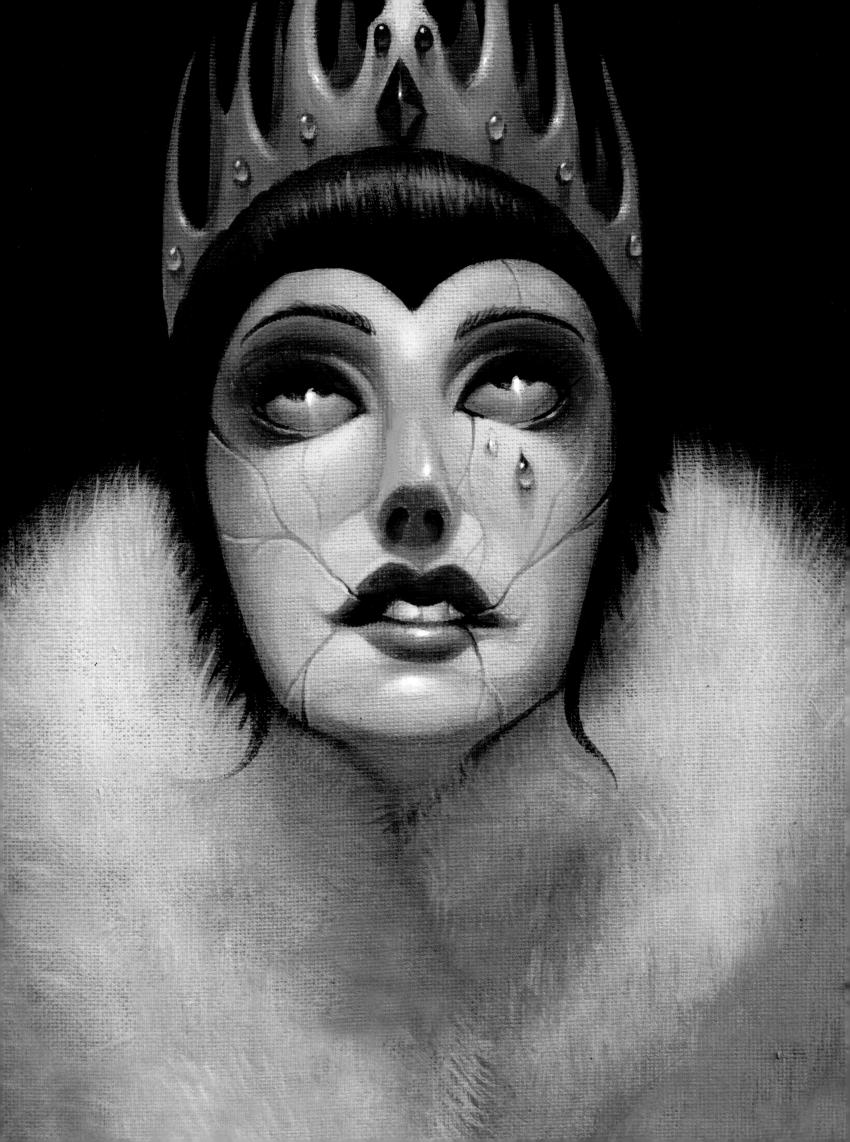

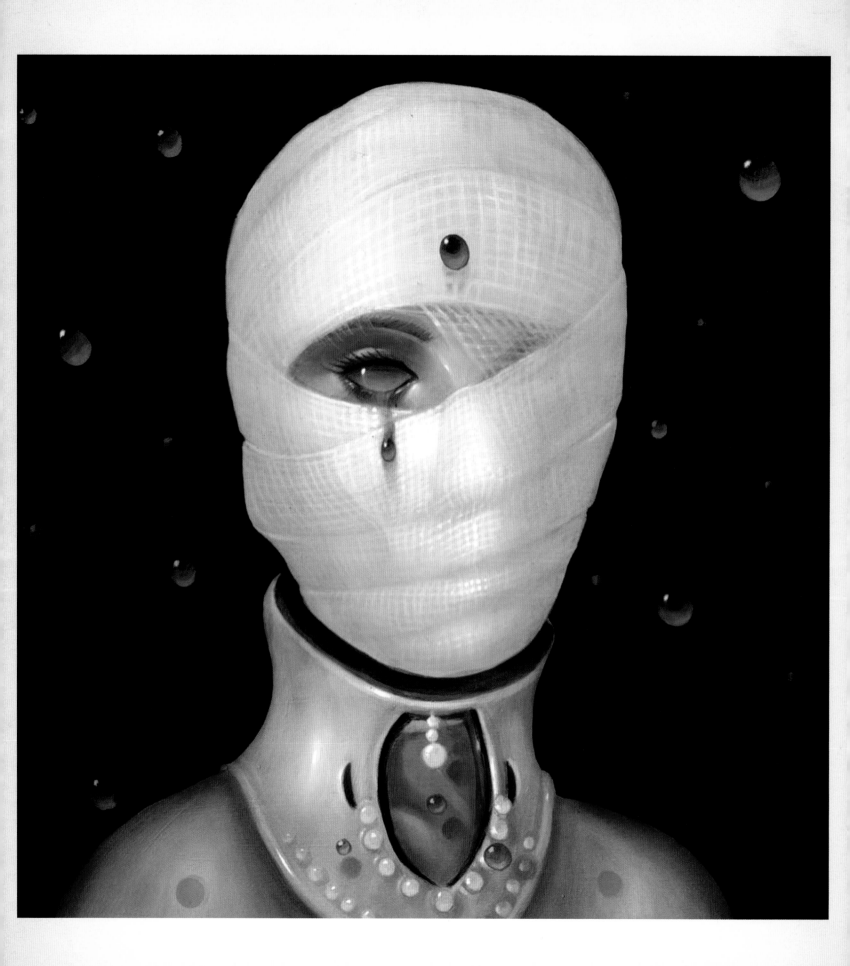

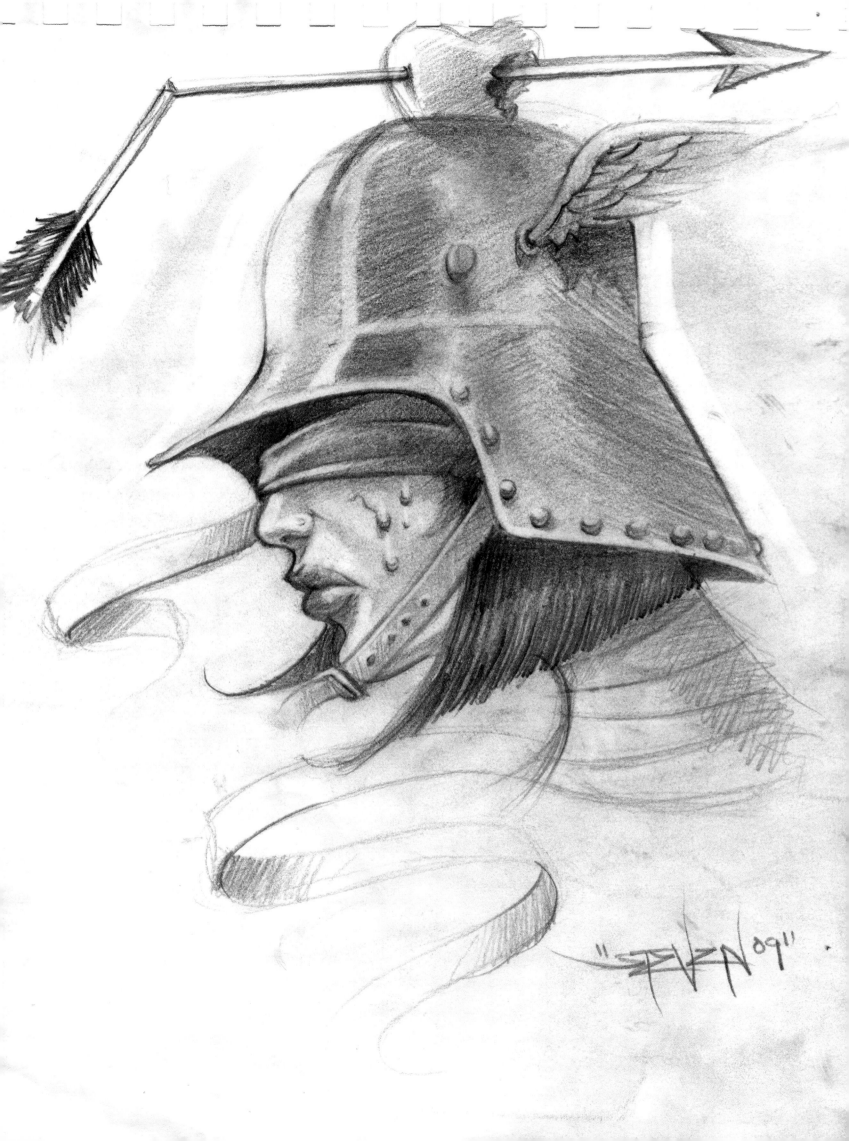

"STEVEN 09"

SZE JONES

SZE JONES IS BEST KNOWN FOR CREATING ICONIC HEROINE characters for some of the best-selling titles of the video game industry. She is currently employed by Naughty Dog as a character artist. Previously, she was the character modeling supervisor and a senior artist at Blur Studio. While at Blur, Sze implemented and managed their character modeling pipeline for eight years.

Some of her notable creations include Lara Croft for *Tomb Raider: Underworld*; Beatrice for *Dante's Inferno*; Anders and Sebrina for *Halo Wars*; Twilek, Jedi Consular and Bounty Hunter for *Star Wars: The Old Republic*; Dark Elf Sorceress for *Warhammer: The Age of Reckoning*; Emmera, Lyra and Cabalist for *Hellgate London*; Keira for *The Age of Conan*; Viral Carrie and Bowman for *Empire Earth*; Antonia for *Everquest II*; *Aeon Flux* and Female Pedestrian for *Prototype*.

Sze Jones began her art, music and dance training at a young age in Hong Kong. At age five, she was enrolled in the Elsa Art House and studied under the founder Lai Bing Chiu. She is trained classically in violin, piano and ballet. In 1997, she graduated with a master of fine arts with a major in computer graphics from the William Paterson University in Wayne, New Jersey. She has since attended numerous local art schools and workshops, including the School of Visual Arts, Joe Kubert School of Cartoon and Graphic Art, Gnomon School of Visual Effects and Otis College. Her ongoing training includes classical painting at Los Angeles Academy of Figurative Arts and traditional Chinese painting and calligraphy with Master Pang Qi.

Her artwork has been featured on Sketch Theatre, ZBrush Central, XSI base, CGSociety, *Play* Magazine, *CG World* Magazine and CG Channel. Sze has also been a guest speaker on FX Mogul Radio and at the Art Institute of Los Angeles, Comic Con, Gnomon and Siggraph. She loves teaching, and her wish is to inspire others and to share her insights and knowledge from her personal creative experience. She is currently teaching online at CGSociety's CG Workshops.

In her spare time, Sze continues to evolve her artistic journey by expressing her passion for life, inner energy and spiritual findings through her paintings, sculptures and dance. She would like her creations to depict the mystical realm of her imagination and offer a serene visual experience to the viewer. She is now performing with the Torrance Chinese classical dance troupe and exhibiting her artworks at The Hive Gallery and Studios in Los Angeles.

SZEJONES.COM

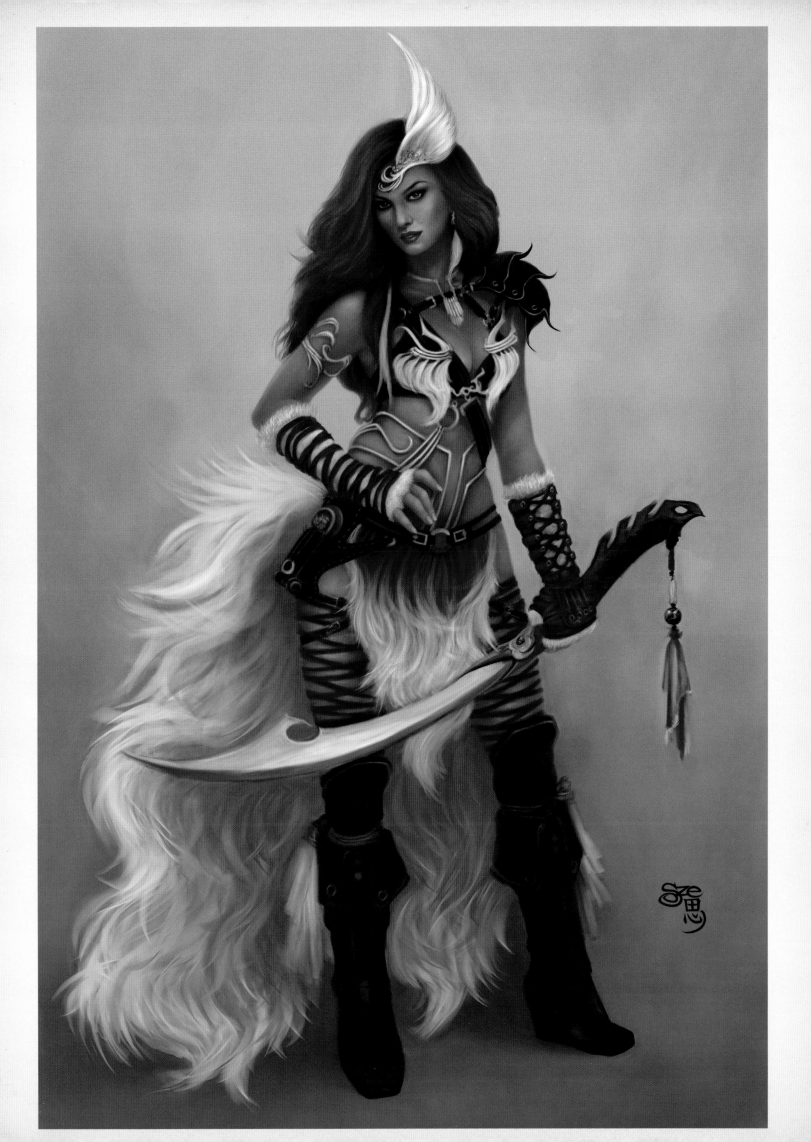

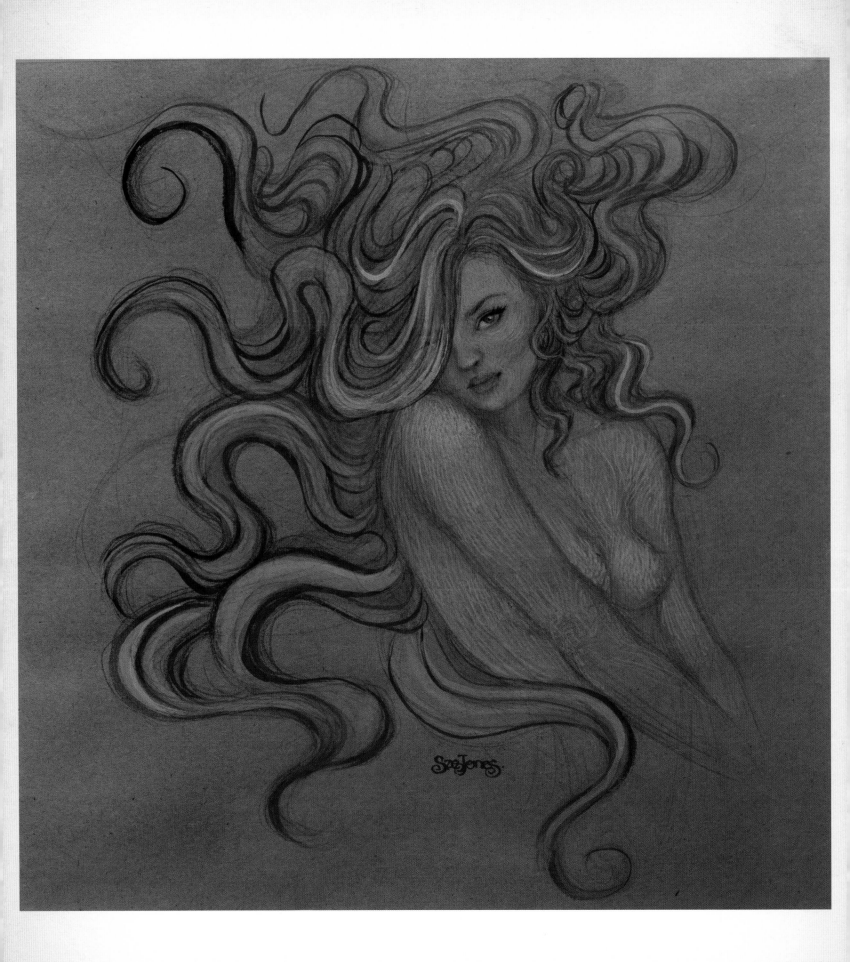

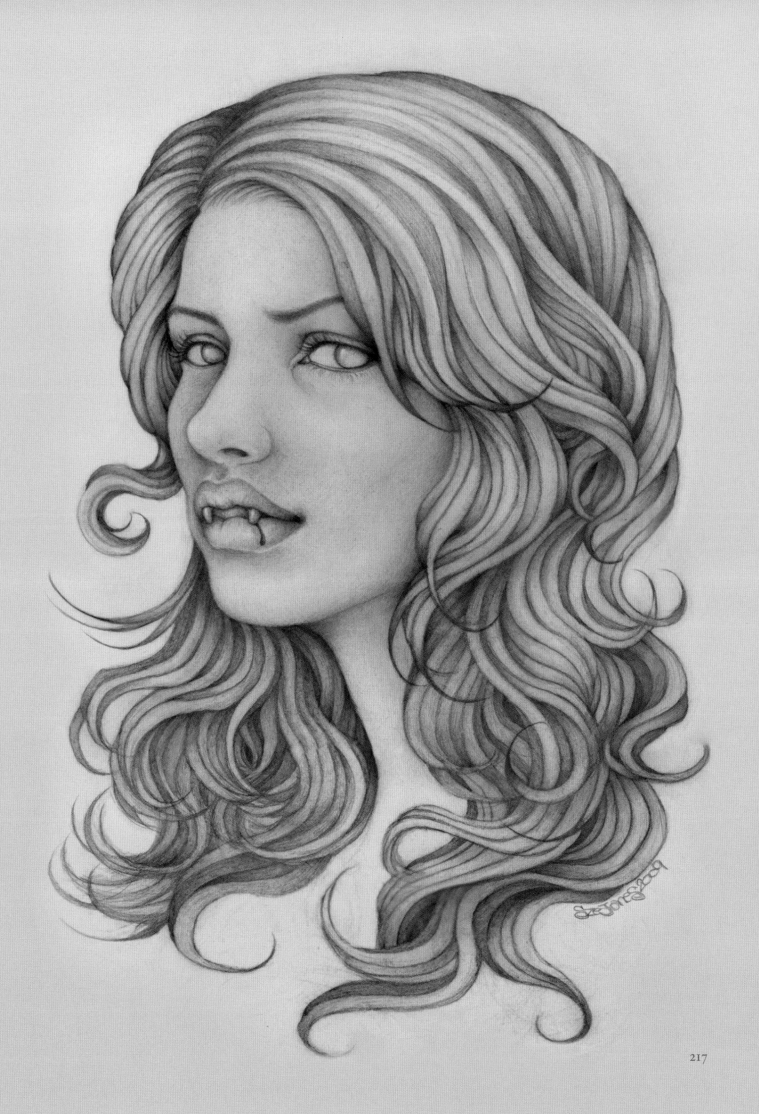

217

TARA MCPHERSON

TARA MCPHERSON IS AN ARTIST BASED OUT OF NEW YORK CITY creating art about people and their odd ways. Her characters seem to exude an idealized innocence, with a glimpse of hard earned wisdom in their eyes. Recalling many issues from childhood and good old life experience, she creates images that are thought provoking and seductive. People and their relationships are a central theme throughout her work.

Tara exhibits her paintings and serigraphs in fine art galleries all over the world. Named the Crown Princess of Poster Art by *ELLE* Magazine, she has created numerous gig posters for rock bands such as Beck, Modest Mouse and the Melvins. Her array of art also includes creating toys with companies like Kidrobot and Dark Horse Comics, painted comics and covers for DC Vertigo, advertising and editorial illustrations for companies such as Wyden+Kennedy and *Spin* Magazine, and teaching a class at Parsons in New York City.

McPherson's art has been included in books such as *Lost Constellations; The Art of Tara McPherson Vol II* (Dark Horse), *Lonely Heart: The Art of Tara McPherson* (Dark Horse), *Fables: 1001 Nights of Snowfall* (DC), *The Art of Modern Rock* (Chronicle), *Illustration Now!* (Taschen), *SWAG* and *SWAG 2* (Abrams), and more. She has lectured at Semi-Permanent, Offset, Institute of Comtemporary Art London, School of Visual Arts, AIGA New York City, AIGA Austin, Columbus College of Art and Design, Parsons, The University of Arizona, MADE in Edmonton and Foyles London. Her art has also been featured in the Oscar Award-winning film *Juno*.

Tara was born in San Francisco, California in 1976 and raised in Los Angeles. She received her BFA from the Art Center in Pasadena, California in August 2001 with honors in Illustration and a minor in Fine Art. She interned at Rough Draft Studios, working on Matt Groening's *Futurama* during college.

She has been featured in *Juxtapoz*, *Esquire*, *Vanity Fair*, *Playboy*, *Bust*, *Magnet*, *Elle*, MTV, Current TV, Super7, *Inked*, *New York Press*, *LA Times*, PBS, *HOW*, *Step*, *Communication Arts*, Society of Illustrators, AIGA, *Seattle Times*, *LA Weekly*, *Gothamist*, DC Comics, and many more.

Some of her clients include DC Comics, Warner Brothers, Dark Horse Comics, Kidrobot, SXSW, Pepsi, Fanta, Goldenvoice, Penguin, Harper Collins, Revolver, Knitting Factory, Playstation 2, House of Blues, Punk Planet, Dogfish Head Brewery and Nike among others.

WWW.TARAMCPHERSON.COM

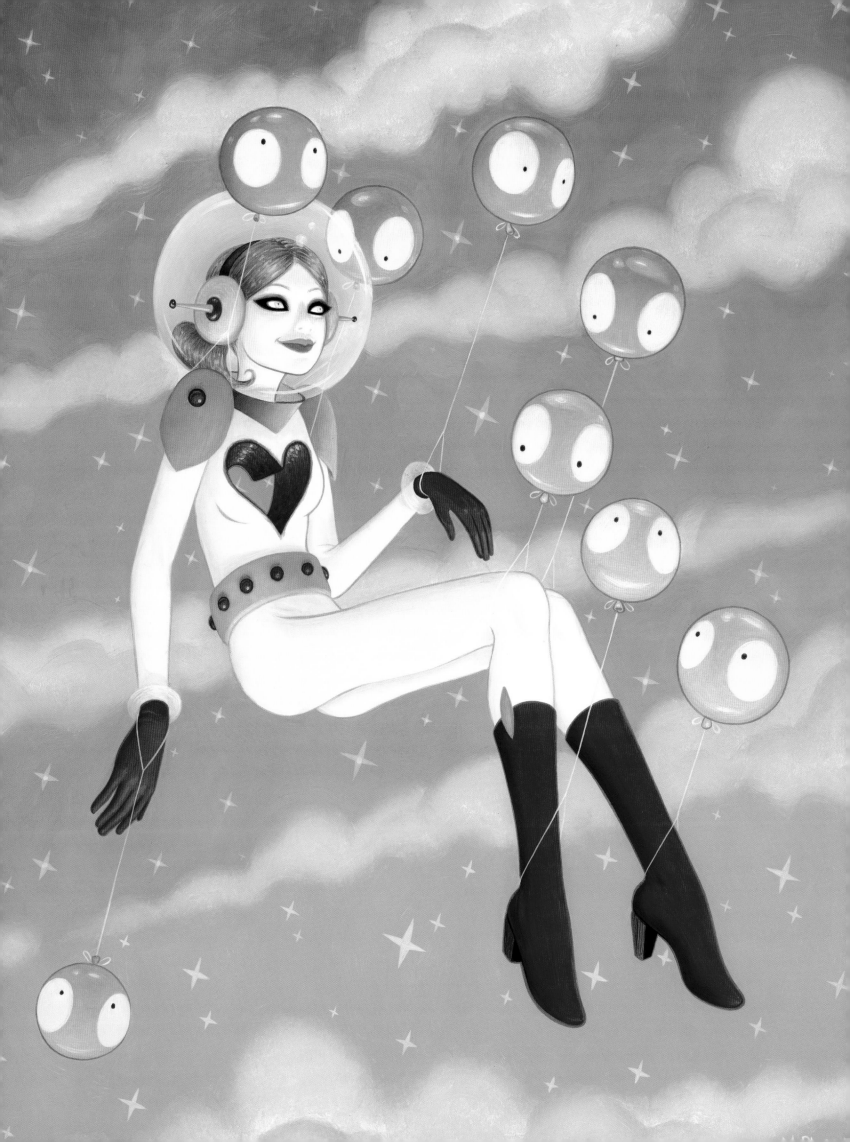

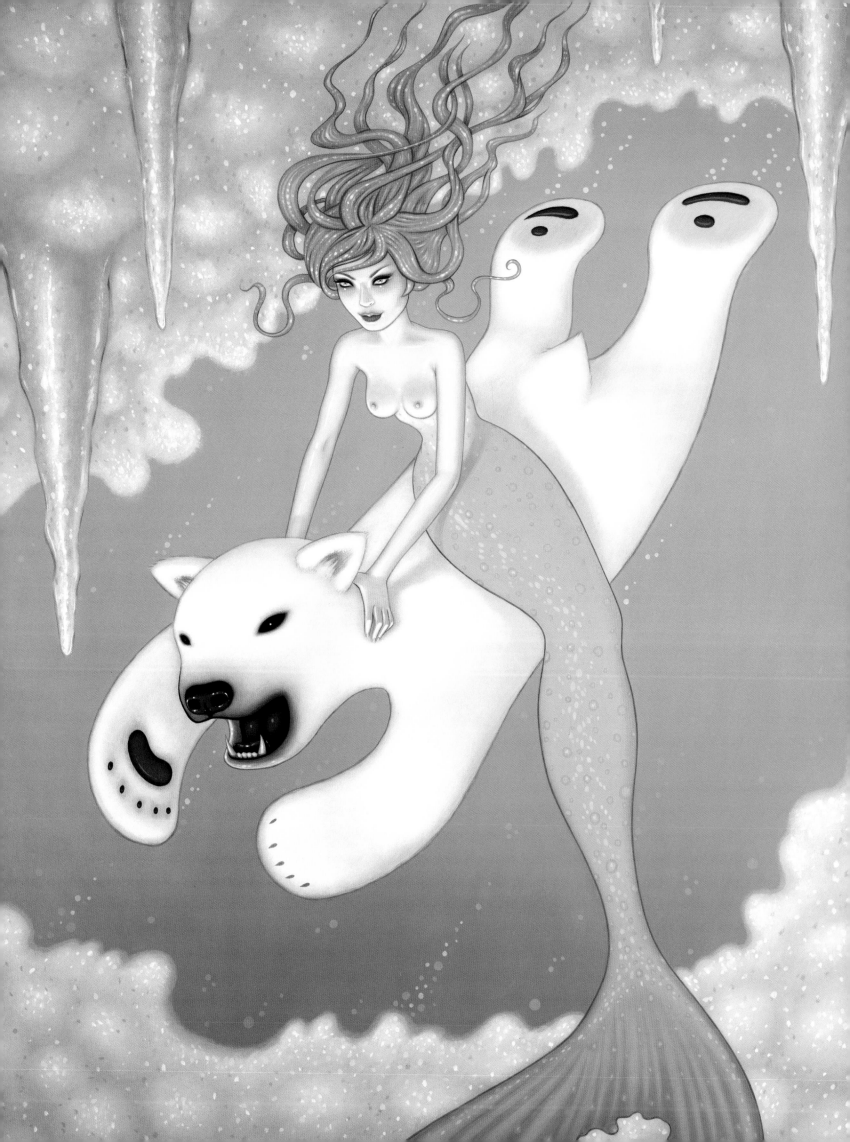

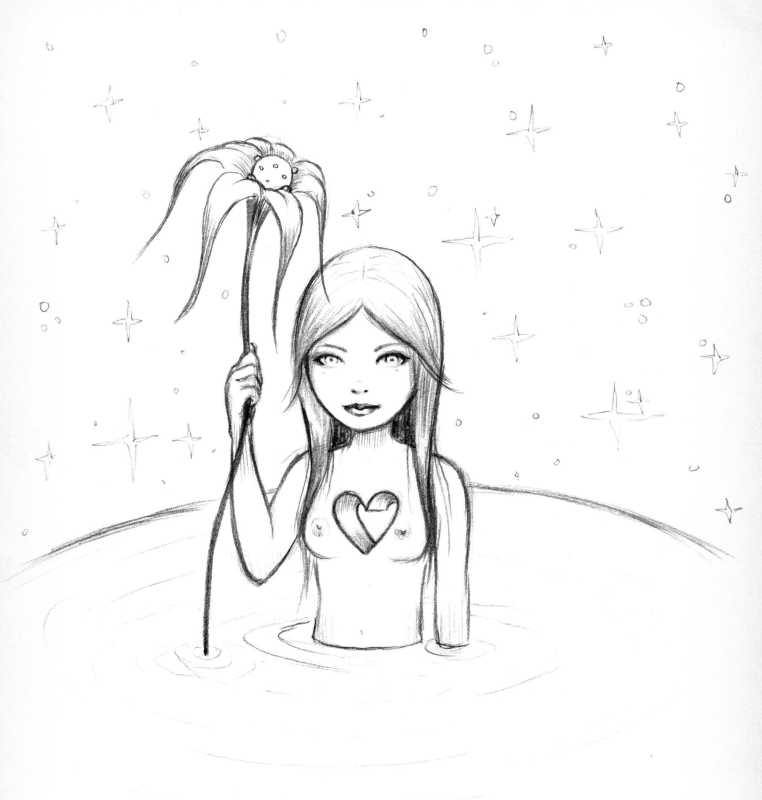

TERRYL WHITLATCH

TERRYL WHITLATCH IS CONSIDERED TO BE ONE OF THE top creature designers and animal anatomists working in the field today. In a career spanning over twenty-five years, Terryl has many projects to her credit, including *Star Wars: The Phantom Menace*, *Star Wars: The Special Edition*, *Jumanji* 1 and 2, *Men in Black*, *Brother Bear, Dragonheart, Alvin and the Chipmunks, Curious George, The Polar Express, The Princess of Mars, Zafari* and *Beowulf* — to name a few.

Her clients include Industrial Light and Magic, Lucasfilm, Ltd., Pixar, Talking Pictures, Walt Disney Feature Animation, PDI, EA, LucasArts, Chronicle Books, Simon and Schuster and various zoos and natural history museums. Terryl is also the author of two books, *The Wildlife of Star Wars* and *The Katurran Odyssey*, volume one of a forthcoming series *The Katurran Trilogy*.

In addition, Terryl is involved with several other book and film concepts, as well as teaching creature design and construction/anatomy at the Academy of Art University in San Francisco, California.

HELPFULBEAR.COM

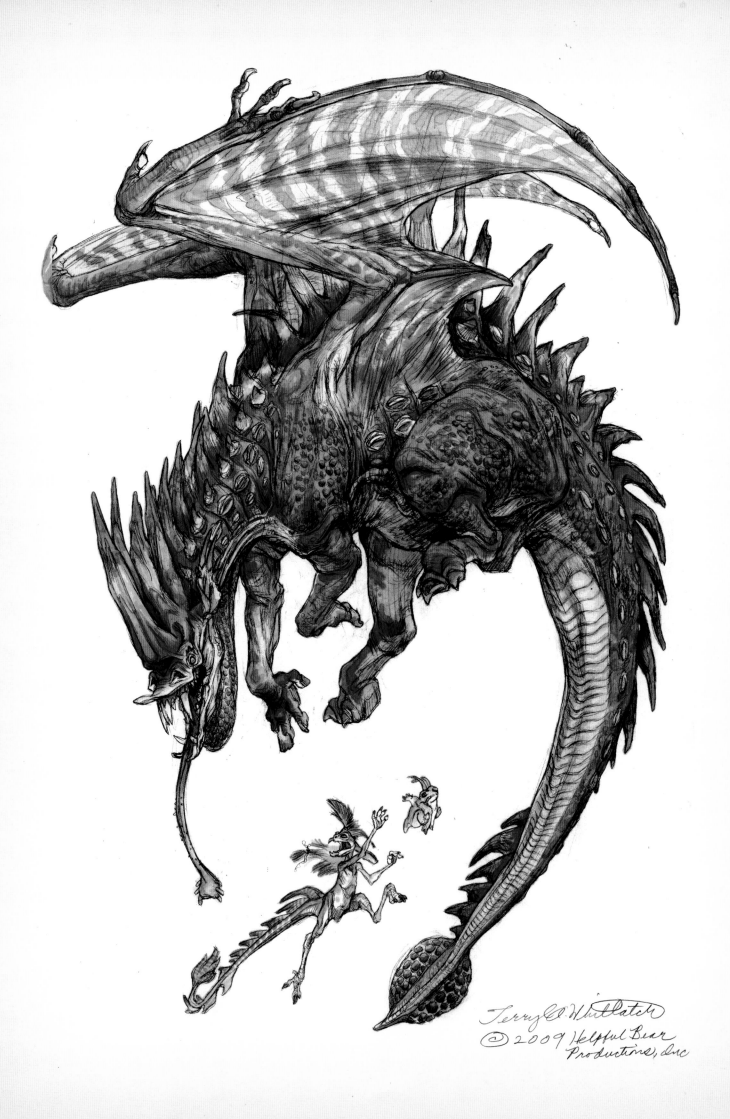

Terryl Whitlatch
©2009 Helpful Bear
Productions, Inc

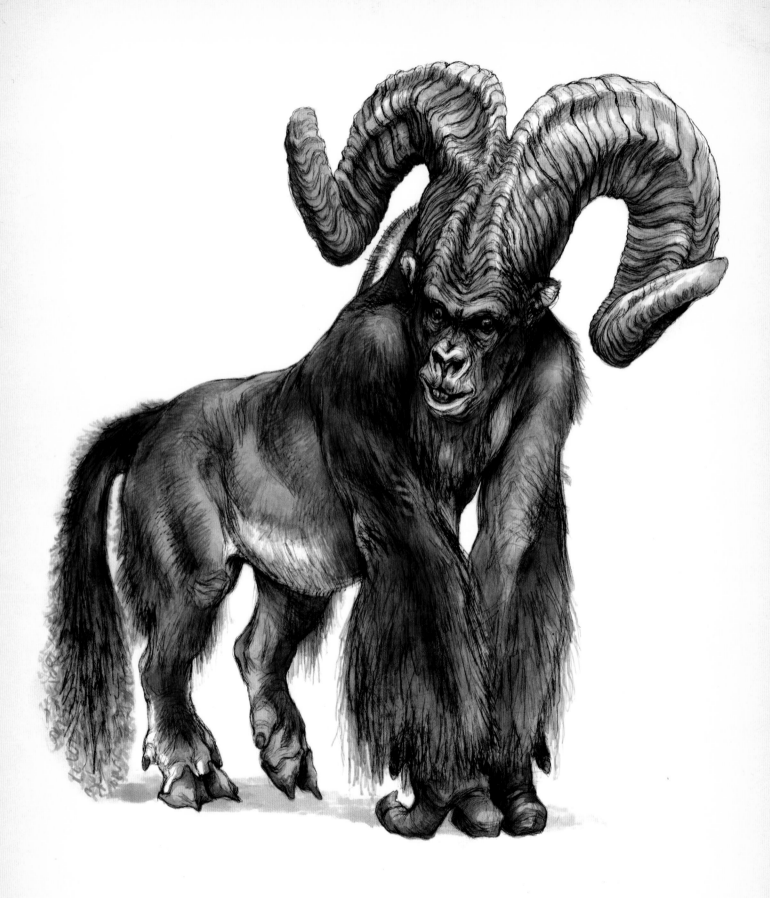

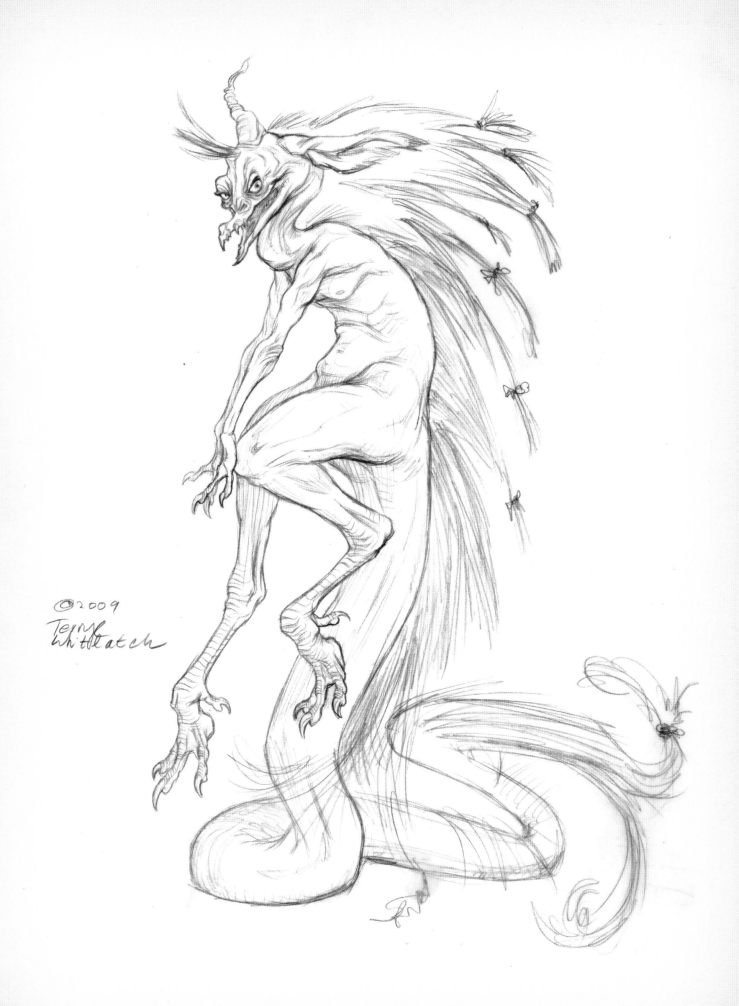

©2009
Terryl
Whitlatch

TOM BAXA

Thomas M. Baxa has been creating fantasy creatures that haunt the imagination for over twenty years. He works primarily in the role-playing game industry where he has contributed to countless games, including *Dungeons and Dragons*, *Shadowrun*, *Vampire*, *Magic: The Gathering* and *World of Warcraft*. Tom has done a multitude of illustrations focusing on dynamic character design and action. His work has a creepy and often disturbing edge to it that appeals to fantasy and horror fans alike.

He currently lives in Los Angeles, California and freelances full-time as an illustrator and concept artist, designing characters for games, books, miniatures, video games and film, while developing his own projects.

BAXAART.COM

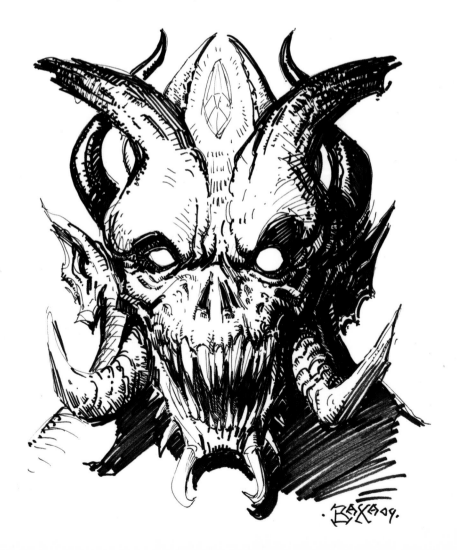

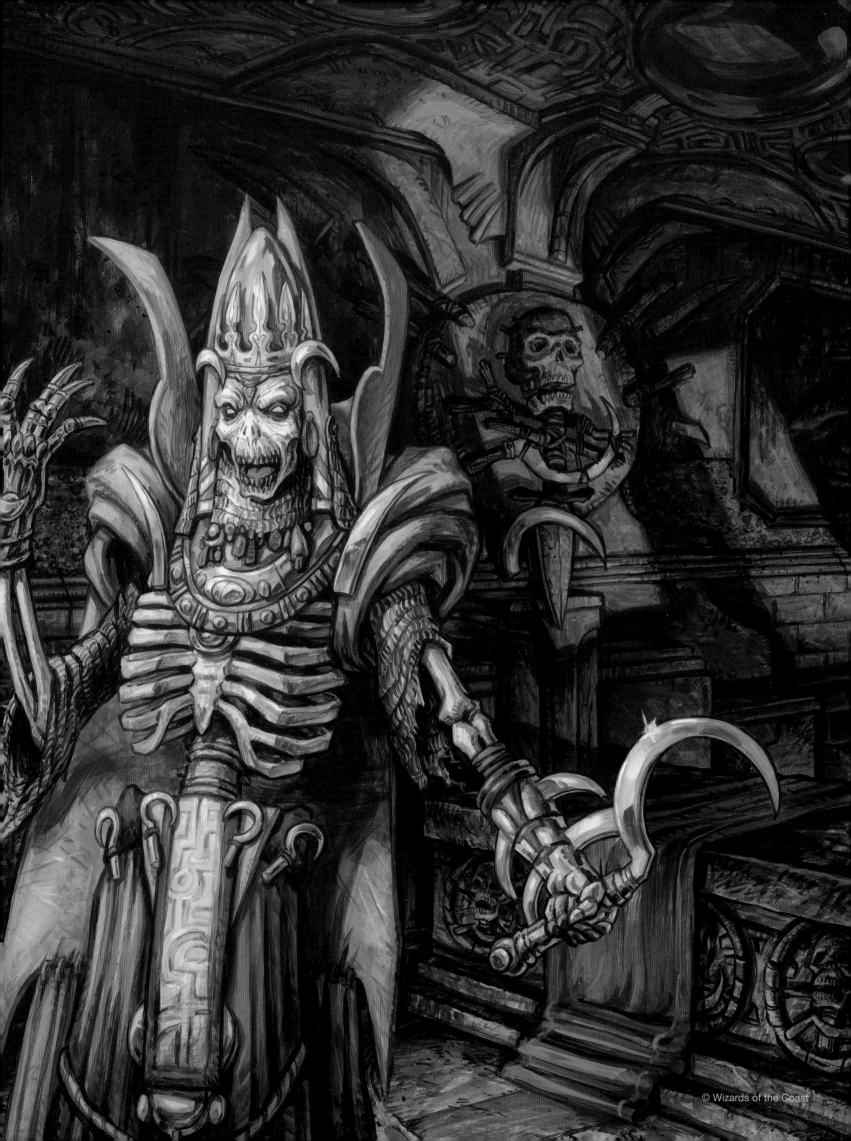

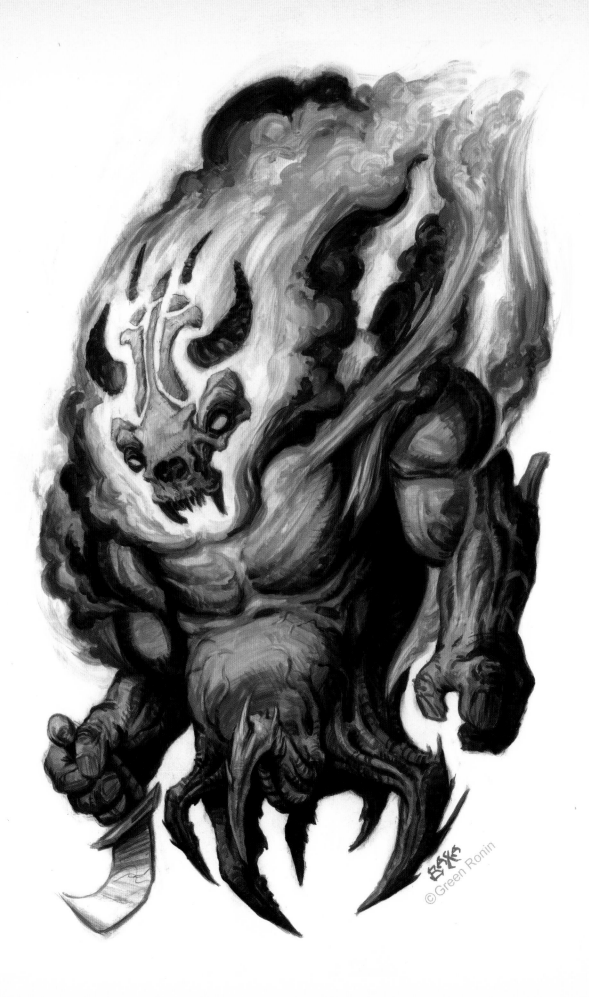

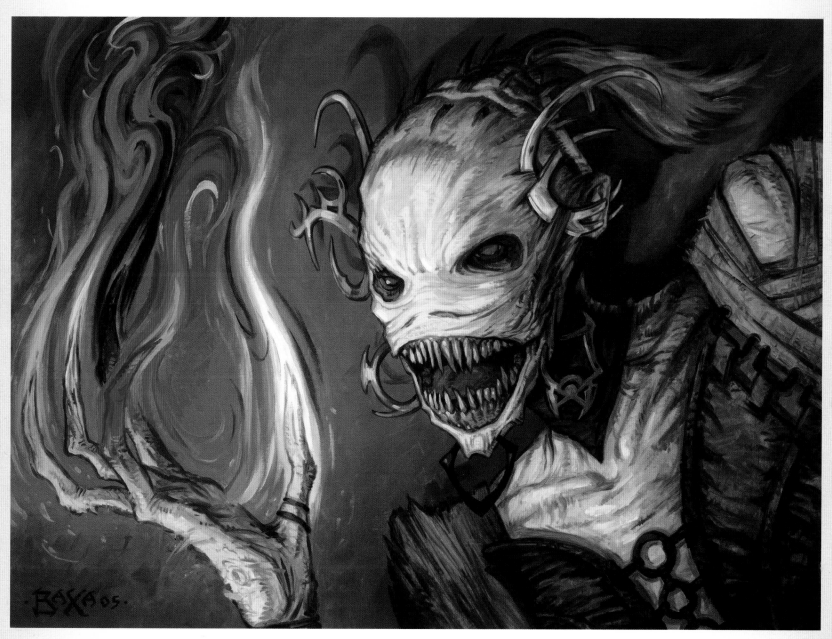

229

TRAVIS LOUIE

Travis Louie's paintings come from the tiny little drawings and many writings in his journals. He's created his own imaginary world that is grounded in Victorian and Edwardian times. It is inhabited by human oddities, mythical beings and otherworldly characters that appear to have had their formal portraits taken to mark their existence and place in society. Using inventive techniques of painting with acrylic washes and simple textures on smooth boards, he's created portraits from an alternate universe that seemingly may or may not have existed.

Travis Louie was born in Queens, New York, about a mile from the site of the 1964 World's Fair. His early childhood was spent making drawings and watching "Atomic Age" sci-fi and horror movies. There were many Saturday afternoon trips to the local comics shop and noon matinees at the RKO Keith's cinema on Northern Boulevard, where he marveled at the 1950's memorabilia: the rocket ships, the superheroes, the giant monsters and old pulp art covers. He did thousands of sketches of genre characters like Godzilla, King Kong and a host of creatures from Ray Harryhausen movies.

After high school, he went to the Pratt Institute in Brooklyn, New York and graduated with a degree from the communication design department with the intent on pursuing a freelance illustration career. The work wasn't as rewarding as he had anticipated. After a few years freelancing, he created a body of paintings and began showing them in local art galleries. The response was very encouraging. He stopped actively pursuing illustration work and began taking on more private commissions and concentrating his efforts on gallery shows.

The influences for his work are many; the genre films, his fascination with human oddities, circus sideshows, old Vaudeville magic acts, Victorian portraits and things otherworldly are all blended together to enable him to bring life to the characters and stories he writes in his journals.

TRAVISLOUIE.COM

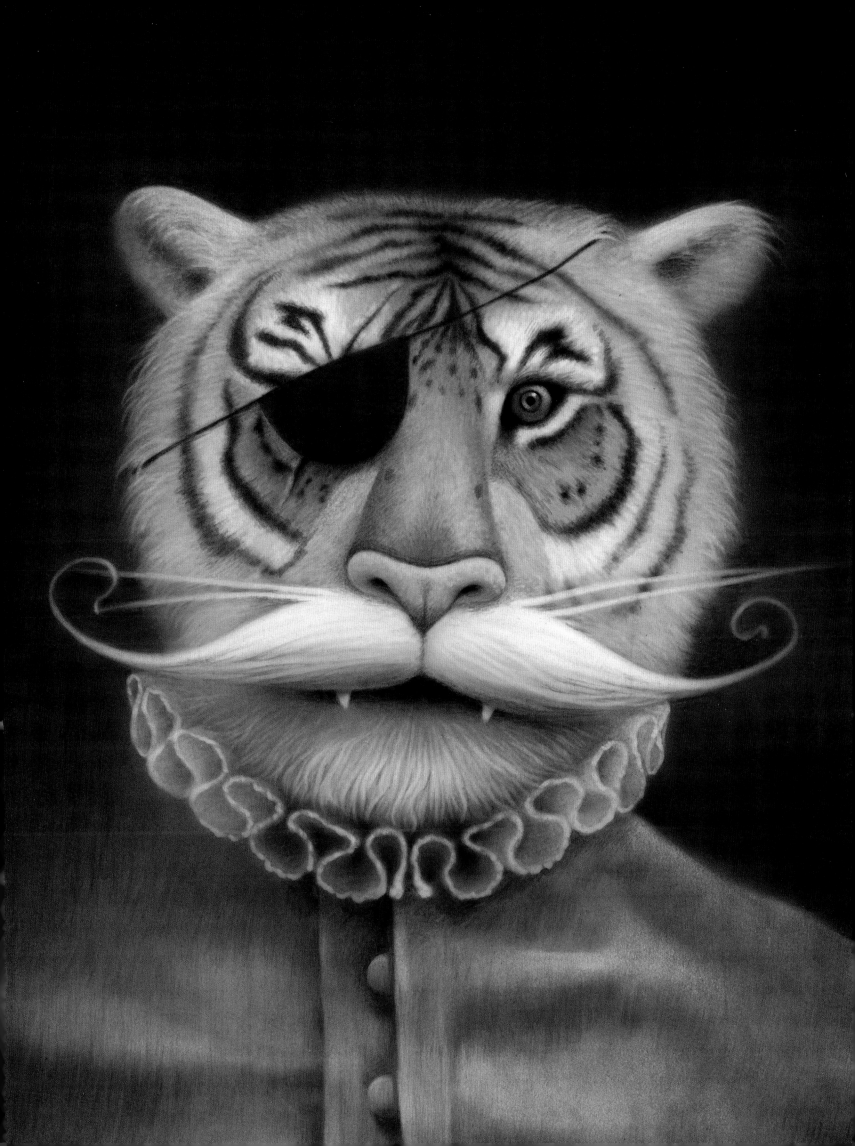

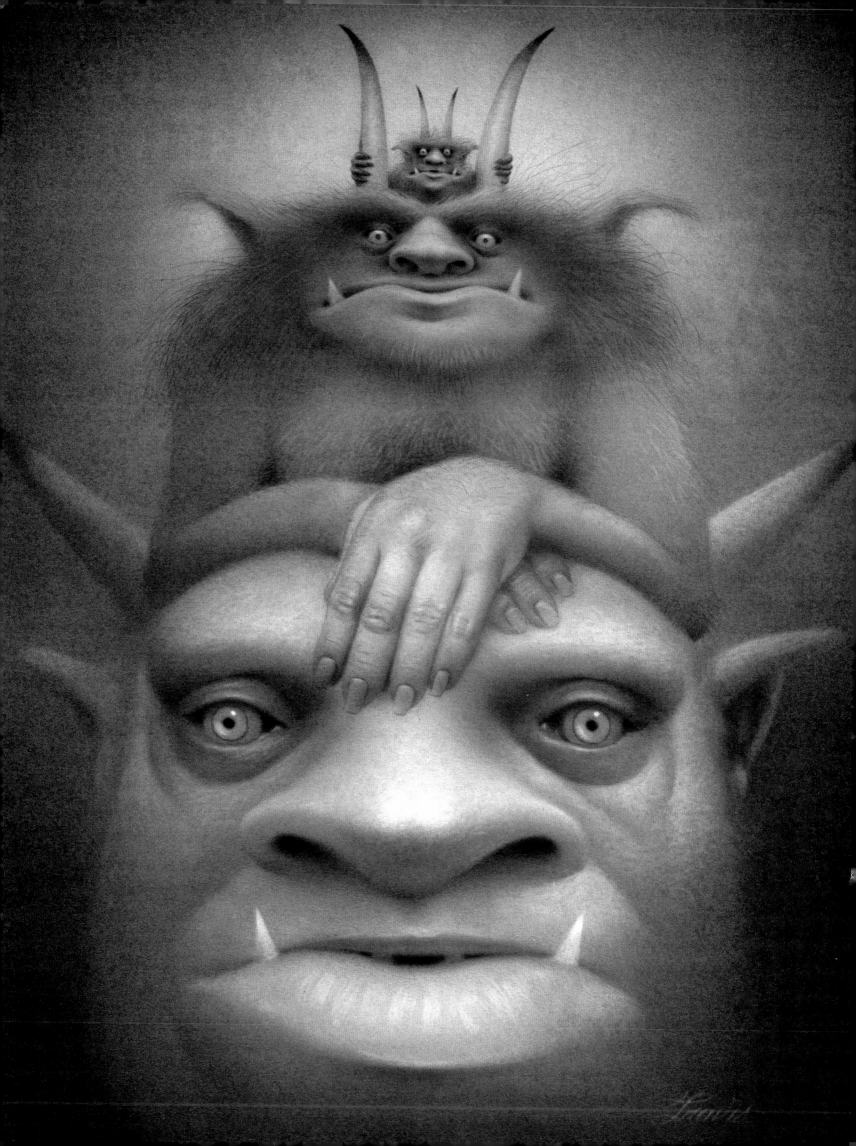

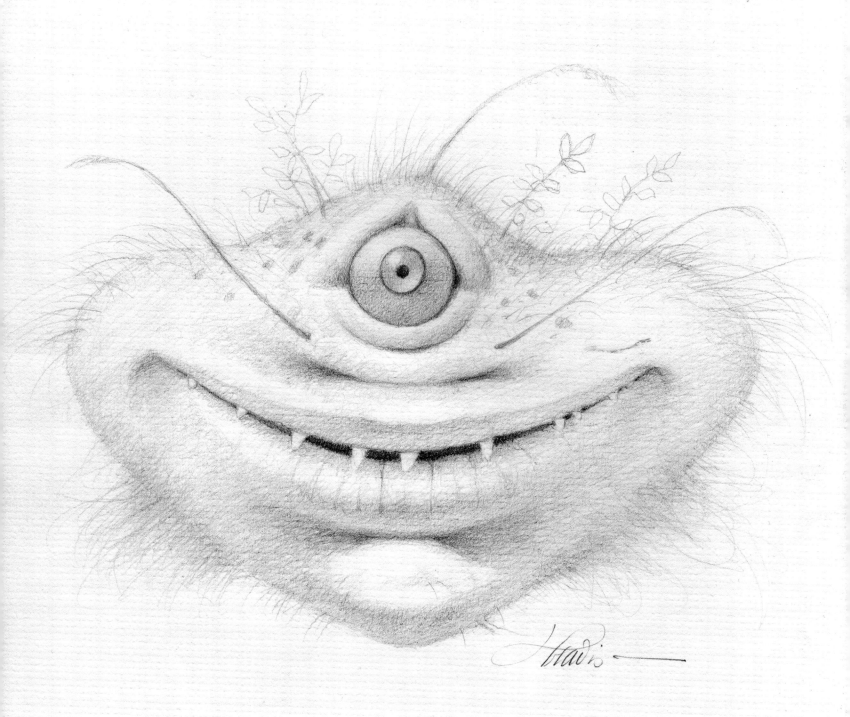

WAYNE BARLOWE

Wayne Barlowe is an author and illustrator who has created images for books, films and galleries. After attending Cooper Union in New York City, he created hundreds of paperback book covers for all of the major publishers as well as illustrations for *Life*, *Time* and *Newsweek*.

He is the author and illustrator of *Expedition*, *Barlowe's Guide to Extraterrestrials*, *Barlowe's Guide to Fantasy*, *Barlowe's Inferno*, *Brushfire: Illuminations from the Inferno*, *The Alien Life of Wayne Barlowe* and *An Alphabet of Dinosaurs*. His character designs can be seen in *Blade 2*, *Galaxy Quest*, *Hellboy* and *Hellboy 2*, *Harry Potter and the Prisoner of Azkaban*, *Harry Potter and the Goblet of Fire*, *Avatar*, *The Hobbit* and *Alien Planet*, a Discovery Channel special based on *Expedition*.

He also contributed many designs to EA's *Dante's Inferno*. He is currently writing the sequel to his first novel, *God's Demon*, entitled *The Heart of Hell*.

WAYNEBARLOWE.COM

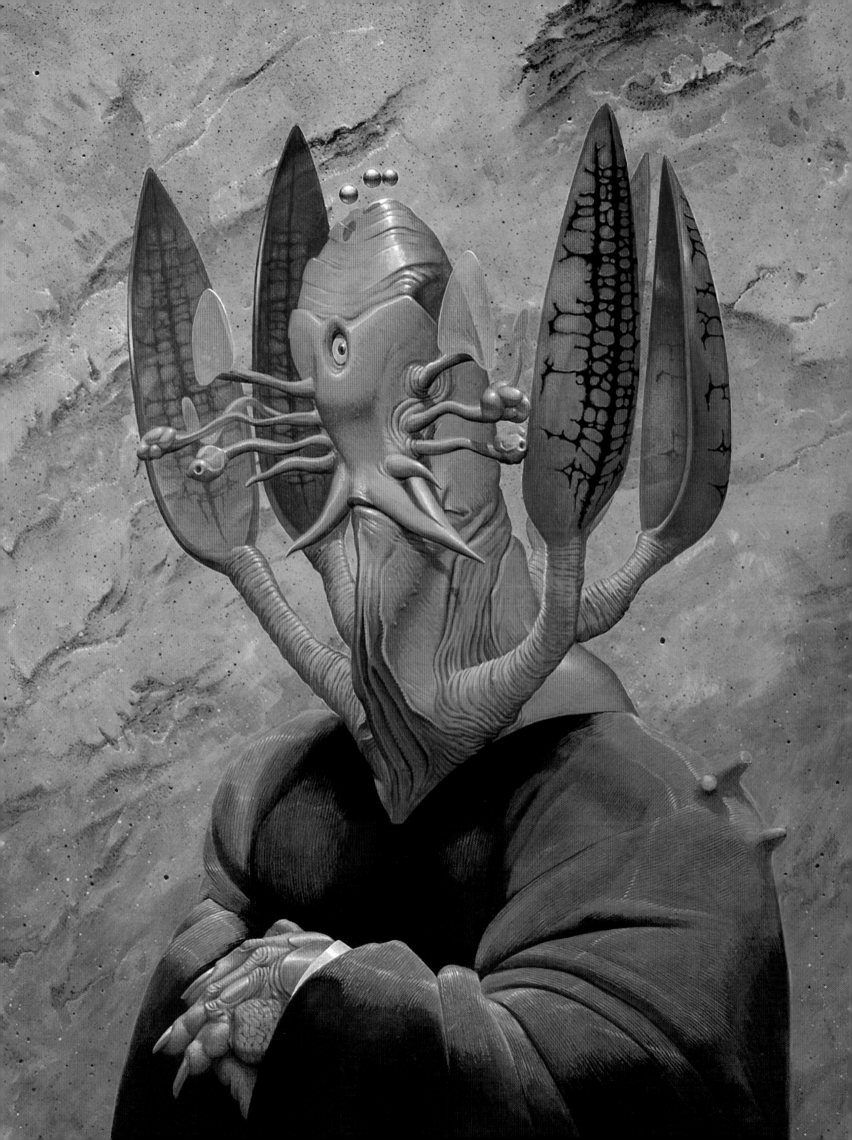

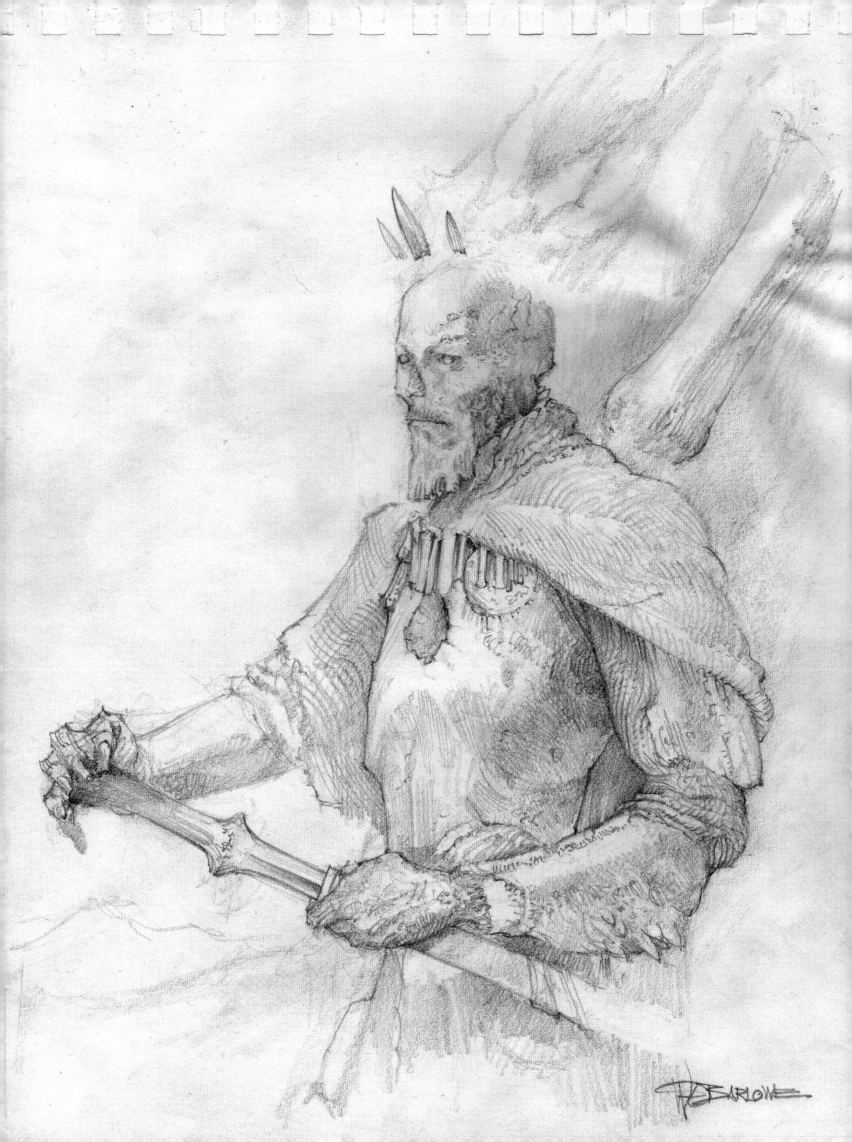